AMERICAN ARCHITECTURE AND ART

AMERICAN STUDIES INFORMATION GUIDE SERIES

Series Editor: Donald Koster, Professor of English, Adelphi University, Garden City, New York

Also in this series:

AFRO-AMERICAN LITERATURE AND CULTURE SINCE WORLD WAR II—*Edited by Charles D. Peavy***

AMERICAN FOLKLORE—*Edited by Richard M. Dorson***

AMERICAN HUMOR AND HUMORISTS—*Edited by M. Thomas Inge***

AMERICAN LANGUAGE AND LITERATURE—*Edited by Henry Wasser***

AMERICAN MUSIC—*Edited by Barbara Hampton***

AMERICAN POPULAR CULTURE—*Edited by Marshall W. Fishwick and Larry Landrum***

THE AMERICAN PRESIDENCY—*Edited by Kenneth E. Davison***

AMERICAN RELIGION AND PHILOSOPHY—*Edited by Ernest R. Sandeen***

AMERICAN STUDIES—*Edited by David W. Marcell***

ANTHROPOLOGY OF THE AMERICAS—*Edited by Thomas C. Greaves***

EDUCATION IN AMERICA—*Edited by Richard G. Durnin***

HISTORY OF THE UNITED STATES OF AMERICA—*Edited by Ernest Cassara**

NORTH AMERICAN JEWISH LITERATURE—*Edited by Ira Bruce Nadel***

SOCIOLOGY OF AMERICA—*Edited by Charles Mark*

WOMAN IN AMERICA—*Edited by Virginia R. Terris***

*in press
**in preparation

The above series is part of the
GALE INFORMATION GUIDE LIBRARY

The Library consists of a number of separate series of guides covering major areas in the social sciences, humanities, and current affairs.

General Editor: Paul Wasserman, Professor and former Dean, School of Library and Information Services, University of Maryland

AMERICAN ARCHITECTURE AND ART

A GUIDE TO INFORMATION SOURCES

*Volume 2 in the American Studies
Information Guide Series*

David M. Sokol

*Associate Professor of History of Architecture and Art
University of Illinois at Chicago Circle*

Gale Research Company
Book Tower, Detroit, Michigan 48226

FI8

Library of Congress Cataloging in Publication Data

Sokol, David M
 American architecture and art.

4 40 (American studies information guide series; v. 2)
(Gale information guide library) — 490 0
 Includes index.
 1. Architecture--United States--Bibliography.
2. Art, American--Bibliography. I. Title.
Z5961.U5S64 [N6505] 016.709'73 73-17563
ISBN 0-8103-1255-7

VITA

David M. Sokol is an associate professor of the history of architecture and art at the University of Illinois, Chicago Circle. He is president of the Chicago Circle chapter of the American Association of University Professors and president of the Wisconsin-North Illinois chapter of the American Studies Association; his other professional affiliations include membership in the American Society for Aesthetics, American Studies Association, College Art Association of America, and Mid-West Organization of Art Historians. He received his M.A. in art history from the Institute of Fine Arts, New York University, and his Ph. D. in American and modern architecture and art from New York University.

Sokol served as a coordinating bibliographer for architecture and art on the AMERICAN QUARTERLY. He is presently a member of the editorial board of the AMERICAN ART REVIEW. Sokol has written an exhibition catalog on the nineteenth-century American painter, John Quidor; he has also written numerous articles for art magazines, reviews, and reference works, and has lectured and presented papers on American art.

CONTENTS

Contents

FOREWORD

The purpose of this series of information guides in American Studies is to present up-to-date aids to research in as many of the facets of American civilization as possible. In this second book of the series, David Sokol's AMERICAN ARCHI-TECTURE AND ART, we have a work that guides us to a judicious selection of both basic and specialized literature in a most important area.

Professor Sokol has organized his material according to a format that ranges in each category he treats from the general to the quite specific. Although the major portion of the book is concerned with architecture and painting, he has included valuable chapters on sculpture and the decorative arts to round out a volume that should be of enormous assistance in locating important sources for study.

It is my belief that both the beginner in search of those works that can best help him to achieve a sense of direction in understanding American art and architecture and the scholar who wants a readily available and reliable biblio-graphical tool will find Professor Sokol's book to be invaluable.

Donald N. Koster
Series Editor

PREFACE

The purpose of this volume is to present the reader with a guide to the basic and specialized literature in the field of American architecture and art. The term art is used here in its broader sense of painting, sculpture, decorative arts, and graphics: in the present century, it should be noted, the lines classifying the various media have become increasingly vague.

A most relevant pair of questions are, "What is American art?" and "Who is an American artist?" American art is defined in this volume as the work done by Americans here or abroad who somehow related their life to their Americanism or those Europeans who produced works with American subjects for American consumption. According to this criterion, which is obviously subjective, I include the painter Benjamin West, who spent two-thirds of his life abroad but who continued to accept American students and to send much of his output to American buyers, but omit the well-known Whistler, who had little contact with the American art scene and whose work was of little influence on American artists. In sculpture, several Americans spent their entire careers in Italy, but continued to influence American taste and style, and are thus included. Similarly in architecture, the work of such Europeans as Gropius and Mies Van der Rohe is included, as their careers here were extremely important in shaping the course of American architecture. Where it is unclear whether or not to include a figure, the tendency has been to do so. In regard to the criteria for selection of materials, I have excluded all unpublished material as generally inaccessible, and confined entries to those written in English. Archival sources have not been included with the exception of the guide to the Archives of American Art, which itself indexes the scope and depth of major archival sources. The newer updated material has been selected in preference to the old and out of print, but the main consideration has been the quality of information in a book or periodical article. Essential standard material that has not been made available in new editions or reprints, even if published in the nineteenth century, is included. Wherever reprints are available, they have been listed.

Periodicals included range from those that are generally identified as art magazines, to specialized journals, to nonart publications. The rationale for inclusion is, again, the quality of the work as a unique source. Reviews of exhibitions are omitted when a catalog is included.

Preface

The exhitition catalogs themselves, especially those substantial ones produced by the major museums, appear frequently as the primary source of information on many painters and sculptors. The catalogs are sometimes listed by author and sometimes by institution. The former course is taken whenever possible and where an examination of library card catalogs and/or major subject bibliographies is likely to disclose the person responsible for the written material. In those cases where a museum director has merely prepared a preface to an annotated catalog, the museum is usually listed as author following the University of Chicago Press guidelines.

Whenever possible, the number of illustrations and the number of color illustrations are noted, especially in those works concerned with painting, as illustrations are so important in evaluating the importance of the work. For that reason many "picture books" with an insignificant amount of text are included. In some of the older volumes, gravure plates are the form of illustrations and they are generally more valuable visually than the average black and white reproduction.

The amount of space devoted to each of the arts reflects both the history of taste and contemporary values. There has been much more written about painting than about almost all the other art forms together, but there have been very few studies on American graphics. While there has been an attempt to list significant work in all areas, the entries reflect both the importance of the material and the availability of information, both of a general and a scholarly nature.

Finally, there is obvious selectivity involved, for one could fill an entire volume this size by attempting to present a significant percentage of the writings on such figures as Frank Lloyd Wright and Winslow Homer. The amount of selectivity has increased, however, as we get closer to our own time, especially in the area of painting. There are so many exhibitions, so many art magazines, and so many "coffee table" books published on painting, that the greatest selectivity was exercised in presenting a balanced picture of the current art scene. Therefore only those contemporary figures with established reputations have been included.

There might well be errors in judgment in the selection of material for inclusion, but I believe that the sum is a fair representation of the history of architecture and art in this country.

Chapter 1
GENERAL REFERENCE SOURCES

BIBLIOGRAPHIES, DIRECTORIES, AND LIBRARY CATALOGS

The following are important guides to material on American architecture and art. Some are international in scope and some deal only with American material. Several of the bibliographies contain biographical material and are so noted. Other important art reference libraries exist, but the ones noted publish catalogs which are readily available.

1. AMERICAN ART ANNUAL. 37 vols. New York and Washington, D.C.: American Federation of Arts, 1898-1948. Frequency varies.

 A rich source of information on American art, although content differs with each issue. Almost uniformly includes major art schools, museums, and professional organizations, and often includes biographical and sales information.

2. AMERICAN ART DIRECTORY. New York: R.R. Bowker Co., for the American Federation of Arts, 1952- . Triennial.

 Continues the directory part of the AMERICAN ART ANNUAL. Museums, art schools, and professional organizations are included.

3. AMERICAN ASSOCIATION OF ARCHITECTURAL BIBLIOGRAPHERS. PAPERS. Charlottesville: University Press of Virginia, 1965- . Annual.

 Provides highly specialized bibliographies on architectural subjects. An issue will usually contain several bibliographies and most will be on American topics.

4. ARTBIBLIOGRAPHIES: CURRENT TITLES. Santa Barbara, Calif.: Clio Press, 1972- . Monthly.

 Provides the contents page of a couple of hundred periodicals in all areas of art.

5 ARTBIBLIOGRAPHIES: MODERN. Santa Barbara, Calif.: Clio Press, 1972- . Semiannual.

Provides abstracts of current books, articles, and exhibition catalogs on twentieth-century art.

6 ART INDEX. New York: H. W. Wilson, 1929- . Quarterly.

The most important guide to the majority of art periodicals published both here and abroad. Articles, book reviews, and reproductions are indexed quarterly and cumulated annually in recent years.

7 Art Institute of Chicago. INDEX TO ART PERIODICALS, COMPILED IN THE RYERSON LIBRARY OF THE ART INSTITUTE OF CHICAGO. 11 vols. Boston: G.K. Hall, 1962.

The major index of periodicals prior to the founding of the ART INDEX. It includes all the important museum publications.

8 Chamberlin, Mary W. GUIDE TO ART REFERENCE BOOKS. Chicago: American Library Association, 1959. xiv, 418 p.

A general bibliography for the whole range of art. Very little of the material indexed and annotated covers American art, and the date of publication precludes any important recent monographs.

9 Cirker, H., and Cirker, B. DICTIONARY OF AMERICAN PORTRAITS. New York: Dover, 1967. 756 p. Illus.

Portraits of thousands of notable Americans with identifying captions. Though the illustrations leave much to be desired, they can still be an important aid in the identification of subjects.

10. Columbia University. AVERY INDEX TO ARCHITECTURAL PERIODICALS. 2nd ed. 15 vols. Boston: G.K. Hall, 1973.

Indexes all periodical material dealing with architecture and architects, in many languages.

11. Columbia University. CATALOG OF THE AVERY MEMORIAL ARCHITEC-TURAL LIBRARY. 2nd ed. 19 vols., plus supplements. Boston: G.K. Hall, 1968. 1972.

A catalog of the finest university art and architecture library in the United States. More than 100,000 titles are listed.

12. Foster, Donald L. A CHECKLIST OF U.S. GOVERNMENT PUBLICATIONS IN THE ARTS. Urbana: University of Illinois Graduate School of Library

2

Science, 1969. 48 p.

> Brings together the publications of several government bureaus on the arts. A great many titles are concerned with the art of other countries.

13 Harvard University. CATALOG OF THE HARVARD UNIVERSITY FINE ARTS LIBRARY: THE FOGG ART MUSEUM. 15 vols. Boston: G.K. Hall, 1971.

> Similar to the Avery catalog mentioned above; much of the material is identical. This collection, too, covers the range of fine arts, with greater strengths in nonwestern art.

14 Hitchcock, Henry-Russell. AMERICAN ARCHITECTURAL BOOKS: A LIST OF BOOKS, PORTFOLIOS AND PAMPHLETS ON ARCHITECTURE AND RELATED SUBJECTS PUBLISHED IN AMERICA BEFORE 1895. Minneapolis: University of Minnesota Press, 1962. 130 p.

> Lists more than 1,400 items and locates them in both public and private institutional libraries.

15 Lucas, E. Louise. ART BOOKS: A BASIC BIBLIOGRAPHY. Greenwich, Conn.: New York Graphic Society, 1968. 245 p.

> A guide to the volumes necessary for the establishment of a good college art library. Works on American subjects occupy a modest part.

16 McCoy, Garnett. ARCHIVES OF AMERICAN ART: A DIRECTORY OF RESOURCES. New York: R.R. Bowker Co., 1972. ix, 163 p.

> A guide to the major collections of papers within the Archives of American Art, which number some two million items. Letters, diaries, notebooks, records, and other papers are included.

17 Metropolitan Museum of Art. New York. THE METROPOLITAN MUSEUM OF ART: LIBRARY CATALOGUE. 25 vols., plus supplements. Boston: G.K. Hall, 1960, 1962, 1965, 1968, and 1970.

> Similar to those of the major university collections; about 150,000 books and sales catalogs are listed. The Metropolitan is not only the major American museum, but contains the largest and most comprehensive slide library.

18 Munro, Isabel Stevenson, and Munro, Kate M. INDEX TO REPRODUCTIONS OF AMERICAN PAINTINGS: A GUIDE TO PICTURES OCCURRING IN MORE THAN EIGHT HUNDRED BOOKS. New York: H.W. Wilson, 1948. 731 p. INDEX TO REPRODUCTIONS OF AMERICAN PAINTINGS: FIRST SUPPLEMENT. New York: H.W. Wilson, 1964. 480 p.

> An index to reproductions of American paintings, but due to

the date of original publication, the SUPPLEMENT is more useful.

19 Park, Esther A. MURAL PAINTERS IN AMERICA: A BIOGRAPHICAL INDEX. Pittsburg: Kansas State Teachers College, 1949. 182 p.

Includes biographical material on nineteenth and twentieth-century American painters. A good guide to the murals themselves.

20 Rath, Frederick L., Jr. SELECTIVE REFERENCE GUIDE TO HISTORIC PRESERVATION. Cooperstown, N.Y.: New York State Historical Association, 1966. 133 p.

A guide to agencies and a bibliography of the literature related to historic preservation.

21 Rauschenbusch, Helmut, ed. INTERNATIONAL DIRECTORY OF ARTS. Berlin: Deutsche Zentraldrukerei AG, 1952- . Annual.

An international and more comprehensive attempt to include the type of material provided in the AMERICAN ART ANNUAL. Items are printed in the language of the country under discussion.

22 READERS' GUIDE TO PERIODICAL LITERATURE. New York: H.W. Wilson, 1900- . 7 times a year.

Indexes general magazines and some special art magazines rather than scholarly journals. Almost exclusively English language. Cumulated annually.

23 Roos, Frank John, [Jr.]. BIBLIOGRAPHY OF EARLY AMERICAN ARCHITECTURE. Urbana: University of Illinois Press, 1968. 389 p.

Well-indexed volume of bibliography on building and architects of the period. Sections on each chronological period and each state and important town within the state. Indexes books and articles with some annotations.

24 St. Louis Public Library. BLACK AMERICAN ARTISTS INDEX. St. Louis, Mo.: 1972. 50 p. Bibliog. pp. 47-50.

An index of artists, schools, and galleries, primarily of the twentieth century, but incorporating available earlier material. References from books, journals, and newspapers.

25 Sims, Lowery S. "Black Americans in the Visual Arts: A Survey of Bibliographic Material and Research Sources." ARTFORUM 11 (April 1973): 66-70.

An up-to-date basic bibliography of black American architects

4

and artists including books, articles, exhibition catalogs, and
visual material.

26 Whitehill, Walter Muir, et al. THE ARTS IN EARLY AMERICAN HIS-
 TORY. Chapel Hill: University of North Carolina Press, 1965. 170 p.

 A detailed bibliography of books and articles on early Ameri-
 can fine and decorative art. An introductory essay is in-
 cluded.

BIOGRAPHICAL SOURCES, DICTIONARIES, AND ENCYCLOPEDIAS

27 Benezit, Emmanuel. DICTIONNAIRE CRITIQUE ET DOCUMENTAIRE
 DES PEINTRES, SCULPTEURS, DESSINATEURS ET GRAVEURS... 8 vols.
 Paris: Librarie Grund, 1948-55. Illus.

 A major biographical dictionary, in French, with moderate
 coverage of American artists.

28 Cederholm, Theresa Dickason. AFRO-AMERICAN ARTISTS: A BIO-
 BIBLIOGRAPHICAL DIRECTORY. Boston: Boston Public Library, 1973.
 345 p. Bibliog. pp. 325-48.

 An up-to-date encyclopedia of thousands of black American
 artists in all media. Bibliography relates to each artist under
 his heading, general material being at back of volume.

29 Clement, Clara, and Hutton, Laurence. ARTISTS OF THE NINETEENTH
 CENTURY AND THEIR WORK. 2 vols. 1889. Reprint (2 vols. in 1).
 St. Louis: North Point, 1969. xxxix, vol. 1, 386 p.; vol. 2, 373 p.

 Generally accurate biographical sketches of over 2,000
 artists, including many American painters, sculptors, and
 graphic artists.

30 Collins, James L. WOMEN ARTISTS IN AMERICA: EIGHTEENTH
 CENTURY TO THE PRESENT. Chattanooga, Tenn.: privately printed,
 1973. Unpaged. Illus.

 A biographical dictionary of women in painting, sculpture,
 printmaking, and a few ceramists. Thousands of entries,
 some minimal, others containing much useful information.
 Although privately printed, readily available.

31 Columbia University. AVERY OBITUARY INDEX OF ARCHITECTS AND
 ARTISTS. Boston: G.K. Hall, 1963. 338 p.

 Although obituaries of architects rather than artists are em-
 phasized, many of the latter are included. Very good cover-
 age of American subjects.

32 Cummings, Paul. A DICTIONARY OF CONTEMPORARY AMERICAN
ARTISTS. New York: St. Martin's Press, 1971. 368 p. Illus.
Bibliog. pp. 343–68.

 A biographical and bibliographical guide to American twentieth-
 century artists both living and dead.

33 Dunlap, William. HISTORY OF THE RISE AND PROGRESS OF THE
ARTS OF DESIGN IN THE UNITED STATES. Introduction by William
P. Campbell. Newly edited by Alexander Wyckoff. Incorporating the
notes and additions compiled by Frank W[illiam] Bayley and Charles
Goodspeed. New ed., rev. and enl. 3 vol. New York: Benjamin
Blom, 1965. Vol. 1, 403 p.; vol. 2, 427 p.; vol. 3, 417 p. Bibliog.
vol. 3, pp. 346–77.

 A well-edited version of Dunlap's classic work. Brief biog-
 raphies and criticism of hundreds of American artists of the
 colonial period and the first third of the nineteenth century.
 A major source, but one that should be used with caution
 when seeking contemporary information on the art in the
 early period.

34 Earle, Helen L. BIOGRAPHICAL SKETCHES OF AMERICAN ARTISTS.
5th ed. Charleston, S.C.: Garnier and Co., n.d. 370 p. Bibliog.
pp. 351–70.

 A biographical dictionary that is limited to artists up to the
 Depression.

35 ENCYCLOPEDIA OF WORLD ART. 15 vols. New York: McGraw-
Hill Book Co., 1959–69. Illus., many in color.

 The major English language art encyclopedia, international
 in scope, but valuable for major articles on American art.
 Contains bibliographical information and many fine color
 plates.

36 Fielding, Mantle. DICTIONARY OF AMERICAN PAINTERS, SCULPTORS
AND ENGRAVERS: FROM COLONIAL TIMES THROUGH 1926. New
York: Paul A. Strook, 1960. 433 p. Bibliog. pp. 424–33.

 Like the work by Dunlap, limited to artists of established
 reputations and suffers from being dated. Editions since 1926
 have been corrected but not updated.

37 Groce, George C., and Wallace, David H. THE NEW YORK HISTORI-
CAL SOCIETY'S DICTIONARY OF ARTISTS IN AMERICA: 1564–1860.
New Haven: Yale University Press, 1957. 759 p.

 A more scholarly source than Dunlap, includes both biographi-
 cal and bibliographical information.

38 Havlice, Patricia Pate. INDEX TO ARTISTIC BIOGRAPHY. 2 vols.
 Metuchen, N.J.: Scarecrow, 1973. viii, 1,362 p.

 A guide to major reference works in many languages. Mod-
 erately useful source for information on American artists.

39 Kelby, William. NOTES ON AMERICAN ARTISTS, 1754-1820: COPIED
 FROM THE ADVERTISEMENTS APPEARING IN THE NEWSPAPERS OF
 THE DAY. New York: New York Historical Society, 1922. 80 p.

 Serves as a particularly slanted biographical guide that pro-
 jects the artists' self image. Interesting Americana.

40 McGRAW-HILL DICTIONARY OF ART. 5 vols. New York: McGraw-
 Hill Book Co., 1969. Illus., many in color.

 A valuable encyclopedia with both biographical and biblio-
 graphical information. As with the ENCYCLOPEDIA OF
 WORLD ART, it is international in coverage but fairly com-
 plete for American subjects.

41 Mallett, Daniel Trowbridge. MALLETT'S INDEX OF ARTISTS. New
 York: Peter Smith, 1948. 493 p. SUPPLEMENT TO MALLETT'S INDEX
 OF ARTISTS. New York: Peter Smith, 1948. 319 p.

 Indexes basic biographical reference works on artists of all
 countries, but stronger on American artists than is Havlice.

42 Park, Helen. A LIST OF ARCHITECTURAL BOOKS AVAILABLE IN
 AMERICA BEFORE THE REVOLUTION. Rev. ed. Los Angeles: Hen-
 nessey & Ingalls, 1973. xv, 79 p. Illus.

 An important reference source for those seeking to research
 the possible sources of early American buildings and the roots
 of their style.

43 PHAIDON DICTIONARY OF TWENTIETH CENTURY ART. London and
 New York: Phaidon Press, 1973. 420 p. plus illus.

 Biographical and bibliographical material on international
 twentieth-century art. Strong on the American movements
 and artists.

44 PRAEGER ENCYCLOPEDIA OF ART. 5 vols. New York: Frederick A.
 Praeger, 1971. Illus., 17 in color.

 The translation of a French encyclopedia. It provides fair
 coverage of American artists and art movements.

45 Shapely, John, et al. THE INDEX OF TWENTIETH CENTURY ARTISTS.
 New York: College Art Association, 1933-36. Monthly.

An important but limited tool; includes both biographical and
bibliographical material. Bound annually.

46 Smith, Ralph Clifton. A BIOGRAPHICAL INDEX OF AMERICAN ART-
ISTS. Baltimore: Williams and Wilkins, 1930. 102 p.

Short entries for almost 5,000 artists.

47 Thieme, Ulrich, and Becker, Felix. ALLGEMEINES LEXIKON DER
BILDENDEN KUNSTLER.... 37 vols. Leipzig: Verlag von Wilhelm
Engelmann, 1907-50.

The largest and best-known international biographical diction-
ary. Written in German, important names, places, and works
of art appear in the language concerned. Superior coverage
of American subjects.

48 Vollmer, Hans. ALLGEMEINES LEXIKON DER BILDENDEN KUNSTLER:
DES XX JAHRHUNDERTS. 6 vols. Leipzig: Veb. E.A. Seemann
Verlag, 1953-62.

Serves as a supplementary biographical and bibliographical
companion to the Thieme-Becker work. Important for Ameri-
can twentieth-century painters.

49 WHO'S WHO IN AMERICAN ART. New York: R.R. Bowker and the
American Federation of Arts, 1936- . Triennial.

Continuation of the biographical part of the AMERICAN ART
ANNUAL. Includes material on Canadian artists.

50 Withey, Henry F. BIOGRAPHICAL DICTIONARY OF AMERICAN AR-
CHITECTS. Los Angeles: New Age, 1956. 678 p.

Brief biographies of nearly 2,000 architects in the period from
1740-1952. Best-known buildings are indicated, and some
bibliographical information is provided.

51 Young, William, ed. A DICTIONARY OF AMERICAN ARTISTS, SCULP-
TORS AND ENGRAVERS: FROM THE BEGINNING THROUGH THE
TURN OF THE TWENTIETH CENTURY. Cambridge, Mass.: William
Young and Co., 1968. 515 p.

Inclusive, yet containing very limited information. Possible
source for beginning research.

Chapter 2

GENERAL HISTORIES, AESTHETICS, AND TASTE

The material contained in this section includes the important general histories of American architecture and art and those that concentrate on one century or era, yet cover more than one art form. Critical and aesthetic theories are also included, as are the generally available histories at major institutions.

GENERAL HISTORIES OF AMERICAN ARCHITECTURE AND ART

52 THE ARTIST IN AMERICA. New York: W.W. Norton & Co., for the editors of ART IN AMERICA, 1967. 256 p. Illus.

 A series of nine essays for the layman by American art critics and scholars, and an introduction by the then director of the Whitney Museum of American Art. Each essay treats a chronological period in our history.

53 Cahill, Holger, and Barr, Alfred H., Jr., eds. ART IN AMERICA: A COMPLETE SURVEY. New ed. New York: Halcyon House, 1939. viii, 162 p. Illus., 17 in color. Bibliog. pp. 153-62.

 *709.75 C13
 1935 Ed.*

 An out-of-date survey of all the arts of America. It remains interesting because of the choices and points of view of the authors, both important critics of modern art.

54 Cohen, George M. A HISTORY OF AMERICAN ART. New York: Dell Publishing Co., 1971. xviii, 364 p. 48 illus. Bibliog. pp. 335-45. Paperbound.

 A brief, balanced survey of American architecture, painting, and sculpture. Provides a reasonable introduction for the general reader but lacks enough illustrations to make all points clear.

55 Green, Samuel M. AMERICAN ART: A HISTORICAL SURVEY. New York: The Ronald Press, 1966. 706 p. Illus. Bibliog. pp. 663-68.

 One of the best standard texts on the whole of American art.

Fair and unemotional coverage of painting, sculpture, and architecture. Minimum attention to graphic art and photography. General discussion of each period followed by reference to specific artists.

56 Larkin, Oliver W. ART AND LIFE IN AMERICA. Rev. ed. New York: Holt, 1960. 559 p. Illus. Bibliog. pp. 491-525.

q 709.73
L32a 2

An important basic survey, though obviously dated. The interpretation of American art history is a personal view of the author, and both the strength and weakness of the book stem from his speculations. Artists tend to be confined to particular stylistic slots.

57 McCoubrey, John W. AMERICAN ART, 1700-1960: SOURCES AND DOCUMENTS. Sources and Documents in the History of Art Series. Englewood Cliffs, N.J.: Prentice Hall, 1965. 226 p.

Contains essays by artists, historians, and cultural critics arranged chronologically rather than thematically.

58 McLanathan, Richard. THE AMERICAN TRADITION IN THE ARTS. New York: Harcourt, Brace and World, 1968. 492 p. Illus. Bibliog. pp. 471-78.

A general survey of American fine and decorative arts unified in several periods. The author attempts to present the common denominators of each period within the context of the culture.

59 Mendelowitz, Daniel M. A HISTORY OF AMERICAN ART. Rev. ed. New York: Holt, Rinehart and Winston, 1970. 522 p. Illus. Bibliog. pp. 510-12.

M53h2
q 709.73

A general textbook survey of American art, from the colonial period to the present. Adopts many standard cliches.

60 Wright, Louis, et al. THE ARTS IN AMERICA: THE COLONIAL PERIOD. New York: Charles Scribner's Sons, 1966. 368 p. Illus.

Essays by authorities on the various arts. This is the first of a two-volume history.

q 709.73
A79

61 _____. THE ARTS IN AMERICA: THE 19TH CENTURY. New York: Charles Scribner's Sons, 1969. 412 p. Illus.

The second volume in the two-part history of American art. Major essays by authorities on architecture, painting, etc.

q 709.73
A791

LARGE PERIOD AND ETHNIC SURVEYS

Included are broad histories of American and European art of a significantly
large period, surveys of several media in one era, and chronological studies of
the American Indian, the Black American, and the Mexican American.

62 Arnason, H. H. HISTORY OF MODERN ART: PAINTING, SCULPTURE,
ARCHITECTURE. New York: Harry N. Abrams, 1968. 667 p. Illus.,
264 in color. Bibliog. pp. 631–43.

709.04
A74h

 Although a general history of modern art, the material on
American twentieth-century figures and movements is given
enough attention to be examined. This American work is
clearly seen in light of European developments.

63 Brody, J.J. INDIAN PAINTERS AND WHITE PATRONS. Albuquerque:
University of New Mexico Press, 1971. xvii, 238 p. 92 black and
white illus., 8 in color.

709.72
B86i

 Sections on pre-Columbian Indian painting and the arrival of
the Europeans. The author presents an explanation of cultural
infiltration and how Indian painting was affected by it.

64 Chase, Judith Wragg. AFRO-AMERICAN ART AND CRAFT. New York:
Van Nostrand Reinhold, 1971. 142 p. Illus. Bibliog. pp. 138–39.

709.73
C48a

 Attempts to document the influence of African art in black
American artists. Well-known, newly discovered, and even
anonymous artists are discussed and illustrated, and some bio-
graphical information is provided.

65 Dockstader, Frederick J. INDIAN ART IN AMERICA: THE ARTS AND
CRAFTS OF THE NORTH AMERICAN INDIAN. Greenwich, Conn.:
New York Graphic Society, 1966. 224 p. 248 illus., many in color.
Bibliog. pp. 222–24.

q709.72
D63i3

 An important survey of the arts of the American Indian which
includes selections from the prehistoric, historic, and contem-
porary periods. Excellent color plates.

66 Dover, Cedric. AMERICAN NEGRO ART. Greenwich, Conn.: New
York Graphic Society, 1960. 186 p. Illus., some in color. Bibliog.
pp. 57–60.

709.73
D74a

 One of the pioneer attempts to document the long neglected
work of Black American artists. More useful for historical
than for contemporary figures.

67 Feder, Norman. AMERICAN INDIAN ART. New York: Harry N.
Abrams, 1969. 445 p. Illus., many in color. Bibliog. pp. 439–44.

709.01
F29a
1971 ED.

 Concentrates on the geographical areas occupied by various

11

Indian groups, rather than on object classifications. Very fine color plates.

68 _____. TWO HUNDRED YEARS OF NORTH AMERICAN INDIAN ART. New York: Frederick A. Praeger, 1972. 128 p. 150 illus., 8 in color. Bibliog. pp. 121-24.

709.72
F29t

The exhibition catalog of the show held at the Whitney Museum of American Art. Feder provides documentation on the variety of art forms produced by the different tribes in this country and Canada.

69 Garrett, Wendell D.; Norton, Paul F.; Gowans, Alan; and Butler, Joseph T. THE ARTS IN AMERICA: THE NINETEENTH CENTURY. New York: Charles Scribner's Sons, 1969. xix, 412 p. 301 illus. Bibliog. pp. 385-90.

q 709.73
A791

A general cultural history section followed by chapters on architecture, painting and sculpture, and the decorative arts. Good general survey text, with well-chosen, clearly captioned illustrations. One of the best surveys for the general reader.

70 Gerdts, William H. PAINTING AND SCULPTURE IN NEW JERSEY. Princeton, N.J.: Van Nostrand, 1966. xix, 276 p. 67 illus., color maps. Bibliog. pp. 253-62.

A history of artists who lived and worked in New Jersey through the twentieth century. The bibliography is an important tool for those artists who were important in other areas as well.

71 Hamilton, George Heard. 19TH AND 20TH CENTURY ART: PAINTING, SCULPTURE, ARCHITECTURE. New York: Harry N. Abrams, 1970. 481 p. 417 black and white illus., 64 in color. Bibliog. pp. 459-64.

q 709.04
H21n

A quite readable survey of American and European art from the beginnings of neoclassicism to the present developments in architecture and art, with emphasis on the European mainstream. All points are well illustrated.

72 Hunter, Sam. AMERICAN ART OF THE 20TH CENTURY. New York: Harry N. Abrams, 1973. 583 p. 988 illus. Bibliog. pp. 525-60.

709.73
H94a

A very solid and easy to read history of architecture and art in twentieth-century America. Profusely illustrated, it explores the important relationships with other countries. The bibliography is by far the most comprehensive one on the art of this century.

73 Locke, Alain, ed. THE NEGRO IN ART: A PICTORIAL RECORD OF THE NEGRO ARTIST AND OF THE NEGRO THEME IN ART. Washington, D.C.: Associates in Negro Folk Education, 1940. 224 p. Illus.

q 709.u
L81n

Bibliog. p. 224.

> Hundreds of illustrations of paintings and sculpture by black
> American artists, and of Negro subjects.

74 National Portrait Gallery. THE LIFE PORTRAITS OF JOHN QUINCY
ADAMS. Washington, D.C.: Smithsonian Institution Press, 1970. Un-
paged. 43 illus.

> All works illustrated were done from life, and the situation
> in which each one was painted or sculpted is indicated. An
> additional section provides biographical information, in brief,
> on each artist included in the survey.

75 _____. PORTRAITS OF THE AMERICAN STAGE, 1771-1971. Wash-
ington, D.C.: Smithsonian Institution Press, 1971. 203 p. 93 illus.

> Catalog of an exhibition of paintings and sculptures of impor-
> tant figures from the theater and music, by American artists.
> Provides biographical material about each subject rather than
> about the artist.

76 Quirarte, Jacinto. MEXICAN AMERICAN ARTISTS. Austin: University
of Texas Press, 1973. 149 p. Illus., some in color. Bibliog. pp. 139-
41.

> Traces the important work of Mexican-American artists in
> various media. Their relationship to the Mexican mainstream
> is analyzed.

77 Rose, Barbara. AMERICAN ART SINCE 1900: A CRITICAL HISTORY.
New York: Frederick A. Praeger, 1967. 320 p. Illus.

> A survey, weighted toward painting, of the developments in
> architecture and art in the United States from the Ashcan
> school to the mid-1960s. Illustrations are plentiful but mixed
> in quality. The author's book of readings has same chapter
> headings.

78 _____. READINGS IN AMERICAN ART SINCE 1900: A DOCUMEN-
TARY SURVEY. New York: Frederick A. Praeger, 1968. xiv, 224 p.
71 illus. Bibliog. pp. 209-24.

> Excerpts from writings by artists and critics on architecture,
> painting, and sculpture. An attempt to provide contemporary
> views of the art around them. The source of each essay is
> provided to enable reading of the original.

79 Tuckerman, Henry T. BOOK OF THE ARTISTS. New York: G.P.
Putnam's Sons, 1867. 639 p.

> A short history of art in America, followed by personal views
> of American artists. The appendix contains a checklist of

public and private collections in the mid-nineteenth century.

SPECIFIC MOVEMENTS AND STYLES

Works which deal with specific stylistic developments in several media.

80 Agee, William C. THE 1930'S: PAINTING AND SCULPTURE IN AMER-
 ICA. New York: Frederick A. Praeger, 1970. 112 p. 86 illus., 13
 in color. Bibliog. pp. 88-90.

 Discusses the ways that the artists caught up in the Depression
 and the new government recognition found themselves divided
 into artistic camps. Aesthetics and social concerns formed
 the basis for the groups.

81 Battcock, Gregory, ed. MINIMAL ART: A CRITICAL ANTHOLOGY.
 New York: E.P. Dutton & Co., 1968. 448 p. Illus. Paperbound.

 709.04 A selection of essays and comments about the American and
 B33m European practitioners of this current art form. Painting,
 photographs, sculpture, and mixed media are discussed and
 illustrated.

82 _____. THE NEW ART: A CRITICAL ANTHOLOGY. New York:
 E.P. Dutton & Co., 1966. 254 p. Illus. Paperbound.

 709.04 A collection of articles from the major art magazines of the
 B33n2 early 1960s. Particular attention is paid to the pop artists
 of the United States.

83 Cahill, Holger, and Barr, Alfred H., Jr., eds. ART IN AMERICA IN
 MODERN TIMES. 1934. Reprint. Essay Index Reprint Series. Free-
 port, N.Y.: Books for Libraries, 1969. 110 p. Illus., 9 in color.

 709.73 Based upon a series of radio broadcasts of October 1934
 C13 through January 1935. The authors were the director and
 1935 ED. curator of the Museum of Modern Art. Architecture, paint-
 ing, sculpture, stage design, photography, and the motion
 picture are all discussed for the period from 1865 to 1934.

84 Geldzahler, Henry. NEW YORK PAINTING AND SCULPTURE: 1940-
 1970. New York: E.P. Dutton & Co., 1969. 494 p. Illus., some
 in color. Bibliog. pp. 455-86.

 An important study of the painting and sculpture, with an
 emphasis on the former, in the avant-garde circles of New
 York. Particular attention is drawn to the birth of both the
 abstract exressionist movement and the group now known as
 the postpainterly abstractionists. Contains a very important
 bibliography.

85 Mumford, Lewis. THE BROWN DECADES: A STUDY OF THE ARTS IN
AMERICA 1865-1895. New York: Harcourt, Brace, c. 1931. 2nd rev.
ed. New York: Dover, 1945. 266 p.

709.73
M96a2

 Mumford's early study of the golden age. He paints a nega-
tive picture of pretension, crassness, and lack of regard for
the artistic developments we consider important at the middle
of the twentieth century.

86 1913 ARMORY SHOW: 50TH ANNIVERSARY EXHIBITION. Henry Street
Settlement at Utica, N.Y.: Munson-Williams-Proctor Institute, 1963.
212 p. Illus., some in color.

 The catalog of the partial recreation of the 1913 exhibit that
changed the course of art in the United States. Many original
documents and other material are reproduced.

87 Northend, Mary Harrod. COLONIAL HOMES AND THEIR FURNISH-
INGS. Boston: Little, Brown and Co., 1912. xxi, 252 p. 112 illus.

 Very old but well illustrated and documenting many no longer
available objects. Information about both architecture and
and decorative arts.

88 O'Connor, Francis V., ed. ART FOR THE MILLIONS. ESSAYS FROM
THE 1930's BY ARTISTS AND ADMINISTRATORS OF THE WPA FEDERAL
ART PROJECT. Greenwich, Conn.: New York Graphic Society, 1973.

709.73
O18a

 312 p. 100 illus. Bibliog. pp. 307-10.

 A collection of essays by the artists who were involved in
the federal art projects of the Depression. The range is wide,
and many write about their general theories on art rather
than about specific techniques or style.

89 Porter, James A. MODERN NEGRO ART. New York: Dryden Press,
1943. Reprint. New York: Arno Press, 1973. 272 p. Illus. Bibliog.
pp. 183-92.

 One of the first meaningful studies of the black artist in
this country. It is a useful supplement to the several recent
studies of more contemporary figures.

90 Ritchie, Andrew Carnduff, ed. ABSTRACT PAINTING AND SCULPTURE
IN AMERICA. New York: Museum of Modern Art, 1951. 159 p. Illus.,

759.915
N53a

 some in color. Bibliog. pp. 156-59.

 An early yet still valuable history of the origins of abstract
art in Europe and its development and maturation in this
country. For the general reader.

91 Rossi, Paul A., and Hunt, David C. THE ART OF THE OLD WEST.
New York: Alfred A. Knopf, 1971. 355 p. 300 illus., 134 in color.

Bibliog. pp. 332-35.

An introduction to the work in the Gilcrease Institute--an institute devoted to art of the American West.

92 Schulze, Franz. FANTASTIC IMAGES: CHICAGO ART SINCE 1945. Chicago: Follett, 1972. 223 p. Illus., some in color.

A survey of those Chicago painters and sculptors who, for the most part, are latter-day surrealists.

93 Taylor, Joshua C.; Griffin, Rachel; and Kingsbury, Martha. ART OF THE PACIFIC NORTHWEST: FROM THE 1930'S TO THE PRESENT. Washington, D.C.: National Collection of Fine Arts, Smithsonian Institution, 1974. 160 p. 138 black and white illus., 5 in color.

94 University of Illinois. CONTEMPORARY AMERICAN PAINTING AND SCULPTURE. Urbana, Ill.: 1948- . Biennial.

Important catalogs of biennial exhibitions of contemporary American figures. The catalogs are always well written and illustrated and serve as a good guide to the work of the well-received young artists. Usually a heavy emphasis on painting.

AESTHETICS, CULTURE, AND TASTE

95 Baker, Paul R. THE FORTUNATE PILGRIMS: AMERICANS IN ITALY, 1800-1860. Cambridge, Mass.: Harvard University Press, 1964. 264 p.

Discusses the entire range of American involvement with Italy in the era covered: the artists, writers, and travellers, both temporary visitors and expatriates. The traveler's attitudes and expectations are documented through extensive quotations.

96 Brooks, Van Wyck. THE DREAM OF ARCADIA: AMERICAN WRITERS AND ARTISTS IN ITALY 1760-1915. New York: E.P. Dutton & Co., 1958. xiii, 272 p.

Cultural background and biographical information on many of the American sculptors, painters, and critics who travelled or lived in Italy, from Benjamin West to Bernard Berenson.

97 Brown, Milton Wolf. THE STORY OF THE ARMORY SHOW. Greenwich, Conn.: New York Graphic Society, 1963. 320 p. Illus. Bibliog. pp. 303-6.

A fully documented history and discussion of the historical show of 1913 written at the time of the fiftieth anniversary of the show.

98 Harris, Neil. THE ARTIST IN AMERICAN SOCIETY: THE FORMATIVE
 YEARS, 1790-1860. New York: George Braziller, 1966. 432 p. Illus.
 Bibliog. pp. 317-24.

 Documents the attitudes of artists in and towards artists in our
 culture, including those who went abroad. The role of patrons
 and art institutions is integrated into the material.

99 Jewell, Edward A. HAVE WE AN AMERICAN ART? New York:
 Longmans, Green, 1939. xvi, 232 p.

 The influential art critic of the NEW YORK TIMES wrote a
 series of essays that make a case for an American quality
 that is unique. The language is a bit flowery for our day,
 but this serves as an indicator of aesthetics and the feeling
 of the time.

100 Kouwenhoven, John A. THE ARTS IN MODERN AMERICAN CIVILIZA-
 TION. Garden City, N.Y.: Doubleday, 1948. Reprint. New York:
 W.W. Norton & Co., 1967. 259 p. 32 illus. Bibliog. pp. 225-50.
 Paperbound.

 A broad view of our culture and how the vernacular has
 played a role in our development and influenced our general
 aesthetic outlook. The thesis advanced is that our building
 developments are due, in large part, to technical innovations.

101 Lancaster, Clay. THE JAPANESE INFLUENCE IN AMERICA. New
 York: Walton H. Rawls, 1963. xix, 292 p. 216 black and white
 illus., 8 in color.

 A period-by-period discussion of Japanese influence on archi-
 tecture, furniture, furnishings, and the fine arts. The chapters
 on the influence of the Chicago school and the development
 of the bungalow are particularly well illustrated to make the
 author's points.

102 Lipman, Jean, ed. WHAT IS AMERICAN IN AMERICAN ART. New
 York: McGraw-Hill Book Co., 1963. 180 p. Illus., some in color.

 A combination of essays on aesthetics and historical material
 on American art. All were written for ART IN AMERICA
 and are collected in this one volume.

103 Lynes, Russell. THE ART-MAKERS OF NINETEENTH CENTURY AMERICA.
 New York: Atheneum, 1970. 514 p. Illus.

 A personal view of the flow and changes of taste during the
 period. Taste is stressed so much more than quality or style
 per se, that the general reader might not become aware of
 the developments not seen fit for inclusion.

104 _____. THE TASTE-MAKERS. New York: Harper and Brothers, 1954.
xiv, 362 p. Illus. Bibliog. pp. 345-46.

A general history of taste, in both the fine and decorative
arts in this country. Both private and corporate matters are
examined for the lay reader.

105 Maass, John. THE GINGERBREAD AGE: A VIEW OF VICTORIAN
AMERICA. New York: Rinehart & Co., 1957. 212 p. Illus. Bibliog.
pp. 199-203.

720.973
M11g

A view of Victorianism in American culture, both "high" and
"popular." Witty selections of illustrations emphasizing archi-
tecture, the decorative arts, and contemporary illustration.

106 Metropolitan Museum of Art. THE SHAPING OF ART AND ARCHITEC-
TURE IN NINETEENTH CENTURY AMERICA. Symposium May 1970.
New York: 1972. 187 p. 85 Illus.

Text of the papers presented by several major historians,
critics, and collectors at the time of the centennial exhibi-
tions at the museum in May 1970. Architecture and art and
the interrelationships with Europe are discussed.

107 Mumford, Lewis. AMERICAN TASTE. San Francisco: The Westgate
Press, 1929. 34 p.

An icy blast at contemporary (1929) taste and at looking back
for sources to counterfeit. Approves of utilization of technol-
ogy rather than burying the head in the sand.

108 Museum of Modern Art. THE MACHINE: AS SEEN AT THE END OF
THE MECHANICAL AGE. Exhibition and catalog essay by K.G. Pontus
Hulten. New York: 1968. 216 p. Illus. Bibliog. p. 211.

Photographs, paintings, sculpture, graphics, and cartoons
illustrating man's reaction to the machine. A few examples
are from the renaissance period and many are European.
There are sufficient American examples to warrant inspection.

109 Stein, Roger B. JOHN RUSKIN AND AESTHETIC THOUGHT IN AMER-
ICA, 1840-1900. Cambridge, Mass.: Harvard University Press, 1967.
xviii, 321 p. 8 illus.

Discussion of Ruskin's influence on modern painters, the
Gothic architectural revival, religious-philosophical thought,
and art/aesthetic education. The reaction against him is
also explored.

INSTITUTIONS, COLLECTIONS, AND PATRONAGE

Histories of the major American art institutions, catalogs of major multiple media collections, and studies of the role of both private patronage and government in the support of the arts.

110 Clark, Eliot. HISTORY OF THE NATIONAL ACADEMY OF DESIGN: 1825-1953. New York: Columbia University Press, 1954. 296 p. Illus.

707
C59h

A history that documents the exciting early years of rivalry with the American Academy, the years of power and influence, and the long decline in the twentieth century.

111 Cowdrey, Mary Bartlett. AMERICAN ACADEMY OF FINE ARTS AND AMERICAN ART-UNION: 1816-1852. 2 vols. New York: New York Historical Society, 1953. Vol. 1, xiv, 311 p. Illus. Vol. 2, v, 504 p.

Important histories and documentation on these two influential nineteenth-century organizations. Lists of patrons and names of members and officers are included as are the titles of publications of the Art-Union. Volume 2 is devoted to the exhibition records of the professional organizations.

112 Cummings, Thomas. HISTORIC ANNALS OF THE NATIONAL ACADEMY OF DESIGN. 1865. Reprint. New York: Da Capo Press, 1969. iv, 364 p.

A chronological history of the institution so important in the history of American painting and sculpture for almost 100 years. Fascinating anecdotes by one of the original members.

113 Fairman, Charles E. ART AND ARTISTS OF THE CAPITOL OF THE UNITED STATES OF AMERICA. Washington, D.C.: Government Printing Office, 1927. xii, 926 p. Illus., facsims., tables.

A detailed history of the commissions for sculpture, decorations, and paintings for the federal capitol. Direct reference to letters, congressional records, etc.

114 Fogg Art Museum. AMERICAN ART AT HARVARD. Cambridge, Mass.: 1972. Unpaged. 176 illus.

The exhibition catalog of a display of the permanent American collection of the university. The work, which is mostly painting, covers the entire history of American art, with particularly important items in early portraiture.

115 Landgren, Marchal E. YEARS OF ART: THE STORY OF THE ART STUDENT'S LEAGUE OF NEW YORK. New York: McBride, 1940.

267 p. 72 illus.

Describes the history of an important art association and school since 1875. Many important figures in American art history appear, especially the Ashcan school members and their followers.

116 Landman, Hedy, ed. EUROPEAN AND AMERICAN ART FROM PRINCETON ALUMNI COLLECTIONS. Princeton, N.J.: Princeton University Press, 1972. 170 p. 137 illus.

Essentially a picture book, and one with a greater collection of European than American work, it nonetheless documents many important American paintings and sculptures.

117 McFaddon, Elizabeth. THE GLITTER AND THE GOLD. New York: Dial Press, 1971. ix, 277 p. Illus. Bibliog. pp. 263–67.

A biography of Luigi Palma di Cesnola, the first director of the Metropolitan Museum of Art. Inevitably, we learn something of the early years of the Met as an institution.

118 McKinzie, Richard D. THE NEW DEAL FOR ARTISTS. Princeton, N.J.: Princeton University Press, 1973. 196 p. Illus. Bibliog. pp. 193–95.

An extremely well-documented study of the various New Deal projects. Explains the role of administrators, government officials, and artists in setting up, maintaining, and closing down the treasury project as well as the better known WPA ones.

119 Marlor, Clark S. A HISTORY OF THE BROOKLYN ART ASSOCIATION. New York: James F. Carr, 1970. vii, 421 p. 16 illus.

Not only does this book provide a history of the Brooklyn Art Association, it includes a complete list of exhibitions, arranged alphabetically by artists.

120 Metropolitan Museum of Art. NINETEENTH CENTURY AMERICA: PAINTINGS AND SCULPTURE. Greenwich, Conn.: New York Graphic Society, 1970. 160 p. 201 illus., 40 in color.

The exhibition catalog of the major show celebrating the 100th anniversary of the Metropolitan Museum of Art. Many of the works illustrated were borrowed from other major collections of American art.

121 Miller, Lillian. PATRONS AND PATRIOTISM: THE ENCOURAGEMENT OF THE FINE ARTS IN THE UNITED STATES, 1790-1860. Chicago: University of Chicago Press, 1966. 335 p. Illus. Bibliog. pp. 269-315.

A documentation of the role of both public and private agencies and organizations, and individual patrons in supporting the fine arts to the time of the Civil War. Many of the important collectors who appear as shadows in the standard texts on American art are here given their due.

122 O'Connor, Francis V., ed. THE NEW DEAL ART PROJECTS: AN ANTHOLOGY OF MEMOIRS. Washington, D.C.: Smithsonian Institution Press, 1972. 339 p. 53 illus. Bibliog. pp. 330-31.

709.73
N5321

Memoirs of the participants in the federal art projects of the Depression. Gathered from various sources.

123 O'Doherty, Brian, ed. MUSEUMS IN CRISIS. Foreword by Nancy Hanks. New York: George Braziller, 1972. ix, 178 p. Illus.

A series of articles taken from ART IN AMERICA. Nancy Hanks is the head of the National Endowment for the Arts.

124 Small, Herbert. HANDBOOK OF THE NEW LIBRARY OF CONGRESS. Boston: Curtis and Cameron, 1897. 128 p. Illus.

A guided tour through the Library of Congress. All paintings, sculpture, and the architecture itself are described in detail. Very authoritative.

125 Swan, Mabel. THE ATHENAEUM GALLERY, 1827-1873. Boston: Merrymount Press, 1940. xiv, 312 p. 10 illus.

A history of this important predecessor of the Museum of Fine Arts in Boston. Included is a full list of the exhibitions and catalogs from 1827 to 1873. Important information for the collecter of nineteenth-century art.

126 Tompkins, Calvin. MERCHANTS AND MASTERPIECES: THE STORY OF THE METROPOLITAN MUSEUM OF ART. New York: E.P. Dutton & Co., 1970. 383 p. Illus.

Discusses the growth of the museum in relation to the wealthy businessmen who collected on a grand scale and gave those collections to the Metropolitan.

127 Wichita Art Museum. CATALOGUE OF THE ROLAND P. MURDOCK COLLECTION. Wichita, Kans.: 1972. 237 p. Illus.

The catalog of an important historical collection of American painting and sculpture from colonial times to the present.

Chapter 3
AMERICAN ARCHITECTURE

GENERAL HISTORIES AND SURVEYS

The following are important, wide-ranging studies of American architecture exclusively, or surveys of architecture in general with important American components. Several are quite old, but still offer a point of view not duplicated by the newer works. Some emphasize style and others materials and techniques, although the distinctions are not always made clear by the titles.

128 Andrews, Wayne. ARCHITECTURE IN AMERICA: A PHOTOGRAPHIC HISTORY FROM THE COLONIAL PERIOD TO THE PRESENT. New York: Atheneum, 1960. 179 p. Illus.

A good survey of buildings and brief information about the architects. Concentrates on the late nineteenth and first half of the twentieth century. Emphasis on the work of Richardson, McKim, Mead, White, Richard Hunt, and Frank Lloyd Wright.

129 Burchard, John, and Bush-Brown, Albert. THE ARCHITECTURE OF AMERICA: A SOCIAL AND CULTURAL HISTORY. Boston: Little, Brown and Co., 1961. x, 595 p. Illus. Bibliog. pp. 513-17.

A discussion of the architects and their work within the context of the social organism and the developments in technology. Five indexes: architects and planners, major American buildings, an international list of cities, general index, index of illustrations.

130 Chernayeff, Ivan, and Erwitt, Elliott. OBSERVATIONS ON AMERICAN ARCHITECTURE. New York: Viking Press, 1972. 143 p. Illus., many in color.

Chernayeff provides a brief introduction which summarizes the importance of developments in American architecture and makes telling comments on the structures so brilliantly photographed by Erwitt. An exceptional picture book.

131 Coles, William A., and Reed, Henry Hope, Jr., eds. ARCHITECTURE
IN AMERICA: A BATTLE OF STYLES. New York: Appleton-Century-
Crofts, 1961. xviii, 412 p. Illus. Bibliog. pp. 394-400.

 Part one consists of brief excerpts of statements on aesthetics
from Vitruvius to Bruno Zen. The larger part two contains
writings covering controversies on five major American pro-
jects in architecture: Columbian Exposition of 1893; National
Gallery of Art, 1938-41; United Nations Building, 1947-52;
Lever House, 1952; and The Price Tower, 1953-55.

132 Condit, Carl W. AMERICAN BUILDING: MATERIALS AND TECH-
NIQUES FROM THE FIRST COLONIAL SETTLEMENTS TO THE PRESENT.
Chicago: University of Chicago Press, 1968. xiv, 329 p. 112 illus.
Bibliog. pp. 295-303.

 This volume is technically oriented and concerns itself almost
completely with describing how major technical problems, such
as the framing of buildings, the span of bridges, industrial
buildings, and others, were solved during each of the four
historical divisions presented.

133 Davidson, Marshall B., ed. THE AMERICAN HERITAGE HISTORY OF
NOTABLE AMERICAN HOUSES. New York: American Heritage Pub-
lishing Co., 1971. 383 p. Illus., many in color.

 A popular but sound survey of historic architecture in the
United States from the earliest colonial days through the
early years of the twentieth century. Many excellent illus-
trations of the diverse eclectic buildings of the mid-nineteenth
century are of particular value.

134 Fitch, James Marston. AMERICAN BUILDING 1: THE HISTORICAL
FORCES THAT SHAPED IT. 2nd rev. ed. Boston: Houghton Mifflin
Co., 1966. xii, 350 p. 239 illus.

 An important view of the social and historical forces that
helped to determine the development of our architecture.
European antecedents, philosophical and literary romanticism,
and other sources are explored with insight and clarity. Can
be utilized profitably without the companion volume.

135 _____. AMERICAN BUILDING 2: THE ENVIRONMENTAL FORCES
THAT SHAPED IT. 2nd rev. ed. Boston: Houghton Mifflin Co., 1972.
xi, 349 p. 103 illus.

 Chapters on topics that reflect our architectural decision mak-
ing: atmosphere, temperature, lighting, noise, and others.
Each is shown to influence, in ways subtle and obvious, our
planning and perceptions. An unusual but necessary point of
view expounded.

136 _____. ARCHITECTURE AND THE AESTHETICS OF PLENTY. New York: Columbia University Press, 1961. xii, 304 p. Illus.

A series of essays on several facets of our culture, and on important historical development. Chapters on Jefferson, Wright, Gropius, and landscape architecture.

137 Giedion, Sigfried. SPACE, TIME AND ARCHITECTURE. 5th ed., rev. and enl. Cambridge, Mass.: Harvard University Press, 1967. lvi, 897 p. 531 illus.

One of the most important treatments of the history of architecture. The sections on American developments in parts 3 and 4, and the whole section on American work in part 5, are relevant to the study of the American scene. Of particular importance is the relationship presented between the balloon frame and industrialization.

138 Gowans, Alan. IMAGES OF AMERICAN LIVING: FOUR CENTURIES OF ARCHITECTURE AND FURNITURE AS CULTURAL EXPRESSION. Philadelphia: J.B. Lippincott, 1964. xv, 498 p. 137 illus.

A century-by-century exploration of the American mind and spirit and an explanation of how our artistic and architectural "artifacts" reflect the culture. Standard as well as less often seen illustrations.

139 Hamlin, Talbot Faulkner. THE AMERICAN SPIRIT IN ARCHITECTURE. New Haven, Conn.: Yale University Press, 1926. 353 p. Illus.

A well-illustrated general history of architecture from the colonial period to the date of writing.

140 Hitchcock, Henry-Russell. ARCHITECTURE: NINETEENTH AND TWENTIETH CENTURIES. Rev. ed. Baltimore: Penguin Books, 1971. 682 p. 369 illus. Bibliog. pp. 629–41.

A classic study of broad architectural developments in the 150-year period. American developments in regard to the revival styles, technological innovation, and creative architects are seen within the overall picture of an emerging worldwide architecture.

141 Kimball, [Sidney] Fiske. AMERICAN ARCHITECTURE. Indianapolis: Bobbs-Merrill Co., 1928. 262 p. Illus.

An old yet quite readable history of developments and styles in American architecture.

142 Mumford, Lewis. STICKS AND STONES: A STUDY OF AMERICAN ARCHITECTURE AND CIVILIZATION. Rev. ed. New York: Dover, 1955. 238 p. 21 illus. Paperbound.

The author's personal view of the history of American archi-
tecture. He refuses to limit his discussion to each particular
building, but shows how architecture is a very important part
of the environment around it.

143 Schuyler, Montgomery. AMERICAN ARCHITECTURE. 2 vols. Edited
by William H. Jordy and Ralph Coe. Cambridge, Mass.: Harvard Uni-
versity Press, Belknap Press, 1961. xxviii, 644 p. 166 illus. Bibliog.
pp. 641-53.

Collected essays of the late nineteenth-century architectural
critics, many of whose opinions are still supported. Essays
on Victorian gothic, Richardson, engineering, architecture,
Beaux Arts Reaction, Sullivan and Wright. Good photographs
and an impressive bibliography of Schuyler's writings on archi-
tectural subjects.

144 Tallmadge, Thomas E. THE STORY OF ARCHITECTURE IN AMERICA.
New York: W.W. Norton & Co., 1927. x, 311 p. 33 illus.

An early but still useful history by one of the early practi-
tioners of Prairie School architecture. Discussion of European
influences, technical developments, etc.

145 Whiffen, Marcus. AMERICAN ARCHITECTURE SINCE 1780: A GUIDE
TO THE STYLES. Cambridge, Mass.: The M.I.T. Press, 1969. x,
313 p. Illus. Bibliog. pp. 281-89.

Comments on the well-known art and those architects with
established historical reputations. However, Whiffin also
presents substantial material on some of the lesser known.
Particular attention is paid to the ignored work of Trost and
Trost in Arizona and Texas.

REGIONAL, STATE, AND CITY SURVEYS

146 Burnham, Alan. NEW YORK LANDMARKS: A STUDY AND INDEX OF
ARCHITECTURALLY NOTABLE STRUCTURES IN GREATER NEW YORK.
Middletown, Conn.: Wesleyan University Press, 1963. 430 p. Illus.

Not confined to the five boroughs of the city, individual
structures in the larger area are noted, and the historic
significance of each is made clear.

147 Condit, Carl W. THE CHICAGO SCHOOL OF ARCHITECTURE: A
HISTORY OF COMMERCIAL AND PUBLIC BUILDING IN THE CHICAGO
AREA, 1875-1925. Chicago: University of Chicago Press, 1964. xviii,
238 p. 196 illus. Bibliog. pp. 221-25.

An updated version of Condit's classic, THE RISE OF THE
SKYSCRAPER. It provides thorough and careful documentation

on the critical period and place in the development of the commercial and office building. The contributions of technology and of such key architects as Burnham, Root, Holabird and Roche, Adler and Sullivan, and others are explored.

148 De Lagerberg, Lars. NEW JERSEY ARCHITECTURE, COLONIAL AND FEDERAL. Springfield, Mass.: W. Whitlam, 1956. 316 p. Illus.

A short introductory text followed by illustrations of both public and private architecture from the beginning of the seventeenth century to the middle of the nineteenth.

149 Dorsey, John, and Dilts, James D. A GUIDE TO BALTIMORE ARCHITECTURE. Cambridge, Md.: Tidewater-Publisher, 1973. I, 246 p. Illus.

A short history of the local architecture followed by a detailed guidebook.

150 Downing, Antoinette F[orrester], and Scully, Vincent Joseph. THE ARCHITECTURAL HERITAGE OF NEWPORT, RHODE ISLAND, 1640-1915. 2nd ed. New York: Clarkson and Potter, 1967. xvi, 526 p. 230 illus.

A detailed study of the various phases of architectural development in Newport. Appendices: A, detailed histories and descriptions of buildings; B, spot restoration program recommended for historic Newport.

151 Eberlein, Harold Donaldson, and Hubbard, Cortlandt V[an] D[yke]. HISTORIC HOUSES AND BUILDINGS OF DELAWARE. Dover, Del.: Public Archives Commission, 1963. 227 p. Illus.

A county-by-county examination of the significant architecture of the state. Much of the text is anecdotal, but the historical significance of each structure is made clear and excellent photographs of exteriors and some interiors are provided.

152 _____. HISTORIC HOUSES OF THE HUDSON VALLEY. New York: Architectural Book Publishing Co., 1942. 208 p. 200 illus.

Although providing very little information other than anecdotal, this volume has many excellent photographs documenting the architectural heritage of the region.

153 Ferry, W. Hawkins. THE BUILDINGS OF DETROIT. Detroit: Wayne State University Press, 1968. xxii, 479 p. 466 illus. Bibliog. pp. 455-56.

Not only a photographic history of both public and domestic architecture, but fine architectural criticism. The text is chronological and the material covered stretches from 1700

to the present.

154 Forman, Henry Chandlee. THE ARCHITECTURE OF THE OLD SOUTH.
 Cambridge, Mass.: Harvard University Press, 1948. xiii, 203 p. 282
 illus. Bibliog. pp. 187-91.

 Traces developments in the medieval style from 1585 to 1850
 in the chapters on Virginia, Maryland, the Deep South, and
 Bermuda.

155 _____. MARYLAND ARCHITECTURE. Cambridge, Md.: Tidewater-
 Publisher, 1968. xvi, 102 p. 87 illus. Bibliog. pp. 87-88.

 Traces the major historical styles from medieval through the
 gothic revival of the mid-nineteenth century in Maryland.
 Domestic and public examples are illustrated. Short but con-
 cise history.

156 Heritage of New York. HISTORIC LANDMARK PLAQUES OF THE NEW
 YORK COMMUNITY TRUST. New York: Fordham University Press,
 1971. 402 p. Illus.

 A guide to both the known and the surprising landmarks of
 New York. Some of the landmarks remain and some are only
 locatable by the plaques.

157 Kirker, Harold. CALIFORNIA'S ARCHITECTURAL FRONTIER. New
 York: Russell and Russell, 1970. 224 p. 64 illus. Bibliog. pp. 197-
 216.

 Chapters on the early adobe builders, the first structures of
 the pioneers, the work of the California Renaissance, and
 the various historical revivals. Many illustrations of buildings
 no longer standing are taken from earlier sources. They are
 of poor visual quality but of great importance historically.

158 Lockwood, Charles. BRICKS AND BROWNSTONE: THE NEW YORK
 CITY ROW HOUSE 1783-1929. New York: McGraw-Hill Book Co.,
 1972. xxv, 262 p. Illus. Bibliog. pp. 257-60.

 Chapters deal with the major revival styles, from federal
 through the colonial revival, and cover the communities
 identified with the row house--Brooklyn Heights, Cobble Hill,
 Greenwich Village, and others. Illustrations of facades,
 interiors, decoration, and old views are included. New York
 developments are put into some historical perspective.

159 Mumford, Lewis. THE SOUTH IN ARCHITECTURE. New York: Har-
 court, Brace and Co., 1941. 147 p.

 A series of four lectures given by the author at Alabama
 College during 1941. His subjects were: The Basis for

American Form; Universalism of Thomas Jefferson; The Region-
alism of H.H. Richardson; and The Social Task of Architec-
ture.

160 Newcomb, Rexford. SPANISH-COLONIAL ARCHITECTURE IN THE
UNITED STATES. New York: J.J. Augustin, 1937. 39 p. 130 illus.

After a note on the historical and economic background of
the region and an introduction to the Spanish architectural
tradition, brief descriptions of style and materials, and a list
of examples are provided for each of the states of the South-
west and Florida.

161 Peisch, Mark L. THE CHICAGO SCHOOL OF ARCHITECTURE. New
York: Random House, 1964. xiii, 177 p. 42 illus. Bibliog. pp. 161-
67.

An interesting analysis of the importance of the school but
contains factual errors in dating, attribution, etc. Divides
sections into domestic and public architecture.

162 Randall, Frank A. HISTORY OF THE DEVELOPMENT OF BUILDING
CONSTRUCTION IN CHICAGO. Urbana: University of Illinois Press,
1949. xvi, 388 p. 62 illus.

Rather than stressing the stylistic units of Chicago architecture,
Randall discusses the various directions being pursued simulta-
neously. Valuable index of names and locations of buildings
and an index of architects and engineers.

163 Sanford, Trent Elwood. THE ARCHITECTURE OF THE SOUTHWEST.
New York: W.W. Norton & Co., 1950. xii, 312 p. 64 illus.

A description of the people, history, and settlement of the
Southwest, and the development of the architecture of the
cities and missions in the area that includes part of Mexico
and part of present-day United States. Illustrated with mis-
sions, pueblos, and later civilization's buildings.

164 Silver, Nathan. LOST NEW YORK. New York: Schocken Paperback,
1971. xiv, 238 p. 244 illus.

A volume concerned with illustrating that part of our archi-
tectural heritage which no longer exists. The author urges
us to realize the threat to our way of living, as well as to
architecture, caused by the destruction of buildings in the
name of progress.

165 Stoney, Samuel Gaillard. THIS IS CHARLESTON: A SURVEY OF THE
ARCHITECTURAL HERITAGE OF A UNIQUE AMERICAN CITY. 2nd rev.
ed. Charleston, S.C.: Carolina Art Association, 1960. x, 137 p.
Illus.

A well-illustrated survey of the older architecture of this major southern colonial city.

166 Tatum, George B. PENN'S GREAT TOWN: 250 YEARS OF PHILADEL-PHIA ARCHITECTURE ILLUSTRATED IN PRINTS AND DRAWINGS. Philadelphia: University of Pennsylvania Press, 1961. 352 p. 145 illus.

Discusses both the planned aspect and urban development of the city, and the individual buildings of importance. The various historical styles are presented chronologically.

STUDIES OF SPECIFIC ARCHITECTURAL FORMS

Studies of various architectural forms—the barn, the railroad station, and others —their evolution and importance in our architectural heritage.

167 Arthur, Eric, and Witney, Dudley. THE BARN: A VANISHING LAND-MARK IN NORTH AMERICA. Greenwich, Conn.: New York Graphic Society, 1972. 256 p. 278 illus., 134 in color.

An important and thorough survey of the architecture of this vernacular structure in both the United States and Canada. The barns of the English, Dutch, etc., are examined in terms of origins and continuity of style.

168 Baer, Kurt, and Rudinger, Hugo. ARCHITECTURE OF THE CALIFORNIA MISSIONS. Berkeley and Los Angeles: University of California Press, 1958. 212 p. 90 illus.

A picture book that includes general statements on sources of style, building materials, and architectural types. Worth-while only as an introduction to the subject.

169 Current, William, and Scully, Vincent [Joseph]. PUEBLO ARCHITEC-TURE OF THE SOUTHWEST. Austin: University of Texas Press, 1971. 97 p. 65 illus.

Views of major Pueblo sites with some discussion as to the building techniques and materials used by the Indians. Some comments on the culture of the Pueblo dwellers is provided. Excellent photographs.

170 Embury, Aymar II. EARLY AMERICAN CHURCHES. Garden City, N.Y.: Doubleday, Page & Co., 1914. xvii, 189 p. 105 illus.

The introduction to church organization in the early colonial period is followed by discussion of the location, style, and history of eighteenth-century churches in the three geographi-cal regions of the colonies. Nineteenth-century churches are examined in Connecticut, Massachusetts, the South, and Middle States. The appendix consists of a chronological table

of early American churches.

171 Meeks, Carroll L.V. THE RAILROAD STATION: AN ARCHITECTURAL
HISTORY. New Haven: Yale University Press, 1956. xxvi, 203 p.
231 illus.

A history of development of the station, here and abroad,
with much information on the American aesthetic and techni-
cal approaches to the problem.

172 Sloane, Eric. AMERICAN BARNS AND COVERED BRIDGES. New
York: Wilfred Funk, 1954. 112 p. Illus.

Traces the origins, structure, and history of both the barns
and bridges and illustrates them with drawings. Much of
the technical material is applicable to understanding of home
construction as well. Easy reading that incorporates general
cultural observations.

173 Snow, Edward Rowe. FAMOUS NEW ENGLAND LIGHTHOUSES. Boston:
Yankee Publishing Co., 1945. 457 p. Illus.

Although lighthouses are a highly specialized form of archi-
tecture, their appearance in New England was frequent enough
and their need for solidity was serious to the point that they
evolved along certain lines into a basic architectural form.
Similarities and differences are illustrated.

174 Wischnitzer, Rachel. SYNAGOGUE ARCHITECTURE IN THE UNITED
STATES: HISTORY AND INTERPRETATION. Philadelphia: Jewish
Publication Society of America, 1955. xv, 204 p. 149 illus. Bibliog.
p. 195.

Chapters on the growth and building of synagogues in each
historic period of our development and how the architecture
of the synagogue related to that of the larger society.

175 Zimiles, Martha, and Zimiles, Murray. EARLY AMERICAN MILLS.
New York: Clarkson N. Potter, 1973. xii, 290 p. 350 illus., 11 in
color.

Profusely illustrated survey of the various types of mills that
are so important a part of our early industrial architecture.
Many geographical areas are ignored, however, and it will
read better to a layman than to a specialist.

URBAN ARCHITECTURE AND CITY PLANNING

176 Jacobs, Jane. THE DEATH AND LIFE OF GREAT AMERICAN CITIES.
New York: Random House, Vintage, 1961. 458 p.

A classic attempt to deal with the problems of life in cities, and how architecture and city planning have not, for the most part, fulfilled the needs of the residents. Offers suggestions for revitalization of our urban areas.

177 Kurtz, Stephen A. WASTELAND: BUILDING THE AMERICAN DREAM. New York: Frederick A. Praeger, 1973. 128 p. 50 illus.

Critical of our architecture for failing to become involved in human needs. Excellent photography by L. Fink.

178 Reps, John W. THE MAKING OF URBAN AMERICA: A HISTORY OF CITY PLANNING IN THE UNITED STATES. Princeton, N.J.: Princeton University Press, 1965. xv, 574 p. 314 illus. Bibliog. pp. 545-62.

An up-to-date and thorough examination of city planning in this country from the European origins of planning to the developments at the beginning of this century. Of particular importance are the chapters on gridiron and checkerboard city development and the effects of land speculation on planning.

179 _____. TOWN PLANNING IN FRONTIER AMERICA. Princeton, N.J.: Princeton University Press, 1969. xii, 473 p. 135 illus. Bibliog. pp. 449-56.

Traces development of plans from the settlement of St. Augustine through the middle of the nineteenth century. Of particular importance are chapters on the cities of New France, the new Utopian cities, and New Amsterdam. Other chapters deal with more frequently documented material.

180 Scully, Vincent [Joseph]. AMERICAN ARCHITECTURE AND URBANISM. New York: Frederick A. Praeger, 1969. 275 p. 525 illus. Bibliog. pp. 257-62.

Architecture in relation to the environment created for human beings. Although the author deals with specific individuals and the "art" of their building, he always brings it back to the way people live.

181 Tunnard, Christopher, and Reed, Henry Hope, Jr. AMERICAN SKYLINE: THE GROWTH AND FORM OF OUR CITIES AND TOWNS. Boston: Houghton Mifflin Co., 1955. 302 p. Illus.

A discussion of how our major cities grew. Emphasis is placed on matters of design of both buildings and areas, and the materials with which they were built.

AESTHETICS, TASTE, AND STYLE

How and why our architectural forms evolved as they did. Studies of the way public and private taste produced our buildings.

182 Andrews, Wayne. ARCHITECTURE, AMBITION, AND AMERICANS. New York: Harper and Brothers, 1955. xxv, 315 p. 166 illus. Bibliog. pp. 289-303.

> The author's thesis is that the American's desire for display of his wealth contributed to the possibility of architects carrying out some of the more daring commissions and enhanced opportunity for innovative solutions to architectural problems.

183 Brown, Sheldon S. REMADE IN AMERICA: THE GRAND TOUR OF EUROPE AND ASIA WITHIN THE U.S.A. Salem, Oreg.: Old Time Bottle Publishing Co., 1972. 384 p. 412 illus.

> Lists, describes, and illustrates near and direct copies of European and Asian buildings, reconstructions, replicas, and piece-by-piece importations. Says more about American taste than architecture.

184 Early, James. ROMANTICISM AND AMERICAN ARCHITECTURE. New York: A.S. Barnes & Co., 1965. 171 p. Illus.

> A study of the writings that helped influence American taste in architecture. The resulting buildings are shown to be an expression of a romantic attitude and associated with historical attitudes.

185 Lancaster, Clay. ARCHITECTURAL FOLLIES IN AMERICA: OR HAMMER, SAWTOOTH AND NAIL. Rutland, Vt.: Charles E. Tuttle Co., 1960. 243 p. 78 illus.

> A witty survey of the unusual and often pretentious buildings erected in this country. After a brief introduction to the tradition of self-conscious building abroad, the author supplies us with examples and background history on the palaces, odd-shaped homes, and other "follies" in our architectural history.

186 Mumford, Lewis. ROOTS OF CONTEMPORARY AMERICAN ARCHITECTURE. New York: Reinhold Publishing, 1952. vii, 454 p.

> Contains an essay by the author and brings together thirty-seven essays by writers, critics, and architects. Brief biographies of each essayist are included. Attention to both the theoretical and practical has been given.

187 Noffsinger, James Philip. THE INFLUENCE OF THE ECOLE DES BEAUX-
 ARTS ON THE ARCHITECTS OF THE UNITED STATES. Washington,
 D.C.: Catholic University of America Press, 1955. ix, 123 p.
 Bibliog. pp. 121–23.

 Chronological treatment of French influence during the periods
 before 1845, 1846–71, 1872–96, the peak years up to 1921,
 and the subsequent decline.

188 Pond, Irving K. THE MEANING OF ARCHITECTURE. Boston: Marshall
 Jones Co., 1918. 226 p. Illus.

 This is a statement of rejection of the Prairie School ideas
 by an architect who had been close to the prime movers of
 the school in the early years.

189 Reed, Henry Hope, Jr. THE GOLDEN CITY. Garden City, N.Y.:
 Doubleday & Co., 1959. 160 p. Illus.

 Posits the idea that the classical image found in our early
 buildings is still a force in more recent architecture. Ex-
 amples of early and modern buildings are frequently and often
 wittily juxtaposed.

Chapter 4

PERIOD SURVEYS OF AMERICAN ARCHITECTURE

The three parts of this chapter will present period surveys of American architecture. Many of the works are confined to a particular form of architecture, e.g., domestic or civic, in a particular geographic area of the country, or to one particular state. Picture books have been included when they are the major source of visual material.

SEVENTEENTH- AND EIGHTEENTH-CENTURY ARCHITECTURE

190 Allcott, John V. COLONIAL HOMES IN NORTH AMERICA. Raleigh, N.C.: The Carolina Charter Tercentenary Commission, 1963. x, 103 p. 72 illus.

 Discussion of construction styles and materials, floor plans of various structures, a note on interiors (often conjecture) and brief mention of directions in later colonial architecture. Illustrations include reconstructions of destroyed buildings and drawings. For the layman.

191 Arthur, Stanley Clisby. NEW ORLEANS: HISTORY OF THE VIEUX CARRE, ITS ANCIENT AND HISTORICAL BUILDINGS. New Orleans: H. Harmonson, 1936. 246 p. Illus.

 The illustrations provide a complete record of the old city.

192 Bacon, Leonard. THE GENESIS OF THE NEW ENGLAND CHURCHES. New York: Harper and Brothers, 1874. 485 p. Illus.

 Contains histories of early churches. Primarily concerned with the congregations' attempts to survive, it nonetheless provides us with information on the architects and illustrations.

193 Baldwin, Frank Conger. "Early Architecture of the Rappahannock Valley." AMERICAN INSTITUTE OF ARCHITECTS. JOURNAL 3 (1915): 113-18, 234-40, 326-36.

A survey in three parts including buildings from 1725 through 1830.

194 Coffin, Lewis A., and Holden, Arthur C. BRICK ARCHITECTURE OF THE COLONIAL PERIOD IN MARYLAND AND VIRGINIA. 1919. Reprint. New York: Dover, 1970. 29 p. 118 plates. Bibliog. pp. 28-29.

After a brief introduction to the cultural history, we are presented with information about some of the most important brick buildings in the area. Plates include many rare details.

195 Congdon, Herbert Wheaton. OLD VERMONT HOUSES. New York: Alfred A. Knopf, 1946. xiv, 192 p. 140 illus.

An introduction to Vermont's history. Chapters on homes of wood, brick, and stone. The final chapters deal with architectural exterior ornamentation and the old meeting houses.

196 Cotter, John L. ARCHAEOLOGICAL EXCAVATIONS AT JAMESTOWN COLONIAL NATIONAL HISTORICAL PARK AND JAMESTOWN NATIONAL HISTORICAL SITE, VIRGINIA. Washington, D.C.: U.S. Department of the Interior, 1958. 299 p. 92 illus.

Tells us just what types of structures existed and the degree of planning which took place at the ill-fated colony.

197 Curtis, Nathaniel Cortland. NEW ORLEANS: ITS OLD HOUSES, SHOPS AND PUBLIC BUILDINGS. Philadelphia: J.B. Lippincott Co., 1933. 267 p. 72 illus.

Good architectural plates of the surprising number of surviving buildings more than 150 years old.

198 Dorsey, Stephen Palmer. EARLY ENGLISH CHURCHES IN AMERICA, 1607-1807. New York: Oxford University Press, 1952. 206 p. Illus.

A survey of the design and structure of the Anglican churches in the colonial period of American history.

199 Downing, Antoinette Forrester. EARLY HOMES OF RHODE ISLAND. Richmond, Va.: Garrett and Massie, 1937. xviii, 408 p. Illus.

The developments in colonial architecture and categories of the individual types of homes found throughout the state. Detailed histories of important structures.

200 Duprey, Kenneth. OLD HOUSES OF NANTUCKET. New York: Architectural Book Publishing Co., 1959. xii, 242 p. Illus. Bibliog. pp. 235-36.

Discussion of architectural developments on the island.

Thorough detailed examination of five specific structures.
Many close-up illustrations of both interiors and exteriors.
Primarily eighteenth-century material from a popular histori-
cal society point of view.

201 Eberlein, Harold Donaldson, and Hubbard, Cortlandt Van Dyke. AMERI-
 CAN GEORGIAN ARCHITECTURE. Bloomington: Indiana University
 Press, 1952. xii, 56 p. 64 illus.

 American Georgian architecture traced from its beginnings in
 Europe through the late "Federal" style. Each chapter deals
 with the three geographic areas: the South, middle colonies,
 and New England. Careful line drawings in the text.

202 Faris, John T. OLD CHURCHES AND MEETING HOUSES IN AND
 AROUND PHILADELPHIA. Philadelphia: J.B. Lippincott Co., 1926.
 xvi, 261 p. Illus.

 Text contains almost no architectural comments, but most of
 the structures are illustrated.

203 Foreman, Henry Chandlee. EARLY NANTUCKET AND ITS WHALE
 HOUSES. New York: Hastings House, 1966. ix, 291 p. Illus.
 Bibliog. pp. 277-81.

 A social and critical study of the island and the architecture
 of its major industry. Old photographs.

204 Garvan, Anthony N.B. ARCHITECTURE AND TOWN PLANNING IN
 COLONIAL CONNECTICUT. New Haven: Yale University Press, 1957.
 xiv, 166 p. Illus. Bibliog. pp. 152-59.

 Views the historical development of some of the major towns
 in terms of town planning. Architects and laymen involved
 in the laying out of areas are seen as planners. Maps, dia-
 grams, and other illustrations.

205 Howells, John Mead. THE ARCHITECTURAL HERITAGE OF THE MERRI-
 MACK. New York: Architectural Book Publishing Co., 1941. xxiii,
 229 p. 302 illus.

 The historical and geographical description of the region is
 followed by more than 300 clear photographs of the exterior
 and interior details of major examples of colonial and some
 early nineteenth-century homes and public buildings. Changes
 from the original construction are noted.

206 _____. LOST EXAMPLES OF COLONIAL ARCHITECTURE, 1931. Rev.
 ed. New York: Dover, 1963. 244 p. Illus.

 Not all structures have completely disappeared; some have
 been severely altered or partially dismantled. Illustrations

from both prints and old photographs.

207 Isham, Norman Morrison. EARLY AMERICAN HOUSES: AND A GLOS-
SARY OF COLONIAL ARCHITECTURAL TERMS. Reprint. New York:
Da Capo Press, 1967. 61 p. 37 p. illus.

The first reproduced work details the methods of construction
and style of colonial homes. Particular attention is paid to
framing techniques. The second work is an illustrated glos-
sary of terms in constant use during the colonial period, al-
though many predate that era and some are still in use.

208 Isham, Norman Morrison, and Brown, Albert F. EARLY CONNECTICUT
HOUSES: AN HISTORICAL AND ARCHITECTURAL STUDY. 1900. Re-
print. New York: Dover, 1970. 303 p. Illus.

The interiors and exteriors are illustrated in an early yet
scholarly survey. Many of the illustrations are not to be
found elsewhere.

209 Jackson, Joseph Francis. AMERICAN COLONIAL ARCHITECTURE: ITS
ORIGIN AND DEVELOPMENT. Philadelphia: David McKay Co., 1924.
Reprint. New York: Johnson Reprint, 1969. viii, 228 p. 48 illus.
Bibliog. pp. 213-15.

Although out of date, this book has value because of its
unusual organization in treating geographic areas rather than
styles.

210 Kelly, J. Frederick. THE EARLY DOMESTIC ARCHITECTURE OF CON-
NECTICUT. New Haven: Yale University Press, 1927. xx, 210 p.
48 black and white illus., 242 drawings.

Chapters on the various methods of plan and framing, masonry,
entrance ways, cupboards, stairs, and other exterior and in-
terior architectural features. Although Connecticut structures
are illustrated and regional peculiarities of construction are
discussed, this serves as a good guide to colonial construction
in general.

211 Kimball, [Sidney] Fiske. DOMESTIC ARCHITECTURE OF THE AMERICAN
COLONIES AND OF THE EARLY REPUBLIC. New York: Charles Scrib-
ner's Sons, 1922. xx, 314 p. 219 illus.

An early but still valuable in-depth survey of architectural
style, influences, materials, and methods of construction from
the earliest settlements through the early Federal style. Re-
gional differences and matters of ornament and detail are
noted.

212 Lanning, John Tate. SPANISH MISSIONS OF GEORGIA. Chapel
Hill: University of North Carolina Press, 1935. 321 p. Illus.

Points out the long ignored Spanish influence in Georgia and documents the existing and no longer extant missions.

213 Marlowe, George Francis. CHURCHES OF OLD NEW ENGLAND: THEIR ARCHITECTURE AND THEIR ARCHITECTS. New York: Macmillan Publishing Co., 1947. xii, 222 p. Illus. Bibliog. pp. 221-22.

Provides basic information on the buildings, their style and design, and when known, who actually did the plans and designs. More concerned with each structure than with an overview.

214 Meixner, Esther Chilstrom. "Swedish Landmarks in the Delaware Valley." SWEDISH PIONEER HISTORICAL QUARTERLY 7 (January 1956): 21-34.

Covers buildings erected by Swedish settlers during the seventeenth century. Homes in Delaware, New Jersey, and Pennsylvania are discussed. The Swedish log cabin is included.

215 Millar, John Fitzhugh. THE ARCHITECTS OF THE AMERICAN COLONIES OR VITRUVIOUS AMERICANUS. Barre, Mass.: Barre Publishers, 1968. 205 p. Illus. Bibliog. pp. 196-97.

There are three chapters: architects who sent designs from England, architects of the South, and of the North. In each area, the important buildings, some information about the architect, and possible historical sources are included. The illustrations of facades and elevations are renderings by Suzanne Carlson.

216 Morrison, Hugh. EARLY AMERICAN ARCHITECTURE: FROM THE FIRST COLONIAL SETTLEMENTS TO THE NATIONAL PERIOD. New York: Oxford University Press, 1952. xiv, 619 p. 484 illus.

This extremely detailed volume is divided into three major sections: seventeenth-century colonial architecture, Spanish and French colonial architecture, and Georgian architecture 1700-80. Physical design, the building broken down into parts, and stylistic development are all provided. Environmental considerations are discussed.

217 Nichols, Frederick D[oreton], and Bear, James A., Jr. MONTICELLO. Charlottesville: University Press of Virginia, 1967. 77 p. 51 illus.

A well-illustrated examination of the home Jefferson designed and lived in for much of his life.

218 Pierson, William H., Jr. THE COLONIAL AND NEOCLASSICAL STYLES. AMERICAN BUILDINGS AND THEIR ARCHITECTS. Vol. I. Garden City, N.Y.: Doubleday & Co., 1970. xxv, 503 p. 333 illus.

The first of a four-volume detailed survey of American

architectural styles. The first section traces Old World background and then examines the colonial developments. Following is a discussion on the evolution of neoclassicism from the early work of Bulfinch through the Greek revival. Many valuable illustrations.

219 Poor, Alfred Easton. COLONIAL ARCHITECTURE OF CAPE COD, NANTUCKET, AND MARTHA'S VINEYARD. New York: William Helburn, 1932. Unpaged. 135 plates.

No text, but very good illustrations of the major colonial buildings, including details of exteriors, elevations, plans, and some interiors.

220 Rawlings, James Scott. VIRGINIA'S COLONIAL CHURCHES: AN ARCHITECTURAL GUIDE. Richmond, Va.: Garrett and Massie, 1963. xi, 286 p. 5 color illus. Bibliog. pp. 271-73.

Describes the size, materials, and appearance of each structure, and comments on degree of restoration.

221 Raymond, Eleanor. EARLY DOMESTIC ARCHITECTURE OF PENNSYLVANIA. New York: William Helburn, 1931. Unpaged. 158 plates.

Large format of photographs of the major homes, barns, and other domestic structures of the colonial period of Pennsylvania's history. Although not all plates are excellent, this volume provides an experience of many important structures no longer in existence.

222 Reps, John W. "Tidewater Colonies, Town Planning in the 17th Century." TOWN PLANNING REVIEW 34 (April 1963): 27-38.

This illustrated article rebuts the argument that there was no planning in the colonial South.

223 _____. TIDEWATER TOWNS: CITY PLANNING IN COLONIAL VIRGINIA AND MARYLAND. Williamsburg, Va.: The Colonial Williamsburg Foundation, 1972. xii, 345 p. 203 illus. Bibliog. pp. 321-28.

After providing a background of the English town planning tradition, Reps traces the chronological development of the planning and growth of the various towns and cities through the eighteenth century. Many good maps and drawings to illustrate his points.

224 Reynolds, Helen Wilkinson. DUTCH HOUSES IN THE HUDSON VALLEY BEFORE 1776. New York: Payson and Clarke, 1929. 467 p. 150 illus.

A general history of the area followed by information about

the types of structures and their architectural details. The
bulk of the volume is divided into chapters on counties, gen-
eral information on each, and a discussion of each major
structure in the area. The illustrations consist of photographs
and views from old paintings and engravings.

225 Rose, Harold Wickliffe. THE COLONIAL HOUSES OF WORSHIP IN
 AMERICA: BUILT IN THE ENGLISH COLONIES BEFORE THE REPUBLIC,
 1607-1789 AND STILL STANDING AD MAJOREM GLORIAM DEI. New
 York: Hastings House, 1963. xv, 574 p. 345 churches. Illus.
 Bibliog. pp. 543-50.

 A general historical and cultural study of the colonial houses
 of worship, of all denominations, throughout the colonies.
 State-by-state survey that describes the structure, what ren-
 ovation has occurred, and present condition. Exterior and
 interior illustrations. For the interested layman.

226 Shurtleff, Harold Robert. THE LOG CABIN MYTH: A STUDY OF
 EARLY DWELLINGS OF THE ENGLISH COLONISTS IN NORTH AMERI-
 CA. Cambridge, Mass.: Harvard University Press, 1939. xxi, 243 p.
 33 illus.

 A study of the American log cabin and its origins in Northern
 Europe. Bibliographical footnotes are an important source of
 information for the scholar.

227 Smith, J. Frazer. WHITE PILLARS: EARLY LIFE AND ARCHITECTURE
 OF THE LOWER MISSISSIPPI VALLEY COUNTRY. New York: William
 Helburn, 1941. 252 p. Illus. Bibliog. pp. 247-49.

 An area-by-area examination of major houses of the lower
 South. Much of the material is architectural description and
 the illustrations are drawings rather than photographs. Major
 homes of the first half of the nineteenth century are included.

228 Wallace, Philip B. COLONIAL CHURCHES AND MEETING HOUSES:
 PENNSYLVANIA, NEW JERSEY, AND DELAWARE. New York: Archi-
 tectural Book Publishing Co., 1931. xii, 291 p. Illus.

 This volume consists of large photographs of buildings and
 details of both interiors and exteriors, as well as measured
 drawings of many of the structures. This is the only survey
 of the middle states' religious architecture.

229 _____. COLONIAL HOUSES OF PHILADELPHIA: PREREVOLUTIONARY
 PERIOD. New York: Architectural Book Publishing Co., 1931. 248 p.
 Illus.

 Entirely a picture book, but one with so many photographs,
 plans, and elevations of important colonial Philadelphian
 homes that it is an important source for understanding stylistic
 and asthetic developments in the major colonial city.

230 ____. COLONIAL IRONWORK IN OLD PHILADELPHIA. New York: Architectural Book Publishing Co., 1930. Reprint. New York: Dover, 1970. 147 p. Illus.

> Large photographs and measured drawings of gates, lamps, and railings, all associated with the decoration of architecture of the colonial period in Philadelphia.

231 Waterman, Thomas Tileston. THE DWELLINGS OF COLONIAL AMERICA. Chapel Hill: University of North Carolina Press, 1950. 312 p. Illus. Bibliog. pp. 291-93.

> A good general survey of colonial domestic architecture. Each section of the country is treated separately and chronologically. Plans and some discussion of architecture vis a vis social needs are included.

232 ____. THE MANSIONS OF VIRGINIA, 1706-1776. Chapel Hill: University of North Carolina Press, 1945. 456 p. Illus. Bibliog. pp. 425-32.

> A history of the great houses of Virginia in the eighteenth century to the time of the Revolution. English prototypes are discussed and illustrated, and a brief history of seventeenth-century developments in Virginia is also provided. Exteriors, interiors, and plans are illustrated.

233 Waterman, Thomas Tileston, and Burrows, John A. DOMESTIC COLONIAL ARCHITECTURE OF TIDEWATER VIRGINIA. New York: Dover, Charles Scribner's Sons, 1932. xvii, 191 p. Illus.

> A house-by-house treatment of the grand plantation houses of the Tidewater with outline plans, information about materials, and a glossary of architectural terms. Oversize volume with large plates.

234 Whiffen, Marcus. THE PUBLIC BUILDINGS OF WILLIAMSBURG: COLONIAL CAPITOL OF VIRGINIA. Williamsburg, Va.: Colonial Williamsburg, 1958. xv, 269 p. Illus. Bibliog. pp. 235-40.

> Provides the English background to Williamsburg and explains how English influence operated in eighteenth-century Virginia, in general. The capitol's buildings are described in detail, based on documentary sources.

235 Wilson, Everett B. MARYLAND'S COLONIAL MANSIONS AND OTHER EARLY HOUSES. New York: A.S. Barnes & Co., 1965. 249 p. Illus. Bibliog. p. 249.

> More than 400 illustrations of both the exteriors and interiors of colonial homes and other buildings in Maryland, all of which were still standing in 1963. Clear illustrations with a

small amount of information on each. Arranged by county.

NINETEENTH-CENTURY ARCHITECTURE

236 Andrew, David S., and Blank, Laurel B. "The Four Mormon Temples in Utah." SOCIETY OF ARCHITECTURAL HISTORIANS. JOURNAL 30 (March 1971): 51-65.

An explanation of the reasons for the uniqueness of the four late nineteenth-century Mormon Temples in Utah. Speculation that the double entrance idea was derived from Quarter Meeting Houses and other elements through contact with Free Masonry.

237 Bracken, Dorothy K., and Redway, Maurine W. EARLY TEXAS HOMES. Dallas, Tex.: Southern Methodist University Press, 1956. xii, 188 p. Illus.

Covers the period from 1745 through the end of the Civil War. Primarily social history, but important architectural monuments are both discussed and illustrated.

238 Bryon, John Albury. "Outstanding Architects in St. Louis between 1804 and 1904." MISSOURI HISTORICAL REVIEW 28 (January 1934): 83-90.

Biographical information on various architects is provided with a list of their major projects.

239 _____, ed. MISSOURI'S CONTRIBUTION TO AMERICAN ARCHITEC-TURE. St. Louis, Mo.: St. Louis Architectural Club, 1928. 368 p. Illus.

Chapters divided chronologically with a short introduction to each period. Covers both the domestic and civic architecture. The bulk of the volume consists of illustrations.

240 Campen, Richard N. ARCHITECTURE OF THE WESTERN RESERVE, 1800-1900. Cleveland: Press of Case Western Reserve University, 1971. xii, 260 p. Illus. Bibliog. pp. 255-58.

An area-by-area survey of the important homes, churches, and public buildings of northeast Ohio.

241 Cochran, Gifford Alexander. GRANDEUR IN TENNESSEE: CLASSICAL REVIVAL ARCHITECTURE IN A PIONEER STATE. New York: J.J. Augustin, 1946. xi, 132 p. Illus. Bibliog. p. 132.

A brief history of the evolution of historical styles and the early history of the state. Almost half the illustrations, exteriors and interiors, present the work of William Strickland.

242 Condit, Carl W. AMERICAN BUILDING ART: THE NINETEENTH CENTURY. New York: Oxford University Press, 1960. xvii, 371 p. 139 illus. Bibliog. pp. 345-51.

> An exploration of materials and building techniques in the development of American architecture. In this volume, wood and iron framing, wood and iron bridge trusses, the development of the suspension and iron arch bridge, and the beginning of concrete construction are discussed.

243 Conover, Jewel Helen. NINETEENTH-CENTURY HOUSES IN WESTERN NEW YORK. Albany: State University of New York, 1966. xii, 161 p. 108 illus. Bibliog. pp. 159-61.

> A brief history of the region is followed by a discussion of the stylistic developments in architecture. The bulk of the book consists of illustrations of homes which are important architecturally, with some description of the style and ornamentation of each.

244 Coolidge, John. MILL AND MANSION: A STUDY OF ARCHITECTURE AND SOCIETY IN LOWELL, MASSACHUSETTS, 1820-1865. New York: Columbia University Press, 1942. xi, 261 p. 92 illus. Bibliog. pp. 223-31.

> The social and cultural history of Lowell. How both homes and public buildings reflected the industrial development and prevailing aesthetic theory.

245 Cooper, J. Wesley. NATCHEZ: A TREASURE OF ANTE-BELLUM HOMES. Philadelphia: E. Stern, 1957. 159 p. Illus.

> Discusses and illustrates the major historic homes of Natchez in the period from 1780 through the beginning of the Civil War.

246 Drury, John. HISTORIC MIDWEST HOUSES. Minneapolis: University of Minnesota Press, 1947. x, 246 p. Illus.

> Historic houses, some architecturally significant, and some only important because of a famous inhabitant. All illustrated, but very little information on the building materials or style.

247 Dubell, Susan I. "Pioneer Home." PALIMPSEST 12 (December 1931): 445-54.

> Provides a good general discussion of pioneer log cabin construction with an emphasis on Iowa.

248 Eaton, Leonard [K.]. AMERICAN ARCHITECTURE COMES OF AGE: EUROPEAN REACTION TO H.H. RICHARDSON AND LOUIS SULLIVAN.

Cambridge, Mass.: The M.I.T. Press, 1972. xiii, 256 p. 142 illus.
Bibliog. pp. 240-42.

A clearly documented and illustrated study of how such major
European architects as Adolf Loos, Karl Moser, and Hendrik
Berlage were influenced by the architecture of Richardson
and Sullivan. Contradicts the argument that Frank Lloyd
Wright was the first American architect to influence Europe.

249 Eberlein, Harold Donaldson, and Hubbard, Cortlandt V[an] D[yke].
HISTORIC HOUSES OF GEORGETOWN AND WASHINGTON CITY.
Richmond, Va.: The Dietz Press, 1958. xiv, 480 p. 100 illus.
Bibliog. pp. xi-xii.

Street-by-street survey of the major domestic landmarks of
the capitol area. High quality photographs and data on each
house listed.

250 Fanning, Ralph Stanlee. "The Classical Revival in the South." GEOR-
GIA REVIEW 8 (Spring 1954): 52-60.

Discusses the architecture during the period from 1790 to
1860, concentrating on private dwellings.

251 Ferry, [W.] Hawkins. "Gothic and Tuscan Revivals in Detroit, 1828-
1875." ART QUARTERLY 9 (1946): 234-56.

Discussion of the structures and the important architects.

252 Flanders, Robert Bruce. NAUVOO: KINGDOM ON THE MISSISSIPPI.
Urbana: University of Illinois Press, 1965. 364 p. Illus.

A history of the original Mormon city and its restored form.
The architecture of both the Temple and the homes is de-
scribed and illustrated.

253 Forman, Henry Chandlee. EARLY MANOR AND PLANTATION HOUSES
OF MARYLAND. Easton, Md.: privately printed, 1934. 271 p. Illus.

A county-by-county survey of the important homes of Mary-
land. Each is illustrated, and various architectural dimen-
sions and features are noted.

254 Frary, I.T. EARLY HOMES OF OHIO. New York: Dover, 1970.
xviii, 336 p. 196 illus. Bibliog. p. 321.

A general history and guidebook to the early houses of Ohio,
with a short chapter on public buildings. The various early
builders are discussed, and cultural history is included.
Many good illustrations.

255 _____. THEY BUILT THE CAPITOL. Richmond, Va.: Garrett and

Massie, 1940. xvi, 324 p. 97 illus. Bibliog. pp. 315-16.

A general introduction to the history of the building of the
capitol in Washington, D.C., which includes information
about the architects and sculptors as well as provides speci-
fications for ready reference. A chronology of events related
to the building project is included.

256 Gifford, Don, ed. THE LITERATURE OF ARCHITECTURE: THE EVOLU-
TION OF ARCHITECTURAL THEORY AND PRACTICE IN NINETEENTH
CENTURY AMERICA. New York: E.P. Dutton & Co., 1966. 640 p.
42 illus. Bibliog. pp. 635-40.

Essays and excerpts from the writings of commentators on the
architecture of the United States from the middle of the
eighteenth century to the end of the First World War. The
author explains his view that nineteenth-century aesthetics
provide a theme, and attempts to explore the dimensions of
those aesthetics through these selections.

257 Gillon, Edmund V. EARLY ILLUSTRATIONS AND VIEWS OF AMERICAN
ARCHITECTURE. New York: Dover, 1971. vii, 295 p. 742 illus.
Bibliog. pp. 287-88.

An entire picture book of reproductions of graphic illustrations
of American architecture, primarily of the nineteenth century.
Arranged by categories of buildings. A good guide to the
taste of the time.

258 Hamlin, Talbot [Faulkner]. GREEK REVIVAL ARCHITECTURE IN AMERI-
CA: BEING AN ACCOUNT OF IMPORT AND TRENDS IN AMERICAN
ARCHITECTURE AND AMERICAN LIFE PRIOR TO THE WAR BETWEEN
THE STATES. London and New York: Oxford University Press, 1944.
xl, 439 p. 94 illus. Bibliog. pp. 383-409.

The classic and comprehensive study of Greek revival archi-
tecture in all its manifestations and in all parts of the coun-
try. Regional and local styles are discussed and illustrated.

259 Hilham, Walter H. BOSTON AFTER BULFINCH: AN ACCOUNT OF
ITS ARCHITECTURE, 1800-1900. Cambridge, Mass.: Harvard University
Press, 1946. 114 p. Illus.

How the city grew and was affected by succeeding historical
styles. Public and private buildings are included.

260 Huxtable, Ada Louise. CLASSIC NEW YORK: GEORGIAN GENTILITY
TO GREEK ELEGANCE. Garden City, N.Y.: Doubleday & Co., 1964.
xvi, 142 p. Illus. Bibliog. pp. 133-35.

Brief guide to Georgian and Greek Revival architecture in
New York City. Various surviving houses are illustrated and
described in terms of the historic styles.

261 Junior League of San Francisco. HERE TODAY: SAN FRANCISCO'S
 ARCHITECTURAL HERITAGE. San Francisco: Chronicle Books, 1968.
 xi, 334 p. Illus.

 Divided into three parts covering San Francisco, San Mateo, and
 Marin Counties. Each section is preceded by a map of the area
 and, within each area, the important structures are examined
 within geographic subdivisions. The appendix lists the impor-
 tant features of approximately 2,000 buildings in the area.

262 Kaufmann, Edgar, Jr., ed. THE RISE OF AN AMERICAN ARCHITEC-
 TURE. New York: Frederick A. Praeger and The Metropolitan Museum
 of Art, 1970. x, 241 p. 202 illus.

 Four essays on questions concerning nineteenth-century archi-
 tecture in America: "American Influence Abroad," by H.R.
 Hitchcock; "The American City, The Ideal and the Real," by
 Albert Fein; "A New View of Skyscraper History, (N.Y. Did
 It First)," by Winston Weisman; and "American Houses: Th.
 Jefferson to F.L. Wright," by V. Scully. Also information
 about the exhibition done for the 100th anniversary of the
 Metropolitan Museum of Art.

263 Kimball, [Sidney] Fiske. "Thomas Jefferson and the First Monument of
 the Classical Revival in America." AMERICAN INSTITUTE OF ARCHI-
 TECTS. JOURNAL 3 (September-November 1915): 370-81, 421-33,
 473-91.

 A three-part article on Jefferson's capitol for the state of
 Virginia, its relationship to Roman architecture, and its place
 in the development of our national style. (See also 357.)

264 Lancaster, Clay. ANTE BELLUM HOUSES OF THE BLUEGRASS. Lex-
 ington: University of Kentucky Press, 1961. xiii, 186 p. Illus.
 Bibliog. pp. 149-54.

 Chapters discuss frame, stone, and brick houses as well as
 describe them in terms of the major historical styles. The
 line drawings and photographs provide clarity.

265 _____. OLD BROOKLYN HEIGHTS: NEW YORK'S FIRST SUBURB.
 Rutland, Vt.: Charles E. Tuttle Co., 1961. 183 p. 47 illus.
 Bibliog. pp. 176-78.

 Describes how the major historical styles were utilized in the
 area and then provides a street-by-street listing of the old
 homes and notations as to special features.

266 Laughlin, Clarence John. "The River Houses." AMERICAN HERITAGE
 7 (June 1956): 54-63.

 A cultural and historical examination of the plantation houses
 that border the Mississippi in Louisiana. Good illustrations.

267 Leiding, Harriette Kershaw. HISTORIC HOUSES OF SOUTH CAROLINA.
 Philadelphia: J.B. Lippincott Co., 1921. xvii, 318 p. Illus.

 A geographical approach to historic architecture which, in
 spite of its age, is of great use. Each of the important
 houses is described in considerable detail. Many fuzzy but
 invaluable photographs.

268 Major, Howard. THE DOMESTIC ARCHITECTURE OF THE EARLY AMER-
 ICAN REPUBLIC: THE GREEK REVIVAL. Philadelphia: J.B. Lippincott
 Co., 1926. 237 p. 256 illus.

 Chapters on the origins and development of the Greek revival
 style, regional variations, and its movement into the West.
 Many little-known buildings are illustrated.

269 Newcomb, Rexford. ARCHITECTURE IN OLD KENTUCKY. Urbana:
 University of Illinois Press, 1953. 185 p. Illus.

 Covers the buildings erected between the Revolutionary period
 and the end of the nineteenth century.

270 _____. ARCHITECTURE OF THE OLD NORTHWEST TERRITORY.
 Chicago: University of Chicago Press, 1950. xvii, 176 p. 140 illus.
 Bibliog. pp. 162–67.

 The early chapters discuss the geographical and environmental
 factors in the region and the make-up of the population.
 Architectural types and the influences of both the South and
 New England are next covered, and are followed by a state-
 by-state exploration of the historical styles.

271 Newell, Frederick Haynes, ed. PLANNING AND BUILDING THE
 CITY OF WASHINGTON. Washington, D.C.: Ransdell, 1932. 258 p.
 Illus.

 The discussion centers on the history of the planning of the
 capitol city and on the role of George Washington as one
 of the important planners.

272 Nichols, Frederick Doreton. THE EARLY ARCHITECTURE OF GEORGIA.
 Chapel Hill: University of North Carolina Press, 1957. xvi, 292 p.
 Illus.

 Illustrations are photos by Frances B. Johnston. The major
 homes and public buildings are examined, and the history of
 the area is provided in a brief essay. Interiors, plans, and
 facades are illustrated. The vast majority of the structures
 date from the first half of the nineteenth century.

273 Reilly, Charles Herbert. McKIM, MEAD & WHITE. London: Ernest
 Benn, 1924. 57 p. 36 illus.

A study of the major buildings of the important nineteenth and early twentieth-century partnership. (See also 379.)

274 Roos, Frank John, Jr. "Ohio: Architectural Cross-road." SOCIETY OF ARCHITECTURAL HISTORIANS. JOURNAL 12 (May 1953): 3-8.

Where Northeast and Southeast meet. Briefly discusses developments from 1772 to the Civil War and the conflict of styles.

275 Schmidt, Carl F. THE OCTAGON FAD. Scottsville, N.Y.: privately printed, 1958. 207 p. Illus.

A survey and history of octagon and "round" houses of the nineteenth century. Illustrations of those surviving.

276 Schuyler, Montgomery. AMERICAN ARCHITECTURE AND OTHER WRITINGS. Edited by William H. Jordy and Ralph Coe. 2 vols. Cambridge, Mass.: Harvard University Press, Belknap Press, 1961. xvi, 665 p. 166 illus. Bibliog. pp. 641-53.

The new edition of Schuyler's long out-of-print pioneering essays recognizing developments in nineteenth-century American architecture. Important chapters on Richardson's revivalism, the developments in engineering as applied to bridge building, the birth of the skyscraper, academic reaction, and early appraisals of Sullivan and Wright.

277 Scott, Mary Winfield. HOUSES OF OLD RICHMOND. Richmond, Va.: The Valentine Museum, 1941. xii, 332 p. Illus. Bibliog. pp. 317-20.

Social and historical material in addition to the description and illustration of each important structure. Primarily a survey of nineteenth-century revival structures, but includes the few remaining eighteenth-century structures. Locations are given by address, lot number, and deed book information.

278 Scully, Vincent Joseph. THE SHINGLE STYLE AND THE STICK STYLE: ARCHITECTURAL THEORY AND DESIGN FROM RICHARDSON TO THE ORIGINS OF WRIGHT. Rev. ed. New Haven: Yale University Press, 1971. lix, 184 p. 163 illus. Bibliog. pp. 165-76.

An extremely thorough pioneering study of domestic architecture in wood during the second half of the nineteenth century. The author makes a case for the American quality of the new style while admitting to the influence of English architecture and the Queen Anne style. Also documents the influence of colonial American building styles.

279 Stanton, Phoebe B. THE GOTHIC REVIVAL AND AMERICAN CHURCH ARCHITECTURE: AN EPISODE IN TASTE, 1840-1856. Baltimore: The Johns Hopkins University Press, 1968. 350 p. 118 illus.

A study of the widespread Gothic revival and its particular manifestations in American church architecture. It documents not only the work of the famous like Upjohn, but that of more restrained and unknown figures as well. The clear illustrations include drawings and plans as well as photographs.

280 Tallmadge, Thomas E. ARCHITECTURE IN OLD CHICAGO. Chicago: University of Chicago Press, 1941. xiii, 218 p. Illus.

The early history of the city serves as a backdrop for the chapters on the early architecture up to 1855, the middle period up to 1880, and the age of the skyscraper and great growth, 1880–93.

281 Whiffen, Marcus. "Early County Court Houses of Virginia." SOCIETY OF ARCHITECTURAL HISTORIANS. JOURNAL 18 (March 1959): 2–10.

Discussion and list of the buildings.

282 White, Theophilus Ballou. PHILADELPHIA ARCHITECTURE IN THE 19TH CENTURY. Philadelphia: University of Pennsylvania Press, 1953. 128 p. Illus.

This is an exhibition catalog which includes the photos of historic buildings illustrated in the book.

TWENTIETH-CENTURY ARCHITECTURE

283 Banham, Reyner. LOS ANGELES: THE ARCHITECTURE OF FOUR ECOLOGIES. New York: Harper & Row, Publishers, 1971. 256 p. 123 illus. Bibliog. pp. 247–52.

A blend of architectural history, criticism, and witty social history. Public and private buildings are examined in regard to overall vistas, access, and environment.

284 Brooks, H. Allen. THE PRAIRIE SCHOOL: FRANK LLOYD WRIGHT AND HIS MIDWEST CONTEMPORARIES. Toronto: University of Toronto Press, 1971. xxiii, 373 p. 247 illus. Bibliog. pp. 349–52.

An intensive and extensive survey of the Prairie School of architecture. After a serious discussion and analysis of the use of the term "Prairie School," the author comments on the philosophical and personal interactions among the group of older and younger architects in the Chicago area. The work of Frank Lloyd Wright in both the development of the school and its breakup is discussed. The later careers of individuals are also documented.

285 Burnham, Daniel H. REPORT ON A PLAN FOR SAN FRANCISCO. 1905. Reprint. Berkeley: Urban Books, 1971. 221 p. Illus.

In 1902, having completed plans for several other cities, Burnham was asked to propose one for San Francisco. It was completed by 1905 and heavily stressed streets and topographical concerns of the unique city on hills. An interesting case study in early twentieth-century planning influenced by the nineteenth-century planner Hausemann.

286 Burnham, Daniel H., and Bennett, Edward H. PLAN OF CHICAGO. Edited by Charles Moore. 1909. Reprint. New York: Da Capo Press, 1970. viii, xviii, 164 p. Illus., some in color.

A reprint of Burnham's influential plan, designed between 1906 and 1908 and accepted in 1910. As the plan was carried out to a large extent, the ideas behind it are still of interest today. Maps and designs are valuable for the person unfamiliar with the city.

287 Cheney, Sheldon. ART AND THE MACHINE: AN ACCOUNT OF INDUSTRIAL DESIGN IN TWENTIETH CENTURY AMERICA. New York: McGraw-Hill Book Co., 1936. xvii, 307 p. Illus. Bibliog. pp. 301-4.

Traces the history of technologies affecting products and discusses both the interaction and conflict between handcraft and machine. Chapters on the applicability of design to interiors; examines modern architecture as an aspect of industrial design.

288 Condit, Carl W. AMERICAN BUILDING ART: THE TWENTIETH CENTURY. New York: Oxford University Press, 1961. xviii, 427 p. 128 illus. Bibliog. pp. 393-405.

Brings the author's exploration of materials and building techniques into the twentieth century. Steel frames, steel truss and girder bridges, and the new uses of concrete and steel are covered. The notes are filled with statistical detail for the scholar to ponder, and the text is easy to read.

289 Danz, Ernst. ARCHITECTURE OF SKIDMORE, OWINGS, AND MERRILL, 1950-1962. New York: Frederick A. Praeger, 1963. 231 p. Illus.

A study of the major projects of the firm that has been responsible for so many of the best known buildings in the United States, from Lever House in New York to the University of Illinois Chicago Campus. The text and technical notes are in both English and German.

290 Drexler, Arthur, and Menges, Alex. ARCHITECTURE OF SKIDMORE, OWINGS, AND MERRILL, 1963-1973. New York: Architectural Book Publishing Co., 1974. 283 p. Illus.

A detailed description of the major projects of one of the

world's largest architectural firms. Described and illustrated
are many of the major campuses, libraries, and skyscrapers
designed by Skidmore, Ownings, and Merrill in the last decade.
Text in both English and German.

291 Gebhard, David. "The Spanish Colonial Revival in Southern California,
 1895-1930." SOCIETY OF ARCHITECTURAL HISTORIANS. JOURNAL
 26 (May 1967): 131-47.

 Discusses the relationships between the revival style and
 various avant garde movements. Particular attention is called
 to the Mission Revival and the Arts and Crafts Movement.

292 Gruen, Victor, and Smith, Larry. SHOPPING TOWNS, U.S.A.: THE
 PLANNING OF SHOPPING CENTERS. New York: Reinhold Publish-
 ing, 1960. 288 p. Illus. Bibliog. pp. 279-81.

 Combines a history and study of the shopping center as a
 major development in American architecture and planning
 with a guide to the practical steps necessary for setting one
 up. Chapters on leases and tenants can be ignored, but the
 ones devoted to utilities, walkways, etc., are of interest to
 the planner and designer.

293 Hamlin, Talbot Faulkner, ed. FORMS AND FUNCTIONS OF TWENTI-
 ETH CENTURY ARCHITECTURE. 4 vols. New York: Columbia Uni-
 versity Press, 1952. Vol. 1, li, 750 p., 710 illus.; vol. 2, xlii,
 638 p., 709 illus.; vol. 3, xlix, 931 p., 629 illus.; vol. 4, xiv,
 946 p., 588 illus.

 A major study of the forms, design, and composition of
 modern architecture with essays by many important architec-
 tural authorities. More than 2,000 illustrations of interiors
 and exteriors. While being international in scope, the
 writers and their subjects are overwhelmingly American.

294 Hasbrouck, Wilbert R. "Chicago's Auditorium Theater." THE PRAIRIE
 SCHOOL REVIEW 4 (1967): 7-21.

 Although the Auditorium Theater is a nineteenth-century build-
 ing, it is also a pioneer skyscraper. It had been closed for
 thirty years, and this record of its partial restoration and
 reopening is an important chapter in twentieth-century his-
 toric preservation.

295 Heyer, Paul. ARCHITECTS ON ARCHITECTURE: NEW DIRECTIONS
 IN AMERICA. New York: Walker and Co., 1966. 415 p. Illus.
 Bibliog. pp. 404-5.

 Background and biographical information on more than forty
 major architects and architectural firms, and transcriptions of
 recorded conversations with them. The design aspects of their

work are stressed. Several figures included are not American, but their work in this country is the focal point of the attention paid them in this study.

296 Hitchcock, Henry-Russell, and Drexler, Arthur, eds. BUILT IN U.S.A.: POST-WAR ARCHITECTURE. New York: Museum of Modern Art, 1952. 128 p. Illus.

Drexler discusses technological achievements and building in terms of a public image. The individual buildings illustrated are primarily by the big names in architecture today, making this a very perceptive contemporary evaluation of the era. Public and private buildings by European architects in America are also included. (See also 448.)

297 Huxtable, Ada Louise. WILL THEY EVER FINISH BRUCKNER BOULE-VARD? New York: Macmillan Publishing Co., 1963. xix, 268 p. Illus.

A collection of essays first published in the NEW YORK TIMES by its architectural critic. They deal with the problems of architecture, preservation, and city planning in the contemporary scene. Concentrates on New York City.

298 Jones, Cranston. ARCHITECTURE TODAY AND TOMORROW. New York: McGraw-Hill Book Co., 1961. vii, 243 p. Illus. Bibliog. pp. 241-43.

Sections on the origins of modernism, the major developments of the international style and its offshoots, and new directions for the future. Architects are quoted and their major works are illustrated. Although this is a study of the major figures in worldwide architecture of the twentieth century, American figures predominate.

299 Jordy, William H. THE IMPACT OF EUROPEAN MODERNISM IN THE MID TWENTIETH CENTURY. AMERICAN BUILDINGS AND THEIR AR-CHITECTS. Vol. 4. Garden City, N.Y.: Doubleday & Co., 1972. xxiv, 469 p. 204 illus.

Seven buildings by six architects are the centers of discussion of the forces at work in contemporary architecture. Rocke-feller Center, Philadelphia Saving Fund Society Building, Ferry Cooperative Dormitory, 860 Lake Shore Drive, Seagram Building, Guggenheim Museum, and Richards Medical Research Building at the University of Pennsylvania are the buildings.

300 _____. PROGRESSIVE AND ACADEMIC IDEALS AT THE TURN OF THE TWENTIETH CENTURY. AMERICAN BUILDINGS AND THEIR AR-CHITECTS. Vol. 3. Garden City, N.Y.: Doubleday & Co., 1972. xxi, 420 p. 168 illus.

A study of the developments of two different architectural points of view and styles, the traditional and the modern. Individual buildings by Sullivan, Wright, the Greene brothers, I. Gill, Maybeck, and McKim become the focal points for discussion of both aesthetics and style.

301 Kampf, Avram. CONTEMPORARY SYNAGOGUE ART. New York: Union of America Hebrew Congregations, 1966. 276 p. Illus.

Presents major and minor examples during the years from 1945 to 1965 by a wide variety of architects. Particularly concerned with ornamentation.

302 Karlowicz, Titus M. "The Chicago School and the Tyranny of Usage." THE PRAIRIE SCHOOL REVIEW 6 (1969): 11-19.

An analysis of the continued controversy as to the proper usage of the term "Chicago School." It is seen as identical to "Prairie School" and to the residential architecture of Wright and his followers and its relation to the development of commercial architecture in Chicago. The author sees reason to unify the two for their similar background.

303 McCallum, Ian. ARCHITECTURE U.S.A. New York: Reinhold Publishing, 1959. 216 p. Illus. Bibliog. pp. 213-16.

An examination of a cross-section of modern American architecture at mid-century. The chapters are essentially biographical presentations of both the very well-known individualists and some of the important large firm architects. Buildings and projects of each are presented by this English critic.

304 McCoy, Esther. FIVE CALIFORNIA ARCHITECTS. New York: Reinhold Publishing, 1966. vii, 200 p. Illus.

A particularly important source of accurate information and analysis of the work of Irving Gill's office. It covers Maybeck, Schindner, and the Greene brothers.

305 McCoy, Robert E. "Rock Crest/Rock Glen: Prairie Planning in Iowa." THE PRAIRIE SCHOOL REVIEW 5 (1968): 5-39.

An exhaustive survey of a small town area in Iowa that saw a development of interest in and construction of prairie architecture between the years 1908-17. The influence of Frank Lloyd Wright on such patrons as James Blythe is illustrated.

306 Mock, Elizabeth, ed. BUILT IN U.S.A., 1932-1944, AND POST WAR ARCHITECTURE. Edited by Henry-Russell Hitchcock and Arthur Drexler. New York: The Museum of Modern Art, 1944. Reprint (2 volumes in 1). New York: Arno Press, 1968. Vol. 1, 128 p.; vol. 2, 128 p.

Illus.

> Reprint of two classic studies of the development of modern architecture in this country. Covers architects from Wright to Rudolph.

307 Stern, Robert A.M. NEW DIRECTIONS IN AMERICAN ARCHITECTURE. New York: George Braziller, 1969. 128 p. 119 illus. Bibliog. p. 120.

> This volume is divided into two sections. The first discusses the work of the new generation of architects: Paul Rudolph, Kevin Roche, Robert Venturi, and others. The second introduces the great problems facing American architecture in the second half of the twentieth century: urban renewal, reintegration, and the "new city."

308 Von Eckardt, Wolf. A PLACE TO LIVE. New York: Delacorte Press, 1967. xviii, 430 p. Illus. Bibliog. pp. 409-14.

> A series of essays (some previously published) on topics relating to our urban design and architecture. How people live and work in our cities is explored, and aesthetics and planning receive witty and thoughtful attention.

309 Waugh, Edward, and Waugh, Elizabeth. THE SOUTH BUILDS: NEW ARCHITECTURE IN THE OLD SOUTH. Chapel Hill: University of North Carolina Press, 1960. 173 p. Illus.

> A brief history of architecture in the South followed by an appraisal of what is being done today on both the domestic and public fronts. The new work is divided into neo-classicism, romanticism, and prefabrication.

310 Woodward, Christopher. SKIDMORE, OWINGS, AND MERRILL. Library of Contemporary Architects. New York: Simon & Schuster, 1970. 136 p. 116 illus., some in color.

> A brief history and analysis of the firm that raises questions as to the viability of such a large multi-officered firm. Illustrations and plans of several of their major projects in the past quarter of a century.

Chapter 5
INDIVIDUAL ARCHITECTS

The following are books and periodical materials on the life, buildings, and style of individual architects throughout the history of American architecture.

BOGARDUS, JAMES 1800-74

311 Bannister, Turpin Chambers. "Bogardus Revisited. Part 1: The Iron Fronts. Part 2: The Iron Towers." SOCIETY OF ARCHITECTURAL HISTORIANS. JOURNAL 15 (December 1956): 12–22; 16 (March 1957): 11–19.

> Discusses Bogardus' influence on later architects and the craze for cast iron construction.

312 Bogardus, James. ORIGINS OF CAST IRON ARCHITECTURE IN AMERI-CA. 1856. Reprint (2 vols. in 1). New York: Da Capo Press, 1970. Part 1, 35 p.; part 2, 16 p. 102 plates.

> Early views of the importance and construction of cast iron architecture by a major practitioner of that building method. Illustrations of plans, elevations, and structural members.

313 Sturges, Walter Knight. "Cast Iron in New York." ARCHITECTURAL REVIEW 114 (October 1953): 232–37.

> Discusses the rise of the development of iron construction in the city and explains the pivotal role played by James Bogar-dus. His important works of the 1840s and 50s illustrate the early usage.

BREUER, MARCEL 1902-

314 Papachristou, Tician. MARCEL BREUER: NEW BUILDINGS AND PRO-JECTS. New York: Frederick A. Praeger, 1970. 239 p. 470 illus., 10 in color.

> Although the architect was born, raised, and worked in Europe,

his work and design have been closely associated with the
United States since his arrival here in 1937. In this volume,
earlier work is sketched, and the bulk of attention is paid to
his projects of the decade from 1960 to 1970. Many detailed
illustrations and notes on the technical and material methods
of construction on each project.

BUCKLAND, WILLIAM 1734-74

315 Beirne, Rosamond R., and Scarff, John Henry. WILLIAM BUCKLAND,
 1734-1774: ARCHITECT OF VIRGINIA AND MARYLAND. Baltimore:
 Maryland Historical Society, 1958. xiii, 175 p. Illus.

720.8
B92B This volume is based on primary documents shown in appen-
 dices. Buckland's early years in England are presented be-
 fore the body of a discussion as to his major work on Ganston
 Hall in Richmond County, Virginia, and in Maryland.

BULFINCH, CHARLES 1763-1844

316 Kirker, Harold. THE ARCHITECTURE OF CHARLES BULFINCH. Cam-
 bridge, Mass.: Harvard University Press, 1969. xxiii, 398 p.
 174 illus.

720.8
B93K A very short biography of the architect is followed by de-
 tailed discussion of each of his buildings. Illustrations of
 plans and interiors, when available, complement those of
 the facades. Very readable yet well annotated scholarly
 notations.

317 Place, C.A. CHARLES BULFINCH: ARCHITECT AND CITIZEN.
 Boston: Houghton Mifflin Co., 1925. xv, 295 p. Illus.

 A life of the architect placed within a social and cultural
 history of the times. Both the discussion of the buildings
 and plans of Bulfinch are narrative rather than analytical.
 A large section is concerned with his activities as architect
 of the Capitol in Washington, D.C.

BURNHAM, DANIEL HUDSON 1848-1912

318 Moore, Charles. DANIEL H. BURNHAM: ARCHITECT, PLANNER OF
 CITIES. Vol. 1. Boston: Houghton Mifflin Co., 1921. xviii, 260 p.
 Illus.

q720.8
B96m Traces the background and life of the architect, his training
 and early practice, his role in the Columbian Exposition, and
 further architectural projects through 1905. Well documented

q 720.8
B96m

and still a standard source.

319 _____ DANIEL H. BURNHAM: ARCHITECT, PLANNER OF CITIES.
Vol. 2. Boston: Houghton Mifflin Co., 1921. ix, 238 p. Illus.

Traces Burnham's life and activities from his 1906 trip to
Europe through his death in 1912. His ideas and philosophy
are presented in the last chapter, and lists of his buildings
are in the appendix.

BYRNE, BARRY 1883-1967

320 Chappell, Sally Anderson. "Barry Byrne, Architect: His Formative
Years." THE PRAIRIE SCHOOL REVIEW 3 (1966): 5-23.

Periodical

The author points out the neglect suffered by Byrne and
protests that he is always identified with others rather than
in his own right. His early years and seven-year experience
with Wright are discussed, as well as his later relationships
with the younger Wrights and his years directing the old office
of Walter Burley Griffin.

CILES, ALFRED 1853-1920

321 Jutson, Mary C.H. ALFRED CILES: AN ENGLISH ARCHITECT IN
TEXAS AND MEXICO. San Antonio, Tex.: Trinity University Press,
1972. xviii, 178 p. 146 illus.

The designer of more than 100 buildings, including ten court-
houses, in Texas, in eclectic styles ranging from Renaissance
to California bungalow. His work in Mexico is also discussed.

DAKIN, JAMES H. 1808-52

322 Scully, Arthur, Jr. JAMES DAKIN, ARCHITECT: HIS CAREER IN NEW
YORK AND THE SOUTH. Baton Rouge: Louisiana State University Press,
1973. xiv, 209 p. 97 illus.

Describes his early years as a partner of Town and Davis, his
work in both the Gothic and Greek Revival styles, and docu-
ments and reappraises his contributions to New Orleans and
the South.

DAVIS, ALEXANDER JACKSON 1803-92

323 Andrews, Wayne. "America's Gothic House: How Alexander Jackson
Davis Guided Our Romantic Movement Back to 'Modern' Architecture."
TOWN AND COUNTRY (November 1947): 114-30, 132, 134-35.

> The Gothic Revivalism of Davis was based on the acceptance
> of basic lightweight construction and use of the basic wood
> materials which eventually, in the shingle style and Prairie
> School work, became the basis for modern domestic architec-
> ture in the United States.

324 Donnell, Edna. "A.J. Davis and the Gothic Revival." METROPOLI-
TAN MUSEUM STUDIES 5 (September 1936): 183-233.

> An illustrated article that gives Davis his due as a leader of
> the revival style. Includes bibliographic material on Gothic
> revival ornamentation.

325 Newton, Roger Hale. TOWN AND DAVIS, ARCHITECTS.

> For main entry, see 428.

DRUMMOND, WILLIAM E. 1876-1946

326 Ganschinietz, Suzanne. "William Drummond: I. Talent and Sensitivity.
II. Partnership and Obscurity." THE PRAIRIE SCHOOL REVIEW 6 (First
quarter 1969): 5-19; (Second quarter 1969): 5-19. Illus.

> Biographical and historical material on Drummond, his back-
> ground, training, years with Wright, early career, etc. The
> author attempts to separate his work from the ouvre of Frank
> Lloyd Wright. Valuable illustrations.

ELLIS, HARVEY 1852-1904

327 Bragdon, Claude. "Harvey Ellis: A Portrait Sketch." ARCHITECTURAL
REVIEW 15 (1908): 173-83.

> Describes Ellis as an important designer and one especially
> valuable for his pen and ink renderings and perspectival draw-
> ings. Several illustrations of his work, so important in con-
> vincing a patron of the validity of a design.

328 Kennedy, Roger G. "Long Dark Corridors: Harvey Ellis." THE PRAIRIE
SCHOOL REVIEW 5 (1969): 5-18.

> Reestablishes the important role of Ellis as a designer in the
> late years of the nineteenth century. The author points out
> how often his designs were attributed to architects for or with

whom he worked. Also provides some bibliographical informa-
tion on this tragic figure in American architectural history.

329 _____. "The Long Shadow of Harvey Ellis." MINNESOTA HISTORY
40 (Fall 1966): 97–108.

Emphasizes Ellis' role as a designer in the Midwest and how
his influence has been felt, yet unattributed, over the years.

ELMSLIE, GEORGE GRANT 1871-1952

330 Gebhard, David, ed. THE WORK OF PURCELL AND ELMSLIE, ARCHI-
TECTS. Park Forest, Ill.: Prairie School Press, 1965. 96 p. Illus.

A reissue, with an introduction by Gebhard, of three issues
of THE WESTERN ARCHITECT; January 1913, and January and
July 1915. There are many illustrations of both completed
buildings and designs.

331 Hamlin, Talbot Faulkner. "George Grant Elmslie and the Chicago
Scene." PENCIL POINTS 22 (September 1941): 575–86.

Explains the architect's role in the Chicago area, specifically
working with Sullivan in the latter's later years. Elmslie's archi-
tectural ornamentation is stressed.

FULLER, RICHARD BUCKMINSTER 1895-

332 McHale, John. R. BUCKMINSTER FULLER. New York: George Brazil-
ler, 1962. 127 p. 103 illus. Bibliog. pp. 122–24.

A study of the man and his ideas. The author attempts to
explain complex philosophical and technical ideas as they re-
late to Fuller's plans for mankind's betterment. The text is
not always clear, but the illustrations are valuable.

333 Marks, Robert W. THE DYMAXION WORLD OF BUCKMINSTER FULLER.
New York: Reinhold Publishing, 1960. 232 p. Illus.

Chapters on his philosophy, a bit of biographical background,
and a tracing of the development of his ideas. Particular at-
tention is paid to his Dymaxion and geodesic developments.

FURNESS, FRANK 1839-1912

334 O'Gorman, James F. THE ARCHITECTURE OF FRANK FURNESS.
Philadelphia: Philadelphia Museum of Art, 1973. 231 p. Illus.

A catalog of the exhibition held in 1973, it has become the major monograph and a well-organized and documented study of the life and work of this eccentric and colorful architect. Illustrations include the exteriors and interiors of forty important buildings, and reproductions of drawings. A checklist of projects and completed buildings is included.

GARDEN, HUGH M.G. 1873-1961

335 Greenard, Bernard C. "Hugh M.G. Garden." THE PRAIRIE SCHOOL REVIEW 3 (1966): 5-18.

Garden's major projects and designs are reexamined, and he is placed squarely in the tradition of Wright and the Prairie School architects. Particular attention is drawn to his use of residential prairie forms in commercial buildings, and only the work up to 1911 is classified as being individual in design.

336 Laughlin, Clarence J[ohn]. "Louisiana Fantasy." THE ARCHITECTURAL REVIEW 141 (May 1967): 330, 383-86.

The long neglected work of Hugh Garden once again recognized as an original contribution with a strong decorative quality which grew out of the turn of the century Prairie School developments.

GILL, IRVING 1870-1936

337 McCoy, Esther. "Irving Gill, Architect." HISTORIC PRESERVATION 24 (April-June 1972): 8-11.

A reintroduction to this early twentieth-century figure who moved from cooperation with the Prairie School aesthetic to a new academicism later in his career.

GOFF, BRUCE 1904-

338 Kostka, Robert. "Bruce Goff and the New Tradition." THE PRAIRIE SCHOOL REVIEW 7 (1970): 5-15.

A discussion of the personal romantic architecture of Goff. His relationship to Wright and, at one point, Mendelsohn. Particular attention is paid to several designs that were never built, and to his unusually shaped homes built with an eye to the special needs of clients.

339 Mohri, Takenobu. BRUCE GOFF IN ARCHITECTURE. Tokyo: Kenchiku Planning Center, 1970. 212 p. Illus.

Written in both Japanese and English, this is the only full
study of the work of one of the most individual architects of
twentieth-century America. The environments created by his
buildings, especially the domestic dwellings, are pointed out
quite clearly, and his feeling for the creation of archetypes
is documented.

340 "Pride of the Prairies: A High Priest of Individualism Is Designing in a
 Strikingly Regional Idiom for His Grass Roots Clients." ARCHITECTURAL
 FORUM 88 (March 1948): 94-101.

 Periodical Explores the unusual and highly personal, for both client and
 architect, structures of Bruce Goff, the innovative admirer of
 Frank Lloyd Wright.

GREENE, CHARLES SUMNER 1868-1957

GREENE, HENRY MATHER 1870-1954

341 Bangs, Jean Murray. "Greene and Greene." ARCHITECTURAL FORUM
 139 (October 1948): 81-89.

 Periodical Explains how the early collaboration of the brothers, in the
 first decade of the twentieth century, pioneered in the uses
 of interpretation of space, warm textured materials, and the
 overhanging roof.

342 "Parting Salute to the Fathers of the California Style." HOUSE AND
 HOME 12 (August 1957): 84-95.

 Periodical The deaths of Charles Greene and Maybeck in the same year
 deprived California of two of her creative spirits in architec-
 ture, those who had been so important to a new freedom near
 the turn of the century. The work and importance of the
 Greene brothers are discussed.

343 Yost, L. Morgan. "Greene and Greene of Pasadena." JOURNAL OF
 THE SOCIETY OF ARCHITECTURAL HISTORIANS 9 (March and May
 1950): 11-19.

 Periodical An examination of the early twentieth-century work of these
 original California architects. Explains their importance in
 the development of an open plan California style.

GRIFFIN, MARION MAHONY 1873-1962

344 Van Zanten, David T. "The Early Work of Marion Mahony Griffin."
 THE PRAIRIE SCHOOL REVIEW 3 (1966): 5-23.

 Periodical The author provides us with biographical data and illustrations

of Griffin's designs and buildings. An attempt is made to
sort out her private commissions from those where she designed
under the name of various architects. The problems in culling
her work from Wright's are presented.

GRIFFIN, WALTER BURLEY 1876-1937

345 Birrell, James. WALTER BURLEY GRIFFIN. Melbourne: University of
Queensland Press, 1964. 203 p. Illus.

720.8
G85B

Although primarily concerned with Griffin's work in Australia,
the first few chapters deal with his training under Wright, his
acceptance of Sullivan's thought, and his early work in Amer-
ica.

346 Van Zanten, David T., ed. WALTER BURLEY GRIFFIN: SELECTED
DESIGNS. Palos Park, Ill.: Prairie School Press, 1970. 113 p.
54 illus. Bibliog. pp. 108-11.

q720.8
G85G

This volume contains many beautiful illustrations of the render-
ings of important Griffin buildings.

GROPIUS, WALTER 1883-1969

347 Fitch, James Marston. WALTER GROPIUS. New York: George Brazil-
ler, 1960. 128 p. 138 illus. Bibliog. pp. 120-23.

720.8
G87F

Divided into three chapters of text, Gropius the Educator, the
Architect and Designer, and the Social Critic. Many quota-
tions from the writings of one of the most lucid of contempo-
rary figures. The author presents Gropius as involved with
much more than the physical reality of one of his buildings.
His influence in America is shown. Includes a bibliography
of writings by and on the architect.

348 Gropius, Walter. APOLLO IN THE DEMOCRACY: THE CULTURAL
OBLIGATION OF THE ARCHITECT. New York: McGraw-Hill Book
Co., 1968. x, 182 p. 71 illus.

720.9
G87ap

A compilation of essays and reminiscences of friends who had
meaning in his long life. He discusses the ideas about archi-
tecture and commitment to planning in the broadest sense of
the word. He points out the importance of the architect as
teacher and as collaborator in increasingly larger planned pro-
jects in the United States.

HARRISON, PETER 1716-75

349 Bridenbaugh, Carl. PETER HARRISON: FIRST AMERICAN ARCHITECT. Chapel Hill: University of North Carolina Press, 1949. xvi, 195 p. 41 illus.

 A life of the architect with descriptions of his buildings; more history than analysis. Appendices list his belongings and his architectural books at the time of his death.

350 Kimball, [Sidney] Fiske. "The Colonial Amateurs and Their Models: Peter Harrison." ARCHITECTURE 53 (June 1926): 154-60; 54 (July 1926): 185-90.

HOOD, RAYMOND M. 1881-1934

351 Kilham, Walter H. RAYMOND HOOD, ARCHITECT: FORM THROUGH FUNCTION IN THE AMERICAN SKYSCRAPER. New York: Architectural Book Publishing Co., 1973. 200 p. 90 illus.

 Utilizes Hood's letters to describe his student days at the Ecole des Beaux Arts and his apprenticeship in Pittsburgh. The author, who worked for Hood, describes his success from the competition for the Chicago Tribune Tower (1922) to his death in 1934. He identifies Hood as the modern developer of the skyscraper.

HUNT, RICHARD MORRIS 1828-95

352 Burnham, Alan. "The New York Architecture of Richard Morris Hunt." SOCIETY OF ARCHITECTURAL HISTORIANS. JOURNAL 11 (May 1952): 9-14.

 Describes the academic triumph of Hunt's architecture in New York after the Civil War. Public and private buildings are discussed, and several are illustrated.

353 Schuyler, Montgomery. "Richard Morris Hunt." THE ARCHITECTURAL RECORD 5 (1895): 97-180. Illus.

 An important early critical view of Hunt's architecture. Specific buildings are illustrated and discussed in detail.

354 Weisman, Winston. "New York and the Problem of the First Skyscraper." SOCIETY OF ARCHITECTURAL HISTORIANS. JOURNAL 12 (March 1953): 13-21.

 Suggests that Chicago did not produce the first skyscraper. New York did, through the hands of Richard Morris Hunt, raising the question of what makes a building a skyscraper.

JEFFERSON, THOMAS 1743-1826

355 Frary, I.T. THOMAS JEFFERSON: ARCHITECT AND BUILDER. Intro-
 duction by Fiske Kimball. Richmond, Va.: Garrett and Massie, 1931.
 xv, 139 p. 96 illus. Bibliog. p. 133.

 This is divided into three parts: Jefferson's involvement with
 Monticello, his public buildings, and other residential works.
 Valuable illustrations of interiors and details.

356 Guinness, Desmond, and Sadler, Julius Trousdale, Jr. MR. JEFFERSON,
 ARCHITECT. New York: Viking Press, 1973. 177 p. Illus., some in
 color.

 A book for popular consumption which has running commentary
 and is divided into chapters relating to major buildings. Ex-
 cellent illustrations.

357 Kimball, [Sidney] Fiske. "Thomas Jefferson and the First Monument of
 the Classical Revival in America." AMERICAN INSTITUTE OF ARCHI-
 TECTS. JOURNAL 3 (September-November 1915): 370-81, 421-33,
 473-91.

 A study of Jefferson as an architect, the sources of his plans,
 and a look at the Virginia State Capitol, which was modelled
 after a Roman temple, probably the Maison Carree. Contains
 plans and photographs, with bibliographical footnotes. (See
 also 263.)

358 O'Neal, William B. "A Checklist of Writings on Thomas Jefferson as
 an Architect." THE AMERICAN ASSOCIATION OF ARCHITECTURAL
 BIBLIOGRAPHERS. JOURNAL 15 (1959): entire issue.

359 Padover, Saul. THOMAS JEFFERSON AND THE NATIONAL CAPITAL.
 Washington, D.C.: Government Printing Office, 1946. 522 p. Illus.

 Contains his written statements on the building of the capital,
 including letters to and from Thornton, Latrobe, and the other
 important architects.

JENNEY, WILLIAM LE BARON 1832-1907

360 Huxtable, Ada Louise. "Home Insurance Building, 1883-85: William
 Le Baron Jenney, arch.-eng." PROGRESSIVE ARCHITECTURE 38 (June
 1957): 207-8.

 Discusses the importance of this structure as one of the first,
 if not the first, skeleton-constructed skyscraper. The building
 itself is described and illustrated.

361 Turak, Theodore. "The Ecole Centrale and Modern Architecture: The
 Education of William Le Baron Jenney." SOCIETY OF ARCHITECTURAL
 HISTORIANS. JOURNAL 29 (March 1970): 40–47.

> Contends that Jenney, who has usually been dismissed as not
> being an architect, really received solid engineering and archi-
> tectural theory from M. Louis Chartes Mary while at the Ecole.

362 _____. "Jenney's Lesser Works: Prelude to the Prairie Style?" THE
 PRAIRIE SCHOOL REVIEW 7 (1970): 5–20.

> A discussion of the residential architecture and park designs of
> Jenney, especially in the planned community of Riverside, Illi-
> nois. A suggestion is made that, as well as influencing the
> directions in skyscraper construction in Chicago, he also may
> have provided some of the seeds for Prairie School residential
> architecture.

JOHNSON, PHILIP CORTELYOU 1906-

363 Jacobus, John M., Jr. PHILIP JOHNSON. New York: George
 Braziller, 1962. 127 p. 116 illus. Bibliog. pp. 123–24.

> Discusses Johnson's buildings and his stylistic development
> through the time of writing (1962). Establishes his place and
> points out his influence in contemporary architecture.

364 Hitchcock, Henry-Russell. PHILIP JOHNSON: ARCHITECTURE 1949–
 1965. New York: Holt, Rinehart, 1966. 115 p. Illus., many in
 color. Bibliog. pp. 30–33.

> Discussion of Johnson's development and major projects from
> 1949 to 1965. He is examined as the heir to Mies and the
> originality of his designs is pointed out. Site plans, diagrams,
> and fine color photographs of the buildings are provided, as
> well as a brief chronology.

KAHN, LOUIS ISADORE 1901-

365 Green, Wilder. "Louis I. Kahn." MUSEUM OF MODERN ART. BUL-
 LETIN 28 (1961): 3–23.

> Discussion of an exhibition in June–July 1961, which concen-
> trated on Kahn's work in New York. He is credited with
> advanced thinking about, and excellent solutions to, problems
> of spatial organization. Considered a major force in contem-
> porary architecture.

366 Scully, Vincent Joseph. "Light, Form, and Power: New Work of

Louis Kahn." ARCHITECTURAL FORUM 121 (August–September 1964): 162–70.

A study of the evolution of Kahn's style and technology in the development of his large buildings and private structures.

367 . LOUIS I. KAHN. New York: George Braziller, 1962. 127 p. 130 illus. Bibliog. pp. 122–27.

Important monograph on an important architect and teacher. The author concentrates on an analysis of how materials are used and the aesthetic results. Provides a brief chronology and illustrates plans, models, and designs.

LATROBE, BENJAMIN HENRY 1764-1820

368 Hamlin, Talbot Faulkner. BENJAMIN HENRY LATROBE. New York: Oxford University Press, 1955. xxxvi, 633 p. 40 illus.

An extremely detailed and well-documented biography of the important architect of Philadelphia, Baltimore, and Washington, D.C. His life and his ideas are set within the context of historical and social conditions of the times. A basic source for understanding the role of architects in the early Federal period.

369 Kimball, [Sidney] Fiske. "The Bank of the United States, 1818-1824." THE ARCHITECTURAL RECORD 58 (December 1925): 581-94.

On the issue of who designed the Bank of the United States in Philadelphia. The author concludes that both Latrobe and William Strickland had a hand in the plan. Illustrated with views of the building and plans.

370 Neil, J. Meredith. "The Precarious Professionalism of Latrobe." AMERICAN INSTITUTE OF ARCHITECTS. JOURNAL 53 (May 1970): 67-71.

Latrobe's determination to stand by what he felt was professionally correct kept him in conflict with the political figures whose other concerns he refused to recognize. A guide to the need for diplomacy in dealing with clients, public or private.

L'ENFANT, PIERRE CHARLES 1755-1825

371 Kite, Elizabeth Sarah. L'ENFANT AND WASHINGTON. 1791-1792. 1929. Reprint. New York: Arno Press, 1971. 182 p.

A collection of published and previously unpublished documents relating to L'Enfant's activities in planning the federal city. The lengthy introduction provides a brief history of the involvement.

372 Spreiregen, Paul D. "The L'Enfant Plan for Washington." AMERICAN
 INSTITUTE OF ARCHITECTS. JOURNAL 39 (January 1963): 26-33.

 Discusses the original plans of the architect and how they have
 been fulfilled by subsequent architects and designers.

McCOMB, JOHN 1763-1853

373 Gilchrist, Agnes Addison. "John McComb Sr. and Jr. in New York,
 1784-1799." SOCIETY OF ARCHITECTURAL HISTORIANS. JOURNAL.
 31 (March 1972): 10-21.

 John McComb's involvement with the rebuilding of New York
 after the Revolutionary War. The role of both McCombs in
 the formation of the General Society of Mechanics and Trades-
 men is discussed.

374 Stillman, Damie. "New York City Hall: Competition and Execution."
 SOCIETY OF ARCHITECTURAL HISTORIANS. JOURNAL 23 (October
 1964): 129-42.

 Discusses this important architectural competition, and the
 winning designs by John McComb in 1802. Plans are illus-
 trated.

McINTIRE, SAMUEL 1757-1811

375 Cousins, Frank, and Riley, Phil M. THE WOOD-CARVER OF SALEM:
 SAMUEL McINTIRE, HIS LIFE AND WORK. Boston: Little, Brown
 and Co., 1916. xx, 168 p. 127 illus.

 After a chapter on the background of Salem architecture, and
 another on McIntyre's genealogy, his homes are studied in
 some detail. There is also a chapter on his public work. The
 greatest attention is paid to his architectural detail and carv-
 ings.

376 Kimball, [Sidney] Fiske. MR. SAMUEL McINTIRE, THE ARCHITECT OF
 SALEM. Portland, Me.: Southworth-Athoensen Press, 1940. xiii,
 157 p. 373 illus.

 This volume is divided into a biography of McIntire and a
 discussion of the style of his buildings and sculpture. The
 appendices provide information as to his books, drawings, and
 documents and discuss problems of attribution.

377 Labaree, Benjamin W., ed. SAMUEL McINTIRE: A BICENTENNIAL
 SYMPOSIUM, 1757-1957. Salem, Mass.: Essex Institute, 1957.
 118 p. 65 illus.

Various papers at the symposium enrich and complement the full-length biography by Kimball. Special emphasis on his furniture and figure carving. The selected bibliography and illustrations are helpful in seeing the detailed ornamentation.

McKIM, CHARLES FOLLEN 1847-1909

378 Moore, Charles. THE LIFE AND TIMES OF CHARLES FOLLEN McKIM. Boston: Houghton Mifflin Co., 1929. Reprint. New York: Da Capo Press, 1969. 356 p. 35 illus.

720.8
M152m
1970

 A biography of McKim which includes material about his contact with other architects and with the American Academy in Rome. Much material is based on McKim's letters. An appendix lists his buildings 1880-1910.

379 Reilly, Charles Herbert. McKIM, MEAD & WHITE. London: Ernest Benn, 1924. 57 p. 36 illus.

 Biographical information on each of the partners, and discussion as to their design solutions for architectural commission. (See also 273.)

MAHER, GEORGE WASHINGTON 1864-1926

380 Rudd, J. William. "George W. Maher: Architect of the Prairie School." THE PRAIRIE SCHOOL REVIEW 1 (1964): 5-11.

 A brief reintroduction to the life and work. Mention of his early apprenticeship with Bauer and Hill, and his more important one with Silsbee. His ideas and major structures, as well as his relationship to the power elite, are discussed.

MAYBECK, BERNARD RALPH 1862-1957

381 Bangs, Jean Murray. "Bernard Ralph Maybeck, Architect, Comes into His Own." ARCHITECTURAL RECORD 103 (January 1948): 72-79.

 An exploration of Maybeck as an original figure in designing rich and visually exciting homes in California. His conceptions of space were finally beginning to be appreciated, in the author's opinion.

382 "Bernard Maybeck: A Parting Salute to a Great Romantic." HOUSE AND HOME 12 (December 1957): 124-29.

 Written soon after the death of Maybeck, it reiterates his importance as a romantic eclectic with taste.

MIES VAN DER ROHE, LUDWIG 1886-1969

383 Drexler, Arthur. LUDWIG MIES VAN DER ROHE. New York: George Braziller, 1960. 127 p. 111 illus. Bibliog. pp. 117-21.

720.8
M63D

 A concise biography and analysis of one of the masters of modern architecture. Although much of his mature work was done in Europe, the later American work is also included as important, especially the major projects in Chicago. The author feels that Mies has rejected almost all concerns except that for structure itself.

384 Hilberseimer, Ludwig. MIES VAN DER ROHE. Chicago: Paul Theobald & Co., 1956. 199 p. 187 illus.

q720.8
M63H

 Stresses the point that Mies' major contribution to all modern architecture has been a vocabulary of glass and steel construction. The author treats Mies' work in categories, giving the largest amount of coverage to his total plan for the Illinois Institute of Technology, and to several of his other commercial structures.

385 Johnson, Philip. MIES VAN DER ROHE. Rev. ed. New York: Museum of Modern Art, 1953. 215 p. Illus. Bibliog. pp. 208-12.

 This volume, by a devoted pupil of the architect, pays greater attention to the early half of Mies' career than to the latter, which was centered in the United States. Johnson emphasizes the influences, including that of Wright, on Mies and in turn shows his influence on glass and steel architecture here. His designs, plans, and buildings for the campus of the Illinois Institute of Technology are presented in detail.

386 Speyer, A. James, and Koeper, Frederick. MIES VAN DER ROHE. Chicago: Art Institute of Chicago, 1968. 120 p. Illus.

 The catalog of an exhibition of Mies' work. Photographs of the buildings, plans, and diagrams of both projects and completed work, and informative comments on the design and importance of each work.

MILLS, ROBERT 1781-1855

387 Armes, Kenneth. "Robert Mills and the Philadelphia Row House." SOCIETY OF ARCHITECTURAL HISTORIANS. JOURNAL 27 (May 1968): 140-46.

Periodical

 Shows how Mills' classicism put its imprint on the standard type of development in the attached home in Philadelphia.

388 Gallagher, H.M. Pierce. ROBERT MILLS: ARCHITECT OF THE WASH-
 INGTON MONUMENT, 1781-1855. New York: Columbia University
 Press, 1935. xxv, 233 p. Illus. Bibliog. pp. 217-20.

 A thoroughly researched and factual presentation of Mills' life
 and work, but somewhat flowery in language. Divided into
 chapters on his life and his work as architect and city planner.
 Appendices include two short essays and an autobiography, plus
 his letters and genealogical information.

OLMSTED, FREDERICK LAW 1822-1903

389 Barlow, Elizabeth. FREDERICK LAW OLMSTED'S NEW YORK. New
 York: Frederick A. Praeger, 1972. 174 p. 150 illus. Bibliog.
 pp. 172-73.

 Discusses and illustrates Olmsted's plans, designs, and illus-
 trations for New York. Contrasts what the city might have
 become to what it is now. Briefly sketches some of his non-
 New York ideas.

390 Fabos, Julius; Milde, Gordon T.; and Weinmayr, V. Michael. FRED-
 ERICK LAW OLMSTED, SR.: FOUNDER OF LANDSCAPE ARCHITECTURE
 IN AMERICA. Amherst: University of Massachusetts Press, 1968. xiii,
 114 p. Illus. Bibliog. pp. 113-14.

 Chapters on Olmsted's work on urban and regional parks, com-
 munity design, campus design, etc. Individual plans and de-
 signs are illustrated with comments on the limits of their adop-
 tion. Includes a chronology and a checklist of his works.

391 Fein, Albert. FREDERICK LAW OLMSTED AND THE AMERICAN EN-
 VIRONMENTAL TRADITION. New York: George Braziller, 1972. xi,
 180 p. 104 illus. Bibliog. pp. 171-76.

 Background on the history of environmental planning is pro-
 vided before the discussion of Olmsted's principles, politics,
 and designs. The bibliography is divided into a section of
 Olmsted's own writings and those of a more general nature.

392 _____. LANDSCAPE INTO CITYSCAPE: FREDERICK LAW OLMSTED'S
 PLANS FOR A GREATER NEW YORK CITY. Ithaca, N.Y.: Cornell
 University Press, 1967. x, 490 p. 19 illus.

 Contains reports and designs Olmsted proposed for Central Park,
 Prospect Park, improvements on Staten Island, etc. A partial
 autobiography is included as well as comments on each section
 by the editor.

393 Roper, Laura Wood. FLO: A BIOGRAPHY OF FREDERICK LAW OLM-
 STED. Baltimore: The Johns Hopkins University Press, 1973. xvii, 555 p.

29 illus.

A very detailed and well-documented life of the great land-
scape architect and planner. Much useful information about
the political and social clashes in the recognition of Olmsted's
ideas.

PEABODY, ROBERT SWAIN 1845-1917

394 Holden, Wheaton A. "The Peabody Touch: Peabody and Stearns of
Boston, 1879-1917." SOCIETY OF ARCHITECTURAL HISTORIANS.
JOURNAL 32 (May 1973): 114-31.

Periodical

A rediscovery of the important firm, which worked in colonial
revival in the later nineteenth century. Peabody's eclectic
residential architecture is emphasized.

RENWICK, JAMES 1792-1863

395 Cox, Warren. "Washington's Forgotten Architecture." ARCHITECTURAL
FORUM 118 (January 1963): 71-78.

Periodical

A discussion of the work of James Renwick in the nation's
capital. The public buildings and others show the richness of
his building style and his feeling for materials.

RENWICK, JAMES, JR. 1818-95

396 McKenna, Rosalie Thorne. "James Renwick, Jr., and the Second Empire
Style in the United States." MAGAZINE OF ART 44 (March 1951):
97-101.

Periodical

Renwick is probably best known for his revival buildings in
the romanesque and Gothic, but the author makes a case for
the importance of his Second Empire work, based on contem-
porary French architecture. Concentrates on the late 1850s.

RICHARDSON, HENRY HOBSON 1838-86

397 Hitchcock, Henry-Russell. THE ARCHITECTURE OF H.H. RICHARDSON
AND HIS TIMES. Rev. ed. Hamden, Conn.: Archor Books, 1961.
xxvi, 343 p. 114 illus. Bibliog. pp. 337-38.

*720.8
R52HA*

Classic study of the life and work of the architect. Informa-
tion on his early years, training, and European experience is
covered in chapter 1, his work through 1873 in chapters 2 and
3, his mature style in chapter 4, his late works, death, and a

discussion of his relevance in the last section.

398 Van Rensselaer, Mariana Griswold. HENRY HOBSON RICHARDSON
 AND HIS WORKS. 1888. Reprint. New York: Dover, 1969. xv,
 152 p. 97 illus. Paperbound.

9720.8
R52V
1967

A widely available reprint of the long out-of-date pioneering
study of Richardson. It remains the standard source of accu-
rate first-hand biographical material. Chronicles almost all
the known Richardson buildings, including drawings and de-
scriptions of various executed projects. Includes appendices
which list his works and document the method of instruction
at the Ecole des Beaux Arts.

ROBERTS, E.E. 1865-1943

399 Purcell, William Gray. "Forgotten Builders: The Nation's Voice."
 NORTHWEST ARCHITECT 8 (1944): 3-7, 13-14.

A discussion of the work of E.E. Roberts in the Midwest.
Domestic work is emphasized.

400 Steiner, Frances. "E.E. Roberts: Popularizing the Prairie School."
 THE PRAIRIE SCHOOL REVIEW 10 (1973): 5-24.

Illustrates how an essentially conservative architect was in-
fluenced by the young practitioners of the Prairie School and
followed their lead, modifying the more radical elements in
the buildings he designed. His commercial architecture is
discussed and a catalog of his buildings is provided.

ROOT, JOHN WELLBORN 1850-91

401 Hoffman, Donald. THE ARCHITECTURE OF JOHN WELLBORN ROOT.
 Baltimore: The Johns Hopkins University Press, 1973. xviii, 263 p.
 169 illus. Bibliog. pp. 248-55.

720.8
R78H

A brief biographical and historical chapter is followed by in-
tensive records and documentation of Root's work on major
projects and buildings as well as by an account of his general
role in the formation of the Chicago school of commercial
architecture.

402 Monroe, Harriet. JOHN WELLBORN ROOT: A STUDY OF HIS LIFE
 AND WORK. 1896. Reprint. Park Forest, Ill.: Prairie School Press,
 1966. xvi, 291 p. Illus.

A rather detailed biographical and historical portrait by his
sister-in-law, the famous poet of Chicago. A large section

is filled with his ideas on architecture and how he reflects his times.

403 Root, John Wellborn. THE MEANINGS OF ARCHITECTURE. Edited by Donald Hoffman. New York: Horizon Press, 1967. 238 p. 95 illus.

The architect outlines his theories of aesthetics and problems of design and structure. He then discusses the state of architecture in his own time. Most of the illustrations are of Chicago buildings.

RUDOLPH, PAUL 1918-

404 Moholy-Nagy, Sibyl, and Schwab, Gerhard. THE ARCHITECTURE OF PAUL RUDOLPH. New York: Frederick A. Praeger, 1970. 239 p. Illus.

Discusses his origins, training, partnership with Twitchell, and break with international style rigidity. Shows how his work obtained richness through acceptance of regional variety and how he expanded the scope and range of his private practice. Documents the influence of Wright's ideology and provides many illustrations.

405 Rudolph, Paul. THE ARCHITECTURE OF PAUL RUDOLPH. New York: Frederick A. Praeger, 1970. 239 p. Illus.

Biography and discussion of Rudolph's influence on the contemporary scene. Good illustrations and chronological list of works. Projects, drawings, and plans are included.

SAARINEN, EERO 1910-61

406 Saarinen, Aline B., ed. EERO SAARINEN ON HIS WORK. New Haven: Yale University Press, 1962. 108 p. Illus.

Large illustrations of the major designs, completed buildings and one piece of furniture, and edited statements of the architect about the works and his feelings about them. Design problems and aesthetic attitudes are emphasized.

407 Spade, Rupert, and Futagawa, Yukio. EERO SAARINEN. New York: Simon & Schuster, 1971. 130 p. 100 illus., some in color. Bibliog. pp. 127-28.

A biographical and analytical study of the younger Saarinen, with emphasis on his design qualities. The author suggests that his Yale training and conservative posture helped make his experiments in an unorthodox manner acceptable to his

wealthy clients.

408 Temko, Allan. EERO SAARINEN. New York: George Braziller, 1962.
127 p. 134 illus. Bibliog. pp. 124-25.

720.8
S112t

A study of his architectural development and work, with min-
imum personal anecdote. The buildings and projects are de-
scribed and evaluated. Illustrations include plans, models,
and buildings under construction.

SAARINEN, ELIEL 1873-1950

409 Christ-Janer, Albert. ELIEL SAARINEN. Chicago: University of Chicago
Press, 1948. x, 154 p. 194 illus. Bibliog. pp. 143-49.

q720.8
S11c
Spec. Coc.

A thorough study of the work of the Finnish-born architect who
did so much major work in this country. As he was long con-
nected with Cranbrook Academy and designed so much in the
area, particular attention is paid to his buildings, projects,
and design drawings.

SCHINDLER, RUDOLPH M. 1887-1953

410 Gebhard, David. R.M. SCHINDLER. Santa Barbara: Art Gallery, Univer-
sity of California, Santa Barbara, 1967. 114 p. Illus. Bibliog. pp. 43-44.

720.8
S336g

This is the catalog of an exhibition of the designs and build-
ings by the expatriate Austrian architect. As he spent most
of his career in California, the greatest number of buildings
illustrated are of that area, but his figure drawings, early stu-
dent work, and other designs are included.

411 _____. SCHINDLER. New York: Viking Press, 1971. 216 p.
159 illus. Bibliog. pp. 205-11.

O

A substantial and well-illustrated study of the Vienna-born
architect who was such an integral part of developments in
California's architecture in the twentieth century. His crea-
tive start in the twenties is documented, as well as his public
and private commissions through the years.

SHRYOCK, GIDEON 1802-80

412 Newcomb, Rexford. "Gideon Shryock: Pioneer Greek Revivalist of the
West." ARCHITECT 11 (October 1928): 41-46.

Resurrects a forgotten architect of the middle of the nineteenth
century.

SILSBEE, JOSEPH LYMAN 1845-1913

413 Sorell, Susan Karr. "Silsbee: The Evolution of a Personal Architectural Style." THE PRAIRIE SCHOOL REVIEW 7 (1970): 5-13.

Provides a bit of biographical background and then catalogs his work in the Chicago area. His evolution from the Queen Anne, through a Richardson Romanesque, to shingle style and an interest in colonial revivalism. Many seldom seen works and designs are reproduced.

STRICKLAND, WILLIAM 1787-1854

414 Gilchrist, Agnes Addison. WILLIAM STRICKLAND: ARCHITECT AND ENGINEER, 1788-1854. Enl. ed. New York: Da Capo Press, 1969. Var. pag. 50 illus.

Contains a life of the architect, an analysis of his style, and the following appendices: a well-documented descriptive catalog, a list of his writings, a list of his art work, and various primary source listings. A supplement is concerned with the Philadelphia Exchange.

415 Kimball, Sidney Fiske. "The Bank of the United States, 1818-1924."

For main entry, see 369.

416 Reps, John W. "Great Expectations and Hard Times: The Planning of Cairo, Illinois." SOCIETY OF ARCHITECTURAL HISTORIANS. JOURNAL 16 (December 1957): 14-21.

Discusses the role of Strickland in trying to establish a plan for structures throughout the new city. Explains the causes of the temporary failure.

SULLIVAN, LOUIS HENRI 1856-1924

417 Bush-Brown, Albert. LOUIS SULLIVAN. New York: George Braziller, 1960. 128 p. 112 illus. Bibliog. pp. 121-22.

A short essay including biography and a discussion of Sullivan's buildings and ideas. Illustrations include details of building ornamentation.

418 Connely, Willard. LOUIS SULLIVAN AS HE LIVED: THE SHAPING OF AMERICAN ARCHITECTURE. New York: Horizon Press, 1960. 322 p. 44 illus. Bibliog. pp. 311-16.

This volume concentrates on an analysis of Sullivan as a complex individual and how his career was influenced by his

personal make-up.

419 Duncan, Hugh Dalziel. CULTURE AND DEMOCRACY: THE STRUGGLE
FOR FORM AND ARCHITECTURE IN CHICAGO AND THE MIDDLE WEST
DURING THE LIFE AND TIMES OF LOUIS H. SULLIVAN. Totowa, N.J.:
Bedminster Press, 1965. xxii, 616 p. Illus.

> Wright's relationship with Sullivan and his ideas as a product
> of the times are an important part of this view of an era and of
> Sullivan as a major theoretical figure within the group. The
> lines are not as drawn in terms of good vs. bad guys as in
> many of the works which deify the central characters.

420 English, Maurice, ed. THE TESTAMENT OF STONE: THEMES OF
IDEALISM AND INDIGNATION FROM THE WRITINGS OF LOUIS SUL-
LIVAN. Evanston, Ill.: Northwestern University Press, 1963. xvii,
227 p.

> Brings together many scattered essays concerned with a unified
> theme. The introductory essay, unlike that written by so many
> editors, presents negative as well as positive criticism about
> the material presented.

421 Morrison, Hugh. LOUIS SULLIVAN: PROPHET OF MODERN ARCHITEC-
TURE. New York: W.W. Norton & Co., 1935. xii, 391 p. 87 illus.
Bibliog. pp. 310-17.

720.8
S95m

> This remains the most authoritative and important study of
> Sullivan. It evaluates his contributions to architectural his-
> tory and discusses the important buildings upon which he makes
> his declaration. The post-1893 career is discussed in some
> detail.

422 Paul, Sherman. LOUIS SULLIVAN: AN ARCHITECT IN AMERICAN
THOUGHT. Englewood Cliffs, N.J.: Prentice-Hall, 1962. xi, 176 p.
8 illus. Bibliog. pp. 147-51.

720.8
S95p

> An attempt to present Sullivan as a major literary and philo-
> sophical figure at the turn of the century. Important analysis
> of his relationship to transcendentalism and pragmatism. His
> ideas on architecture and education are outlined.

423 Sullivan, Louis H. THE AUTOBIOGRAPHY OF AN IDEA. New York:
Dover, 1956. 330 p. 34 illus. Paperbound.

720.8
S95s2

> This autobiography of Sullivan provides information about his
> childhood, schooling, and architectural training, but more
> about the ideas about the world and architecture which he
> absorbed and were to become his principles.

424 _____. DEMOCRACY: A MAN-SEARCH. Edited by Blaine Hedges.
Detroit: Wayne State University Press, 1961. xxxiii, 388 p.

Contains a critical introduction to the least known of Sullivan's three major pieces of writing. The ideas of Sullivan owe great debts to other social thinkers of his day, especially Whitman.

425 _____. KINDERGARTEN CHATS AND OTHER WRITINGS. New York: George Wittenborn, 1947. 252 p.

720.4
S95K

This is Sullivan's classic treatise on architectural education, indeed on education in general. He explains his methods of developing and establishing a personal style.

426 Szarkowski, John. THE IDEA OF LOUIS SULLIVAN. Minneapolis: University of Minnesota Press, 1956. 163 p. 94 illus.

9720.8
S95sz

A short biography and an excellent set of photographs set off by quotations that get at the spirit of his work.

THORNTON, WILLIAM 1761-1828

427 Rusk, William Sener. "William Thornton, Architect." PENNSYLVANIA HISTORY 2 (1935): 86-98.

Periodical

Thornton is presented as carrying on the gentleman-architect tradition of Jefferson.

TOWN, ETHIEL 1784-1844

428 Newton, Roger Hale. TOWN AND DAVIS, ARCHITECTS. New York: Columbia University Press, 1942. xx, 315 p. Illus.

They are presented as the pioneers in revival architecture in this country. Extensively documented. The public and private work, in city and country, is illustrated. Both classical and Gothic types of structures are shown in the development of their ouvre.

TROST, HENRY CHARLES 1860-1933

429 Engelbrecht, Lloyd C. "Henry Trost: The Prairie School in the Southwest." THE PRAIRIE SCHOOL REVIEW 6 (1969): 5-29.

Periodical

A careful study of the long-forgotten architect of Texas. Biographical data are quite thorough and provide interesting speculation about his undocumented Chicago years in an attempt to find the influences for his transplanted Prairie work in the Southwest. His major buildings are illustrated and Sullivan's influence is pointed out.

TRUMBULL, JOHN 1756-1843

430 Sizer, Theodore. "John Trumbull, Amateur Architect." SOCIETY OF ARCHITECTURAL HISTORIANS JOURNAL 8 (1949): 1-6.

> Makes a case for Trumbull's having attempted some designing in keeping with his role as gentleman artist.

431 _____. "John Trumbull: Museum Architect." WALPOLE SOCIETY NOTEBOOK (1940): 19-34.

> Discusses the painter/architect's role in designing the museum for Yale, which was to receive his collection of paintings done on historical themes pertaining to the American Revolution.

UPJOHN, RICHARD M. 1807-78

432 Upjohn, Everard M. RICHARD UPJOHN: ARCHITECT AND CHURCH-MAN. New York: Columbia University Press, 1939. xvii, 243 p. Illus. Bibliog. pp. 227-28.

> The architect's life and works are presented in terms of his role as builder of churches.

433 Walter, Thomas U. "Richard Upjohn, F.A.I.A., 1802-1878." AMERI-CAN INSTITUTE OF ARCHITECTS. JOURNAL 8 (December 1947): 272-76.

> The reprint of Walter's words written as an obituary at the time of his friend's death. He outlines the contributions of Upjohn and his place in nineteenth-century American architecture.

VAUX, CALVERT 1824-95

434 Dunning, Brian. "Pioneer of the Weekend Cottage." COUNTRY LIFE 134 (October 1963): 894-97.

> Discusses the ideas of Calvert Vaux in regard to his romantic residential architecture. Illustrated with his plans and designs for country homes.

435 Vaux, Calvert. VILLAS AND COTTAGES. 1864. Reprint. New York: Dover, 1971. 348 p. 370 illus.

> A reprint of Vaux's original book of plans and designs for homes and public buildings for the American public. His ideas about the placement and type of building in regard to its natural setting are expressed in this work.

WALTER, THOMAS USTICK 1804-87

436 "The Girard College Architectural Competition, 1832." SOCIETY OF
ARCHITECTURAL HISTORIANS. JOURNAL 16 (May 1957): 20-27.
Illus.

> Discusses the competition for the design of the college, won
> by Thomas U. Walter. Illustrated with his drawings and in-
> cludes a discussion of his neoclassical style.

437 Rusk, William Sener. "Thomas U. Walter and His Works." AMERICANA
33 (April 1939): 151-79.

> Reestablishes Walter as a major builder in the Greek revival
> style and provides us with a bibliography of a long out-of-
> fashion architect of many of Pennsylvania's important buildings
> and a central figure in the building of the state capitol.

WHITE, STANFORD 1853-1906

438 Baldwin, Charles Crittenton. STANFORD WHITE. New York: Dodd,
Mead & Co., 1931. Reprint. New York: Da Capo Press, 1971.
xii, 399 p. 39 illus.

> A loosely organized biography that is based on direct quota-
> tions from White's contemporaries.

439 McQuade, Walter. "Stanford White and the Wherewithal." THE AR-
CHITECTURAL FORUM 123 (November 1905): 70.

> Illustrates the design of a tomb for J.P. Morgan.

440 Myer, John Walden. "The New York Work of Stanford White." MU-
SEUM OF THE CITY OF NEW YORK. BULLETIN 5 (March 1942): 46-
52.

> Discusses the residential and public work of the young designer
> of the firm of McKim, Mead and White. Special attention
> paid to Madison Square Garden.

441 Reilly, Charles Herbert. McKIM, MEAD & WHITE.
For main entry, see 379.

WRIGHT, FRANK LLOYD 1867-1959

More has been written about Frank Lloyd Wright than about any other architect
in history. The following selections, extracted from close to 1,000 items, are
obviously a highly subjective group. The reader is urged to examine the bib-
liographies of Karpel and Muggenberg for additional guidance.

442 Blake, Peter. THE MASTER BUILDERS. New York: Alfred A. Knopf, 1960. 399 p. Illus.

> One of the major figures discussed is Wright, in a chapter "Frank Lloyd Wright, The Mastery of Space," pp. 265-390.

443 Crawford, Alan. "Ten Letters from Frank Lloyd Wright to Charles Robert Ashbee." ARCHITECTURAL HISTORY 13 (1970): 64-76.

> The author presents the letters in which Wright expresses his disillusionment and bitterness toward his contemporaries.

444 Drexler, Arthur. THE DRAWINGS OF FRANK LLOYD WRIGHT. New York: Bramhall House, 1962. 320 p. 303 illus.

> Drawings and designs for both completed and never started structures. The "Notes to the Plates" provide detailed information, including media, size, etc., of each illustration. The introduction explains Wright's method of working.

445 Eaton, Leonard K. TWO CHICAGO ARCHITECTS AND THEIR CLIENTS: FRANK LLOYD WRIGHT AND HOWARD VAN DORENSTAW. Cambridge, Mass.: The M.I.T. Press, 1969. ix, 259 p. Illus. Bibliog. pp. 239-42.

> This work is valuable for the presentation of material about Wright's clients and how such relationships affected his life and work. Good illustrations of house interiors.

446 Hines, Thomas S., Jr. "Frank Lloyd Wright—The Madison Years: Records versus Recollections." SOCIETY OF ARCHITECTURAL HISTORIANS. JOURNAL 26 (December 1967): 227-33.

> Proves that Wright's early years and education are not what he said they were and suggests that he had to create a history that squared with his image as genius and creator.

447 Hitchcock, Henry-Russell. IN THE NATURE OF MATERIALS, 1887-1941: THE BUILDINGS OF FRANK LLOYD WRIGHT. New York: Duell, Sloan, and Pierce, 1942. Reprint. New York: Da Capo Press, 1973. xlix, 143 p. 412 illus. Bibliog. pp. xxxix-xlv.

> A major critical analysis of the work of Wright that concentrates on the evolution of his building style in terms of both plan and materials. More than 400 illustrations of exteriors, some interiors, and plans.

448 Hitchcock, Henry-Russell, and Drexler, Arthur, eds. BUILT IN U.S.A.: POST-WAR ARCHITECTURE. New York: Museum of Modern Art, 1952. 128 p. Illus.

> More attention is paid to Wright that to any other architect. Several illustrations of his work. (See also 296.)

449 Jacobs, Herbert. FRANK LLOYD WRIGHT: AMERICA'S GREATEST
ARCHITECT. New York: Harcourt, Brace and World, 1965. 223 p.
Illus.

A journalistic biography.

450 James, Cary. THE IMPERIAL HOTEL: FRANK LLOYD WRIGHT AND
THE ARCHITECTURE OF UNITY. Rutland, Vt.: Charles E. Tuttle Co.,
1968. 133 p. 63 illus. Bibliog. p. 125.

The Imperial Hotel is used as an example of Wright's ideas on
organic architecture. Includes a selection of quotations from
Wright's writings and an excellent selection of interior and
exterior photographs.

451 Karpel, Bernard. "What Men Have Written about Frank Lloyd Wright:
A Bibliography Arranged by Decades from 1900-1955." HOUSE BEAUTI-
FUL 97 (November 1955): 377.

A detailed list of writings by and about Wright up to the year
1955. Sections are divided between books and periodicals.
Some annotated. Updated in October 1959 special issue of
HOUSE BEAUTIFUL.

452 Kaufmann, Edgar, Jr., and Raeburn, Ben, eds. FRANK LLOYD WRIGHT:
WRITINGS AND BUILDINGS. Cleveland: World Publishing Co., 1963.
346 p. Illus. Paperbound.

This is a compilation of the important writings and lectures
in which he enunciated his philosophy and castigated his critics.
Locations of known Wright structures at rear of book.

453 Kostka, Robert. "Frank Lloyd Wright in Japan." THE PRAIRIE SCHOOL
REVIEW 3 (1966): 5-23.

Although Wright has written much about his Japanese interlude,
this article is a detailed study of not only the Imperial Hotel
but also of several of the eight homes and public buildings he
designed while in Japan.

454 Manson, Grant C. FRANK LLOYD WRIGHT TO 1910: THE FIRST
GOLDEN AGE. New York: Reinhold Publishing, 1958. x, 228 p.
135 illus. Bibliog. pp. 219-22.

Manson emphasizes the relationship and kindred spirit quality
between the early Wright and the ideals of the Arts and Crafts
movement.

455 Muggenberg, James R. "Frank Lloyd Wright in Print, 1959-1970."
AMERICAN ASSOCIATION OF ARCHITECTURAL BIBLIOGRAPHERS.
PAPERS 9 (1972): 85-132.

This is an exhaustive update of writings on Wright since 1959.

Serves as a complement to the earlier bibliography by Karpel.
Individual sections on books, articles, and manuscript material.
Annotated. Contains many unpublished sources that will be
difficult to locate.

456 Museum of Modern Art. MODERN ARCHITECTURE: INTERNATIONAL
EXHIBITION. New York: 1932. 199 p. Bibliog. pp. 29-55.

The essay on Wright was written by Henry Russell Hitchcock,
who stresses the individuality and freedom from conformity in
Wright's building.

457 Pawley, Martin. INTRODUCTION AND NOTES TO "FRANK LLOYD
WRIGHT: PUBLIC BUILDINGS." New York: Simon & Schuster, 1970.
130 p. 94 illus. Bibliog. p. 127.

How his ideas were applied to the public buildings rather
than to the more usually discussed private homes.

458 Scully, Vincent Joseph. FRANK LLOYD WRIGHT. New York: George
Braziller, 1960. 125 p. 127 illus. Bibliog. pp. 117-18.

A brief introduction to the man, his use of materials, and his
unconventional spirit. Includes a few illustrations of buildings
by those who influenced him.

459 Smith, Norris K. FRANK LLOYD WRIGHT: A STUDY IN ARCHITEC-
TURAL CONTENT. Englewood Cliffs, N.J.: Prentice-Hall, 1966.
178 p. Illus.

The idea that Wright's later work is indebted to historical
prototypes because his fame was bringing him a wide range
of commissions is convincingly presented.

460 Storrer, William Allin. THE ARCHITECTURE OF FRANK LLOYD WRIGHT:
A COMPLETE CATALOG. Cambridge, Mass.: The M.I.T. Press, 1974.
Unpaged. 433 illustrated entries.

A documentation of every known or probable building by Wright.
Information about their current condition is provided as well as
their date and general location.

461 Untermeyer, Louis. MAKERS OF THE MODERN WORLD. New York:
Simon & Schuster, 1955. 809 p.

Although written as a social and cultural tract, it contains a
chapter on Wright and his architectural ideas.

462 Wijdeveld, H.T., ed. THE LIFE-WORK OF THE AMERICAN ARCHI-
TECT FRANK LLOYD WRIGHT. Soutpoort, Holland: C.A. Mees, 1925.
164 p.

The important essay by J.J.P. Oud analyzes the influence of Frank Lloyd Wright on European architecture during the early years of the twentieth century.

463 Wright, Frank Lloyd. AN AUTOBIOGRAPHY. New ed. New York: Horizon Press, 1957. 561 p.

This is Wright's rather didactic declaration that he alone was the spokesman of and responsible for the whole Prairie School group. The other architects are presented as followers. The style is modelled very much after Sullivan's autobiography.

464 _____. THE DISAPPEARING CITY. New York: William F. Payson, 1932. 90 p. 6 illus.

A critique of our choked and crowded cities. Wright introduces his "broadacre" concept: a minimum of one acre for every family or dwelling unit.

465 _____. "Frank Lloyd Wright." ARCHITECTURAL FORUM 88 (January 1948): entire issue.

Periodical

He completely designed and wrote this entire issue on his evolution and contemporary work.

466 _____. GENIUS AND THE MOBOCRACY. Rev. ed. New York: Horizon Press, 1971. 247 p. Illus.

A blast at cities, regular lots, conformity, and the practice of architecture as he observed it. More critical than many of his other writings, he seems unsure of the newer trends of the international style.

467 _____. THE NATURAL HOUSE. New York: Horizon Press, 1954. 223 p. Illus.

Discusses his revised philosophy of domestic architecture and its relationship to occupants. A rejection of the traditional "box" with attic and basement.

468 Wright, Olgivanna Lloyd. FRANK LLOYD WRIGHT: HIS LIFE, HIS WORK, HIS WORDS. New York: Horizon Press, 1966. 224 p. Illus. Bibliog. pp. 223-24.

Narrative interspersed with quotes from Wright's writings, but the sources are frustratingly not given.

469 _____. OUR HOUSE. New York: Horizon Press, 1959. 308 p.

Mrs. Wright discusses the architect, the founding of Taliesin, and the ideas of the fellowship conceived by Wright.

WRIGHT, LLOYD 1890-

470 Bowly, Devereux, Jr. "Unity Temple: A Masterpiece on the Way to Restoration." INLAND ARCHITECT 16 (December 1972): 18-19.

Describes the restoration under way of this historic structure and explains the involvement of Lloyd Wright, the architect's son. Includes illustrations.

471 Gebhard, David, and Von Breton, Harriette. LLOYD WRIGHT, ARCHITECT: 20th CENTURY ARCHITECTURE IN AN ORGANIC EXHIBITION. Santa Barbara: University of California Press, 1971. 101 p. 98 illus.

The catalog of an exhibition of the work of this son of Frank Lloyd Wright, showing how he developed a style in the 1920s. Illustrated with plans, drawings, and completed residential and commercial projects. Includes a list of writings by the architect and a catalog of works.

Chapter 6

AMERICAN PAINTING

GENERAL HISTORIES AND SURVEYS

The following includes surveys of American painting from the colonial period
through the mid-twentieth century, museum catalog surveys, and surveys of
painting by types.

472 Baigell, Matthew. A HISTORY OF AMERICAN PAINTING. New York:
Frederick A. Praeger, 1971. 288 p. 230 illus., 30 in color.

A good introduction to the stylistic developments and the
major individuals. A better selection of illustrations than
in most surveys.

473 Barker, Virgil. AMERICAN PAINTING: HISTORY AND INTERPRETA-
TION. New York: Macmillan Publishing Co., 1950. 717 p. Illus.

A pioneering and still useful survey for important American
painters. The more recently discovered individuals and certain
out-of-the-mainstream romanticists are slighted, but the aes-
thetic judgements and historical interpretations still command
respect.

474 Burroughs, Alan. LIMNERS AND LIKENESSES: THREE CENTURIES OF
AMERICAN PAINTING. New York: Russell and Russell, 1965. 246 p.
Illus. Bibliog. pp. 231-46.

One of the earliest systematic studies of the major develop-
ments in American painting.

475 Caffin, Charles Henry. THE STORY OF AMERICAN PAINTING. 1907.
Reprint. New York: Johnson Reprint Co., 1970. xii, 396 p. Illus.

A combination of social-cultural history and historical docu-
mentations. Important as a document of a viewpoint of the

turn of the century.

476 Eliot, Alexander. THREE HUNDRED YEARS OF AMERICAN PAINTING. New York: Time, Inc., 1957. x, 318 p. Illus. in color.

The first section covers the colonial period through the early federal period. The second is concerned with the early genre masters through the early twentieth-century realists; the third includes the rest of the modern and regional developments. Many color illustrations and easy to read text.

477 Mather, Frank Jewett, Jr. ESTIMATES IN ART. New York: Henry Holt and Co., 1931. xii, 337 p. 16 illus.

Biographies of sixteen American painters, from Gilbert Stuart through Arthur B. Davies. Each chapter is separate and, although the selections of subjects reflect both the author's taste and times, his criticism is generally valid.

478 Richardson, Edgar Preston. PAINTING IN AMERICA: FROM 1502 TO THE PRESENT. New York: Thomas Y. Crowell, 1956. 456 p. Illus., some in color. Bibliog. pp. 425-36.

A general pioneering text on American painting. The largest part is devoted to the nineteenth century.

479 Wilmerding, John, ed. THE GENIUS OF AMERICAN PAINTING. New York: William Morrow and Co., 1973. 352 p. Illus., some in color. Bibliog. pp. 344-48.

Individual chapters on the colonial period, first half of the nineteenth century, etc., written by authorities on each era. Good general introduction to the history of American painting although perspectives shift with each new author. Profusely illustrated.

GENRE AND LIMITED SURVEYS

480 Allen, Edward B. EARLY AMERICAN WALL PAINTINGS: 1710-1850. New Haven, Conn.: Yale University Press, 1926. Reprint. New York: Da Capo Press, 1970. xiv, 110 p. 127 illus.

A detailed survey of the panels and frescoes on the walls of American homes, painted in the last half of the eighteenth and first half of the nineteenth century in New England. Each house is studied individually and attributions for many of the works are provided. Valuable as the only real source for a kind of painting that undoubtedly was much more widespread than that which survives would indicate.

481 American Watercolor Society. 200 YEARS OF WATERCOLOR PAINTING IN AMERICA: AN EXHIBITION COMMEMORATING THE CENTENNIAL OF THE AMERICAN WATERCOLOR SOCIETY. New York: Metropolitan Museum of Art, 1966. 64 p. Illus., plates.

A combination of the work of present members and, more important, documentation and illustrations of the important work in the medium over the last two centuries.

482 Born, Wolfgang. AMERICAN LANDSCAPE PAINTING: AN INTERPRE-TATION. New Haven: Yale University Press, 1948. 228 p. 142 illus.

A look at American landscape painting from the early panoramic views and romantic landscapes through the hard-edged works of the precisionists.

483 Dunn, Dorothy. AMERICAN INDIAN PAINTING OF THE SOUTHWEST AND PLAINS AREA. Santa Fe: University of New Mexico Press, 1968. xxviii, 429 p. Illus., 33 in color. Bibliog. pp. 385-414.

Traces the history of painting in these areas and presents an analysis of the relationship of the past to the present artistic activities of contemporary Indians. Contains an important bibliography of books, articles, and archival material.

484 Flexner, James Thomas. FIRST FLOWERS OF OUR WILDERNESS: AMER-ICAN PAINTING, THE COLONIAL PERIOD. Boston: Houghton Mifflin Co., 1947. Reprint. New York: Dover, 1969. 369 p. Illus. Bibliog. pp. 323-41.

This is the first volume in the author's trilogy of the history of American painting. He discusses the work of the limners, early European influences and important artists, and the American careers of West and Copley.

485 _____. THE LIGHT OF DISTANT SKIES: AMERICAN PAINTING, 1760-1835. New York: Harcourt, Brace, 1954. Reprint. New York: Dover, 1969. 307 p. Illus. Bibliog. pp. 253-83.

Volume two of the Flexner trilogy. It covers the careers of the generations of students of West and the rise of the academies in this country.

486 _____. THAT WILDER IMAGE: THE PAINTING OF AMERICA'S NA-TIVE SCHOOL FROM THOMAS COLE TO WINSLOW HOMER. Boston: Little, Brown, 1962. Reprint. New York: Dover, 1969. 407 p. Illus. Bibliog. pp. 375-94.

This final volume of the Flexner trilogy centers on the main-stream of American painting in the nineteenth century, roman-ticism, and romantic realism. The greatest attention is paid to the Hudson River school and its descendants.

487 Gardner, Albert Ten Eyck. HISTORY OF WATERCOLOR PAINTING IN AMERICA. New York: Reinhold Publishing, 1966. 160 p. Illus., many in color.

759.13
G 22 h

> A book for the general reader. Three hundred years of topographical views, landscapes, portraits, and genre painting in this often overlooked medium.

488 Gerdts, William H., and Burke, Russell. AMERICAN STILL LIFE PAINTING. New York: Frederick A. Praeger, 1971. 264 p. Illus., some in color. Bibliog. pp. 257-59.

> The most important one-volume survey of this genre. Examples from the colonial period through the mid-twentieth century with a witty, well-written text based on impeccable research.

489 Lipman, Jean. AMERICAN PRIMITIVE PAINTING. London: Oxford University Press, 1942. Reprint. New York: Dover, 1972. 158 p. 101 illus. Bibliog. pp. 139-42.

759.1
L 76

> This survey of a form that includes some trained and many completely untrained painters is a good format to assist the lay reader in coming to grips with the work. The author has a fine eye and chooses examples of outstanding quality.

490 Lipman, Jean, and Winchester, Alice. PRIMITIVE PAINTERS IN AMERICA, 1750-1950. New York: Dodd, Mead and Co., 1950. 182 p. Illus.

759.13
L 76 P

> Individual essays by authorities on each of sixteen American primitives, from the earliest days through the present. Each essay contains whatever biographical information was known and notes on personal style.

491 Little, Nina Fletcher. AMERICAN DECORATIVE WALL PAINTING, 1700-1850. Rev. ed. New York: E. P. Dutton & Co., 1972. 169 p. Illus. Bibliog. pp. 160-62.

> A history of wall painting as found in the early history of domestic art in this country. Much of this form is lost, but important surviving examples are documented.

492 McCoubrey, John W. AMERICAN TRADITION IN PAINTING. New York: George Braziller, 1963. 128 p. 68 illus. Bibliog. p. 126.

759.13
M 13 1a

> An attempt to understand the history of American painting through five brief essays on the colonial portrait, the landscape, etc.

493 Prown, Jules David. AMERICAN PAINTING: FROM ITS BEGINNINGS TO THE ARMORY SHOW. Geneva: Skira, 1970. 145 p. Illus., many in color. Bibliog. pp. 135-39.

759.13
P 96a

A brief treatment of American painting until 1913, with many fine illustrations. The text is easy to read but well researched.

494 Sadik, Marvin. "The Negro in American Art." ART IN AMERICA 52 (June 1964): 74–83.

Concerned with the treatment of the black American as a subject, primarily in genre painting. Although the general trend was to stereotype, there are some painters shown to have presented the Negro without condescension.

495 Sherman, Frederic Fairchild. EARLY AMERICAN PAINTING. New York: The Century Co., 1932. xxi, 289 p. Bibliog. pp. 277–80.

An old but interesting study of painting in the colonial period and up to 1850. Chapters on portrait painters of the different era, and separate ones on landscape, historical, genre, and religious painting. Biographical information on each painter mentioned.

496 Wehle, Harry B. AMERICAN MINIATURES, 1730–1850: ONE HUNDRED AND SEVENTY THREE PORTRAITS...AND A BIBLIOGRAPHICAL DICTION- ARY OF THE ARTISTS BY THEODORE BOLTON. New York: Doubleday & Co., for the Metropolitan Museum of Art, 1927. 127 p. Illus. Bibliog. pp. 117–18.

A history of the once popular form of painting, from colonial figures through the generation of the younger reales. Various media in painting are surveyed.

497 Williams, Hermann Warner, Jr. MIRROR TO THE AMERICAN PAST. A SURVEY OF AMERICAN GENRE PAINTING: 1750–1900. Greenwich, Conn.: New York Graphic Society, 1973. 248 p. 219 black and white illus., 16 in color. Bibliog. pp. 229–40.

A survey presented in broad categories of genre, incorporates contrast with Europe, and examines the individual painters. Extensive illustrations and bibliography of surveys, exhibition catalogs, and monographs.

498 Wilmerding, John. A HISTORY OF AMERICAN MARINE PAINTING. Salem, Mass.: The Peabody Museum; Boston: Little, Brown and Co., 1968. 279 p. Illus., some in color. Bibliog. pp. 247–68.

A comprehensive and carefully researched survey of an impor- tant but out of fashion genre. Centers on the nineteenth century, marine painting's golden age. Contains the most extensive bibliography on the subject.

COLLECTIONS OF AMERICAN PAINTING

499 Corcoran Gallery of Art. A CATALOGUE OF THE COLLECTION OF
AMERICAN PAINTINGS IN THE CORCORAN GALLERY OF ART. Vol.
1. PAINTERS BORN BEFORE 1850. Washington, D.C.: 1966. 169 p.
Illus.

759.13
C79c

An illustrated catalog of the permanent collection of paintings
by early American artists. Biographical selections on each
artist represented, and black and white illustrations of each
documented work.

500 Gardner, Albert Ten Eyck, and Feld, Stuart D. AMERICAN PAINTINGS:
A CATALOGUE OF THE COLLECTION OF THE METROPOLITAN MUSE-
UM OF ART. I. PAINTERS BORN BY 1815. New York: Metropolitan
Museum of Art, 1965. ix, 292 p. Illus.

759.13
N53a

Catalog of the major holdings of early American art at the
Metropolitan Museum of Art. Biographical information is
provided for each artist illustrated, and references and prove-
nance for each work are supplied.

501 Goodyear, Frank [H.], Jr. AMERICAN PAINTINGS IN THE RHODE
ISLAND HISTORICAL SOCIETY. Providence: The Rhode Island Histori-
cal Society, 1974. 116 p. 82 black and white illus., 6 in color.

A catalog of an important collection of American art, showing
the topography, ships, history, and citizens of the state.
Particularly rich in late eighteenth- and early nineteenth-
century works. Good illustrations and biographical informa-
tion.

502 Museum of Fine Arts. Boston. AMERICAN PAINTINGS IN THE MUSE-
UM OF FINE ARTS. 2 vols. Boston: 1969. Vol. 1. Text: xii,
320 p.; Vol. 2. Plates: xv, 377 p. 615 illus., many in color.

The catalog of one of the most comprehensive and distinguished
collections of American art. Detailed information on each
work, and biographical and bibliographical information on
the painters.

503 National Portrait Gallery, Smithsonian Institution. CHECKLIST OF THE
PERMANENT COLLECTION. Washington, D.C.: 1972. 54 p.

An important guide to the largest collection of portraits of
famous Americans and a major tool in establishing which
American painters were portraitists on commission. Covers
the entire history of the country to the present.

Chapter 7

PERIOD SURVEYS OF AMERICAN PAINTING

COLONIAL PAINTING

The colonial era of American history was rich in decorative arts and painting on furniture and commercial signs. As there was almost no religious art in a nonconformist Protestant society, and landscape and still life had yet to take hold of the popular imagination, the bulk of the painting was portraitive. It has been discussed, for the most part, in writings on the individual artists of the eighteenth century. The few useful surveys follow.

504 Belknap, Waldron V., Jr. AMERICAN COLONIAL PAINTING: MA-
 TERIALS FOR A HISTORY. Cambridge, Mass.: Harvard University Press,
 Belknap Press, 1959. 377 p. Illus. Bibliog. pp. 337-44.

 This is a collection of writings and essays on the history of
 various colonial painters and their relationship to the colonial
 scene. Sources are taken from primary sources and much non-
 art historical material.

505 Dresser, Louisa. SEVENTEENTH CENTURY PAINTING IN NEW ENG-
 LAND. Worcester, Mass.: Worcester Art Museum, 1935. 187 p. Illus.

 An exhibition catalog that concentrates on the portraits of
 well-known citizens, from the works of the limners through
 more highly trained figures such as Captain Smith. Bio-
 graphical information on each subject and bibliographical
 data on each work.

506 Flexner, James Thomas. "George Washington as an Art Collector." THE
 AMERICAN ART JOURNAL 4 (Spring 1972): 24-35.

 Discusses taste and aesthetics as motivating his acquisitions
 in advance of popular accepted work. Documents the actual
 works he purchased and his growing interest in landscape
 painting.

507 Hagen, Oskar. THE BIRTH OF THE AMERICAN TRADITION IN ART.

759.1
H14

New York: Scribner's, 1940. 159 p. Illus.

This is an aesthetic, cultural, and stylistic analysis of colonial painting and a pioneering effort at discerning just what brought the work of the various colonial painters together to produce American art.

508 Kelby, William. NOTES ON AMERICAN ARTISTS, 1754-1800. New York: Lenox Hill, 1971. 96 p. Illus.

A brief study of the individual painters of the second half of the eighteenth century, chiefly in New England and primarily portraitive. Several of the painters are transplanted Europeans who had an influence on the younger native would-be artists.

509 Lee, Cuthbert. EARLY AMERICAN PORTRAIT PAINTERS: THE FOURTEEN PRINCIPAL EARLIEST NATIVE-BORN PAINTERS. New Haven: Yale University Press, 1929. 350 p. Illus. Bibliog. pp. 315-34.

A biographical history of these colonial painters, not all of whom, research has shown, were native-born. Many of the facts are questionable, but the flavor of the role of the painter in that era still comes through.

510 Morgan, John Hill. EARLY AMERICAN PAINTERS: ILLUSTRATED BY EXAMPLES IN THE COLLECTION OF THE NEW YORK HISTORICAL SOCIETY. New York: New York Historical Society, 1921. 136 p. Illus. Bibliog. p. 121.

An early yet still useful study of American colonial painting (includes some nineteenth-century works). The majority of the illustrated works are portraits.

511 Pleasants, J. Hall. FOUR LATE EIGHTEENTH CENTURY ANGLO-AMER-ICAN LANDSCAPE PAINTERS. Worcester, Mass.: American Antiquarian Society, 1943. 146 p. Illus.

758.1
P72f

Explores the early landscape tradition in this country as brought over by the Englishmen under discussion. Topographical qualities, often mixed with a feeling for genre, especially in the work of F. Guy, are illustrated.

512 Quimby, Ian M.G., ed. AMERICAN PAINTING TO 1776: A REAP-PRAISAL. Winterthur Conference Report, 1971. Charlottesville: The University Press of Virginia, 1971. 384 p. Illus. Bibliog.

Papers read at the conference cover questions of definition of early colonial painting. Explores research on several individual figures, and provides information on methods of identification based on technical matters.

NINETEENTH-CENTURY PAINTING

This century was the era of the romantic landscape, popular genre painting, and the rise of an interest in realistic still life. Many of the works in this section document the scope and extent of those interests.

513 Baur, John I.H. AMERICAN PAINTING IN THE NINETEENTH CENTURY: MAIN TRENDS AND MOVEMENTS. New York: Frederick A. Praeger, 1953. 60 p. Illus.

A general introduction to portraitive landscape and genre in nineteenth-century America. Discusses the academic styles and the work oriented to the general public. It provides the layman with an introduction to the major figures and some biographical information as well.

514 Bloch, E. Maurice. "The American Art Union's Downfall." THE NEW YORK HISTORICAL SOCIETY QUARTERLY 37 (1953): 351-59.

A study of the importance of this organization that, at its peak of success, was buying, commissioning, and auctioning off paintings as well as distributing prints of the popular works in genre and landscape.

515 Callow, James T. KINDRED SPIRITS: KNICKERBOCKER WRITERS AND AMERICAN ARTISTS, 1807-1855. Chapel Hill: University of North Carolina Press, 1967. xxii, 287 p. 20 illus. Bibliog. pp. 253-73.

09.7471
C16K

Discusses the various social and artistic relationships between the artists and writers especially in regard to the writers' subjects for landscape and genre painting. Includes a list of reviews in Knickerbocker magazines and comments on American landscape painters by the writers.

516 Corn, Wanda M. THE COLOR OF MOOD: AMERICAN TONALISM. San Francisco: DeYoung Memorial Museum, 1972. 46 p. 14 illus.

This exhibition catalog documents an important part of romantic painting generally slighted in the major surveys and places both the works and the artists in their historical perspective. Primarily identified with the nineteenth century.

517 Curry, Larry. THE AMERICAN WEST: PAINTERS FROM CATLIN TO RUSSELL. New York: Viking Press, in association with the Los Angeles County Museum of Art, 1972. 198 p. Illus., some in color. Bibliog. pp. 192-98.

There has always been a strong attraction to the paintings of the American West on the part of the general public and a few specialized collectors. This volume provides biographical and stylistic information on those figures who either concentrated exclusively on such work or who made special trips

out west to provide background for a series of works. Many concentrated on the life of the Indian.

518 Dickason, David Howard. THE DARING YOUNG MEN: THE STORY OF THE AMERICAN PRE-RAPHAELITES. Bloomington: Indiana University Press, 1953. x, 304 p. Illus.

709.73
D54d

Documents the relationship between the American painters and not only their English counterparts, but the English theorists who influenced both groups. Of particular importance to the author was the influence of John Ruskin and his aesthetic theories. Very few of the paintings illustrated appear in the general surveys of American painting.

519 Dickson, Harold E. ARTS OF THE YOUNG REPUBLIC: THE AGE OF WILLIAM DUNLAP. Chapel Hill: University of North Carolina Press, 1968. 234 p. Illus.

709.73
D55a

An attempt to document, through an exhibition and its catalog, the work of those artists Dunlap thought important in preparing his biographical dictionary (see chapter 1). The greatest number of those works in the exhibition were portraits by the late colonial and early nineteenth-century painters.

520 Ewers, John Canfield. ARTISTS OF THE OLD WEST. Garden City, N.Y.: Doubleday & Co., 1965. 240 p. Illus., some in color. Bibliog. pp. 237-40.

This is a good introductory survey of the subject, and one aimed at the lay reader. The artists and works illustrated are, for the most part, those best known to the general public. That the degree of realism used in this painting is closer to the later generations of landscape painting is a particular thesis of the writer.

521 Flexner, James Thomas. NINETEENTH CENTURY AMERICAN PAINTING. New York: G. P. Putnam's Sons, 1970. 256 p. Illus., 60 in color.

759.13
F6ln

This basic survey of the major developments in nineteenth-century American painting is generally anecdotal in content and easily grasped by the casual reader. A general flavor of Americana permeates the entire text, and the author has a talent for making one identify with the artists and periods under discussion.

522 Frankenstein, Alfred. AFTER THE HUNT: WILLIAM HARNETT AND OTHER AMERICAN STILL LIFE PAINTERS, 1870-1900. Rev. ed. Berkeley and Los Angeles: University of California Press, 1969. xix, 200 p. 136 illus.

The author's classic study of the work of Harnett and his followers and imitators. A major portion is devoted to separating

the paintings of John Peto from those by Harnett. Makes a
strong case for careful evaluation of style and application of
scientific techniques. (See also 823.)

523 _____. THE REALITY OF APPEARANCE: THE TROMPE L'OIEL TRADI-
TION IN AMERICAN PAINTING. Greenwich, Conn.: New York
Graphic Society, 1970. 156 p. 105 illus., 8 in color.

159.13
C15r

A survey of the major practitioners of this technique in nine-
teenth-century America. Particular attention is paid to William
Harnett, John Huberle, Raphaelle Peale, and John Peto.
Biographical information on the painters and clear illustrations.

524 Gerdts, William H. "The Influence of Ruskin and Pre-Raphaelitism on
American Still Life Painting." THE AMERICAN ART JOURNAL 1 (Fall
1969): 80-97.

3 rd
Floor

Points out how the influences of both the critic and the En-
glish painters were found not only in literary history painting,
but in still-life as well. The influence of the magazine THE
CRAYON is documented, as is that of its successor, THE NEW
PATH. Illustrations of many little-known landscapes in that
tradition.

525 Hills, Patricia. THE AMERICAN FRONTIER: IMAGES AND MYTHS.
New York: Whitney Museum of American Art, 1973. 63 p. 56 illus.

159.13
H65a

An exhibition catalog which brings together works from different
periods and schools in order to present the American's view of
the frontier. The commentary is clearly written and provides
interesting insights. Scholarly research, yet suited to the
viewing public.

526 _____. THE PAINTER'S AMERICA: RURAL AND URBAN LIFE, 1810-
1910. New York: Frederick A. Praeger, 1974. vii, 160 p. 159 black
and white illus., 8 in color. Bibliog. pp. 154-56.

Essentially a study of both rural and urban genre painting in
nineteenth-century America. Both the well-known giants of
the mode and those whose output was smaller or whose repu-
tations have been eclipsed are covered. Analyzes the moral
and political background that caused certain images to appear
and reappear throughout the period. Very good bibliography.

527 Hirschl & Adler Galleries. THE AMERICAN SCENE: A SURVEY OF
THE LIFE AND LANDSCAPE OF THE NINETEENTH CENTURY. New
York: 1969. 72 p. 91 illus., some in color.

The catalog of an exhibition held to salute the centennials of
both the Metropolitan Museum of Art and the Museum of Fine
Arts, Boston--two of the major collections of American paint-
ing in the country. Information about each painting and its
history.

528 Hoopes, Donelson F. THE AMERICAN IMPRESSIONISTS. New York:
Watson-Guptill, 1972. 160 p. Illus., 64 in color. Bibliog. pp. 155-
57.

A study of the major figures in late nineteenth-century Ameri-
can painting influenced by the example of the French impres-
sionists. Includes such orthodox impressionists as Mary Cassatt
and individuals who used their example to create a personal
style, such as Twactman. Includes several figures into the
early twentieth century, though the inclusion of Bellows is
questionable.

529 Hoopes, Donelson [F.], and Von Kalnein, Wend. THE DUSSELDORF
ACADEMY AND THE AMERICANS. Atlanta, Ga.: The High Museum
of Art, 1973. 135 p. 150 illus. Bibliog. p. 135.

This volume contains information about the Academy of Dus-
seldorf, the nature and orientation of the faculty, and the
influence it exerted on the American artists. Illustrations by
both German and American painters.

530 Howat, John K. THE HUDSON RIVER AND ITS PAINTERS. New York:
Viking Press, 1972. 207 p. Illus., many in color. Bibliog. pp. 193-
201.

An unusual format which travels the Hudson geographically in
surveying the paintings that have been inspired by that major
artery of commerce and travel. Many little-known works by
both the standard Hudson River School painters and their more
obscure followers are illustrated in color. Minimal text by
the curator of American painting at the Metropolitan Museum
of Art.

531 Howat, John K., and Pilgrim, Diane. AMERICAN IMPRESSIONIST AND
REALIST PAINTINGS AND DRAWINGS FROM THE COLLECTION OF
MR. & MRS. RAYMOND HOROWITZ. New York: Metropolitan Museum
of Art, 1973. 164 p. 50 illus.

The catalog of an important exhibition of the large and usually
unseen holdings of the Horowitz family. Also valuable for
the most up-to-date critical thinking on the importance of
the American impressionist movement. Contains a good selec-
tion of color illustrations.

532 Lowe Art Museum. 19th CENTURY AMERICAN TOPOGRAPHIC PAINT-
ERS. Coral Gables, Fla.: University of Miami, 1974. 95 p. Illus.,
some in color. Bibliog. pp. 92-94.

A brief introduction to the catalog of an exhibition of the
native landscape through the eyes of painters from Washington
Allston through Alexander Wyant. Contains paragraph-length
biographies of each of the dozens of painters represented and
illustrated. The title is somewhat misleading as many of the

works are landscapes and not topographical studies at all.

533 Luck, Robert H. TWICE AS NATURAL: 19th CENTURY AMERICAN GENRE PAINTING. New York: Finch College Museum of Art, 1973. 17 p. 23 illus.

Takes a fairly broad view of genre painting, including discussion of several little known artists such as Charles F. Ulrick and Enoch W. Perry. In addition, works of painters known primarily for their landscapes, such as F.H. Lund, are shown in a genre context.

534 McGrath, Robert L. EARLY VERMONT WALL PAINTINGS, 1790-1850. Hanover, N.H.: University Press of New England, 1972. xviii, 106 p. 42 illus.

Divided into four chapters: "The Archeology of Early American Murals"; "Painting on Overmantels"; "Houses with Scenic Murals"; and "Mural Painting in the Later Nineteenth Century." Individual houses and their work are discussed in each chapter, and attempts are made to find sources in European art.

535 Museum of Fine Arts. Boston. M. AND M. KAROLIK COLLECTION OF AMERICAN PAINTINGS: 1815-1865. Cambridge, Mass: Harvard University Press, for the Museum of Fine Arts, Boston, 1949. ix, 544 p. 233 illus.

The catalog of one of the major collections of nineteenth-century American painting. The various works are well documented and their relationship to general movements can be established through the essay on the period by the critic John Baur. The collection itself is a survey of the work of the important painters of the period in genre, landscape, and portraiture.

536 _____. M. AND M. KAROLIK COLLECTION OF AMERICAN WATER-COLORS AND DRAWINGS, 1800-1875. 2 vols. Boston: 1962. Vol. 1, 337 p.; vol. 2, 352 p. Illus., some in color. Bibliog. vol. 1, p. 328; vol. 2, p. 345.

These volumes serve as a survey of almost all the important painters at work during the time span under discussion. As with the previously mentioned catalog, the paintings and drawings are well documented. In addition, a good deal of biographical information is provided on the more obscure as well as the generally known painters.

537 [O'Doherty], Barbara Novak. AMERICAN PAINTING OF THE NINETEENTH CENTURY: REALISM, IDEALISM, AND THE AMERICAN EXPERIENCE. New York: Frederick A. Praeger, 1969. 350 p. Illus., some in color. Bibliog. pp. 335-39.

Lengthy essays on key figures in American nineteenth-century

painting, from Copley as background, to Harnett. The role of each in defining some aspect of artistic development is explored and constant comparison with contemporary European developments is made.

538 _____. THE ARCADIAN LANDSCAPE: NINETEENTH CENTURY AMERI-CAN PAINTERS IN ITALY. Lawrence: University of Kansas Museum of Art, 1973. Unpaged. 45 illus.

Barbara Novak wrote the essay for this exhibition catalog documenting the idealized landscapes painted by Americans such as Cole, Inness, and the many others who sought inspiration in the land of the renaissance.

539 _____. "Some American Words: Basic Aesthetic Guidelines, 1825-1870." THE AMERICAN ART JOURNAL 1 (Spring 1969): 78-91.

An exploration of both the sources of aesthetic dictates in this period, native and imported, and the particular concern with the conceptions of "real" and "ideal." The views of both critics and the painters themselves are examined and juxtaposed.

540 Pisano, Robert G. THE STUDENTS OF WILLIAM MERRITT CHASE. Huntington, N.Y.: Heckscher Museum, 1973. 44 p. Illus. Bibliog. p. 44.

A catalog of an exhibition of works by both obscure and well-known students of Chase, from both his Shinnecock summer school and the regular art schools. Illustrated works cover both the end of the nineteenth and the early twentieth century, but emphasis is on the former.

541 Richardson, Edgar Preston. AMERICAN ROMANTIC PAINTING. New York: Weyhe, 1944. 50 p. 211 illus.

An introduction to general developments in nineteenth-century American painting is followed by brief biographical sketches of the painters in the various types of expression. The illustrations include landscapes, genre, and portraits.

542 Rovetti, Paul F. "The Tillon Collection of Nineteenth Century American Folk Painting." AMERICAN ART REVIEW 1 (July 1974): 104-19.

Based on an exhibition at the William Benton Museum of Art, this article summarizes the strengths of the collection and illustrates portraits, landscapes, still lifes, and baptismal certificates. Explores the full range of folk painting of the era.

543 Sheldon, George W. RECENT IDEALS OF AMERICAN ART: ITS OIL PAINTINGS AND WATERCOLORS IN THE GALLERIES OF PRIVATE COLLECTORS. New York: Appleton, 1890. 150 p. 175 illus.

An extremely old work, but one which illustrates the general aesthetic sensibilities and popular taste of the end of the nineteenth century. The illustrations of academic works, especially, are of interest in an era that saw little of such paintings. Genre and literary/historical paintings obviously established a trend at that time.

544 Sweet, Frederick A. THE HUDSON RIVER SCHOOL AND THE EARLY AMERICAN LANDSCAPE TRADITION. Chicago: Art Institute of Chicago, 1945. 123 p. Illus.

759.13
S 97h

A good but old exhibition catalog which provides biographical data on the major early painters of the American scene. The chronological order used in the catalog has been copied in recent years, but it is often difficult for the general reader to use.

545 Tillou, Peter H. NINETEENTH-CENTURY FOLK PAINTING: OUR SPIRITED NATIONAL HERITAGE. Storrs, Conn.: The William Benton Museum of Art, the University of Connecticut, 1973. 210 p. 150 illus.

59.13
Ts7h

Catalog of an up-to-date exhibition of this genre of painting. A good selection of examples of the popular subjects for the folk artist: portraiture, still life, and landscape.

546 Von Saldern, Axel. TRIUMPH OF REALISM. Brooklyn, N.Y.: The Brooklyn Museum, 1967. 185 p. 101 illus., 5 in color. Bibliog. pp. 183-85.

A study of realism in both Europe and the United States. An essay on the style is followed by an exhibition catalog with complete biographical information on each artist discussed and basic information on each painting. The major Americans included are Chase, Duveneck, Eakins, Harnett, Henri, Homer, and Sargent.

547 Westermeier, Clifford P. COLORADO'S FIRST PORTRAIT SCENES BY EARLY ARTISTS. Albuquerque: University of New Mexico Press, 1971. 206 p. 500 illus.

An exhaustive survey of the early admirers of the land including both topographical and idealized scenes. The text is an excellent point of departure for the specialist interested in further biographical details and stylistic developments of the individuals documented.

548 Wunderlich, Rudolf. "Artists of the Civil War." KENNEDY QUARTERLY 2 (May 1961): 37-88.

The works in this study show how wide the range of treatment of the war was: from genre, to topography, to figure painting. Major artists like Winslow Homer and figures whose identities are lost all participated in recording the great experience and

are included in this catalog.

TWENTIETH-CENTURY PAINTING

The literature available on contemporary American art is staggering in size, necessitating a high degree of selectivity and restraint in the compilation of the following items. Much valuable information about specific movements will be found in monographs and studies on individual artists.

549 Agee, William C. SYNCHROMISM AND COLOR PRINCIPLES IN AMERICAN PAINTING. New York: Knoedler, 1965. 53 p. Illus., some in color.

The catalog of the most important examination of the synchromist movement since the 1910s. Works by the standard masters of the scientific movement and others interested in color theories are featured.

550 Andrew Crispo Gallery. PIONEERS OF AMERICAN ABSTRACTION. New York: 1973. 80 p. 86 illus., 32 in color.

A good general exhibition catalog of the work of the major figures of the 1940s and 50s. Includes fine color plates and information on the distinctness of the individuals involved.

551 Art Institute of Chicago. ARTISTS OF CHICAGO AND VICINITY. Chicago: 1897-1969. Annual. 1971- . Biennial.

The catalogs of the biennial exhibitions of artists from the city and its environs. Includes some sculpture but primarily serves as a guide to current trends and taste of the art crowd in the second city. Quite a different selection than usually found in the Whitney or Museum of Modern Art. The best guide to Chicago developments.

552 Ashton, Dore. THE NEW YORK SCHOOL: A CULTURAL RECKONING. New York: Viking Press, 1972. x, 246 p. 52 illus.

A cultural history of the New York scene, particularly in the late 1940s and early 1950s when so many of the people who were to become first generation abstract expressionists gathered there as young "radicals" in art. Discusses the intellectual climate and the various theories favored by the painters.

553 Baigell, Matthew. "American Abstract Expressionism and Hard-Edge: Some Comparisons." STUDIO INTERNATIONAL 171 (January 1966): 10-15.

A brief look at the important figures and styles of the two movements. Raises questions as to the commonality of their sources and the importance of the European nonobjective

tradition as opposed to the recent popularity of expressionism.

554 _____. THE AMERICAN SCENE: AMERICAN PAINTING OF THE 1930's. New York: Frederick A. Praeger, 1974. 214 p. 140 illus., some in color. Bibliog. p. 212.

> A survey of the two main currents in American painting in the 1930s--regionalism and social realism. Presents a biographical and artistic analysis of many of the central figures in the two movements and an attempt to show their common commitment to the American scene.

555 Barker, Virgil. FROM REALISM TO REALITY IN RECENT AMERICAN PAINTING. Lincoln: University of Nebraska Press, 1959. 93 p. Illus.

> The critic's theory on the meaning and influences behind the new abstract painting of the 1950s. He discusses the American tradition of realism and explains the interest in the paint itself in relation to realism in nineteenth-century painting.

556 Baur, John I.H. THE EIGHT. New York: Brooklyn Museum, 1943. 39 p. Illus.

> One of the first catalogs of an exhibition of the works of the original group show of these protesters against academic domination of the American art scene. The original show and the events around it are documented, and several of the paintings illustrated were exhibited in the 1908 exhibition at Macbeth Galleries in New York.

557 _____. REVOLUTION AND TRADITION IN AMERICAN PAINTING. Cambridge, Mass.: Harvard University Press, 1951. 170 p. Illus. Bibliog. p. 159-60.

> This volume is a survey of the first half century of painting in twentieth-century America. The importance of the European contacts vis a vis the Armory show and the influx of abstractionists in the late 1930s are clearly and convincingly explained.

558 Bearden, Romare, ed. FIFTEEN UNDER FORTY: PAINTING BY YOUNG NEW YORK STATE BLACK ARTISTS. Saratoga, N.Y.: Gallery Museum, Saratoga Performing Arts Center, 1970. Unpaged. 15 illus.

> Biographical information on each of the young black American painters illustrated in this exhibition catalog. Some are particularly concerned with the black experience in their paintings, and others seem to exist in the mainstream of post-painterly abstraction.

559 Brown, Milton W[olf]. AMERICAN PAINTING FROM THE ARMORY SHOW TO THE DEPRESSION. Princeton, N.J.: Princeton University Press, 1955. 244 p. Illus. Bibliog. pp. 201-37.

The pioneering study of the developments in American painting in a critical period in our artistic development. The new forces of modernism, developed by the spirit of the Ashcan group, but more specifically by the Armory show, were battling the forces of tradition and the academic reaction. The Depression was to provide a temporary victory for the proponents of realism.

560 _____. "The Ash Can School." AMERICAN QUARTERLY 1 (Summer 1949): 127-34.

3rd Floor

Discusses style, the views of the Ashcan School, their concern for social problems, and how it influenced their painting.

561 Bruce, Edward, and Watson, Forbes. ART IN FEDERAL BUILDINGS: AN ILLUSTRATED RECORD OF THE TREASURY DEPARTMENT'S NEW PROGRAM IN PAINTING AND SCULPTURE. Volume 1: MURAL DESIGNS. Washington, D.C.: Art in Federal Buildings, 1936. 309 p. Illus.

709.73
A782

Documentation on the murals done for the Treasury Department during the Depression. A second volume, on the sculpture, was never written. The authors were the main supporters of the project.

562 Coplans, John. "The New Paintings of Common Objects." ARTFORUM 1 (November 1962): 26-29.

3rd Floor

A brief introduction to pop art as it emerged on the popular vision. Discusses the background of commercial art and the reaction against abstract expressionism.

563 Doty, Robert. CONTEMPORARY BLACK ARTISTS IN AMERICA. New York: Whitney Museum of American Art, 1971. 64 p. Illus., some in color. Bibliog. pp. 60-64.

The catalog of an exhibition, at a major museum, of the new young black American painters. Many styles are represented, from the nonfamiliar stylized forms of Jacob Lawrence to the completely nonobjective work of several of the recent newcomers.

564 Elderfield, John. "American Geometric Abstraction in the Late Thirties." ARTFORUM II (December 1972): 35-42.

Discusses the work of the pioneering American painters who were involved in the American Abstract Artists group. Points out how many of these young painters laid the groundwork for today's dominance of Americans in the modern art scene.

565 Fox, Elton C. SEVENTEEN BLACK ARTISTS. New York: Dodd, Mead and Co., 1971. 306 p. Illus.

A general history of black American artists in recent times. Biographical information on both the older generation of realists and the new young abstractionists. A good source of illustrations of these often unpublished works.

566 Geldzahler, Henry. AMERICAN PAINTING IN THE TWENTIETH CENTURY. New York: Metropolitan Museum of Art, distributed by the New York Graphic Society, 1965. 236 p. Illus. Bibliog. pp. 227-30.

A survey of American paintings from the permanent collection of the Metropolitan Museum of Art. The book provides specific information on the museum's holdings for the researcher and general biographical and stylistic information for the general reader.

567 Gies, Dorothy. "Fiftieth Anniversary for the Eight." ART IN AMERICA 45 (Winter 1957-58): 61-64.

Recounts the details of the famous exhibition of the assorted rebels against the Academy and the success of their cause.

568 Greenberg, Clement. POST PAINTERLY ABSTRACTION. Los Angeles: Los Angeles County Museum of Art, 1964. 72 p. Illus.

The catalog of an important exhibition in which the works of the hard-edged successors to the abstract expressionists are illustrated and their individual responses to the challenges of modern painting are discussed.

569 Gurin, Ruth, ed. AMERICAN ABSTRACT ARTISTS: 1936-1966. New York: Ram Press, 1966. Unpaged. Illus.

A brief history of this independent group of painters who pioneered in modern developments in twentieth-century art over a period of thirty years. While not all pursuing the same style, each was dedicated, as the author shows, to freedom of expression.

570 Hess, Thomas B. ABSTRACT PAINTING: BACKGROUND AND AMERICAN PHASE. New York: Viking Press, 1951. 164 p. Illus., some in color.

Provides a brief history of abstract painting in Europe before settling down to make the case for the importance and vitality of the work of the Americans, primarily those of the 1940s and 50s.

571 Janis, Sidney. THEY TAUGHT THEMSELVES: AMERICAN PRIMITIVE PAINTERS OF THE 20TH CENTURY. New York: Dial Press, 1942. 236 p. Illus., 2 in color.

The catalog of a major exhibition of naive twentieth-century

American painters which contributed to the popularity of several of these artists. Written for the layman, very little is done to explain the styles utilized other than generalizations about the individuals' backgrounds. A good source of illustrations.

572 Kozloff, Max. "American Painting during the Cold War." ARTFORUM II (May 1973): 43-54.

This is the revised version of the author's text for an exhibition earlier in the year. The recent movements of pop art and abstract paintings are discussed in terms of the values and attitudes within both the artists and the American public.

573 _____. "The Critical Reception of Abstract Expressionism." ARTS MAGAZINE 40 (December 1965): 27-33.

Explores the impact of abstract expressionism on both the general public and the special art crowd.

574 Kulterman, Udo. THE NEW PAINTING. Greenwich, Conn.: New York Graphic Society, 1972. 44 p. Illus., some in color. Bibliog. pp. 39-42.

A study of the new directions in realist figure painting spearheaded by the American painters. Biographical information is provided for about forty-five painters from all over the country, showing that not all important painters have moved to New York City.

575 Lippard, Lucy R. POP ART. New York: Frederick A. Praeger, 1966. 216 p. Illus., some in color. Bibliog. pp. 206-8.

A well-researched study of the pop movement and the importance of the American cultural environment in producing the major figures in its development. Essays by several influential critics on aspects of the development are included.

576 McLanathan, Richard. THE BRANDYWINE HERITAGE. Greenwich, Conn.: New York Graphic Society, 1971. 120 p. 80 illus., 18 in color.

A study of the famous painters and illustrations of the Brandywine area of Pennsylvania, concentrating on the generations of Wyeths. Background and historical information on the area and its people.

577 Miller, Dorothy [C.], ed. AMERICANS, 1942; FOURTEEN AMERICANS, 1946; FIFTEEN AMERICANS, 1952; TWELVE AMERICANS, 1956; SIXTEEN AMERICANS, 1959; AMERICANS, 1963. New York: Museum of Modern Art, 1942. Var. pag.

An extremely important series of catalogs of the major exhibitions of American painting at the Museum of Modern Art.

16 Americans
709.73 N535

12 Americans
09.73
N53t

Although some cover sculpture, they are essentially one of the valuable guides to the taste of an important avant-garde institution in regard to contemporary painting. Several of the catalogs contain statements by the artists themselves, explaining their work. A surprisingly high percentage of those selected for these shows have maintained their reputations over the years. An excellent guide to what was happening in the American art world at any given period covered by the catalogs.

578 Monte, James K. 22 REALISTS. New York: Whitney Museum of American Art, 1970. 63 p. Illus. Bibliog. pp. 60-63.

O The catalog of a major exhibition of American realist painters including those who use the photograph as their point of departure. The major figures tend to dominate the movement, but attention is paid to lesser-known painters from all parts of the country.

579 Motherwell, Robert, ed. "Statements by Artists of the New York School." POSSIBILITIES 1 (Winter 1947-48): entire issue.

O The pioneering abstractionists state their case and explain the aesthetic basis for their movement away from traditional American realism.

580 National Collection of Fine Arts. THE DISAPPEARANCE AND REAPPEARANCE OF THE IMAGE: AMERICAN PAINTING SINCE 1945. Washington, D.C.: Smithsonian Institution, 1969. 84 p. Illus.

O Discusses the evolution from the general acceptance of abstract expressionism to the pop movement and into the development of the "new realism." Biographical information and discussion of styles and technique of the artists under examination.

581 Norman, Dorothy, ed. 291. No. 1-12; Mar. 1915-Feb. 1916. Arno Series of Contemporary Art. New York: Arno Press, 1972. 46 p. Illus., some in color.

O The magazine 291 was the production of Alfred Stieglitz and his friends and associates in his important avant-garde gallery. The introduction explains the importance of 291 in introducing the American artists and public to important developments by both European and American artists.

582 Pitz, Henry C. THE BRANDYWINE TRADITION. Boston: Houghton Mifflin Co., 1969. 252 p. Illus., some in color. Bibliog. pp. 183-92.

O This is an introduction to the work of the Wyeths and the other artists who have both worked in and drawn inspiration from the Brandywine River part of Pennsylvania.

583 Read, Helen Appleton. NEW YORK REALISTS, 1900-1914. New York: Whitney Museum of American Art, 1937. 21 p.

The catalog of an exhibition of the work of the Ashcan painters and their immediate followers. The way they differed from and rejected the "realism" of the accepted National Academy style is discussed, and their reception by the public is outlined.

584 Reich, Sheldon. "The Halpert Sale: A Personal View." AMERICAN ART REVIEW I (September–October 1973): 77-90.

Discusses not only the sale of the Halpert Collection and the value of the paintings, but also Halpert's role in supporting and exhibiting the pioneer American abstractionists in their earlier years. A study of the relationship between a dealer and her stable of painters.

585 Rose, Barbara. AMERICAN PAINTING: THE TWENTIETH CENTURY. Geneva: Skira/World, 1970. 126 p. Illus., some in color. Bibliog. pp. 119-26.

A view of American painting that presents the evolution from early social realism to the point where abstraction had triumphed. More than a picture book, but has a fine selection of color plates.

586 Rublowsky, John. POP ART. New York: Basic Books, 1965. 174 p. Illus., some in color.

A study of the phenomenon of pop art. Biographical and stylistic information on the major New York clique of painters, especially those influenced by advertising. Sculpture is included, but is usually the work of figures who are also known as painters.

587 Sandler, Irving. THE TRIUMPH OF AMERICAN PAINTING: A HISTORY OF ABSTRACT EXPRESSIONISM. New York: Frederick A. Praeger, 1970. 301 p. Illus., some in color. Bibliog. pp. 281-98.

An important examination of the artists of this movement and how abstract expressionism came to be the accepted modernism of the 1940s and 50s. It is both a history of the movement and of its major practitioners: Baziotes, Gorky, Gottlieb, Kline, Pollock, and others. Valuable bibliography.

588 Seuphor, Michel, ed. "La Peinture aux Etats-Unis." ART D'AUJOURD' HUI (Paris) 2 (June 1951): entire issue.

An important issue of the French periodical devoted exclusively to the painting developments, primarily abstract expressionism, in American art. Emphasis on the New York scene.

589 Solomon, Alan [R.]. TOWARD A NEW ABSTRACTION. New York: The
 Jewish Museum, 1963. 40 p. 9 color illus. Bibliog. pp. 37-39.

 Nine brief essays on the postabstract expressionist painters of
 the late 1950s and early 60s. An attempt to trace the indi-
 vidual artist's routes out of abstract expressionism is found in
 the introduction.

590 _____, ed. AMERICAN PAINTING NOW. Montreal: Expo, 1967.
 Unpaged.

 The catalog of the exhibition of American painting shown at
 Expo '67 and the Institute of Contemporary Arts, Boston.
 Various abstractionists, pop figures, and realists are discussed
 and their works illustrated.

591 Solomon, Alan [R.], and Mulas, Ugo. NEW YORK: THE NEW ART
 SCENE. New York: Holt, Rinehart and Winston, 1967. 341 p. Illus.

 A general introduction to "what's happening" through photo-
 graphs of the major figures in New York during the 1960s.
 Biographical information and estimates of the importance of
 the artists are provided.

592 Tuchman, Maurice. NEW YORK SCHOOL: THE FIRST GENERATION.
 Greenwich, Conn.: New York Graphic Society, 1972. 229 p. Illus.
 Bibliog.

 An analysis of the rise and purposes of abstract expressionism
 through the eyes and words of the pioneer artists and the critics
 who first acclaimed the movement. The volume is based on
 an earlier exhibition catalog prepared by the author.

593 University of Illinois. CONTEMPORARY AMERICAN PAINTING. Urbana:
 1948-53. Annual. 1955- . Biennial.

 A series of catalogs of exhibitions of the current American
 painting at a university with an impressive collection of Ameri-
 can twentieth-century art. Each one contains a cross section
 of developments rather than following regional trends. Has
 the diversity of the Whitney Biennial exhibitions.

594 Weller, Alan S. THE JOYS AND SORROWS OF RECENT AMERICAN
 ART. Urbana: University of Illinois Press, 1968. 185 p. Illus.

 A series of lectures by a perceptive critic of modern art.
 Discusses the influence of European masters at different times
 during the century and explores the trends at the time of
 writing.

595 Whitney Museum of American Art. BIENNIAL EXHIBITIONS OF CON-
 TEMPORARY AMERICAN PAINTING. New York: 1932-74.

These seventeen exhibitions and their catalogs document the view of a major American museum on what important developments have been taking place in American painting. The catalogs are of varying lengths, are illustrated, and are an important source of biographical information and stylistic analysis on the painters invited to exhibit. Many of the artists, some very well established and others almost unknown, have continued in the vanguard of American developments and others have been relegated to obscurity. Together, these catalogs form an important study in the taste of the critical establishment and are worth examining.

596 Young, Mahonri Sharp. THE EIGHT: THE REALIST REVOLT IN AMERI-
 CAN PAINTING. New York: Watson-Guptill, 1973. 160 p. Illus.,
 some in color. Bibliog. p. 157.

 Discusses the revolt against the authority and standards of the
 National Academy in the work of the group of painters who
 held their historic exhibition in 1908 and laid the groundwork
 for the Armory show of 1913. Admits to the differences in
 their style and sources and stresses the commonality of their
 attitudes.

Chapter 8

INDIVIDUAL PAINTERS

The following are books and articles on the life, style, and technique of individual painters from the seventeenth century to the present. They represent a conscious selection of the available material so as to permit adequate coverage of the painters of the past. There are so many art magazine articles and exhibition catalogs for contemporary artists that much has had to be omitted, especially short notes on recent work containing little historical or stylistic analysis. Many important works on earlier artists were written quite some time ago, but inclusion here indicates that they have not been superseded by any current writing and remain a valuable source.

ABBEY, EDWIN AUSTIN 1852-1911

597 Foster, Kathleen A. "Edwin Austin Abbey." AMERICAN ART REVIEW 1 (March, April 1974): 83-95.

Describes his career and the changes in his reputation, and discusses the reasons for his expatriation. Illustrates the variety of his work and stresses the importance of his draughtsmanship.

598 Lucas, Edward Verrall. EDWIN AUSTIN ABBEY, ROYAL ACADEMICIAN. 2 vols. New York: Charles Scribner's Sons, 1921. 518 p. 200 illus.

Although chatty and anecdotal, it is our only major source of information on the painter whose murals were the academic success of his time.

599 Yale University. PAINTINGS, DRAWINGS AND PASTELS BY EDWIN AUSTIN ABBEY. February 19-March 22, 1939. Meriden, Conn.: Meriden Gravure, 1939. 24 p. 12 illus.

The introduction to the exhibition catalog was written by the noted American critic, Royal Cortissoz, who admired Abbey's paintings.

ALBERS, JOSEF 1888-

600 Albers, Josef. INTERACTION OF COLOR. New Haven: Yale University Press, 1963. Var. pag. Illus. in color.

752
A33i

Albers' major pedagogic work, it has been of tremendous influence as has been his teaching at Yale for generations of American painters. Illustrates his basic color theories and their application.

601 Gomringer, Eugen. JOSEF ALBERS: HIS WORK AS A CONTRIBUTION TO VISUAL ARTICULATION IN THE TWENTIETH CENTURY. New York: Wittenborn and Co., 1968. 185 p. Illus., some in color. Bibliog. pp. 189-91.

The major historical and critical work on this important Bauhaus painter. Based on an exhibition catalog, it illustrates his importance for developments in modern painting.

ALBRIGHT, IVAN 1887-

602 Sweet, Frederick [A.]. IVAN ALBRIGHT. Chicago: Art Institute of Chicago, 1964. 56 p. Illus., some in color.

759.13
A34c

The major exhibition catalog of the work of the American surrealist. The Art Institute owns many of the best-known Albright paintings which provided the nucleus of the show. Includes a statement by the artist.

ALLSTON, WASHINGTON 1779-1843

603 Allston, Washington. LECTURES ON ART AND POEMS. Edited by Richard Henry Dana, Jr. New York: Baker & Scribner, 1850. Reprint. New York: Da Capo Press, 1972. xi, 380 p.

Still interesting reading as Allston proclaims the moral and didactic values of art as put forth by his European mentors.

604 Detroit Institute of Arts. WASHINGTON ALLSTON, 1774-1843: A LONG EXHIBITION OF PAINTINGS, DRAWINGS AND MEMORABILIA. May-June, 1947. Introduction by Edgar Preston Richardson. Detroit: 1947. 36 p. 11 illus.

In a brief introduction to the work of one of the outstanding early romantic painters in America, Allston is credited with bringing the Anglo-German avant-garde of the early nineteenth century to New England.

605 Flagg, Jared Bradley. THE LIFE AND LETTERS OF WASHINGTON

ALLSTON. 1892. Reprint. New York: Benjamin Blom, 1969. xiii, 435 p. 18 black and white illus.

This biography is based on primary sources: the letters of Allston to several of his contemporaries. The letters are excellent background for a study of romantic thought in the early years of the nineteenth century in the United States.

606 Fuller, Margaret. "A Record of Impressions Produced by the Exhibition of Mr. Allston and Pictures in the Summer of 1839." DIAL 1 (July 1840): 73-84.

A contemporary view of Allston's work by the editor of the most sophisticated and advanced cultural journal of the day. His paintings are praised for their sentiment and noble truths.

607 Gerdts, William H. "Allston's Belshazzar's Feast." ART IN AMERICA 61 (March-April 1973): 59-66; (May-June 1973): 58-65.

A detailed study of the famous albatross of Allston, his never completed painting, and its place in his life and work as well as in American historical painting. The support of patrons and financial matters are fully discussed and the critical reaction is explored.

608 Richardson, Edgar Preston. WASHINGTON ALLSTON: A STUDY OF THE ROMANTIC ARTIST IN AMERICA. Chicago: University of Chicago Press, 1948. ix, 233 p. 60 illus. Bibliog. pp. 220-28.

In addition to providing a good biography of the artist as a study of the romantic figure or "hero," the author gives us an excellent catalog of paintings by Allston locatable at the date of publication.

609 Sweetser, Moses Foster. ALLSTON. Artist-Biographies Series. Boston: Houghton, Osgood and Co., 1879. vi, 192 p.

This is one of a series of fifteen biographies of American artists, many of which are not easily located. The author provides a carefully compiled list of the works of Allston and identifies their owners. A good source of information about collectors in the last quarter of the nineteenth century.

AMES, EZRA 1768-1836

610 Bolton, Theodore. EZRA AMES OF ALBANY: PORTRAIT PAINTER, CRAFTSMAN, ROYAL ARCH MASON, BANKER, 1768-1836. New York: New York Historical Society, 1955. xix, 398 p. 118 black and white illus. Bibliog. pp. 359-70.

A carefully documented biography that utilizes letters, account

113

books, and other primary sources. Resurrects an important figure in early federal period painting. Many of the biographical entries relate to aspects of his life other than his art.

ANSHUTZ, THOMAS POLLOCK 1851-1912

611 Bowman, Ruth. "Nature, the Photograph, and Thomas Anshutz." ART JOURNAL 33 (Fall 1973): 32-40.

3 rd
Floor

Provides biographical information on the painter, discusses the success of "Ironworkers: Noontime," and shows the place photography occupied in the composition of his paintings.

612 Goodyear, Frank H., Jr. "Ironworkers: Noontime." AMERICAN ART REVIEW 1 (January-February 1974): 34-46.

Discusses not only the importance of the painting as a monument of realism, but how it was created. Illustrations of preparatory drawings. Also briefly outlines the painter's significant role as a teacher of many of the important twentieth-century American artists.

613 Heard, Sandra Denney. THOMAS P. ANSHUTZ. Philadelphia: Pennsylvania Academy of the Fine Arts, 1973. 27 p. 7 illus.

The catalog of the only major exhibition of an important realist painter in late nineteenth and early twentieth-century America. The teacher of Henri, Glackens, Sloan, Sheeler, and Marin, to name the best known, he receives some long overdue recognition.

AUDUBON, JOHN JAMES 1785-1851

614 Adams, Alexander B. JOHN JAMES AUDUBON: A BIOGRAPHY. New York: G.P. Putnam's Sons, 1966. 510 p. 16 illus. Bibliog. pp. 475-86.

A flowery and anecdotal biography based on accurate and acceptable sources.

615 Audubon, John James. THE 1826 JOURNAL OF JOHN JAMES AUDUBON. Transcribed with an introduction and notes by Alice [Elizabeth] Ford. Norman: University of Oklahoma Press, 1967. xii, 409 p. 37 illus.

The Audubon journal gives the reader both an account of his adventures and problems in accomplishing his artistic task and references to his dealings with the outside world and commercial problems.

616 _____ . THE IMPERIAL COLLECTION OF AUDUBON ANIMALS: THE QUADRUPEDS OF NORTH AMERICA. Edited by Victor H. Cahalane. Maplewood, N.J.: Hammond, 1967. 307 p. Illus., many in color. Bibliog. p. 307.

Reproductions of the paintings taken from engravings. Brief introductory text.

617 _____ . THE ORIGINAL WATER COLOR PAINTINGS BY JOHN JAMES AUDUBON FOR THE BIRDS OF AMERICA. Reproduced for the first time from the collection at the New York Historical Society. Introduction by Marshall B. Davidson. 2 vol. New York: American Heritage Publishing Co., 1966. 431 color plates.

This is the most useful and valuable set of reproductions of Audubon's works. They are reproduced from the original paintings rather than from earlier reproductions.

618 Ford, Alice Elizabeth. JOHN JAMES AUDUBON. Norman: University of Oklahoma Press, 1964. xiv, 488 p. 40 illus. Bibliog. pp. 451-69.

Concentrates on presenting clear and sufficient documentation on the facts of the artist's life. Exhaustive bibliography.

AVERY, MILTON 1893-1965

619 Breeskin, Adelyn. MILTON AVERY. Greenwich, Conn.: New York Graphic Society, 1970. 96 p. 196 illus., some in color.

Based on an exhibition of the painter's life work, both the abstracts and figure paintings are included. His lyricism is praised by both the author and the painter Rothko in his tribute to Avery.

620 Kramer, Hilton. MILTON AVERY: PAINTINGS 1930-1960. New York: Thomas Yoseloff, 1962. 30 p. 112 illus., some in color.

Biographical and stylistic information on the development of the artist. The sources of his style and his place in the main- stream of twentieth-century American painting are discussed by the critic-author.

BACON, PEGGY 1895-

621 Demuth, Charles. PEGGY BACON. New York: Intimate Gallery, 1928. Unpaged. Illus.

An introduction to an artist who painted gently mocking scenes of American life. Part of the group of social realists, she has been neglected even more than her associate, Gropper.

BADGER, JOSEPH 1708-65

622 Bayley, Frank William. FIVE COLONIAL ARTISTS OF NEW ENGLAND:
JOSEPH BADGER, JOSEPH BLACKBURN, JOHN SINGLETON COPLEY,
ROBERT FEKE, JOHN SMIBERT. Boston: privately printed, 1929.
448 p. Bibliog. pp. 447-48.

Provides biographical information on these five figures about
whom the amount of information varies. Badger was the house-
painter turned portraitist who was the best of the native born
in Boston between Feke and Copley. Joseph Blackburn is pre-
sented as an influential colorist from England who took much
of the business vacated by the death of Smibert. Smibert, him-
self, and the circumstances of his arrival in New England, are
described as well as his influence on Feke and Copley. Some
information on the elusive Feke (yet very incomplete) gives us
a glimpse of an interesting figure, but the material on Copley
is completely superseded by later publications.

BAZIOTES, WILLIAM 1912-63

623 Alloway, Lawrence. WILLIAM BAZIOTES: A MEMORIAL EXHIBITION.
New York: Solomon R. Guggenheim Museum, 1965. 51 p. Illus.
Bibliog. pp. 44-45.

This catalog of a retrospective exhibition illustrates many of
the late abstract paintings that still seem connected to the
surrealism of the 1930s and 40s. The artist's feeling for color
and the poetic quality of the paintings are expressed clearly.

624 Sandler, Irving. "Baziotes: Modern Mythologist." ART NEWS 63
(February 1965): 28-31.

An analysis of the subjects of Baziotes' paintings, showing
how his biomorphic forms are linked to image, legend, and
universal myth.

BELLOWS, GEORGE 1882-1925

625 Art Institute of Chicago. GEORGE BELLOWS: PAINTINGS, DRAWINGS,
AND PRINTS. Chicago: 1946. 92 p. 136 illus.

The catalog of an exhibition which brought together the largest
amount of Bellows' work at one time. The text, however,
reveals little new material.

626 Boswell, Peyton, Jr. GEORGE BELLOWS. New York: Crown Publishers,
1942. 112 p. 40 illus., 2 in color. Bibliog. pp. 26-30.

Brief biography and discussion of the works. The analysis of

the work puts it into a contemporary rather than historical
context.

627 Braider, Donald. GEORGE BELLOWS AND THE ASH CAN SCHOOL OF
PAINTING. New York: Doubleday & Co., 1971. 153 p. 32 illus.

Good detailed biography. Concerned with Bellows' political
beliefs and various aspects of his works rather than with sty-
listic analysis. Attempts to explain why his popularity was
greater than that of the others in the group.

628 Eggers, George W. GEORGE BELLOWS. American Artist Series. New
York: Whitney Museum of American Art, 1931. 60 p. 20 illus. Bibliog.
pp. 16-18.

Typical Whitney publication of the 1930s. Brief biography
and generally good stylistic analysis.

629 Morgan, Charles H. GEORGE BELLOWS: PAINTER OF AMERICA. New
York: Reynal and Co., 1965. 381 p. 29 illus., 4 in color.

The most clearly written biography of the painter. More detail
than the other Bellows biographies, but indifferent illustrations.

BENTON, THOMAS HART 1889-1975

630 Baigell, Matthew. THOMAS HART BENTON. New York: Harry N.
Abrams, 1974. 278 p. Illus., some in color. Bibliog. pp. 269-73.

A full-length biography that discusses the evolution of the
painter's style and subjects, from his training and early ab-
stract work to his well-known expressionistic figure painting.
Draws upon Benton's own writings and his pungent statements
on art and the art world.

631 Benton, Thomas Hart. AN AMERICAN IN ART: A PROFESSIONAL AND
TECHNICAL AUTOBIOGRAPHY. Lawrence: University of Kansas Press,
1969. 197 p. 68 illus.

Contains two basic sections and the illustrations. The first is
autobiography directed to Benton's artistic development, train-
ing, and stylistic modifications. The second deals with the
American regionalist movement, its values and followers.

632 _____. AN ARTIST IN AMERICA. 3rd ed. Columbia: University of
Missouri Press, 1968. xxii, 369 p. 76 illus.

An autobiography that tells us much about the places to which
Benton travelled in the West and South, and about his develop-
ment as an artist.

633 _____. A THOMAS HART BENTON MISCELLANY. Edited by Matthew Baigell. Lawrence: University of Kansas Press, 1971. 156 p.

A collection of writings by the artist divided into four sections: to 1917; the 1920s; the 1930s to 1940s; and after. The painter comments on the role of art subject matter in art, art and social struggle, and museums.

634 Fath, Creekmore, ed. THE LITHOGRAPHS OF THOMAS HART BENTON. Austin: University of Texas Press, 1969. xii, 195 p. 80 illus.

A complete catalog with full-page illustrations, edition information, and information about the subject when available. Draws on letters and recollections of Benton himself.

BERMAN, EUGENE 1899-1972

635 Berman, Eugene. THE GRAPHIC WORK OF EUGENE BERMAN. New York: Clarkson N. Potter, 1971. xviii, 332 p. Illus.

Essentially a large picture book of the drawings and sketches of the artist. Contains a brief biographical foreword by Russell Lynes and a preface and notes by the artist. Hundreds of black and white illustrations.

636 Levy, Julien. EUGENE BERMAN. New York: American Studio Books, 1947. 80 p. Illus.

q 159.1
B51L

A brief text provides some biographical information and an evaluation of Berman's work as compared with that of the great draughtsmen of the past.

BIERSTADT, ALBERT 1830-1902

637 Hendricks, Gordon. A. BIERSTADT. Fort Worth, Tex.: Amon Carter Museum, 1972. 48 p. 20 illus., some in color.

759.13
B58zh

An important exhibition catalog and the only one to provide a large selection of the paintings. The text is scholarly but easy to read.

638 _____. ALBERT BIERSTADT: PAINTER OF THE AMERICAN WEST. New York: Harry N. Abrams, 1974. 352 p. 424 illus., 63 in color.

759.13
B58zh

A full scale biography and detailed study of the painter's ouvre. In addition to the many hundreds of illustrations, we are provided with a checklist of all Bierstadt's paintings in American public collections. Much information on the artist never before available in published form.

BINGHAM, GEORGE CALEB 1811-79

639 Bloch, E. Maurice. GEORGE CALEB BINGHAM. 2 vols. Berkeley: University of California Press, 1967. Vol. 1, xiv, 337 p.; vol. 2, xi, 238 p. 197 illus., some in color. Bibliog. vol. 1, pp. 263-97.

759.13
B61b

This major monograph is more concerned than any other with the painter's style and the sources of his art. Many of the drawings and studies for major paintings are reproduced.

640 Christ-Janer, Albert. GEORGE CALEB BINGHAM OF MISSOURI: THE STORY OF AN ARTIST. New York: Dodd, Mead and Co., 1940. xx, 171 p. 14 plates, 7 in color. 56 drawings. Bibliog. pp. 146-48.

The correspondence between Bingham and Rollins is a basic source for this biography. A thoughtful discussion of style and influences make it a good general reference for Bingham. Much of the biographical material is based on the early research by Rusk.

641 Larkin, Lew. BINGHAM: FIGHTING ARTIST. Kansas City, Mo.: Burton Publishing Co., 1954. 358 p. 13 illus.

Journalistic biography.

642 McDermott, John Francis. GEORGE CALEB BINGHAM: RIVER PORTRAIT-IST. Norman: University of Oklahoma Press, 1959. xxviii, 451 p. 79 paintings. 112 sketches.

A biography with strongly expressed opinions. Sketchbooks are reproduced and a valuable comprehensive checklist of works is included.

643 Museum of Modern Art. GEORGE CALEB BINGHAM: THE MISSOURI ARTIST, 1811-1879. January 30-March 7, 1935. New York: W. E. Rudge's Sons, 1935. 20 p. 11 black and white illus.

Careful and solid biography in this exhibition catalog. Bingham is placed squarely in the artistic mainstream of his day as the passion for both genre and detailed compositions is defined.

644 National Collection of Fine Arts. GEORGE CALEB BINGHAM: 1811-1879. October 19, 1967 to January 1, 1968. Washington, D.C.: Smithsonian Institution Press, 1967. 99 p. Bibliog. pp. 97-99.

59.13
B61s

Good general biography by Bloch and discussion of style, with the text being based on Bloch's own earlier work. Provides a condensed version of the longer study for the interested layman.

645 Rusk, Fern Helen. GEORGE CALEB BINGHAM: THE MISSOURI ARTIST. Jefferson City, Mo.: The Hugh Stephens Co., 1917. 135 p. 49 black and white illus.

This pioneering study was originally a master's thesis on Bingham. Much of the material later to become standard in the biographies is first found here. Greater attention is paid to his political career than has been paid by later writers.

646 Westervelt, Robert F. "The Whig Painter of Missouri." THE AMERICAN ART JOURNAL 2 (Spring 1970): 46-53.

Asserts that "The County Election of 1852" is actually a reflection of Bingham's Whig political bias and general distrust of universal manhood suffrage. The author calls attention to social criticism in the manner in which the various genre subscenes are presented.

BIRCH, THOMAS 1779-1851

647 Gerdts, William H. THOMAS BIRCH, 1779-1851: PAINTINGS AND DRAWINGS; WITH A SELECTION OF MINIATURES BY HIS FATHER, WILLIAM RUSSELL BIRCH, 1755-1834, AND A GROUP OF PAINTINGS BY OTHER ARTISTS OF THE PHILADELPHIA MARITIME TRADITION. Philadelphia: Maritime Museum, 1966. 64 p. Illus.

An exhibition catalog which concentrates on the maritime work of Birch, an important pioneer in American topographical painting. The portraits of both father and son are reproduced.

BLACKBURN, JOSEPH 1700?-81

648 Bayley, Frank William. FIVE COLONIAL ARTISTS OF NEW ENGLAND: JOSEPH BADGER, JOSEPH BLACKBURN, JOHN SINGLETON COPLEY, ROBERT FEKE, JOHN SMIBERT.

For main entry, see 622.

649 Morgan, John Hill, and Foote, Henry Wilder. AN EXTENSION OF LAWRENCE PARK'S DESCRIPTIVE LIST OF THE WORKS OF JOSEPH BLACKBURN. Reprinted from the proceedings of the American Antiquarian Society for April 1936. Worcester, Mass.: American Antiquarian Society, 1937. 69 p.

Documents the works of Blackburn which appeared on the scene or were rediscovered since Park prepared his study.

650 Park, Lawrence. JOSEPH BLACKBURN: A COLONIAL PORTRAIT PAINTER. Worcester, Mass.: American Antiquarian Society, 1923. 62 p. 5 plates.

Contains a descriptive list of the works and some information about this influential immigrant painter; also describes the link between Smibert and Copley in Boston.

BLAKELOCK, RALPH ALBERT 1847-1919

651 Daingerfield, Elliott. RALPH ALBERT BLAKELOCK. New York: Frederic
F. Sherman, 1914. 40 p. 10 illus.

A short and sympathetic biography by a friend of the painter.

652 University of California. Santa Barbara Art Galleries. THE ENIGMA
OF RALPH A. BLAKELOCK. January 7-February 2, 1969. Santa
Barbara: University of California Press, 1969. 86 p. 52 illus., 4 in
color.

The text of this exhibition catalog was written by David Geb-
hard. He concentrates on Blakelock as a personal romantic
and explores his place in the history of nineteenth-century
American painting.

653 Whitney Museum of American Art. RALPH ALBERT BLAKELOCK:
CENTENARY EXHIBITION. April 22-May 22, 1947. Text by Lloyd
Goodrich. New York: 1947. 55 p. 16 black and white illus.

A well-researched biography and a perceptive discussion of
the visionary works of the painter. Nature as a source of
his romantic imagery is illustrated.

654 Young, J.W. BLAKELOCK: HIS ART AND HIS FAMILY. Chicago:
Young's Art Galleries, 1916. 54 p. 19 illus.

This catalog, written during the artist's lifetime, contains a
short biography, a catalog of paintings, and some anecdotal
material. The author was trying to maintain the prices of the
aging and ill artist.

BLASHFIELD, EDWIN HOWLAND 1848-1936

655 Blashfield, Edwin H. MURAL PAINTING IN AMERICA. New York:
Charles Scribner's Sons, 1913. xvi, 312 p. 49 illus.

A greatly expanded version of the lectures delivered at the
Art Institute of Chicago in March 1912. The views express
the feelings that motivated the artist's own work in the mural
genre.

656 Cortissoz, Royal. THE WORKS OF E.H. BLASHFIELD. New York:
Charles Scribner's Sons, 1937. 16 p. 75 illus.

The introduction provides a brief analysis of the artist's im-
portance as a mural painter. His intellectual processes are
put forth as being of the greatest importance to his work.
The author supports his strong academic proclivity.

BLOOM, HYMAN 1913-

657 O'Doherty, Brian. "Hyman Bloom." ART IN AMERICA 49 (1961): 45-47.

> Discusses Bloom's background and training, and speculates on the reasons for his mystical subject treatments in rich, and to the author, materialistic choice of color. His method of painting and secretive attitude about his work are pointed out.

658 Wight, Frederick S. HYMAN BLOOM. Boston: Institute of Contemporary Art, 1954. 115 p. Illus., some in color.

> Illustrates the expressionistic distortions of form so evident in the work of this abstract painter. Shows the importance of both paint and color in heightening the effects of both his secular and religious subjects.

BLUME, PETER 1906-

659 Currier Gallery of Art. PETER BLUME, PAINTINGS AND DRAWINGS IN RETROSPECT: 1925-1964. Catalogue introduction by Charles Buckley. Manchester, N.H.: 1964. 48 p. 23 illus.

> Discusses the evolution of his style from the early years through the time of writing. Concerned with the artist's method of preparing and completing a painting, and with the manner in which he organizes his sources, this is an excellent guide to his surrealistic output.

660 Getlein, Frank. PETER BLUME. New York: Kennedy Galleries, 1968. Unpaged. Illus., some in color.

> The catalog of an exhibition of Blume's works over a period of almost forty years and an analysis of his hard-edged surrealist forms and their place in the American scene.

BLYTHE, DAVID GILMOUR 1815-65

661 Abrahams, Evelyn. "David G. Blythe." ANTIQUES 27 (May 1935): 180-83.

> The first modern attempt to reintroduce the genre work of Blythe to the general public. Emphasis on his broad anecdotalism.

662 Miller, Dorothy [C.]. THE LIFE AND WORK OF DAVID G. BLYTHE. Pittsburgh: University of Pittsburgh Press, 1950. 142 p. Illus. Bibliog. pp. 135-38.

The only serious study of this unusual genre painter. The author attempts to piece together facts to fill in the obvious gaps in his history. Questions of style are not pursued as carefully as is the biographical material. Contains a checklist of paintings and two carvings.

BODMER, KARL [CHARLES] 1809-93

663 Ewers, John Canfield. EARLY WHITE INFLUENCE UPON PLAINS IN-
DIAN PAINTING: GEORGE CATLIN AND CARL BODMER AMONG
THE MANDAN INDIANS. Smithsonian Publication 4201, 1957. Reprint.
Seattle: Shorey Book Store, 1971. 11 p. Illus. Bibliog. p. 11.

Good descriptions of the style of both artists and methods of
working to prepare their canvases.

664 Josleyn Art Museum. CATLIN, BODMER, MILLER: ARTIST EXPLORERS
OF THE 1830's. Omaha, Neb.: 1963. 35 p. Illus., some in color.

The text discusses the subjects of the paintings and drawings
of the two painters who travelled through the plains to record
the life of the Indian tribes.

BOLOTOWSKY, ILYA 1907-

665 Breeskin, Adelyn, and Svendsen, Louise Averill. ILYA BOLOTOWSKY.
New York: Solomon R. Guggenheim Museum, 1974. 133 p. 94 illus.,
some in color. Bibliog. pp. 132-33.

Catalog of the first major contemporary exhibition of the work
of an early nonobjective painter whose ideas predate some of
the minimalists.

666 Campbell, Lawrence. "Squaring the Circle and Vice-Versa." ART NEWS
68 (February 1970): 38-44.

Discusses the artist's work as being in the tradition of Mondrian
and the other European figures early concerned with nonobjec-
tive form since the start of World War II.

BROOKS, JAMES 1906-

667 Hunter, Sam. JAMES BROOKS. New York: Frederick A. Praeger,
1963. 55 p. Illus., some in color.

The catalog of an exhibition of the WPA social realist who,
over the years, has developed a particularly flowing, lyrical ab-
stract style. Discusses his relationship to mainstream developments.

BRUCE, PATRICK HENRY 1880-1937

668 Baur, John I.H. "Rediscovery: Patrick Henry Bruce." ART IN AMERI-
CA 48 (Fall 1960): 87.

> Though this is a short article, it provides basic biographical
> information with a brief outline of Bruce's different phases
> and his relationship to the pioneer developments in nonobjec-
> tive art.

669 Wolf, T.M. "Patrick Henry Bruce." MARSYAS 15 (1970-71): 73-85.

> Solid scholarship in biography and stylistic analysis. Must be
> considered the standard work on Bruce. Includes bibliographi-
> cal material and illustrates the geometric paintings of his ma-
> ture style.

BRUSH, GEORGE DE FOREST 1855-1941

670 Bowditch, Nancy Douglas. GEORGE DE FOREST BRUSH. Peterborough,
N.H.: Noone House, 1970. xxi, 257 p. 49 illus. Bibliog. pp. 243-
45.

> Reminiscences and recollections by the painter's oldest daughter,
> herself one of his pupils. Provides a good and obviously
> sympathetic biography, but no critical evaluation of his work.

BURCHFIELD, CHARLES 1893-1967

671 Baur, John I.H. CHARLES BURCHFIELD. New York: Macmillan Pub-
lishing Co., for the Whitney Museum of American Art, 1956. 86 p.
75 illus. 5 in color. Bibliog. pp. 82-85.

> Catalog of a major retrospective of the work of the painter.
> The biographical data include an interpretation of psychologi-
> cal factors influencing the paintings. Discusses the evolution
> of his style and his view of nature.

672 Burchfield, Charles. CHARLES BURCHFIELD. Edited by Edith H. Jones.
New York: Frederick A. Praeger, 1968. 15 p. 57 illus.

> Has autobiographical sketch only; the rest consists of un-
> numbered pages of illustrations.

673 Downes, Rackstraw. "Watercolorist for All Seasons." ART NEWS 69
(May 1970): 54-57.

> Little biographical information but provides authoritative
> analysis of Burchfield's style and influence, with good

illustrations of the points made about the changes in his work.

674 Fleishman, Lawrence A. BURCHFIELD. New York: Kennedy Galleries, 1974. 32 p. 9 black and white illus., 16 in color.

This catalog gives brief biographical information, comments on Burchfield's place in American modern art, and provides good reproductions of the paintings.

675 Krasne, B. "Charles Burchfield—Profile." ART DIGEST 27 (December 15, 1952): 9.

An excellent source for biographical information and some analysis of the forces that molded Burchfield's distinctive personal landscape style.

676 Munson-Williams-Proctor Institute. CHARLES BURCHFIELD: CATALOG OF PAINTINGS IN PUBLIC AND PRIVATE COLLECTIONS. Utica, N.Y.: 1970. 367 p. 250 illus., 17 in color. Bibliog. pp. 333-44.

Good introduction, catalog of complete works. Has analytical information on each period and detailed catalog entries. A major biographical and bibliographical source.

677 Richardson, Edgar Preston. "Charles Burchfield." MAGAZINE OF ART 37 (October 1944): 208-12.

Concentrates on the influence of the surrounding countryside evident in the artist's work.

678 Watson, E.W. "Charles Burchfield, 1942." AMERICAN ARTIST 6 (May 1942): 4-11.

Biographical information, commentary on technique, and stylistic analysis in an introduction for the layman.

CASSATT, MARY 1844-1926

Mary Cassatt spent her entire creative life in Europe and her work is so identifiable with that of the major French impressionists that it appears excessively chauvinistic to include her in a study on American architecture and art. However, as she is an American by birth, and one of our few outstanding women painters of the nineteenth century, two major studies are cited.

679 Breeskin, Adelyn. MARY CASSATT: A CATALOGUE RAISONNE OF THE OILS, PASTELS, WATERCOLORS AND DRAWINGS. Washington, D.C.: Smithsonian Institution Press, 1970. 322 p. Illus., some in color. Bibliog. pp. 307-9.

A detailed presentation of the extensive ouvre of the artist.

Documentation on physical properties, provenance, and litera-
ture on the known works.

759.1
C345

680 Sweet, Frederick [A.]. MISS MARY CASSATT: IMPRESSIONIST FROM
 PENNSYLVANIA. Norman: University of Oklahoma Press, 1966.
 242 p. Illus., some in color. Bibliog. pp. 222–28.

 This volume concentrates most heavily on biographical matters
 and uses her letters as the primary source of information. Doc-
 uments her relationship with her impressionist friends, especially
 Degas.

CATLIN, GEORGE 1796–1872

681 Catlin, George. EPISODES FROM LIFE AMONG THE INDIANS, AND
 LAST RAMBLES. Edited by Marvin C. Ross. Norman: University of Okla-
 homa Press, 1959. xxv, 357 p. 152 plates. Bibliog. pp. 343–44.

 This material complements that which is found in Catlin's
 LETTERS AND NOTES and other earlier writings that serve
 as a guide to his travels among the Indians of the United
 States.

682 _____. LETTERS AND NOTES ON THE MANNERS, CUSTOMS AND
 CONDITIONS OF THE NORTH AMERICAN INDIANS. 2 vols. London.
 1841. Reprint. New York: Dover, 1973. Vol. 1, xxiii, 264 p.;
 vol. 2, xvi, 266 p.

 Catlin's biographers describe the difficulty encountered in get-
 ting this work published. It records the results of years of
 travel among the various Indian tribes.

683 De Voto, Bernard Augustine. ACROSS THE WIDE MISSOURI. Boston:
 Houghton Mifflin Co., 1947. 483 p. 81 illus. Bibliog. pp. 457–68.

 This volume is actually a history of the fur trade. It is illus-
 trated with works of Catlin, Bodmer, and Miller.

684 Ewers, John Canfield. EARLY WHITE INFLUENCE UPON PLAINS INDI-
 AN PAINTING: GEORGE CATLIN AND CARL BODMER AMONG THE
 MANDAN INDIANS.

 For main entry, see 663.

685 _____. "George Catlin, Painter of Indians of the West." In SMITH-
 SONIAN INSTITUTION ANNUAL REPORT, pp. 483–583. Washington,
 D.C.: Smithsonian Institution Press, 1956. Bibliog. pp. 527–28. 35 illus.

 A study of Catlin's Indian painting as documentary evidence
 concerning the tribes and their customs. Careful analysis of
 his fidelity to sources.

686 Haberly, Lloyd. PURSUIT OF THE HORIZON: A LIFE OF GEORGE
CATLIN, PAINTER AND RECORDER OF THE AMERICAN INDIAN. New
York: Macmillan Publishing Co., 1948. xiii, 239 p. 17 illus.

A journalistic biography that reads like an historical novel.

687 Halpin, Marjorie. CATLIN'S INDIAN GALLERY: THE CATLIN PAINT-
INGS IN THE U.S. NATIONAL MUSEUM. Washington, D.C.: National
Gallery of Art, 1965. 32 p. 21 illus.

In this catalog, we are presented with Catlin's words (from
diaries or letters) placed next to illustrations from his hand.

688 McCracken, Harold. GEORGE CATLIN AND THE OLD FRONTIER.
New York: Dial Press, 1959. 216 p. 129 black and white illus., 36
in color. Bibliog. pp. 212-14.

An easy to read biography which provides the reader with the
feeling that he genuinely knows the artist. No new material
has been uncovered. Documents the importance of Catlin's
work for our understanding of Indian life in the plains.

689 Plate, Robert. PALETTE AND TOMAHAWK: THE STORY OF GEORGE
CATLIN. New York: David McKay Co., 1962. 248 p. 30 drawings.
Bibliog. pp. 247-48.

690 Roehm, Marjorie (Catlin), ed. THE LETTERS OF GEORGE CATLIN AND
HIS FAMILY: A CHRONICLE OF THE AMERICAN WEST. Berkeley:
University of California Press, 1966. xxi, 463 p.

The letters are edited so as to provide a feeling of continuity
in the life and travels of the artist. A genealogical table
and the diary of Francis Catlin are included.

CHASE, WILLIAM MERRITT 1849-1916

691 John Herran Art Institute. CHASE CENTENNIAL EXHIBITION. Novem-
ber 1-December 11, 1949. Indianapolis: 1949. 83 p. 26 illus.

An exhibition catalog that includes a brief biography and a
well-documented catalog.

692 Phillips, Duncan. "William M. Chase." AMERICAN MAGAZINE OF
ART 8 (December 1916): 45-50.

This was the obituary of the artist presented by a major col-
lector of American art and a perceptive critic of painting.
Chase is praised as a teacher.

693 Roof, Katherine Metcalf. THE LIFE AND ART OF WILLIAM MERRITT

CHASE. New York: Charles Scribner's Sons, 1917. xiii, 252 p.
35 illus.

Written soon after Chase's death, this biography was a tribute
to the painter. It is a personal and chatty work, with anec-
dotes and direct quotations.

694 Santa Barbara Art Gallery. FIRST WEST COAST RETROSPECTIVE EXAM-
INATION OF PAINTINGS BY WILLIAM MERRITT CHASE. Santa Barbara:
University of California, 1964. Unpaged. 45 illus., 2 in color. Bibliog.

The catalog of a major exhibition which discusses Chase's
style and influence on his students. It includes biographical
recollections by the author.

CHURCH, FREDERIC EDWIN 1826-1900

695 Huntington, David C. THE LANDSCAPES OF FREDERIC EDWIN CHURCH:
VISION OF AN AMERICAN ERA. New York: George Braziller, 1966.
xii, 210 p. 116 illus., 8 in color. Bibliographical references included
in 'notes' pp. 197-204.

A discussion of Church's travels throughout the world in search
of the dramatic and sublime effects of nature. He is shown
to be one of the last of the great romantics. His relationship
to his teacher Cole and the development of his museum-home
Olana are discussed.

696 Lindquist-Cock, Elizabeth. "Frederic Church's Stereographic Vision."
ART IN AMERICA 61 (September-October 1973): 70-75.

Documents Church's use of the photograph and stereograph
in capturing the subject matter for his large panoramic can-
vases.

697 National Collection of Fine Arts. FREDERIC CHURCH. Washington,
D.C.: Smithsonian Institution Press, 1966. 85 p. 17 illus., 1 in color.

This exhibition catalog contains an extended chronology and
a detailed annotated catalog of his works, and illustrates his
well-known landscapes.

COLE, THOMAS 1801-48

698 Albany Institute of History and Art. THOMAS COLE. November 1-
December 15, 1941. Albany: 1941. 13 p.

A short but useful catalog. Discusses Cole's views on nature
in relationship to his painting, and to landscape in America.

699 Baltimore Museum of Art. ANNUAL II: STUDIES ON THOMAS COLE: AN AMERICAN ROMANTICIST. Baltimore: 1967. 129 p. 50 illus.

> This volume contains essays by various authors. Of particular uniqueness is the inclusion of the correspondence between Cole and Robert Gilmore, Jr., in the appendices of letters and notebook items. Also noteworthy is the in-depth study of "A Wind Scene," and its place in Cole's work and development.

700 Bryant, William Cullen. THOMAS COLE, A FUNERAL ORATION DE-LIVERED BEFORE THE NATIONAL ACADEMY OF DESIGN. New York: National Academy of Design, May 4, 1848. Unpaged.

> Bryant was a very close friend of the painter and shared with him similar views about nature. His oration is, as can be expected, a hymn to nature as well as a eulogy for his friend.

701 Memorial Art Gallery. THOMAS COLE. Introduction and catalog by Howard S. Merritt. Rochester, N.Y.: University of Rochester, 1969. 120 p. 58 black and white illus., 8 in color. Bibliog. pp. 115-17.

> The introduction is helpful and informative to the general exhibition viewer. In addition there is a detailed and annotated catalog. Includes the landscapes and some literary paintings.

702 Noble, Louis L. THE LIFE AND WORKS OF THOMAS COLE. 1853. Reprint. Edited by Elliot C. Vesell. Cambridge, Mass.: Harvard University Press, Belknap Press, 1964. xxix, 324 p. 24 illus.

> This is a fairly thorough and convincing life by a close friend and religious advisor of the painter. More emphasis on the life and character of Cole than on his paintings.

703 Wadsworth Atheneum. THOMAS COLE 1801-1848: ONE HUNDRED YEARS LATER. November 12, 1948-January 1, 1949. Hartford, Conn.: 1948. viii, 60 p. xxi plates. Bibliog. pp. 59-60.

> Brief but good biography and an astute critical evaluation.

COPLEY, JOHN SINGLETON 1737-1815

704 Amory, Martha Bobcock. THE DOMESTIC AND ARTISTIC LIFE OF JOHN SINGLETON COPLEY, R.A. 1882. Reprint. New York: Da Capo Press, 1970. xii, 478 p.

> Written by a descendant of the painter, the work is important only as a source of anecdotal material not available from earlier sources.

705 Bayley, Frank W[illiam]. THE LIFE AND WORKS OF JOHN SINGLETON COPLEY. Boston: Taylor Press, 1915. 285 p.

Both the biography and many of the artistic judgements are based on the 1873 book by Perkins (see 711). Places Copley in the forefront of American realist painting.

706 Copley, John Singleton. LETTERS AND PAPERS OF JOHN SINGLETON COPLEY AND HENRY PELHAM, 1739–1776. 1914. Reprint. New York: Da Capo Press, 1970. xxii, 384 p. Illus.

Contains important correspondence between Copley and Benjamin West in England. Sheds light on the early career of Copley.

707 Flexner, James Thomas. JOHN SINGLETON COPLEY. Boston: Houghton Mifflin Co., 1948. xv, 139 p. 37 plates.

Contains very good historical insights as to the reasons for the artist's actions and departure for England. Particularly good for the general and young adult reader.

708 Frankenstein, Alfred. THE WORLD OF COPLEY: 1738–1815. New York: Time-Life Books, 1970. 192 p. Illus., some in color. Bibliog. p. 185.

A general cultural history of the era, with Copley as the focal point. As it is written for the nonspecialist, stylistic criticism is kept to a minimum.

709 Museum of Fine Arts. Boston. JOHN SINGLETON COPLEY 1738–1815; A LOAN EXHIBITION OF PAINTINGS, PASTELS, MINIATURES AND DRAWINGS, IN COMMEMORATION OF THE TWO HUNDRETH ANNIVERSARY OF THE ARTIST'S BIRTH. February 1–March 15, 1936. Boston: 1938. 34 p.

A useful early exhibition catalog.

710 Parker, Barbara Melville, and Wheeler, Anne Bolling. JOHN SINGLETON COPLEY: AMERICAN PORTRAITS IN OIL, PASTEL AND MINIATURE. Boston: Museum of Fine Arts, 1938. ix, 284 p. 130 plates.

The catalog of a major exhibition of Copley's work on the two-hundredth anniversary of his birth. Discusses his importance as a recorder of colonial society and proves him to have been extremely successful before his departure for England.

711 Perkins, Augustus Thorndike. A SKETCH OF THE LIFE AND A LIST OF THE WORKS OF JOHN SINGLETON COPLEY. Boston: privately printed, 1873. viii, 144 p.

Valuable as a source of information regarding the collectors of Copley paintings in the nineteenth century and their where-

abouts at the time of the exhibition. An early but reliable
biographical source, much used by later writers on Copley.

712 Prown, Jules David. JOHN SINGLETON COPLEY. 2 vols. Cambridge,
Mass.: Harvard University Press, 1966. xxiv, 491 p. 678 illus. Bib-
liog. pp. 201-2 and 463-72.

Volume 1 covers the American years and volume 2 the English.
This is a meticulous biography and accounting of the work
done on both sides of the Atlantic. It was published for the
National Gallery. Contains an extensive bibliography and
remains the definitive study.

COX, KENYON 1856-1919

713 Cox, Kenyon. ARTIST AND PUBLIC. New York: Charles Scribner's
Sons, 1914. xii, 228 p. 32 illus.

A series of essays on both American and European art, culled
from various sources. Gives particularly strong support to
realist-classical sculpture and academic painting. Cox stood
in high critical esteem early in the century.

714 _____. ART MUSEUMS AND SCHOOLS: FOUR LECTURES DELIVERED
AT THE METROPOLITAN MUSEUM OF ART. New York: Charles Scrib-
ber's Sons, 1913. 144 p.

Cox's lecture is entitled "Museums of Art and Teachers of
Art." He reacted adversely to the general level of academic
art instruction in his time.

CROPSEY, JASPER F. 1823-1900

715 Bermingham, Peter. JASPER F. CROPSEY, 1823-1900: A RETROSPEC-
TIVE VIEW OF AMERICA'S PAINTER OF AUTUMN. College Park:
University of Maryland, 1968. 65 p. Illus. Bibliog. pp. 64-65.

An exhibition catalog which features Cropsey's oils and water-
colors and contrasts them to the work of Cole, Johnson, and
Inness. The documentation of the work is very useful.

716 National Collection of Fine Arts. JASPER F. CROPSEY 1823-1900.
Essay by William S. Talbot. Washington, D.C.: Smithsonian Institution
Press, 1970. 144 p. Illus., some in color. Bibliog. pp. 111-12.

The major study of an important landscape painter of the
second half of the nineteenth century. Well-documented,
exhaustive scholarship for both the careful biography and
perceptive analysis of the sources and visual importance of
his style.

CURRY, JOHN STEUART 1897-1946

717 Baigell, Matthew. "The Relevance of Curry's Paintings of Black Freedom." KANSAS QUARTERLY 2 (Fall 1970): 19-29.

> Discusses the painter's paintings such as "The Fugitive," and others that were early comments on the themes of social and .political justice.

718 Bruening, Margaret. "In the Studio of John Steuart Curry." STUDIO 113 (1937): 326-30.

> An early examination of the painter's work, his sources, and the general concerns in his midwest subject matter of small town and farm life.

719 Craven, Thomas. "John Steuart Curry." SCRIBNER'S MAGAZINE 103 (January 1938): 40.

> Discusses the influence of the French masters of the early nineteenth century and of Rubens on the painter, as he discovered their work in Paris. Coloristic and textural effects are attributed to the Baroque painter almost directly.

720 Schmeckebier, Laurence Eli. JOHN STEUART CURRY'S PAGEANT OF AMERICA. New York: America's Artists Group, 1943. xviii, 363 p. 341 illus., 8 in color.

> The major source of biographical information on the painter, from his background and early years as an illustrator to his training in Paris and career in New York and Wisconsin.

DAVIES, ARTHUR BOWEN 1862-1928

721 Burroughs, Bryson. "Arthur B. Davies." THE ARTS 15 (February 1929): 79-93.

> Written soon after the death of the artist, it serves as an obituary and summing up of his importance rather than as a thorough stylistic analysis.

722 Cortissoz, Royal. ARTHUR B. DAVIES. American Artists Series. New York: William Edwin Rudge, 1931. 76 p. 20 illus. Bibliog. pp. 16-19.

> This is one of the volumes in the American Artists Series of the Whitney Museum of American Art. The author pays tribute to the artist without providing much specific criticism. A valuable checklist of paintings is included, and the bibliography is an important guide to Davies' status during his lifetime.

723 Davies, Arthur B. THE ETCHINGS AND LITHOGRAPHS OF ARTHUR B.
 DAVIES. Compiled and with an introduction by Frederic Newlin Price.
 New York: M. Kennerley, 1929. 23 p. 205 plates.

> This is a fairly comprehensive view of the graphic work of
> an artist known today primarily for his evocative romantic
> paintings.

724 "The Early and Later Work of Arthur B. Davies." ART IN AMERICA 6
 (October 1918): 195-99.

> A discussion of the evocative early work compared with that
> influenced by modernism in the 1910s.

725 Eliot, Clark. "Arthur B. Davies." ART IN AMERICA 17 (August 1929):
 234-42.

> A tribute to the recently deceased painter, the main concern
> is the development of his personal style and its moody evoca-
> tive quality.

726 Metropolitan Museum of Art. CATALOGUE OF A MEMORIAL EXHIBI-
 TION OF THE WORKS OF ARTHUR B. DAVIES. February 17-March
 30, 1930. New York: 1930. xviii, 36 p. 124 illus.

> More useful for the wide range of illustrations than for the
> brief text, it brought together the greatest number of Davies
> pieces in a retrospective exhibition and provided an attempt
> at a chronology.

727 Phillips Collection. ARTHUR B. DAVIES: ESSAYS ON THE MAN AND
 HIS ART. Cambridge, Mass.: The Riverside Press, 1924. xiii, 77 p.
 39 black and white plates.

> This book was sponsored by the Phillips Collection and con-
> tains essays by Duncan Phillips, Frank J. Mather, Jr., and
> others. It contains a biographical sketch, criticism, etc.

DAVIS, GENE 1920-

728 GENE DAVIS: AN EXHIBITION. San Francisco: San Francisco Museum
 of Art; Washington, D.C.: Washington Gallery of Modern Art, 1968.
 23 p. Illus., some in color. Bibliog. pp. 17-18.

> The catalog of an exhibition of this artist known for his paint-
> ings of solid stripes of color, varying in thickness and color.
> Places him in the vanguard of hard-edged abstractionists of
> of the 1960s.

DAVIS, STUART 1894-1964

729 Blesh, Rudi. STUART DAVIS. New York: Grove Press, 1960. 64 p. Illus., some in color.

> An introduction to the life and work of a pioneer American abstractionist. Strongest in area of biographical anecdote and the artist's approach to his work.

730 Davis, Stuart. "What Abstract Art Means to Me." MUSEUM OF MODERN ART BULLETIN 18 (1951): 14-15.

> A personal view of the relationship of the artist to his work and of how the subjects of his paintings relate to his creative process and the final work.

731 Goosen, E.C. STUART DAVIS. New York: George Braziller, 1959. 129 p. Illus., some in color. Bibliog. pp. 121-23.

> Traces the life and work of the painter, from his early years with the Ashcan School, his contact with European modernism in the Armory show, and his travels abroad. The formation of and changes in his style over a period of almost fifty years are discussed.

732 Gorky, Ashile. "Stuart Davis." CREATIVE ART 9 (September 1931): 212-17.

> Short but adequate discussion of Davis' cubist influences, through the eyes of a fellow abstractionist. The article contains seven illustrations of Davis' work.

733 Kelder, Diane. STUART DAVIS. New York: Frederick A. Praeger, 1971. 212 p. 52 black and white illus., 10 in color. Bibliog. pp. 201-9.

> Provides the reader with biographical material by the artist, and critical evaluation by his contemporaries. Davis' articulate presentations of his own ideas on art are also included.

734 National Collection of Fine Arts. STUART DAVIS MEMORIAL EXHIBITION. Essay by H.H. Arnason. Washington, D.C.: Smithsonian Institution Press, 1965. 98 p. Illus. Bibliog. pp. 90-96.

> The catalog of the major retrospective exhibition organized at the time of the artist's death. His thoughts on art, the origins of his style, and his growth to be a major force in American painting are chronicled.

735 Sweeney, James Johnson. STUART DAVIS. New York: Museum of Modern Art, 1945. 40 p. 24 illus., 3 in color. Bibliog. pp. 37-40.

> The catalog of a major retrospective of Davis' oils and

watercolors. Biographical data, from the early Ashcan School days through the oils of World War II, are provided. Contains an extensive checklist of works.

DE KOONING, WILLEM 1904-.

736 Hess, Thomas B. WILLEM DE KOONING. American Artists Series. New York: George Braziller, 1959. 128 p._ Illus., some in color. Bibliog. pp. 119-24.

An introduction to the work of this painter of abstract form. Popular American Artists Series format includes general references to the style of the maturing De Kooning, many illustrations, a chronology, and a useful bibliography.

737 Kozloff, Max. "The Impact of De Kooning." ARTS YEARBOOK 7 (1964): 77-88.

Discusses the role of De Kooning as a senior surviving early abstract artist of the action painter tradition. Comments on his use of thick paint and distorted images.

738 Museum of Modern Art. WILLEM DE KOONING. Exhibition and catalogue essay by Thomas B. Hess. New York: 1968. 170 p. Illus., 16 in color. Bibliog. pp. 151-59.

The major monograph on the artist and his work. His painting is examined in regard to sources and stylistic development, and his contribution to abstract painting's arrival is discussed. Well-researched bibliography, and a variety of seldom reproduced illustrations.

739 Rosenberg, Harold. DE KOONING. New York: Abrams, 1974. 294 p. 208 illus., some in color. Bibliog. pp. 287-94.

Based on research and conversations with the artist. This is an authoritative study and is particularly valuable for examining the painter's own thoughts on both the art scene and his relationship with his peers.

DEMUTH, CHARLES 1883-1935

740 Davidson, A[braham]. "Charles Demuth: Stylistic Development." RHODE ISLAND SCHOOL OF DESIGN BULLETIN 54 (March 1968): 9-16.

Shows his development into a precisionist and the interest in force lines that were to play an increasing influence in his work.

741 Faison, S. Lane. "Fact and Art in Charles Demuth's Architectural Pictures." MAGAZINE OF THE ARTS 43 (April 1950): 122-28. Illus.

> Author's point is that Demuth's architectural paintings are closer to recording the truth than to showing Cubist influences. Thirteen illustrations of his buildings and cityscapes.

742 Farnham, Emily. CHARLES DEMUTH: BEHIND A LAUGHING MASK. Norman: University of Oklahoma Press, 1971. 238 p. Illus., some in color. Bibliog. pp. 212-20.

> This somewhat awkwardly organized biography provides a genuine sense of the cultural milieu in which the artist lived and created. Contains the most thorough account of his life and work. Discusses both his architectural and plant-life subjects.

743 Lee, Sherman. "Illustrations and Landscape Watercolors of Charles Demuth." ART QUARTERLY 5 (1941): 158-75.

> Good biographical information used to develop an understanding of Demuth's intellectual approach.

744 Murrell, William. CHARLES DEMUTH. American Artists Series. New York: William Edwin Rudge, 1931. 54 p. Illus.

> One of the many short monographs on American artists produced for the American Artists Series. A solid evaluation of Demuth's style.

745 Museum of Modern Art. CHARLES DEMUTH. Catalogue essay by Andrew C. Ritchie. New York: 1950. 96 p. Illus. Bibliog. pp. 93-96.

> Major exhibition catalog on Demuth. Catalogs 158 oils and watercolors, with many illustrated. A brief biography and a discussion of still-lifes, landscapes, and vaudeville scenes are included. Some information on his book illustrations and decorative work.

DICKINSON, EDWIN 1891-

746 Goodrich, Lloyd. EDWIN DICKINSON. New York: Whitney Museum of American Art, 1965. 55 p. Illus., some in color. Bibliog. pp. 53-54.

> Catalog of an exhibition of the surrealistically influenced paintings whose forms seem so clearly drawn yet melt into other objects so mysteriously.

DINE, JAMES 1935-

747 Gordon, John. JIM DINE. New York: Frederick A. Praeger, 1970. 102 p. 59 illus., 4 in color. Bibliog. 98-101.

> The catalog of a Whitney exhibition that includes a short statement by the artist, a list of his major exhibitions, and a catalog of 126 works.

DOUGHTY, THOMAS 1793-1856

748 Doughty, Howard N. "Thomas Doughty: Painter of Scenery." APPA-LACHIA 13 (June 1947): 307-9.

> A basic statement about the artist's interest in nature painting and his fidelity to his sources. His painstaking concern for detail is noted, as well as the fact that he influenced subsequent landscapists.

749 Goodyear, Frank H., Jr. THOMAS DOUGHTY, 1793-1856: AN AMERICAN PIONEER IN LANDSCAPE PAINTING. Philadelphia: Pennsylvania Academy of Fine Arts, 1973. 47 black and white illus., 5 in color.

> The major source of information on the life and works of this important forerunner of the mature Hudson River School. Discusses his moves to Boston and his travel in France and comments upon the changes in his style. The catalog includes illustrations of many paintings not usually seen.

DOVE, ARTHUR G. 1880-1946

750 McCausland, Elizabeth. "Dove; Man and Painter." PARNASSUS 9 (December 1937): 3-6.

> Provides biographical information and briefly discusses Dove's abstract canvases.

751 Phillips, Duncan. "Arthur Dove 1880-1946." MAGAZINE OF THE ARTS 40 (May 1947): 192-97.

> Good biographical information as well as analysis of influences that helped create the painter's soft biomorphic abstract forms.

752 Ray, Man. "Arthur Dove, the Boldest Pioneer." THE ARTS 32 (September 1958): 34-41. Illus.

> Biographical information based on Frederick Wight's monograph of Dove, adequate analysis of his painting, with twelve illustrations.

753 Rylander, Dorothy. ARTHUR G. DOVE: THE YEARS OF COLLAGE. College Park: University of Maryland Press, 1967. 51 p. Illus.

> This catalog contrasts the paintings of Dove to his lesser-known collages and those of several of the other artists of his time. Careful stylistic analysis and minimal biographical data.

754 Solomon, Alan [R.]. ARTHUR G. DOVE 1880–1946: A RETROSPECTIVE EXHIBITION. Ithaca, N.Y.: Cornell University Press, 1954. 40 p. Illus. Bibliog. pp. 37–40.

> An exhibition in honor of this Cornell graduate. Surveys his work, concentrating on his soft-edged abstractions.

755 Wight, Frederick S. ARTHUR G. DOVE. Berkeley and Los Angeles: University of California Press, 1958. 98 p. Illus., some in color. Bibliog. pp. 91–92.

> A major exhibition catalog which clearly documents the life and work of this early American abstractionist, from the early years in Paris to his death.

DOW, ARTHUR WESLEY 1857-1922

756 Cox, George J. "The Horizon of A.W. Dow." INTERNATIONAL STUDIO (June 1923): 186–93.

> This illustrated eulogy to Dow discusses the life and work of this important figure in the history of American art education and teacher of Georgia O'Keeffe. His ideas of freedom in art are expressed.

DUBOIS, GUY PENE 1884-1958

757 Cortissoz, Royal. GUY PENE DUBOIS. New York: Whitney Museum of American Art, 1931. 56 p. Illus. Bibliog. pp. 12–15.

> Typical early Whitney artist monograph. An introduction to the silent figures of the painter with a selection of illustrations.

DUNCANSON, ROBERT S. 1821-72

758 Cincinnati Art Museum. ROBERT S. DUNCANSON: CENTENNIAL EXHIBITION. Cincinnati: 1972. 42 p. Illus., some in color. Bibliog. pp. 16–17.

> The catalog of an exhibition of the paintings of the black

American landscape painter who lived and worked in the Cincinnati vicinity in the manner of the Hudson River School.

DUNLAP, WILLIAM 1766-1839

759 Addison Gallery of American Art. WILLIAM DUNLAP, PAINTER AND CRITIC: REFLECTIONS ON AMERICAN PAINTING OF A CENTURY AGO. Andover, Mass.: 1939. 46 p. Illus. Bibliog. p. 46.

This is a catalog of an exhibition of works based on information contained in Dunlap's "History," primarily his portraits.

760 Dunlap, William. DIARY OF WILLIAM DUNLAP. 3 vol. New York: Printed for the New York Historical Society, 1930. 964 p. Indexed. 39 black and white illus.

This includes the eleven located diaries covering his activities for most of the years from late 1786 through the end of 1834. A source of fascinating information about the life of this enterprising painter and playwright. Details his experiences painting the politicians in Washington.

DURAND, ASHER BROWN 1796-1886

761 Durand, John. THE LIFE AND TIMES OF A.B. DURAND. 1894. Reprint. New York: Da Capo Press, 1970. ix, 232 p. 15 illus.

This volume is a naturally sympathetic biography by the artist's son. He provides many solid observations about the artistic milieu of the day. Much of the material is based on letters and contemporary documents.

762 Grolier Club. CATALOGUE OF THE ENGRAVED WORK OF ASHER B. DURAND EXHIBITED AT THE GROLIER CLUB. April MDCCXCV. New York: The Grolier Club, 1895. 103 p.

Contains a short biography and analysis of the work that is more flattering than objective. Valuable for including information about many engravings unknown to the public today.

DURRIE, GEORGE HENRY 1820-63

763 Coudrey, Bartlett. GEORGE HENRY DURRIE, 1820-1863: CONNECTICUT PAINTER OF AMERICAN LIFE. Hartford, Conn.: Wadsworth Atheneum, 1947. 50 p. 43 illus. Bibliog. p. 19.

The catalog of an exhibition of the works of this painter of the American scene. His peopled landscapes border on genre

and serve as the basis for many prints.

DUVENECK, FRANK 1848-1919

764 Chapellier Gallery, N.Y. FRANK DUVENECK. New York: 1972. 96 p. Illus., some in color. Bibliog. pp. 94–96.

> The catalog of an important recent exhibition of this nineteenth-century painter, whose fame was unrivalled but who lived to find himself in obscurity.

765 Cincinnati Art Museum. EXHIBITION OF THE WORK OF FRANK DU-VENECK. May 23–June 21, 1936. Cincinnati: 1936. 82 p. 42 illus. Bibliog. pp. 16–18.

> This early catalog contains a detailed but unresearched check-list of known or attributed paintings by the artist to be used with caution. Provides fertile ground for further research.

766 Duveneck, Josephine Whitney. FRANK DUVENECK: PAINTER, TEACHER. San Francisco: John Howell Books, 1970. 169 p. 53 black and white illus., 4 in color. Bibliog. pp. 167–69.

> This biography was written by Duveneck's daughter-in-law, based on letters, family papers, sketchbooks, and personal recollections. Her judgments appear unbiased.

767 Heermann, Norbert. FRANK DUVENECK. Boston and New York: Houghton Mifflin Co., 1918. ix, 84 p. 23 illus.

> A chatty anecdotal biography that discusses the paintings within the context of the artistic milieu and the artist's personality.

768 Young, Mahonri Sharp. "The Two Worlds of Frank Duveneck." THE AMERICAN ART JOURNAL 1 (Spring 1969): 42–103.

> Contrasts his years in Boston and Cincinnati with his active, happy student years in Munich and other European experiences. Describes his relationship with Chase and the German students.

EAKINS, THOMAS COWPERTHWAITE 1844-1916

769 Goodrich, Lloyd. THOMAS EAKINS: HIS LIFE AND WORK. New York: Whitney Museum of American Art, 1933. Reprint. New York: AMS Press, 1970. 225 p. 72 plates. Bibliog. pp. 217–20.

> This has been one of the best critical biographies and has remained a standard work on Eakins since the original printing.

The author explores the painter's place in the history of American art as well as in his own time.

770 _____. THOMAS EAKINS: RETROSPECTIVE EXHIBITION. September 22-November 21, 1970. New York: Whitney Museum of American Art, 1970. 72 p. 33 black and white illus., 8 in color.

This is an updated but condensed version of Goodrich's 1933 Eakins monograph. It is more concerned with artistic analysis than are the works of other biographers.

771 Hendricks, Gordon. THE LIFE AND WORK OF THOMAS EAKINS. New York: Grossman Publishers, 1974. 384 p. 500 black and white illus., 55 in color.

Thorough study of Eakins' life based on contemporary documents. A valuable part of the book is the carefully researched checklist of works in public collections. Includes paintings, sculpture, and photographs.

772 _____. THE PHOTOGRAPHS OF THOMAS EAKINS. New York: Grossman Publishers, 1972. viii, 214 p. 291 illus.

This carefully researched and documented work contains a complete catalog of all known or attributed photographs by Eakins.

773 Hoopes, Donelson F. EAKINS WATERCOLORS. New York: Watson-Guptill, 1971. 87 p. Illus., 32 in color. Bibliog. p. 9.

The major source of information and illustrations on the painter's work in this medium.

774 McKinney, Roland Joseph. THOMAS EAKINS. New York: Crown Publishers, 1942. viii, 112 p. 72 illus., 8 in color. Bibliog. pp. 23-29.

This book has a good selection of works illustrated. The short essay is based on the earlier writings of Goodrich and other researchers.

775 Metropolitan Museum of Art. THOMAS EAKINS MEMORIAL EXHIBITION. November 5-December 3, 1917. New York: 1917. viii, 17 p. 60 illus.

As with the Pennsylvania Academy catalog, this too is valuable as a guide to the Eakins collectors during his lifetime.

776 Pennsylvania Academy of the Fine Arts. MEMORIAL EXHIBITION OF THE WORKS OF THE LATE THOMAS EAKINS. December 23, 1917-January 13, 1918. Philadelphia: J.B. Lippincott Co., 1917. 99 p. 72 illus.

This exhibition catalog contains a brief eulogizing essay but is more valuable for pinpointing owners of known Eakins at the time of his death.

777 Schendler, Sylvan. EAKINS. Boston: Little, Brown and Co., 1967. xix, 300 p. 158 illus.

The author has his own perspective on the cultural climate of Philadelphia and the consequent isolation of Eakins. He draws freely on Goodrich and confines his discussion and illustrations to the paintings.

EARL, RALPH 1751-1801

778 Goodrich, Laurence B. RALPH EARL, RECORDER FOR AN ERA. Albany: State University of New York Press, 1967. vii, 96 p. 41 black and white illus.

Places Earl in terms of his portraits of prominent New Englanders, rather than seeing him in broader context as a West-trained painter. Biographical information.

779 Sawitzky, William. CONNECTICUT PORTRAITS BY RALPH EARL, 1751-1881. August 1-October 15, 1935. Gallery of Fine Arts, Yale University. New Haven: Yale University Press, 1935. 30 p.

Limited to Earl's work in his home state, it includes work of both the periods before and after his stay in England during the Revolutionary War.

780 Whitney Museum of American Art. RALPH EARL, 1751-1801. October 16-November 21, 1945. Text by William Sawitzky. New York: L.F. White Co., 1947. 30 p. 16 illus.

The text is based on the author's earlier researches on Earl. Several additional works were uncovered by the date of the exhibition.

EASTMAN, SETH 1808-75

781 Bushnell, David I., Jr. SETH EASTMAN: THE MASTER PAINTER OF THE NORTH AMERICAN INDIAN. Washington, D.C.: Smithsonian Institution Press, 1932. 18 p. 15 illus.

The author traces Eastman's career through his military experience and uses army records as his primary source of documentation.

782　McDermott, John Francis. SETH EASTMAN: PICTORIAL HISTORIAN OF
THE INDIAN. Norman: University of Oklahoma Press, 1961. x, 271 p.
116 illus., 8 in color. Bibliog. pp. 256–61.

> This volume contains a detailed biography and attempts to
> date the various works through knowledge of the painter's
> chronology; where he was and when as a guide to the works.

783　_____ . SETH EASTMAN'S MISSISSIPPI. Urbana: University of Illinois
Press, 1973. ix, 149 p. 79 illus.

> The text contains detailed discussion of the important sketch-
> book that records Eastman's observations during his years in
> and around Fort Snelling.

784　Marion Koogler McNay Art Institute. A SETH EASTMAN SKETCHBOOK,
1848–1849. Austin: University of Texas Press, 1961. xxvi, 68 plates.

> The entire sketchbook of landscape drawings is reproduced as
> a complement to the usual concentration on the artist's Indian
> work. Lois Bunkhalter wrote the introduction.

EDMONDS, FRANCIS WILLIAM 1806-63

785　Mann, Maybelle. "Francis William Edmonds: Mammon and Art." THE
AMERICAN ART JOURNAL 2 (Fall 1970): 92–106.

> A reintroduction to the work of a once popular genre painter
> who was an active figure in the art world and was, at the
> same time, a banker and financier. Clear discussion of both
> his life and art.

EICHHOLTZ, JACOB 1776-1842

786　Beal, Rebecca J. JACOB EICHHOLTZ, 1776–1842: PORTRAIT PAINTER
OF PENNSYLVANIA. Philadelphia: The Historical Society of Pennsyl-
vania, 1969. xxxiii, 402 p. 256 illus., 4 in color. Bibliog. pp. 393–
402.

> A massive study of this important early portraitist. Catalogs
> and describes almost 1,000 paintings attributed to his hand.
> Biographical introduction and a detailed bibliography.

EILSHEMIUS, LOUIS MICHEL 1864-1941

787　Karstrom, Paul. THE ROMANTICISM OF EILSHEMIUS. New York:
Dannenberg Galleries, 1973. 20 p. Illus.

The only recent catalog of his romantic personal paintings.
The illustrations show us several seldom seen paintings.

788 Schack, William. AND HE SAT AMONG THE ASHES. New York:
American Artists Group, 1939. 303 p. Illus.

The full-length biography of the complex personality who
painted and wrote poetry. Documents his European periods as
well as his years in America.

EVERGOOD, PHILIP 1901-73

789 Baur, John I.H. PHILIP EVERGOOD. New York: Whitney Museum
of American Art, 1960. 125 p. Illus., some in color. Bibliog. pp. 122-
23.

A retrospective exhibition surveying his painting to the date
of writing. Shows the wide variety of his subjects, landscape,
genre, and figure painting, and his sources in such artists as
El Greco and the German Expressionists.

790 Whitney Museum of American Art. TWENTY YEARS OF PAINTING BY
PHILIP EVERGOOD. Catalogue essay by Oliver [W.] Larkin. New York:
1946. Unpaged. Illus.

Concentrates on the paintings of the thirties and forties which
show the painter's concern for the human condition. Lively,
folk art realism combined with mildly stated social statements.

FEININGER, LYONEL 1871-1956

791 Feininger, T. Lux. LYONEL FEININGER: CITY AT THE EDGE OF THE
WORLD. New York: Frederick A. Praeger, 1965. 124 p. 74 black
and white illus., 15 in color.

Lyonel Feininger's son describes his father's art and its rele-
vance to trivial objects his father made.

792 Hess, Hans. LYONEL FEININGER. New York: Harry N. Abrams,
1961. 355 p. Illus., 30 in color. Bibliog. pp. 319-40.

The major full-scale study of Feininger's life and work.
Describes his Bauhaus years and his influence on both German
and American art. Contains an oeuvre catalog by Julia
Feininger.

793 Miller, Dorothy [C.], ed. LYONEL FEININGER - MARSDEN HARTLEY.
1944. Reprint. New York: Arno Press, 1966. Bibliog. pp. 51-52.

Catalog of the joint exhibition of the important abstract
painters in the United States. Discusses style and influences
on their work.

794 Werner, Alfred. "Lyonel Feininger 1871-1956." AMERICAN ARTIST 24
(October 1960): 26-31.

Once past attacks on abstract-expressionists, the author pre-
sents excellent biographical information and artistic influences
upon Feininger. Contains eleven illustrations from different
periods in his career.

FEKE, ROBERT c.1705-c.1752

795 Bayley, Frank William. FIVE COLONIAL ARTISTS OF NEW ENGLAND:
JOSEPH BADGER, JOSEPH BLACKBURN, JOHN SINGLETON COPLEY,
ROBERT FEKE, JOHN SMIBERT.

For main entry, see 622.

796 Foote, Henry Wilder. ROBERT FEKE, COLONIAL PORTRAIT PAINTER.
Cambridge, Mass.: Harvard University Press, 1930. Reprint. New York:
Da Capo Press, 1970. 223 p. 38 illus.

The author brings Feke to the attention of a broader public
with this book. Presents the outlines of the little-known life
and provides a point of departure for future research.

797 Poland, William Carey. ROBERT FEKE, THE EARLY NEWPORT PORTRAIT
PAINTER AND THE BEGINNINGS OF COLONIAL PAINTING. Provi-
dence: Rhode Island Historical Society, 1907. 26 p.

The brief essay identifies Feke as one of the early domestically
trained painters of America.

798 Whitney Museum of American Art. ROBERT FEKE. October 8-October
30, 1946. Essay by Lloyd Goodrich. New York: 1946. 36 p.
13 illus.

The biographical information is based on the research of Foote,
but the style in the portraits is analyzed with an eye to sources
and influence in colonial painting.

FOSTER, JOHN 1648-81

799 Green, Samuel Abbott. JOHN FOSTER: THE EARLIEST AMERICAN
ENGRAVER AND THE FIRST BOSTON PAINTER. Boston: Massachusetts
Historical Society, 1909. 149 p. 2 portraits. 2 maps.

The major source of information about the elusive early American craftsman, known for his few portraits and a woodcut or two.

FRANCIS, SAM 1923-

800 Albright-Knox Art Gallery. SAM FRANCIS: PAINTINGS, 1947-1972. Buffalo, N.Y.: 1972. 152 p. Illus., some in color. Bibliog. pp. 140-41.

> Catalog of a major retrospective exhibition of the colorful abstract paintings. Biographical information and stylistic analysis in several essays contained in this work.

FRANKENTHALER, HELEN 1928-

801 Goosen, E.C. HELEN FRANKENTHALER. New York: Whitney Museum of American Art, 1969. 72 p. Illus., some in color. Bibliog. pp. 68-72.

> The catalog of the major exhibition of her paintings in which her style and relation to other abstractionists are discussed. Surveys her entire career and serves as a point of departure for study of her work.

802 Rose, Barbara. FRANKENTHALER. New York: Harry N. Abrams, 1972. 272 p. 205 illus., some in color. Bibliog. pp. 265-72.

> The most carefully documented study of this lyrical abstractionist and the largest number of illustrations of her work ever shown in one place. Biographical and complete bibliographical information.

FULLER, GEORGE 1822-84

803 Metropolitan Museum of Art. CENTENNIAL EXHIBITION OF THE WORKS OF GEORGE FULLER. April 19-May 20, 1923. New York: 1923. xix, 8 p. 34 illus.

> This volume is a useful catalog of Fuller's painting and contains the names of his patrons.

804 Millet, Josiah B., ed. GEORGE FULLER: HIS LIFE AND WORK. Boston and New York: Houghton, Mifflin and Co., 1886. v, 93 p. 8 illus.

> The sketch of Fuller's life is based, for the most part, on letters and other primary sources. The other contributions

are tributes by friends of the artist.

805 Van Renssaelaer, Mariana [Griswold]. SIX PORTRAITS: DELLA ROBBIA, CORREGGIO, BLAKE, COROT, GEORGE FULLER, WINSLOW HOMER. Boston and New York: Houghton, Mifflin and Co., 1894. 277 p.

> The Fuller biography is quite informal and chatty. It is accurate factually but adulatory in tone. The choice of the six tells us something about aesthetic judgements of the time, as the author was a major critic of the day.

GIFFORD, SANFORD ROBINSON 1823-80

806 Cikovsky, Nicolai, Jr. SANFORD ROBINSON GIFFORD (1823-1900). Austin: University Art Museum of the University of Texas, 1970. Illus.

> The landscape paintings of Gifford are examined in light of realist landscape painting in nineteenth-century America.

GLACKENS, WILLIAM 1870-1938

807 DuBois, Guy Pene. WILLIAM GLACKENS. American Artists Series. New York: Whitney Museum of American Art, 1931. 57 p. 20 illus. Bibliog. pp. 15-16.

> Brief biographical summary typical of the Whitney series of the 1930s on American art.

808 Flint, Janet A. DRAWINGS BY WILLIAM GLACKENS. Washington, D.C.: National Collection of Fine Arts, Smithsonian Institution Press, 1972. 58 illus.

> A well-illustrated introduction to the seldom seen drawings of this important portrayer of the passing scene.

809 Glackens, Ira. WILLIAM GLACKENS AND THE ASH CAN GROUP: THE EMERGENCE OF REALISM IN AMERICAN ART. New York: Crown Publishers, 1957. 267 p. 77 illus., some in color.

> Written by Glackens' son. Deals with the artist's life from a personal point of view. Contains correspondence and concerns itself with aspects of his life rather than style, etc.

810 WILLIAM GLACKENS IN RETROSPECT. St. Louis, Mo.: City Art Museum, 1966. Unpaged. Illus., 3 in color.

> A short essay on the meaning of Glackens' art and a survey of his works from the early Ashcan days to his late pastel-like works.

GORKY, ARSHILE 1905-48

811 Levy, Julien. ARSHILE GORKY. New York: Harry N. Abrams, 1966. 235 p. Illus., 40 in color. Bibliog. pp. 235-38.

A substantial monograph on the painter with many excellent illustrations. Details the biography and the artistic searching and development of this pioneer in American abstraction.

812 Mooradian, Karlen. AN EXHIBITION OF DRAWINGS BY ARSHILE GORKY. Oklahoma City: Oklahoma Art Center, 1973. 36 p. 40 illus.

As Gorky's mature painting style is so heavily indebted to drawing, this exhibition catalog should be of special interest to anyone studying his technique.

813 Rosenberg, Harold. ARSHILE GORKY: THE MAN, THE TIME, THE IDEA. New York: Grove Press, 1962. 144 p. Bibliog. pp. 138-43.

A general study of the painter's life and style. His roots in surrealism are documented and his relationship with the New York school is explained.

814 Schwabacher, Ethel. ARSHILE GORKY. New York: Whitney Museum of American Art, 1957. 159 p. Illus., some in color. Bibliog. pp. 153-55.

An anecdotal biography written by a student and friend of the painter. Explains his relationships with other American abstract artists.

GOTTLIEB, ADOLPH 1903-74

815 ADOLPH GOTTLIEB: PAINTINGS, 1959-71. London: Marlborough, 1971. 66 p. Illus., some in color.

A brief introductory statement on the evolution of the artist's mature work followed by a good selection of color illustrations of his work.

816 Doty, Robert, and Waldman, Diane. ADOLPH GOTTLIEB. New York: Frederick A. Praeger, 1968. 121 p. Illus., some in color. Bibliog. pp. 116-21.

A biographical and bibliographical study of the painter and his paintings. Well-documented entries in this important exhibition catalog. Discusses the development of his painterly abstractions.

GRAVES, MORRIS 1910-

817 Wight, Frederick S. MORRIS GRAVES. Berkeley and Los Angeles: University of California Press, 1956. 64 p. Illus., some in color. Bibliog. pp. 61-62.

A brief study of one of the most mystical romanticists of the twentieth century. Essays discuss his view of nature, his poetry, and the influence of the Orient on his work. The only major source on the artist.

GREENWOOD, JOHN 1727-92

818 Burroughs, Alan. JOHN GREENWOOD IN AMERICA, 1745-1752. Andover, Mass.: Addison Gallery of American Art, Phillips Academy, 1943. 87 p. 43 illus.

Greenwood spent a considerable part of his career in the Indies and in Holland. This volume centers upon the American experience as a portrait painter, however, and discusses his relationship to eighteenth-century painters in New England.

GROPPER, WILLIAM 1897-

819 Freunlich, August L. WILLIAM GROPPER: RETROSPECTIVE. Los Angeles: Ward Ritchie Press, 1968. 128 p. Illus., some in color. Bibliog. p. 33.

The only real monograph on this painter of social criticism. General text provides biographical information and comments on the themes in his work.

GUSTON, PHILIP 1913-

820 Ashton, Dore. PHILIP GUSTON. New York: Grove Press, 1960. 63 p. Illus., 12 in color.

An introduction to the paintings of an important member of the New York school of abstract expressionism. Some biographical information is provided.

821 Solomon R. Guggenheim Museum. PHILIP GUSTON. Catalog essay by H.H. Arnason. New York: 1962. 125 p. Illus. Bibliog. pp. 120-25.

This catalog of a major exhibition of the artist traces his development from his early expressionistic figure paintings through his mature abstract expressionist style of the early sixties.

HARDING, CHESTER 1792-1866

822 White, Margaret E. A SKETCH OF CHESTER HARDING, ARTIST, DRAWN
BY HIS OWN HAND. NEW EDITION WITH ANNOTATIONS BY HIS
GRANDSON, W.P.G. HARDING. 1890. Reprint. New York: Da
Capo Press, 1970. xxiv, 204 p. 30 illus.

A candid and interesting account of the life of the artist, an
important portraitist in his own time. He speaks of his per-
sonal experiences and his sitters.

HARNETT, WILLIAM MICHAEL 1850-92

823 Frankenstein, Alfred. AFTER THE HUNT: WILLIAM HARNETT AND
OTHER AMERICAN STILL LIFE PAINTERS, 1870-1900. Rev. ed.
Berkeley and Los Angeles: University of California Press, 1969. xix,
200 p. 136 illus.

Although other painters are discussed in this work, Harnett
occupied such an important role in the development of the
genre and the author has made such significant researches
into his oeuvre, that this must be considered the definitive
work on the painter. (See also 522.)

HARTLEY, MARSDEN 1877-1943

824 Ames, (Polly) Scribner. MARSDEN HARTLEY IN MAINE (THROUGH
THE EYES OF KATIE YOUNG OF COREA, MAINE). Foreword by
Elizabeth McCausland and afterword by Carl Sprinchorn. Edited by Richard
Sprague. Orono: University of Maine Press, 1971. 36 p. Illus.

Old friends discuss loneliness and last works of Marsden
Hartley.

825 Eldredge, Charles. MARSDEN HARTLEY: LITHOGRAPHS AND RELATED
WORKS. Lawrence: University of Kansas Museum of Art, 1972.
27 illus.

Explores the lesser-known graphic output and compares it to
his expressionistic painting.

826 Gallup, D. "Weaving a Pattern: Marsden Hartley and Gertrude Stein."
MAGAZINE OF THE ARTS 41 (November 1948): 256-61.

Excellent account of the milieu of Paris and its influence
upon Hartley. Includes illustrations.

827 Hartley, Marsden. ADVENTURES IN THE ARTS. New York: Boni and
Liveright, 1921. Reprint. New York: Hacker Art Books, 1972. 254 p.

Illus.

Autobiographical account of an early abstractionist who visited France and was influenced by Cezanne, worked with Stieglitz, and retreated into isolation.

828 Jaffe, Irma B. "Cubist Elements in the Painting of Marsden Hartley: A Phenomenological View." ART INTERNATIONAL 14 (April 1970): 33-38.

Good analysis of the cubist tendencies evident in Hartley's paintings. Includes bibliographical references.

829 McCausland, Elizabeth. MARSDEN HARTLEY. Minneapolis: University of Minnesota Press, 1952. 80 p. Illus. Bibliog. pp. 76-80.

The major monograph on the painter presents biographical data and explores the influences on his maturing style.

HASELTINE, WILLIAM STANLEY 1835-1900

830 Plowden, Helen Haseltine. WILLIAM STANLEY HASELTINE: SEA AND LANDSCAPE PAINTER. London: F. Muller, 1947. 210 p. 31 illus.

Nostalgic but factual biography by the painter's daughter. Lacks documentation.

HASSAM, CHILDE 1859-1935

831 Adams, Adeline. CHILDE HASSAM. New York: American Academy of Arts and Letters, 1938. 144 p. 29 illus.

A very offhand and journalistic biography. Offers some idea of the life and life-style of the man but not an analysis of his work.

832 Griffith, Fuller. THE LITHOGRAPHS OF CHILDE HASSAM: A CATALOG. Washington, D.C.: Smithsonian Institution Press, 1962. vii, 66 p. 45 illus.

The only work that provides any discussion of Hassam's efforts with this medium. A strong artistic analysis as well as a complete catalog is provided.

833 Hassam, Childe. CATALOGUE OF THE ETCHINGS AND DRY-POINTS OF CHILDE HASSAM. New York: Charles Scribner's Sons, 1925. xiv, 96 p. Illus.

Presents the graphic work of the artist usually thought of in terms of his impressionist paintings. The introduction by the critic Royal Cortissoz is more complimentary than meaningful.

834 Steadman, William E. CHILDE HASSAM, 1859–1935. Tucson: University of Arizona Museum of Art, 1972. 150 p. 93 illus., 19 in color. Bibliog. p. 150.

> Detailed catalog and most complete source of illustrations of his work as a whole.

HEADE, MARTIN JOHNSON 1819-1904

835 McIntyre, Robert George. MARTIN JOHNSON HEADE, 1819–1904. New York: Pantheon Press, 1948. 71 p. 24 illus.

> Brief biography followed by a poetic appreciation of his art. Contains a useful checklist of works and owners.

836 Stebbins, Theodore E., Jr. MARTIN JOHNSON HEADE. New York: Whitney Museum of American Art, 1969. Unpaged. Illus. Bibliog.

> Catalog of an exhibition of portraits, landscapes, and the exotic floral paintings of his travels.

HEALY, GEORGE PETER ALEXANDER 1813-94

837 Bigot, Marie (Healy). LIFE OF GEORGE P.A. HEALY. N.p., n.d. 105 p.

> Written by Healy's daughter, this is not a critical biography. It includes a good selection of his letters and quotations from journals.

838 DeMare, Marie. GEORGE PETER ALEXANDER HEALY, AMERICAN ARTIST: AN INTIMATE CHRONICLE OF THE NINETEENTH CENTURY. New York: David McKay Co., 1954. xvi, 304 p. 51 illus.

> Reads like an historical novel. Some quotations from letters. Discusses the artist's relationship with his sitters.

839 Healy, George Peter Alexander. REMINISCENCES OF A PORTRAIT PAINTER. 1894. Reprint. New York: Da Capo Press, 1970. ix, 221 p. 21 illus.

> Chatty autobiography used as the base for all succeeding biographies of the artist.

HENRI, ROBERT 1865-1929

840 Grafly, Dorothy. "Robert Henri." AMERICAN MAGAZINE OF ART 22 (June 1931): 435–45.

3 rd
Floor

A biography which also discusses the painter's work and the sources and development of his style.

841 Henderson, Rose. "Robert Henri." AMERICAN MAGAZINE OF ART 21 (January 1930): 3-12.

Henri's biography. Includes his philosophies of painting and life, written as a memorial.

842 Henri, Robert. THE ART SPIRIT. Philadelphia: J. B. Lippincott Co., 1923. 292 p.

Presents the basic text of Henri's important ideas on art and art education and includes notes on his classes by a former student.

843 Homer, William Innes. ROBERT HENRI AND HIS CIRCLE. New York: Cornell University Press, 1969. 308 p. 70 illus., 4 in color. Bibliog. pp. 291-300.

The most important study of Henri to date. It is concerned with his reputation as a teacher and leader, and presents his landscapes and other seldom seen work as well as the often reproduced portraits. Draws upon the work of Henri's sister-in-law.

844 Metropolitan Museum of Art. CATALOGUE OF A MEMORIAL EXHIBITION OF THE WORK OF ROBERT HENRI. New York: 1931. 19 p. 78 illus.

A brief memorial essay by his most famous student, John Sloan. Important for the illustrations.

845 Read, Helen Appleton. ROBERT HENRI. American Artists Series. New York: William Edwin Rudge, 1931. 58 p. Illus. Bibliog. pp. 16-18.

Published for the Whitney series on American artists. As with others in the series, the information provided will satisfy the casual museum visitor who wants to know a little bit about the life of the artist.

846 Watson, Forbes. "Robert Henri." ARTS 16 (September 1929): 3-6.

An obituary appreciation by a noted contemporary critic that concentrates on Henri's achievements as a teacher.

847 Yarrow, William, and Bouche, Louis. ROBERT HENRI: HIS LIFE AND WORKS. New York: Boni and Liveright, 1921. 115 p. 40 illus.

Good yet brief biography of Henri and the era in which he lived, written in his lifetime.

Individual Painters

HENRY, EDWARD LAWSON 1841-1919

848 McCausland, Elizabeth. THE LIFE AND WORK OF EDWARD LAWSON
HENRY, N.A., 1849-1919. Albany: University of the State of New
York Press, 1945. 381 p. 162 illus. Bibliog. pp. 363-67.

> Solid biography and well-documented catalog of work in all
> media. The bibliography lists every conceivable mention of
> the painter.

HICKS, EDWARD 1780-1849

849 Carnegie Institute. SELF-TAUGHT PENNSYLVANIA ARTISTS: HICKS,
KANE, PIPPIN. October 21-December 4, 1966. Pittsburgh: Carnegie
Institute Press, 1966. 121 p. Illus.

> Good short essay and many illustrations of Hicks' variations
> on major themes.

850 Ford, Alice [Elizabeth]. EDWARD HICKS: PAINTER OF THE PEACEABLE
KINGDOM. Philadelphia: University of Pennsylvania Press, 1952. xvi,
161 p. 37 black and white illus., 4 in color. Bibliog. pp. 123-26.

> Short biography with descriptive catalog. Provides contrasting
> illustrations of the variations on the religious themes he repeated
> so many times.

851 Hicks, Edward. MEMOIRS OF THE LIFE AND RELIGIOUS LABORS OF
EDWARD HICKS. Philadelphia: Merrihew & Thompson, 1851. 365 p.

> An autobiography more concerned with religion than description
> of his life as an artist. Does, however, provide insights into
> the reasons for his paintings.

HOFMANN, HANS 1880-1966

852 Hofmann, Hans. SEARCH FOR THE REAL, AND OTHER ESSAYS. Edited
by Sara T. Weeks and Bartlett H. Hayes, Jr. Cambridge, Mass.: The
M.I.T. Press, 1967. 73 p. Illus.

> Includes a brief biographical sketch of this European painter
> who, through both his art school and the force of his work,
> influenced so many American painters.

853 Hunter, Sam. HANS HOFMANN. Rev. ed. New York: Harry N.
Abrams, 1964. 227 p. Illus., 50 in color.

> A stylistic analysis by the author and essays by Hofmann on
> his thoughts about art are supported by a large series of excel-
> lent plates documenting the developments in his style of painting.

759.13
171 5

854 Seitz, William C. HANS HOFMANN. New York: Doubleday & Co.,
1963. 64 p. Illus., 8 in color. Bibliog. pp. 60–62.

The catalog of a major retrospective exhibition which includes
a consideration of his importance as a major abstractionist,
discussion of his technique, and documentation on the various
paintings.

HOMER, WINSLOW 1836-1910

855 Beam, Phillip C. WINSLOW HOMER AT PROUT'S NECK. Boston: Little,
Brown and Co., 1966. xxii, 282 p. 92 illus. Bibliog. pp. 265–72.

Biography that concentrates on the years after Homer's return
from England in 1882. Sensitive discussion of his style in his
later years. Detailed bibliography.

856 Cox, Kenyon. WINSLOW HOMER. New York: Frederic F. Sherman,
1914. 66 p. 12 illus.

Contains aesthetic judgments by an influential artist and critic
written a few years after the painter's death. A good foil
to the general biographies but difficult to obtain.

857 Downes, William Howe. THE LIFE AND WORKS OF WINSLOW HOMER.
Boston: Houghton Mifflin Co., 1911. 306 p. Illus. Bibliog. pp. 291–95.

Because of the careful recent research on the painter, this is
quite outdated. However, it does provide documentation for
much material later used by other biographers, and the author
had the advantage of being known to the artist.

858 Flexner, James Thomas, and the editors of Time–Life Books. THE WORLD
OF WINSLOW HOMER, 1836–1910. Time–Life Library of Art. New York:
Time–Life Books, 1966. 190 p. Illus., some in color. Bibliog. p. 185.

Typical of the other works in this series. We are presented
with a view of the artist's life and work in a social and
cultural context.

859 Gardner, Albert Ten Eyck. WINSLOW HOMER: AN AMERICAN ARTIST,
HIS WORLD AND HIS WORK. New York: Clarkson N. Potter, 1961.
xiv, 263 p. Profusely illustrated, 36 in color. Bibliog. p. 235.

A carefully developed integrated study of both the life and
works of the artist. It utilizes direct quotations of critics con-
temporary with Homer, and investigates the possible influences
on his stylistic development.

860 Goodrich, Lloyd. THE GRAPHIC ART OF WINSLOW HOMER. New

York: Museum of Graphic Art, 1968. 136 p. 103 illus.

The only volume on Homer to concentrate on his graphics.
The works are well documented, and clear illustrations are
provided.

861 . WINSLOW HOMER. New York: Whitney Museum of American
Art, 1944. 241 p. 63 plates. Bibliog. pp. 234-36.

The standard biography and the source for Goodrich's later
writings on Homer.

862 . WINSLOW HOMER. New York: Whitney Museum of American
Art, 1973. 143 p. 96 illus., some in color.

The text is based on the author's own 1959 abridgment of the
1944 volume. The size, range, and quality of both the works
and illustrations makes this a key exhibition catalog.

863 Gould, Jean. WINSLOW HOMER. New York: Dodd, Mead and Co.,
1962. 305 p. 46 illus.

Easy to read general text obviously based on earlier writings.
Various "conversations" are recorded but lack documentation.

864 Hannaway, Patti. WINSLOW HOMER IN THE TROPICS. Richmond, Va.:
Westover, 1973. 296 p. 70 color plates, some black and white illus.
Bibliog. pp. 283-86.

Valuable for the many color reproductions of the works of the
Caribbean vacations. The bibliography is useful.

865 Hoopes, Donelson F. WINSLOW HOMER WATERCOLORS. New York:
Watson-Guptill, 1969. 87 p. 32 color illus. Bibliog. p. 10.

A brief introduction to Homer's handling of the medium and
some comparisons to his oils. Primarily valuable for the
quality of the illustrations.

866 Museum of Modern Art. WINSLOW HOMER, ALBERT P. RYDER, THOMAS
EAKINS. New York: 1930. 31 p. Illus.

A pioneering exhibition on the "Big 3" of American nineteenth-
century painting. Many later works provide greater information.

867 University of Arizona Art Gallery. YANKEE PAINTER: WINSLOW
HOMER. October 11-December 1, 1963. Tucson: 1963. 89 p.
Illus., some in color.

William Steadman, Jr.'s text is based on the writings of
Goodrich and Gardner. Has some rarely illustrated works
and can be easily digested.

868 Watson, Forbes. WINSLOW HOMER. New York: Crown Publishers, 1942. 112 p. 99 illus., 8 in color. Bibliog. pp. 25-29.

> No real text in this work, but it provides a guide to the location of many works at the date of publication and has clear illustrations.

869 Wilmerding, John. WINSLOW HOMER. New York: Frederick A. Praeger, 1972. 224 p. 148 black and white illus., 50 in color. Bibliog. pp. 221-22.

> Good general integration of the paintings and the graphics. High quality plates include instructive comparisons with European work.

HOPPER, EDWARD 1882-1967

870 DuBois, Guy Pene. EDWARD HOPPER. American Artists Series. New York: Whitney Museum of American Art, 1931. 55 p. Illus. Bibliog. pp. 13-14.

> This early monograph in the American Artists Series was written by an artist-critic friend of the artist who comments on the quality of stillness in the paintings.

871 Goodrich, Lloyd. EDWARD HOPPER. New York: Abrams, 1971. 306 p. 246 illus., 88 in color. Bibliog. pp. 297-300.

> The single, most valuable monograph on the painter was written by his long-time friend and director of the Whitney Museum. The text provides both biographical information and discussion of the works, almost all the well-known ones being illustrated in color.

872 _____. EDWARD HOPPER: SELECTIONS FROM THE HOPPER BEQUEST TO THE WHITNEY MUSEUM OF AMERICAN ART. New York: Whitney Museum of American Art, 1971. 66 p. Illus., some in color.

> Complements the major Goodrich study by including the little-known bequest material. Helps round out our knowledge of his style.

873 Lanes, Jerrold. "Edward Hopper: French Formalist, Ashcan Realist; Neither or Both?" ARTFORUM 7 (October 1968): 44-69.

> Analyzes the imagery and format of the paintings and suggests that they are more timeless than they are either American or descendants of the formalist tradition.

874 Museum of Modern Art. EDWARD HOPPER RETROSPECTIVE. Catalogue essays by Alfred H. Barr, Jr. and Charles Burchfield. New York:

1933. Reprint. New York: Arno Press, 1972. 83 p. Illus. Bibliog. p. 22.

>This catalog, reprinted with ones on Demuth and Sheeler, was prepared for a major exhibition of Hopper's painting. Essays by the painter Burchfield and the director of the museum, Alfred H. Barr, Jr.

HUNT, WILLIAM MORRIS 1824-79

875 Knowlton, Helen Mary. ART-LIFE OF WILLIAM MORRIS HUNT. Boston: Little, Brown and Co., 1899. xii, 219 p. Illus.

>The author draws upon Hunt's letters and other writing to document his life and activities.

876 Shannon, Martha A.S. BOSTON DAYS OF WILLIAM MORRIS HUNT. Boston: Marshall Jones Co., 1923. x, 165 p. 41 illus.

>This biography credits Hunt with bringing the major French developments in painting to the United States. The biographical material is drawn freely from the Knowlton volume (see above).

INDIANA, ROBERT 1928-

877 Institute of Contemporary Art. ROBERT INDIANA. Catalogue introduction by John W. McCourbey. Philadelphia: University of Pennsylvania Press, 1968. 63 p. Illus., some in color. Bibliog. pp. 60-61.

>The catalog of a travelling exhibition by this major pop artist. Includes an introduction with some biographical information and comments on his importance to the pop movement.

INMAN, HENRY 1801-46

878 Gerdts, William [H.]. "Inman and Irving." ANTIQUES 74 (November 1958): 420-23.

>Discusses the treatment of Rip van Winkle in the early work of this successful portrait painter.

INNESS, GEORGE 1825-94

879 Cikovsky, Nicolai, Jr. GEORGE INNESS. New York: Frederick A. Praeger, 1971. 159 p. 94 illus., 10 in color. Bibliog. pp. 155-56.

A good concise biography. Critical analysis of Inness' style concludes that his later interest in color was not influenced by the impressionists.

880 _____. "George Inness and the Hudson River School: The Lackawanna Valley." AMERICAN ART JOURNAL 2 (Fall 1970): 36-57.

Suggests that stylistically as well as emotionally, Inness left the "School" sooner than is usually believed. Beneficial for analyzing middle period painting.

881 Cournos, John. "Half-Forgotten Poet." ART NEWS 43 (July 1944): 8-10.

Deals primarily with Inness' later paintings and the emotion and drama within them. A good source.

882 Inness, George. LETTER TO RIPLEY HITCHCOCK. Mt. Vernon, N.Y.: William E. Rudge, 1928. 10 p.

A good source of autobiographical information. This long letter explains Inness' religious beliefs and discusses his training toward the end of explaining the development of his work.

883 Inness, George, Jr. LIFE, ART, AND LETTERS OF GEORGE INNESS. 1917. Reprint. New York: Da Capo Press, 1969. 290 p. Illus.

A biography and discussion of the paintings by the artist's son. Points out the religious influences on the painter's work and describes his travels.

884 Ireland, Leroy. THE WORKS OF GEORGE INNESS: AN ILLUSTRATED CATALOGUE RAISONNE. Austin: University of Texas Press, 1965. 476 p. Illus. Bibliog. pp. 455-59.

The single, most important source on Inness. A discussion of the artist's life and work with a completely documented catalog of all his known works in chronological order.

885 McCausland, Elizabeth. GEORGE INNESS, AN AMERICAN LANDSCAPE PAINTER, 1825-1894. New York: American Artists Group, 1946. 87 p. Illus. Bibliog. pp. 84-87.

The catalog of a travelling exhibition that includes a brief biography and useful entries.

886 Smith, Jacob G. "George Inness and the American Landscape Painter." AMERICAN ARTIST 20 (April 1956): 28-33.

Informative biographical article dealing primarily with Inness' stylistic changes in regard to other landscape painters of the nineteenth century.

JARVIS, JOHN WESLEY 1780-1840

887 Bolton, Theodore, and Croce, George C., Jr. "John Wesley Jarvis: An Account of His Life and the First Catalogue of His Work." ART QUARTERLY 1 (1938): 299-321.

Provides a brief biographical sketch and a catalog of those works identified as being painted by this important portrait painter of the early nineteenth century.

888 Dickson, Harold E. JOHN WESLEY JARVIS: AMERICAN PAINTER, 1780-1840. New York: The New York Historical Society, 1949. xx, 476 p. 105 illus. Bibliog. pp. 384-99.

Letters of the artist and other family documents are quoted in this exhaustive study. The social and political history of his time is used as a setting for his activities. A checklist of more than 400 works is provided. Discusses his travels and relations with students, especially Henry Inman.

889 Harrington, John Walker. "John Wesley Jarvis, Portraitist." AMERICAN MAGAZINE OF ART 18 (1927): 577-84.

The rediscovery of Jarvis as an important figure, after years of obscurity. Discusses his role in portraying the emerging middle class in the nineteenth century.

JENKINS, PAUL 1923-

890 Elsen, Albert. PAUL JENKINS. New York: Harry N. Abrams, 1973. 284 p. Illus., 56 in color.

Biographical information and a view of the painter's career to date. An analysis of the place of his abstractions in recent developments in painting.

JOHNS, JASPER 1930-

891 The Jewish Museum. JASPER JOHNS. New York: 1964. 63 p. Illus. Bibliog. pp. 61-63.

Critical essay by Alan Solomon and first-hand account of Johns' attitudes by John Cage. Catalogs 174 works and makes a strong case for Johns as a leader of the postabstract expressionism generation. Detailed bibliography of books and articles in which Johns is discussed and/or illustrated.

892 Kozloff, Max. JASPER JOHNS. New York: Harry N. Abrams, 1968. 195 p. Illus., 41 in color. Bibliog. p. 195.

Discusses the artist's role as a pioneer of pop art. Concentrates on his paintings although some sculpture/mixed media forms are included. The color plates present a good survey of his work through the mid-sixties.

893 Steinberg, Leo. JASPER JOHNS. New York: Wittenborn and Co., 1963. 45 p. Illus., some in color. Bibliog. pp. 43-44.

Concentrates on critical analysis of the formal and iconographic importance of the artist's creations.

JOHNSON, EASTMAN 1824-1906

894 Baur, John I.H. EASTMAN JOHNSON, 1824-1906: AN AMERICAN GENRE PAINTER. New York: Brooklyn Institute of Arts & Sciences, 1940. Reprint. New York: Arno Press, 1969. 82 p. 42 illus.

The reprinted exhibition catalog provides us with an easy to read biography and a descriptive listing of 472 works. Important bringing together of the work for the first time.

895 Crosby, Everett U. EASTMAN JOHNSON AT NANTUCKET. Nantucket Island, Mass.: privately printed, 1944. 67 p. 60 illus.

A catalog of the work done by Johnson during the years that he lived and worked in Nantucket. A narrow but important view.

896 Hills, Patricia. EASTMAN JOHNSON. New York: Clarkson N. Potter in association with the Whitney Museum of American Art, 1972. xxiii, 126 p. Illus., some in color. Bibliog. pp. 124-26.

Provides a thorough study of the painter's work. Particular attention is drawn to his neglected studies of the American Indian. This exhibition catalog has the largest number of illustrations of his paintings and sketches.

JOHNSTON, JOSHUA 1765-1839

897 Pleasants, J. Hall. JOSHUA JOHNSTON, THE FIRST AMERICAN NEGRO PORTRAIT PAINTER. Baltimore: The Maryland Historical Society, 1942. 29 p. 11 black and white illus.

The only real source of information about Johnston. The author provides little in the way of solid biography, but that information will probably never be uncovered. Does provide illustrations of some of his paintings to show his place in painting of that era.

KANE, JOHN 1860-1934

898 Arkus, Leon Anthony. JOHN KANE, PAINTER. Pittsburgh: University of Pittsburgh Press, 1971. 343 p. Illus., some in color. Bibliog. pp. 337-38.

> Biographical information, a catalogue raisonne, and the inclusion of the painter's autobiography, SKY HOOKS, makes this the indispensable work on this self-taught painter.

899 Carnegie Institute. SELF-TAUGHT PENNSYLVANIA ARTISTS: HICKS, KANE, PIPPIN.

> For main entry, see 849.

KAPROW, ALLAN 1927-

900 Kaprow, Allan. ASSEMBLAGE, ENVIRONMENTS AND HAPPENINGS. New York: Harry N. Abrams, 1966. 341 p. Illus.

> The author is one of the originators of the "happening" as a participatory art form. He explains his ideas on this form, and describes major events. Many illustrations of actual "happenings."

901 Pasadena Art Museum. ALLAN KAPROW. Pasadena, Calif.: 1967. 53 p. Illus. Bibliog. pp. 46-51.

> The catalog of an exhibition of the paintings by the artist, especially of his abstract works.

KARFIOL, BERNARD 1886-1952

902 Slusser, Jean P. BERNARD KARFIOL. New York: Whitney Museum of American Art, 1931. 54 p. Illus. Bibliog. p. 13.

> The catalog of an exhibition of the sensuous paintings of this immigrant artist. Reflects the influence of the precubist Picasso.

KENSETT, JOHN FREDERICK 1816-72

903 Howat, John K. JOHN FREDERICK KENSETT, 1816-1872. New York: American Federation of Arts, 1968. Unpaged. Illus. Bibliog.

> Provides some biographical information on this important nineteenth-century landscape painter, and stresses the importance of light in his detailed studies.

904 Johnson, Ellen H. "Kensett Revisited." THE ART QUARTERLY 20
 (Spring 1957): 71-92.

 Examines the landscapes of the painter as one of the second
 generation Hudson River School. Details his development as
 an engraver, trips abroad, and turn to landscape painting.

KENT, ROCKWELL 1882-1971

905 Kent, Rockwell. ROCKWELLKENTIANA: FEW WORDS AND MANY
 PICTURES. New York: Harcourt, Brace, 1933. 64 p. Illus. Bibliog.
 pp. 57-64.

 A catalog of Kent's paintings, graphics, and drawings, with
 essays on art and life by the witty and outspoken artist.

906 West, Richard. ROCKWELL KENT: THE EARLY YEARS. Brunswick,
 Me.: Bowdoin College Museum of Art, 1969. Unpaged. Illus.

 The catalog of an exhibition of the paintings and drawings
 completed by 1935. Shows Kent to be tentatively experi-
 menting with modern ideas from abroad.

KLINE, FRANZ 1910-62

907 Dawson, Fielding. AN EMOTIONAL MEMOIR OF FRANZ KLINE.
 New York: Pantheon, 1967. 147 p.

 A biographical study written by a close friend. Valuable
 source of information on the Black Mountain College years
 and the developing avant-garde art scene of the 1950s.

908 Gordon, John. FRANZ KLINE, 1910-1962. New York: Whitney
 Museum of American Art, 1968. Illus., some in color. Bibliog.
 pp. 64-67.

 This catalog of a retrospective exhibition is the major source
 of information on Kline's stylistic development and provides
 documentation on the major paintings.

KNATHS, KARL 1891-1971

909 Mocasanyi, Paul. KARL KNATHS. Washington, D.C.: The Phillips
 Gallery, 1957. 101 p. Illus., some in color.

 The major source of information on the artist, it provides
 biographical information but is weak on stylistic analysis.

KRASNER, LEE 1909-

910 Marlborough Gallery. LEE KRASNER. New York: 1968. 16 p. Illus.

> The catalog of a major exhibition of her abstract sexpression-istic style.

911 Robertson, Bryan. "The Nature of Lee Krasner." ART IN AMERICA 61 (November–December 1973): 83–87.

> A study of the abstract paintings of Krasner, of her maturation and philosophy. Her sources and debt to Matisse and her husband, Pollock.

KUHN, JUSTUS ENGELHARDT ?-c.1717

912 Pleasants, J. Hall. JUSTUS ENGELHARDT KUHN, AN EARLY EIGHTEENTH CENTURY MARYLAND PORTRAIT PAINTER. Worcester, Mass.: American Antiquarian Society, 1937. 40 p. 10 illus.

> Both the artist's early and late years are shown to be shrouded in mystery. Several of his portraits are illustrated in an attempt to define his style.

KUHN, WALT 1877-1949

913 Adams, Philip Rhays. WALT KUHN, 1877-1949. Cincinatti: Art Museum, 1960. Unpaged. Illus., some in color.

> The catalog of a major retrospective exhibition of Kuhn's paintings. Some biographical information and discussion of his style.

914 Getlein, Frank. WALT KUHN; 1877-1949. New York: Kennedy Galleries, 1967. Unpaged. 50 illus.

> A brief biographical introduction and a collection of illustrations of Kuhn's work in still-life and the better-known figure studies.

915 Kuhn, Walt. "The Story of the Armory Show." ART NEWS ANNUAL 37 (1939): 63-64, 168-74.

> Kuhn, as one of the major principals in the historic exhibition of 1913, discusses its organization and importance in the development of American artists' awareness of the European art scene.

KUNIYOSHI, YASUO 1893-1953

916 A SPECIAL LOAN RETROSPECTIVE EXHIBITION OF WORKS OF YASUO
KUNIYOSHI, 1892-1953. Gainesville: University of Florida Press, 1969.
Unpaged. Illus., some in color.

> A catalog of an exhibition that concentrates on the artist's
> last five years and documents each one. Essays by authorities
> on his art and a personal statement by the artist.

917 YASUO KUNIYOSHI. New York: American Artists Group, 1945.
64 p. Illus.

> An autobiographical text with illustrations of the increasingly
> abstract paintings. He comments on his thoughts about art and
> painting.

LAFARGE, JOHN 1835-1910

918 Cortissoz, Royal. JOHN LA FARGE: A MEMOIR AND A STUDY.
Boston and New York: Houghton Mifflin Co., 1911. xii, 268 p.
15 illus.

> Based, for the most part, on extensive interviews with the
> artist, and on letters from him; this biography constantly
> justifies his life in terms of his art, and vice versa.

919 La Farge, John. THE AMERICAN ART OF GLASS. N.p., 1893. 22 p.

> A brief history of stained glass making followed by a discus-
> sion of the use of the medium in the United States.

920 _____. AN ARTIST'S LETTERS FROM JAPAN. New York: The Century
Co., 1903. xiv, 293 p. 48 illus.

> Fascinating first-hand observations by an urbane and sophisti-
> cated artist. Interesting reactions to Japanese culture but not
> very helpful for contributing to an understanding of his own
> art.

921 _____. THE HIGHER LIFE IN ART. New York: The McClure Co.,
1908. xii, 187 p. Illus.

> This volume is a collection of lectures given by the artist at
> the Art Institute of Chicago in 1903. They very clearly ex-
> press his indebtedness to and respect for French art.

922 _____. REMINISCENCES OF THE SOUTH SEAS. Garden City, N.Y.:
Doubleday, Page & Co., 1916. 480 p. 48 illus., some in color.

> Narrative recollection and letters from the artist to his son,

illustrated by the paintings depicting his South Seas adventure.

923 Metropolitan Museum of Art. AN EXHIBITION OF THE WORK OF JOHN
LA FARGE. March 23-April 26, 1936. New York: 1936. viii, 16 p.
74 illus.

An exhibition catalog that contains a short biography and
illustrations of paintings, stained glass, and water colors.

924 Waerm, Cecelia. JOHN LA FARGE: ARTIST AND WRITER. London:
Seely and Co.; New York: Macmillan and Co., 1896. 104 p. 36 illus.,
some in color.

Contains some important biographical information and intertwines
his writing with his art.

LANE, FITZ HUGH 1804-65

925 Baur, John I.H. "Early Studies in Light and Air by American Landscape
Painters." BULLETIN, BROOKLYN MUSEUM 9 (Winter 1948): 1-9.

Includes comments on Lane, and makes the case for him as
a luminist painter.

926 Wilmerding, John. FITZ HUGH LANE. American Art and Artists Series.
New York: Frederick A. Praeger, 1971. 203 p. 101 black and white
illus., 10 in color. Bibliog. pp. 190-93.

The various chapters discuss the life and work together. Many
good illustrations and a checklist appendix of Lane's work in
public collections, paintings, and graphics.

927 _____. FITZ HUGH LANE, 1804-1865: AMERICAN MARINE PAINTER.
Salem, Mass.: The Essex Institute, 1964. x, 100 p. 18 illus. bibliog.
pp. 90-92.

A scholarly text and checklist of all known works by Lane.
Included is a list of known copies of his paintings and graphics.

LAWRENCE, JACOB 1917-

928 Brown, Milton W[olf]. JACOB LAWRENCE. New York: Whitney Museum
of American Art, 1974. 64 p. Illus., some in color. Bibliog. pp. 61-
64.

The catalog of a major exhibition of the most important
twentieth-century black American artist. Illustrates his work
over a long career and provides biographical information and
some stylistic analysis.

929 Saarinen, Aline B. JACOB LAWRENCE. New York: American Federa-
tion of Arts, 1960. 14 p. Illus. Bibliog. pp. 12-14.

> The catalog of a modest exhibition of the angular and expres-
> sive paintings of this commentator on social relationships.

LAWSON, ERNEST 1873-1939

930 Berry-Hill, Sidney. ERNEST LAWSON, N.A.: AMERICAN IMPRESSION-
IST. England: Leigh-on-Sea, 1968. 66 p. 73 illus., 6 in color.

> Some biographical information and an analysis of Lawson's
> unique impressionistic style. His strong colorism and concern
> for structure differentiates him from his American peers.

931 DuBois, Guy Pene. ERNEST LAWSON. American Artists Series. New
York: Whitney Museum of American Art, 1932. 56 p. Illus. Bibliog.
pp. 15-16.

> Written by an influential artist-critic of the time. Lawson's
> strongly colored impressionist paintings are discussed.

932 Phillips, Duncan. "Ernest Lawson." AMERICAN MAGAZINE OF ART
8 (May 1917): 257-63.

> A noted collector and critic discusses the unique qualities of
> Lawson's impressionistic paintings.

LEBRUN, FEDERICO 1900-64

933 Seldis, Henry J. RICO LEBRUN: AN EXHIBITION OF DRAWINGS,
PAINTINGS, AND SCULPTURE. Los Angeles: Los Angeles County Mu-
seum of Art, 1967. 82 p. Illus. Bibliog. pp. 67-75.

> Biographical and bibliographical information on the artist and
> documented study of his work. Although he was primarily
> thought of as a painter, this exhibition catalog contains some
> of his sculpture.

LEUTZ, EMANUEL 1816-98

934 Howat, John K. "Wahington Crossing the Delaware." METROPOLITAN
MUSEUM OF ART BULLETIN 26 (March 1968): 289-99.

> Discusses the successful and notorious painting and its history
> in relation to the painter and his Dusseldorf connections.

935 Stehle, Raymond L. THE LIFE AND WORKS OF EMANUEL LEUTZE.

Washington, D.C.: privately published, 1972. 285 p.

The first part is the story of his life and the second is an an-
notated list of works by Leutze. Included is an article on the
painter's sketchbooks extracted from QUARTERLY JOURNAL OF
THE LIBRARY OF CONGRESS 21 (1964): 1–124.

LEVINE, JACK 1915–

936 Getlein, Frank. JACK LEVINE. New York: Harry N. Abrams, 1966.
26 p. 167 illus., some in color.

Biographical information on this social critic is provided, as
are some comments on style. The main value of the book is
in the full survey of illustrations.

937 Werner, Alfred. "The Peopled World of Jack Levine." THE PAINTER
AND SCULPTOR 2 (Summer 1959): 24–29.

Discusses the often shadowy but persistant figures in the biting
socially critical paintings of the artist.

LICHTENSTEIN, ROY 1923–

938 Coplins, John, ed. ROY LICHTENSTEIN. New York: Frederick A.
Praeger, 1973. 200 p. 84 illus., 10 in color. Bibliog. pp. 185–95.

Contains interviews with the artist and critical essays by major
contemporary writers on art.

939 Waldman, Diane. ROY LICHTENSTEIN. New York: Harry N. Abrams,
1971. 248 p. 183 illus., 85 in color. Bibliog. pp. 240–41.

The major monograph on this pop artist. Biographical informa-
tion plus an interview with the artist. Discussion of his style.

LINDNER, RICHARD 1901–

940 Ashton, Dore. RICHARD LINDNER. New York: Harry N. Abrams,
1969. 217 p. 187 illus., 80 in color. Bibliog. pp. 215–17.

A major monograph on this German-American painter. Bio-
graphical and bibliographical information plus an analysis and
illustrations of his strongly colored critical and erotic figures.

LOUIS, MORRIS 1912-62

941 Fried, Michael. MORRIS LOUIS. New York: Harry N. Abrams, 1970. 220 p. Illus., some in color. Bibliog. p. 220.

> A major monograph based on the 1967 travelling exhibition. Includes biographical information, and a discussion of Louis' color-striped paintings in regard to influences and his place in post-painterly abstract painting.

LUKS, GEORGE BENJAMIN 1867-1933

942 Cary, Elizabeth Luther. GEORGE LUKS. American Artists Series. New York: Whitney Museum of American Art, 1931. 54 p. Bibliog. p. 12.

> Brief biographical essay and illustrations of Luks' paintings.

943 Newark Museum. GEORGE BENJAMIN LUKS. Newark, N.J.: 1934. 57 p. 26 illus. Bibliog. p. 15.

> Exhibition catalog written soon after the painter's death. Contains a short biography and five essays on Luks by Sloan and other friends.

944 Trovato, Joseph S. GEORGE LUKS. New York: Munson-Williams-Proctor Institute, 1973. 58 p. Illus.

> The catalog of a recent exhibition that updates our knowledge about the life of the painter and provides a fresh look at the uneven production of this brash Ashcan painter.

MACDONALD-WRIGHT, STANTON 1890-1973

945 Macdonald-Wright, Stanton. "Artist Speaks." With a note on Synchromism by Barbara Rose. ART IN AMERICA 55 (May 1967): 70-73.

> Some biographical information, but primarily an excellent discussion of what Synchromism was to Morgan Russell and Macdonald-Wright.

946 Scott, David. THE ART OF STANTON MACDONALD-WRIGHT. Washington, D.C.: Smithsonian Institution Press, 1967. 100 p. Illus., some in color. Bibliog. pp. 62-64.

> The major monograph on the founder of the Synchromist movement. Discusses his importance in the introduction, while the rest of the catalog consists of his writings on color theory. Includes his entire "A Treatise on Color" of 1924.

947 Walker, John Alan. "Interview: Stanton Macdonald-Wright." AMERI-
CAN ART REVIEW 1 (January-February 1974): 59-68, 125.

> An interview recorded during the last year of Macdonald-Wright's
> life, in February 1973. He discusses his thoughts on painting
> and color, his Parisian experiences, the WPA project, and
> associations with friends. Illustrated with paintings and photo-
> graphs of the artist at various stages in his career.

MARCA-RELLI, CONRAD 1913-

948 Agee, William C. MARCA-RELLI. New York: Frederick A. Praeger,
1967. 80 p. Illus., some in color. Bibliog. pp. 78-80.

> This is the catalog of the painting/collages of an abstract
> painter important in the New York scene after World War II.
> Documentation of the works.

949 Arnason, H.H. MARCA-RELLI. New York: Harry N. Abrams, 1963.
Unpaged. Illus., many in color.

> The author presents the painter as a classicist of the abstract
> school. Discusses the paintings and collages.

MARIN, JOHN 1870-1953

950 Benson, E.M. JOHN MARIN: THE MAN AND HIS WORK. New York:
American Federation of Arts, 1935. 111 p. 51 black and white illus.,
2 in color.

> A biography that includes several of Marin's letters. The for-
> mat of two parts, the man and his work, tends to disrupt the
> continuity of the study.

951 Curry, Larry. JOHN MARIN, 1870-1953. Los Angeles: Los Angeles
County Museum of Art, 1970. 100 p. Illus., some in color.

> The catalog of a major exhibition. Includes discussion of the
> formation of his style and documentation of the individual works.

952 Davidson, Abraham. "John Marin: Dynamism Codified." ARTFORUM
10 (April 1971): 37-41. Illus.

> Brief biography and analysis of Marin's later works, seen in
> relation to abstract expressionism.

953 Gray, Cleve, ed. JOHN MARIN BY JOHN MARIN. New York: Holt,
Rinehart and Winston, 1970. 176 p. 100 illus., 16 in color. Bibliog.
pp. 174-76.

The text is the writings of Marin, one of the more articulate
of pioneer abstractionists in America.

954 Helm, MacKinley. JOHN MARIN. Boston: Pellegrini and Cudahy,
1948. 255 p. 64 black and white illus., 9 in color.

An important biography with extensive quotations from the
artist. Includes a foreword by Marin.

955 Reich, Sheldon. JOHN MARIN. A STYLISTIC ANALYSIS AND CATA-
LOGUE RAISONNE. 2 vols. Tucson: The University of Arizona Press,
1970. xiii, 891 p. 209 illus., some in color. Bibliog. pp. 273-97.

The major work on Marin. The first part is an exhaustive
biography and stylistic analysis. Part 2 is an extremely well
documented catalog of all his known works. Most important
bibliography on the artist.

MARSH, REGINALD 1898-1954

956 Goodrich, Lloyd. REGINALD MARSH. New York: Harry N. Abrams,
1972. 307 p. 239 illus., 85 in color. Bibliog. pp. 299-304.

The major study of Marsh's work, enriched by illustrations of
hundreds of his paintings and drawings. Presents him as more
of an observer of the passing scene than a social critic.

957 Laning, Edward. EAST SIDE, WEST SIDE, ALL AROUND THE TOWN:
A RETROSPECTIVE EXHIBITION OF PAINTINGS, WATERCOLORS AND
DRAWINGS BY REGINALD MARSH. Tucson: University of Arizona
Museum of Art, 1969. 175 p. Illus., some in color.

The catalog of an exhibition which presents the works showing
Marsh's never-ending interest in the street scene of New York.

958 _____. THE SKETCHBOOKS OF REGINALD MARSH. Greenwich, Conn.:
New York Graphic Society, 1973. 160 p. 208 illus.

Marsh was a prolific draughtsman who constantly sketched the
people around him and in the public places he frequented.
The bulk of those sketches are presented here.

959 Sasowsky, Norman. REGINALD MARSH: ETCHINGS, ENGRAVINGS,
LITHOGRAPHS. New York: Frederick A. Praeger, 1956. x, 60 p.
Illus.

Presents Marsh's graphic work as it relates to his paintings of
similar themes. The artist worked extensively in these media.

MARTIN, HOMER DODGE 1836-97

960 Carroll, Dana H. FIFTY-EIGHT PAINTINGS BY HOMER D. MARTIN.
New York: privately printed by Frederic F. Sherman, 1913. 140 p.
58 illus.

A catalog of landscapes with a description of each.

961 Martin, Elizabeth Gilber. HOMER MARTIN: A REMINISCENCE. New
York: William Macbeth, 1904. ix, 58 p. 12 illus.

Memories of life with the painter, by his wife. Provides good
biographical details. Published by his dealer. Illustrated with
his landscapes.

962 Mather, Frank Jewett, Jr. HOMER MARTIN: POET IN LANDSCAPE.
New York: Privately printed by Frederic F. Sherman, 1912. 76 p.
13 illus., 1 in color.

The artist is represented as being a tragic figure, able to
paint only when inspiration struck, and not too well appre-
ciated in his own time.

MAURER, ALFRED HENRY 1868-1932

963 McCausland, Elizabeth. A.H. MAURER. New York: A.A. Wyn, 1951.
289 p. 65 illus. Bibliog. pp. 279-82.

This is based on the exhibition catalog written by the same
author two years earlier, but is more comprehensive. The
correspondence with Gertrude Stein and other of Maurer's
avant-garde friends is included. The works are well documented.

964 Mellorio, J.R. "Maurer Enigma." ARTS 34 (January 1960): 30-35.

Excellent biographical note with stress upon the outward
Maurer and the inner struggles he suffered. Includes illus-
trations of his paintings.

965 Reich, Sheldon. ALFRED H. MAURER 1868-1932. Washington, D.C.:
The National Portrait Gallery, Smithsonian Institution, 1973. 167 p.
Illus. Bibliog.

This is the catalog of a recent exhibition. The catalog entries
are updated, and careful documentation of the chronology and
stylistic development is provided.

MILLER, ALFRED J. 1810-74

966 De Voto, Bernard Augustine. ACROSS THE WIDE MISSOURI.

For main entry, see 683.

709.72
M647B

967 Miller, Alfred J. BRAVES AND BUFFALO: PLAINS INDIAN LIFE IN
1837. Toronto: University of Toronto Press, 1973. 176 p. Illus. in
color.

Illustrations of water colors with descriptive notes by the
artist.

968 Ross, Marvin C., ed. THE WEST OF ALFRED JACOB MILLER. Rev. ed.
Norman: University of Oklahoma Press, 1968. lxxxiii, 208 p. 208
black and white illus., 8 in color. Bibliog. pp. lxi-lxviii.

A brief biography precedes the descriptive catalog of the 208
watercolor paintings owned by the Walters Art Gallery. Ex-
tracts from Miller's account book, from 1846 to his death in
1874, give us an idea of his prices during his lifetime. The
bibliography is detailed and valuable.

759.1
M62 M'

MILLER, KENNETH HAYES 1876-1952

969 Burroughs, Alan. KENNETH HAYES MILLER. New York: Whitney
Museum of American Art, 1935. 15 p. Illus.

The biography of a major teacher and important figure painter
of the early twentieth century. Important for the illustrations
of seldom seen paintings.

MORAN, THOMAS 1837-1926

970 Bassford, Amy O., and Fryxell, Fritiof. HOME-THOUGHTS FROM AFAR:
LETTERS OF THOMAS MORAN TO MARY NIMMO MORAN. East Hamp-
ton, N.Y.: East Hampton Free Library, 1967. xv, 152 p. 29 illus.

The letters of Moran to his wife from various places in Mexico
and the West.

971 Fryxell, Fritiof, ed. THOMAS MORAN: EXPLORER IN SEARCH OF
BEAUTY. East Hampton, N.Y.: East Hampton Free Library, 1958. xii,
84 p. 26 illus.

This volume of tribute contains a short biography that utilizes
information provided by the artist's family, reminiscences by
Moran's daughter and a friend, and essays on his graphics and

watercolors.

972 University of California, Riverside. THOMAS MORAN, 1837-1926.
 April 17 to June 7, 1963. Riverside: 1963. 48 p. 30 illus. Bibliog.
 pp. 22-23.

 Notes on Moran and the tradition of landscape painting in
 America, his oil paintings, drawings, and watercolors. A
 catalog of forty-three works is included.

973 Wilkins, Thurman. THOMAS MORAN: ARTIST OF THE MOUNTAINS.
 Norman: University of Oklahoma Press, 1966. xvi, 315 p. 40 black
 and white illus., 8 in color. Bibliog. pp. 261-93.

 A solid and thoroughly documented biography describing the
 various travels Moran undertook on behalf of his art. The
 appendix is a narrative discussion of his work.

MORSE, SAMUEL FINLEY BREESE 1791-1872

974 Larkin, Oliver W. SAMUEL F.B. MORSE AND AMERICAN DEMOCRATIC
 ART. Boston: Little, Brown and Co., 1954. viii, 215 p. Illus.
 Bibliog. pp. 201-3.

 A general biography of Morse as man, artist, and inventor.
 The figure is placed in his historical and cultural environment
 with no particular attempt at letting any of his activities be-
 come a focal point.

975 Mabee, Carleton. THE AMERICAN LEONARDO: A LIFE OF SAMUEL
 F.B. MORSE. New York: Alfred A. Knopf, 1943. xix, 410 p.
 21 illus. Bibliog. pp. 381-82.

 Tries to balance out Morse the inventor with Morse the artist
 and preserves the complexity and often contradictory aspects
 of his life.

976 Metropolitan Museum of Art. SAMUEL F.B. MORSE: AMERICAN
 PAINTER. February 16-March 27, 1932. New York: 1932. ix, 49 p.
 59 illus.

 A factual biography based in large part on the painter's
 letters. A list of paintings by Morse in included.

977 Morse, Edward Lind, ed. SAMUEL F.B. MORSE: HIS LETTERS AND
 JOURNALS. 2 vols. 1914. Reprint. New York: Da Capo Press,
 1970. Vol. 1, 440 p.; vol. 2, 548 p. Illus.

 Morse's son has edited the extensive letters and personal material
 to present a smooth chronology in the artist's own words.

978 Prime, Samuel Irenaeus. THE LIFE OF SAMUEL F.B. MORSE, LL.D. New York: D. Appleton and Co., 1875. xii, 776 p. 10 illus.

> Divided into three parts: Morse's career as an artist, the dozen years employed in developing the telegraph, and the evaluation of his contributions to "mankind." Informed and based upon letters and other primary source material, but not critical.

MOSES, ANNA MARY ROBERTSON 1860-1961

979 Kallir, Otto. GRANDMA MOSES. New York: Harry N. Abrams, 1975. 350 p. Illus., some in color.

> The definitive biography and discussion of the work of the artist by her biographer of the past quarter-century. Good illustrations and a discussion of her paintings in regard to decorative quality.

980 _____, ed. GRANDMA MOSES: MY LIFE HISTORY. New York: Harper and Brothers, 1948. 140 p. Illus., 16 in color.

> The autobiography of the self-taught artist who expresses her appreciation for the popularity of her work done so late in life.

MOTHERWELL, ROBERT 1915-

981 Arnason, H.H. "On Robert Motherwell and His Early Work." ART INTERNATIONAL 10 (January 1966): 17-35.

> Comments on the surrealistic early paintings with their imagery and the development into abstract expressionism.

982 O'Hara, Frank. ROBERT MOTHERWELL: WITH SELECTIONS FROM THE ARTIST'S WRITINGS. New York: Doubleday & Co., 1965. 96 p. Illus., 10 in color. Bibliog. pp. 86-93.

> The catalog of a major retrospective exhibition of the painter. His influences and stylistic development are well documented by this friend of long standing, and the highly literate artist's writings are sampled.

MOUNT, WILLIAM SIDNEY 1807-68

983 Brooklyn Museum. WILLIAM SIDNEY MOUNT, 1807-1868. January 23-March 8, 1942. New York: Brooklyn Institute of Arts and Sciences, 1942. 31 p. 10 illus.

Containing a chronology and a catalog of 107 then located
works, this is the catalog of the first major exhibition of
Mount's paintings since his death.

984 Cowdrey, Bartlett. "Prints after Lost Paintings by Mount." ANTIQUES
41 (April 1942): 244-45. Illus.

Discussion of five lost paintings, known only from lithographs.

985 Cowdrey, Bartlett, and Williams, Hermann Warner, Jr. WILLIAM SIDNEY
MOUNT: AN AMERICAN PAINTER. New York: Columbia University
Press, 1944. xiii, 54 p. 78 illus. Bibliog. pp. 43-47.

An important early source of biographical information that has
remained a classic for the study of this important genre painter.

986 Frankenstein, Alfred. PAINTER OF RURAL AMERICA: WILLIAM SIDNEY
MOUNT. Stony Brook, N.Y.: The Suffolk Museum at Stony Brook, 1968.
71 p. 1 illus.

The catalog of forty-five major paintings is well documented
by references to Mount's letters and journals. Contains impor-
tant information about his opinions on art.

987 The Suffolk Museum at Stony Brook. THE MOUNT BROTHERS: AN
EXHIBITION. August 23-September 28, 1947. Stony Brook, N.Y.:
1947. 48 p. Illus. Bibliog. p. 48.

The catalog of an exhibition of the paintings of three Mount
brothers, William Sidney, Henry Smith, and Shepard Alonzo.
Emphasis on biography and discussion of William's success.
Genealogical tables are included.

988 Werner, Charles J. "William S. Mount and His Art." In HISTORIC
MISCELLANIES RELATING TO LONG ISLAND, pp. 29-43. Huntington,
N.Y.: Tobias A. Wright Press, 1917. Illus.

Contains the first checklist (118) of paintings by Mount.

MURCH, WALTER TANDY 1907-67

989 WALTER MURCH: A RETROSPECTIVE EXHIBITION. Providence: Rhode
Island School of Design, 1966. Unpaged. Illus. Bibliog.

An exhibition catalog that provides both biographical and
bibliographical material on this once popular surrealist. Ana-
lyzes his style and imagery.

MURPHY, GERALD 1888-1964

990 Butterfield, Jan. "Gerald Murphy." AMERICAN ART REVIEW 1 (July-October 1974): 122-35.

3rd floor

> Discusses the life and short career of this early "precisionist" painter. Describes his late conversion to painting, illustrates the paintings, explores his style, and explains why he stopped painting. Defines current attempts to resurrect his work.

759.13 M97R

991 Rubin, William [S.]. THE PAINTINGS OF GERALD MURPHY. New York: Museum of Modern Art, 1974. Illus.

> Although only fourteen paintings by Murphy are known, this exhibition presents him as an important pioneer of hard-edged abstraction in the mid 1920s. Draws upon his notes for documentation.

MURPHY, J. FRANCIS 1853-1921

992 Clark, Eliot. J. FRANCIS MURPHY. New York: privately printed by E.F. Sherman, 1926. 63 p. 12 illus.

> The early and important biography of the landscape painter. His career is divided into three parts: Hudson River School, French 1830s influence, and his own impressionist style.

993 Murphy, J. Francis. PAINTINGS AND DRAWINGS. New York: American Art Association, 1926. 151 p. Illus.

> The sale catalog of 302 drawings and paintings left at the artist's death. Each work is described and many are reproduced. The major source of illustrations of his work.

NEAGLE, JOHN 1796-1865

994 Pennsylvania Academy of Fine Arts. CATALOGUE OF AN EXHIBITION OF PORTRAITS BY JOHN NEAGLE. Philadelphia: 1925. 158 p. Illus.

> Contains a short biography by Mantle Fielding and a descriptive catalog of 137 works. Neagle is presented as a powerful colorist, concerned with the character of his sitters. He dominated much of the portrait market in Philadelphia for the second quarter of the nineteenth century.

NEWMAN, BARNETT 1905-70

995 Alloway, Lawrence. BARNETT NEWMAN: THE STATIONS OF THE
CROSS, LEMA SABACHTHANI. New York: Solomon R. Guggenheim
Museum, 1966. 39 p. Illus. Bibliog. pp. 34-35.

A discussion of the paintings and an analysis of the religious
theme in relation to completely nonobjective painting.

996 Hess, Thomas B. BARNETT NEWMAN. New York: The Jewish Museum,
1965. Unpaged. Illus., some in color. Bibliog.

759.13
N55h

Explores the meaning of the work of an abstract artist who
had evolved into a leader among the minimalists in painting
and sculpture.

NOLAND, KENNETH 1924-

997 Fried, Michael. KENNETH NOLAND. New York: The Jewish Museum,
1965. Unpaged. Illus., some in color. Bibliog.

An early important exhibition catalog which illustrates the
artist's target and chevron paintings.

NORDFELDT, ERDER JULIUS 1878-1955

998 Coke, Van Deren. NORDFELDT THE PAINTER. Albuquerque: University
of New Mexico Press, 1972. 149 p. 70 black and white illus., 17 in
color. Bibliog. pp. 145-46.

The life and work of the Scandinavian-born artist who lived
and worked in so many parts of America. Much of the infor-
mation was obtained from the artist and his letters. His knowl-
edge of early twentieth-century French painting is apparent.

O'KEEFFE, GEORGIA 1887-

999 Goodrich, Lloyd. GEORGIA O'KEEFFE. New York: Frederick A.
Praeger for the Whitney Museum of American Art, 1970. 195 p. 72 illus.,
13 in color. Bibliog. pp. 191-95.

759.13
0419

The major study to date, this monograph includes a biographical
sketch, the influences of Stieglitz and his circle on her work,
and an attempt to place it in the American art scene. Clear
catalog entries and many illustrations.

1000 Grimp, D. "Georgia Is a State of Mind." ART NEWS 69 (October
1970): 48-51.

3rd
floor

Typical article around the time of O'Keeffe's second retrospective in 1970, offering condensed biography and stylistic analysis.

1001 Willard, C. "Georgia O'Keeffe." ART IN AMERICA 51 (October 1963): 92–96.

3rd
floor

Photographs of O'Keeffe with excellent narrative of her life as told to author.

OLITSKI, JULES 1922-

1002 Moffett, Kenworth. JULES OLITSKI. Boston: Museum of Fine Arts, 1973. 71 p. Illus., some in color. Bibliog. pp. 58–61.

759.13
047

The catalog of an important exhibition. Biographical information and detailed documentation on the individual abstract works in the catalog.

PAGE, WILLIAM 1811-85

1003 Page, William. "The Art of the Use of Color in Imitation in Painting." BROADWAY JOURNAL 1 (February 8–March 29, 1845): 131–33.

3rd
floor

Page's own ideas on art reflect his interest in the painting of the Venetian Renaissance.

1004 Richardson, Edgar Preston. "Two Portraits by William Page." ART QUARTERLY 12 (Winter 1949): 3–16.

3rd
floor

The reintroduction of Page to the twentieth-century art world.

1005 Taylor, Joshua C. WILLIAM PAGE: THE AMERICAN TITIAN. Chicago: University of Chicago Press, 1957. xxiii, 293 p. 57 illus. Bibliog. pp. 281–86.

The definitive work on Page. It is divided into chapters relating to his residences in different cities and contains a chapter on his theories of art. A descriptive and analytical catalog of more than 200 items.

PEALE, CHARLES WILLSON 1741-1827

1006 Briggs, Berta N. CHARLES WILLSON PEALE: ARTIST AND PATRIOT. New York: McGraw-Hill Book Co., 1952. 262 p. 10 illus.

759.13
P358b

A useful biography based on earlier research. Shows Peale in two of his important roles but emphasizes the latter.

1007 Detroit Institute of Arts. THE PEALE FAMILY: THREE GENERATIONS
OF AMERICAN ARTISTS. Organized by Charles H. Elam. Detroit: 1967.
150 p. Illus.

> This exhibition catalog discusses and illustrates the work of a
> number of the Peale artists. The core of the exhibition was
> provided by the important Peale paintings owned by the mu-
> seum itself.

1008 Morgan, John Hill. TWO EARLY PORTRAITS OF GEORGE WASHINGTON,
PAINTED BY CHARLES WILLSON PEALE. Princeton, N.J.: Princeton
University Press, 1927. 29 p. 2 illus.

> Discusses more about Peale and his painting than the two
> Washington portraits at hand. An old but useful study.

1009 Pennsylvania Academy of the Fine Arts. CATALOG OF AN EXHIBITION
OF PORTRAITS BY CHARLES WILLSON PEALE, JAMES PEALE, AND
REMBRANDT PEALE. Philadelphia: 1923. 238 p. 115 illus.

> This exhibition catalog discusses only the portraits by the three
> important members of the painting Peales. Many had never
> been reproduced before.

1010 Sellers, Charles Coleman. CHARLES WILLSON PEALE. New York:
Charles Scribner's Sons, 1969. xiv, 510 p. 110 black and white illus.,
14 in color.

> The major study of Peale. His life and art are both well
> documented. His many activities are discussed in a fine
> attempt at integrating the many facets of a complex person-
> ality.

PEALE, JAMES 1749-1831

1011 Detroit Institute of Arts. THE PEALE FAMILY: THREE GENERATIONS
OF AMERICAN ARTISTS.

> For main entry, see 1007.

1012 Pennsylvania Academy of the Fine Arts. CATALOG OF AN EXHIBITION
OF PORTRAITS BY CHARLES WILLSON PEALE, JAMES PEALE, AND
REMBRANDT PEALE.

> For main entry, see 1009.

1013 Walker Galleries. PAINTINGS AND WATER COLORS BY JAMES PEALE
AND HIS FAMILY, 1744-1891. February 13-March 11, 1939. New
York: 1939. Unpaged. 4 illus.

> Shows the still-life tradition so strong in the Peale family for

three generations. Other paintings, including portraits, are
discussed.

PEALE, RAPHAELLE 1774-1825

1014 Detroit Institute of Arts. THE PEALE FAMILY: THREE GENERATIONS
OF AMERICAN ARTISTS.

For main entry, see 1007.

PEALE, REMBRANDT 1778-1860

1015 Mahey, John A. "The Studio of Rembrandt Peale." THE AMERICAN
ART JOURNAL 1 (Fall 1969): 20-40.

Biographical information about Peale, his values, and his place
in the art world of his time. Also lists the inventory of his
studio at his death.

1016 Municipal Museum of Baltimore. AN EXHIBITION OF PAINTINGS BY
REMBRANDT PEALE. November 29, 1937-January 2, 1938. Baltimore:
1937. 19 p. Illus.

Contains a brief biography and a catalog of seventy-two
paintings by Peale.

1017 Peale, Rembrandt. INTRODUCTION TO THE STUDY OF GRAPHICS: A
MANUAL EXERCISE FOR THE EDUCATION OF THE EYE. Philadelphia:
Edward C. Biddle, 1935. xvii, 132 p. 41 illus.

A textbook for learning to draw and letter by a noted painter.

1018 _____. NOTES ON ITALY: WRITTEN DURING A TOUR IN THE YEARS
1829 AND 1830. Philadelphia: Carey and Lea, 1831. 328 p.

Peale describes the art and architecture that he sees and ex-
plains how he was impressed by various works such as Michel-
angelo's Moses.

1019 Pennsylvania Academy of the Fine Arts. CATALOG OF AN EXHIBITION
OF PORTRAITS BY CHARLES WILLSON PEALE, JAMES PEALE, AND
REMBRANDT PEALE.

For main entry, see 1009.

Individual Painters

PEARLSTEIN, PHILIP 1924-

759.13
P35p

1020 Nochlin, Linda. PHILIP PEARLSTEIN. Athens: Georgia Museum of Art, University of Georgia, 1970. Unpaged, 80 illus. Bibliog.

The catalog of an exhibition of the nudes and other figure studies of this proponent of the new realism.

PETO, JOHN F. 1854-1907

1021 The Brooklyn Museum. JOHN F. PETO. New York: The Brooklyn Institute of Arts and Sciences, 1950. 50 p. 23 illus.

An exhibition catalog containing a critical biography by Alfred Frankenstein and a catalog of fifty-one paintings. Peto's work is separated from that of Harnett, and the essay makes a case for the importance of the powdery texture and muted color.

3rd
floor

1022 Goodrich, Lloyd. "Harnett and Peto: A Note on Style." ART BULLE-TIN 31 (March 1949): 57-58.

Peto's presentation of form is presented as weaker than Harnett's, and his use of light and opaque coloring is emphasized.

PHILLIPS, AMMI 1788-1865

3rd
floor

1023 Holdridge, Barbara, and Holdridge, Laurence. "Ammi Phillips." ART IN AMERICA 48 (Summer 1960): 98-103.

An introduction to the paintings of Phillips.

1024 Museum of American Folk Art. AMMI PHILLIPS: PORTRAIT PAINTER, 1788-1865. New York: Clarkson N. Potter, 1968. 56 p. Illus., 3 in color. Bibliog. p. 56.

Contains a short biography, a discussion of the possible influences on his style, and a chronology of his work.

PINE, ROBERT EDGE 1730-88

1025 Hart, Charles Henry. "The Congress Voting Independence: A Painting by Robert Edge Pine and Edward Savage in the Hall of the Historical Society of Pennsylvania." THE PENNSYLVANIA MAGAZINE OF HISTORY AND BIOGRAPHY, January 1905, pp. 1-16.

A study of Pine's only well-known painting and background information on its importance. He is known to have studied with Benjamin West.

PIPPIN, HORACE 1888-1946

1026 Carnegie Institute. SELF-TAUGHT PENNSYLVANIA ARTISTS: HICKS, KANE, PIPPIN.

759.13
T5312

> For main entry, see 849.

1027 Rodman, Selden. HORACE PIPPIN: A NEGRO PAINTER IN AMERICA. New York: Quadrangle Press, 1947. 88 p. Illus., some in color.

759.1
P66r

> This only useful study of an important "naive" black artist. Contains sufficient illustration to suggest his style and imagery.

POLLOCK, JACKSON 1912-56

1028 Friedman, B.H. JACKSON POLLOCK: ENERGY MADE VISIBLE. New York: McGraw-Hill Book Co., 1972. 293 p. Illus. Bibliog. pp. 263-78.

59.13
P77f

> An anecdotal biography of the best-known figure of the abstract expressionism movement of the late 40s and 1950s. Details his training, the WPA period, and his activities in New York.

1029 O'Connor, Francis V. JACKSON POLLOCK. New York: Museum of Modern Art, 1967. 148 p. Illus. Bibliog. pp. 137-43.

759.13
P77oc

> The catalog of a major retrospective exhibition of Pollock's works. An extended bibliography traces his background, education, the personal relationships with his dealer, his teacher, Benton, and his wife and friends. Included is the text of an interview with the action painter on his work.

1030 O'Hara, Frank. JACKSON POLLOCK. New York: George Braziller, 1959. 125 p. Illus., some in color. Bibliog. pp. 119-20.

759.13
P77o

> The text of this study is concerned with tracing the influences which helped create Pollock's action style of painting.

1031 Robertson, Bryan. JACKSON POLLOCK. New York: Harry N. Abrams, 1960. 215 p. Illus., 3 in color. Bibliog. pp. 195-96.

> Valuable for the illustrations and analysis of the sources of his style.

1032 Rose, Bernice. JACKSON POLLOCK: WORKS ON PAPER. New York: The Museum of Modern Art, 1969. 108 p. 42 illus.

759.13
P77p

> A discussion of Pollock's style and a selection of illustrations of his drawings, collages, and paintings on paper rather than the large canvases.

POONS, LARRY 1936-

1033 Tuchman, Phyllis. "An Interview with Larry Poons." ARTFORUM 9 (December 1970): 45-50.

3rd floor

> An illustrated article based on an interview. Some biographical details but more a source of information about his op qualities and use of color.

POOR, HENRY VARNUM 1888-1970

1034 Boswell, Peyton, Jr. VARNUM POOR. New York: Harper and Brothers, 1941. 77 p. Illus., some in color. Bibliog. p. 77.

> A study of the somewhat abstract landscapes and figure paintings of this important figure in the WPA story. Biographical information on his upbringing and travels.

PORTER, RUFUS 1792-1884

1035 Auer, May Hale. "Rufus Porter." THE DECORATOR (April 1951): 12-17.

3rd floor

> An introduction to the stencils and designs of the artist.

1036 Lipman, Jean. RUFUS PORTER: YANKEE PIONEER. New York: Clarkson N. Potter, 1968. ix, 202 p. 104 black and white illus., 22 in color. Bibliog. pp. 189-92.

> Biographical account of the nineteenth-century portraitist and muralist. Solid documentation of the identified works and an attempt to discuss the man and his work in a cultural setting.

1037 _____. "Rufus Porter, Yankee Wall Painter." ART IN AMERICA (January 1945): 133-200.

3rd floor

> The first serious discussion of Porter's frescoes in regard to serious art. The author traces the scattered works.

PRATT, MATTHEW 1734-1805

1038 Sawitzky, William. MATTHEW PRATT, 1734-1805. New York: The New York Historical Society, 1942. x, 103 p. 43 illus.

> An important critical study of his work and place in the painting of the early federal period. Includes a descriptive catalog of the paintings.

PRENDERGAST, CHARLES 1863-1948

1039 Philips Academy. THE PRENDERGASTS: RETROSPECTIVE EXHIBITION
OF THE WORK OF MAURICE AND CHARLES PRENDERGAST. Andover:
1938. 53 p. Illus. Bibliog. p. 52.

> The catalog of an exhibition of the work of the Prendergast
> brothers. Essays by several critics and friends of the two men.
> Charles is shown to be more eclectic and traditional than
> Maurice.

1040 Wattenmaker, Richard J. THE ART OF CHARLES PRENDERGAST. Boston:
Museum of Fine Arts, 1968. 119 p. Illus., some in color. Bibliog.
p. 38.

709.73
P92 zw

> The catalog of an exhibition of the paintings of the man other-
> wise known as a frame-maker and supporter of his more famous
> brother, Maurice.

PRENDERGAST, MAURICE 1859-1924

1041 Breuning, Margaret. MAURICE PRENDERGAST. American Artists Series.
New York: Whitney Museum of American Art, 1931. 59 p. Illus.
Bibliog. p. 17.

59.1
N62p

> This was the introductory study of Prendergast's impressionistic
> painting. Provides some biographical information.

1042 Brooks, Van Wyck. "Anecdotes of Maurice Prendergast." MAGAZINE
OF ART 31 (October 1938): 564-69.

?

> Though anecdotal, there is solid information also present on
> his life and dealings with friends. Contains illustrations.

1043 MAURICE PRENDERGAST: WATERCOLOR SKETCHBOOK. Cambridge,
Mass.: Harvard University Press, 1960. 95 p. Illus., some in color.

759.13
P92p

> A picture book of his early sketches and a critical discussion
> of the work in a separate pamphlet by Peter Wick.

1044 Philips Academy. THE PRENDERGASTS: RETROSPECTIVE EXHIBITION
OF THE WORK OF MAURICE AND CHARLES PRENDERGAST.

> For main entry, see 1039.

1045 Rhys, Hedley Howell. MAURICE PRENDERGAST, 1859-1924. Cambridge,
Mass.: Harvard University Press, 1960. 156 p. 112 black and white
illus., 39 in color. Bibliog. p. 64.

> The most comprehensive study of the artist and his work. A
> good biographical study and discussion of his training and the

evolution of his style. Important source of information on his relationships with others.

QUIDOR, JOHN 1801-81

1046 Baur, John I.H. JOHN QUIDOR. Utica, N.Y.: Munson-Williams-Proctor Institute, 1965. 71 p. Illus., some in color.

> An updating of the 1942 Brooklyn Museum exhibition catalog with essentially the same text. Some biographical information and a good analysis of style by the man who rediscovered the painter.

1047 Rohdenburg, Ernest. "The Misreported Quidor Court Case." THE AMERI-CAN ART JOURNAL 2 (Spring 1970): 74-80.

> Discusses the case in which Quidor sued his teacher, the portrait painter Jarvis, for not teaching him his trade. Quidor won.

1048 Sokol, David M. "John Quidor: Literary Painter." THE AMERICAN ART JOURNAL 2 (Spring 1970): 60-73.

> Provides information about the mission fifteen years of his life, 1836-51, and contrasts the early treatment of literary subjects to his later work.

1049 _____. JOHN QUIDOR: PAINTER OF AMERICAN LEGEND. Wichita, Kans.: Wichita Art Museum, 1973. 84 p. 26 illus. Bibliog. pp. 82-83.

> The catalog of an exhibition of Quidor's paintings based on the stories of Irving and Cooper. Biographical and stylistic information and the source for each work.

RANNEY, WILLIAM TYLEE 1813-57

1050 Grubar, Francis S. WILLIAM RANNEY: PAINTER OF THE EARLY WEST. New York: Clarkson N. Potter, 1962. iv, 65 p. 54 illus., 2 in color. Bibliog. pp. 60-65.

> Good short essay in spite of obvious gaps in knowledge of artist's life. Excellent catalog entries provide valuable information on works.

RATTNER, ABRAHAM 1895-

1051 Getlein, Frank. ABRAHAM RATTNER. New York: Kennedy Galleries, 1969. 47 p. Illus., 13 in color.

759.13
R23g

The catalog of an exhibition of an early American abstractionist wedded to the human figure. Some biographical information.

RAUSCHENBERG, ROBERT 1925-

1052 Forge, Andrew. RAUSCHENBERG. New York: Harry N. Abrams, 1969. 231 p. Illus., some in color. Bibliog. pp. 230-31.

709.73
R24f

Provides the greatest amount of information and illustrations on the abstractionist turned pop artist who was a major force in the latter movement. Some biographical data and an attempt at explaining the development of his style.

1053 Rauschenberg, Robert. ILLUSTRATIONS FOR DANTE'S INFERNO. New York: Harry N. Abrams, 1964. 172 p. Illus.

An interesting set of his works illustrates his own imagery used for the well-known subject.

1054 Solomon, Alan R. ROBERT RAUSCHENBERG. New York: The Jewish Museum, 1963. 65 p. Illus. Bibliog. pp. 63-64.

709.73
R24zj

Exhibition and catalog was the first critical study of the artist. The catalog of fifty-five items is useful. Also contains a complete bibliography of commentary and criticism to the date of writing.

RAY, MAN 1890-

1055 Langsner, Jules. MAN RAY: AN EXHIBITION ORGANIZED BY THE LOS ANGELES COUNTY MUSEUM OF ART. Los Angeles: Los Angeles County Museum of Art, 1966. 148 p. 25 black and white illus., 87 in color. Bibliog. pp. 144-45.

Essays by Ray, Andre Breton, and Carl Betz encompass all aspects of Ray's life and work. This catalog of a retrospective exhibition includes his work in various media over half a century.

1056 Ray, Man. SELF PORTRAIT. Boston: Little, Brown and Co., 1963. 402 p. 36 illus.

A valuable autobiography of a painter, photographer, collagest

and pioneer dadaist. Describes his early years, training, European associations, and interest in the arts.

REINHARDT, ADOLPH FREDERICK 1913-67

1057 Lippard, Lucy [R.]. "Ad Reinhardt: One Art." ART IN AMERICA 62 (September–October 1974): 65-75.

3rd Floor

> Traces his career and the evolution in his painting style from the 1940s to the end. His outlook, feelings about the art world, and his attitudes toward political life in and out of art.

1058 _____. AD REINHARDT: PAINTINGS. New York: The Jewish Museum, 1966. Illus., some in color. Bibliog. pp. 73-76.

> The catalog of a major retrospective exhibition of his work, from his early abstractions to his late shades of black op paintings. Some stylistic analysis and search for sources.

1059 Reinhardt, Ad. "Ad Reinhardt on his Art." STUDIO INTERNATIONAL 174 (December 1967): 265-73.

3rd floor

> An illustrated article in which the artist discusses his large paintings in shades of one color and the philosophical thinking behind his art.

REMINGTON, FREDERIC 1861-1909

1060 Allen, Douglas. FREDERIC REMINGTON AND THE SPANISH AMERICAN WAR. New York: Crown Publishers, 1971. 192 p. Illus.

> Emphasizes this well-known part of Remington's output. Discusses the work and his journalistic connection, but provides no artistic analysis.

1061 Garland, Hamlin. THE BOOK OF THE AMERICAN INDIAN. New York: Harper and Brothers, 1923. 274 p. 35 illus.

> Illustrated with Remington's paintings.

1062 Hassrick, Peter H. FREDERIC REMINGTON. New York: Harry N. Abrams, 1973. 218 p. 94 illus., 60 in color. Bibliog. pp. 215-18.

709.73 R38h

> Well-detailed catalog with complete references to each work. Excellent bibliography.

1063 McCracken, Harold. FREDERIC REMINGTON: ARTIST OF THE OLD WEST. Philadelphia: J.B. Lippincott Co., 1947. 157 p. 29 drawings,

48 illus., 23 in color. Bibliographic checklist pp. 123-55.

Year-by-year and medium-by-medium checklist is an important if somewhat outdated tool for studying individual works by the artist.

1064 _____. THE FREDERIC REMINGTON BOOK. Garden City, N.Y.: Doubleday & Co., 1966. 284 p. 389 illus., 32 in color.

A history of the West, with Remington's work used for documentation and illustration. Good biographical study.

1065 Wear, Bruce. THE BRONZE WORLD OF REMINGTON. Tulsa, Okla.: Gaylord, 1966. 149 p. 41 illus.

A discussion of the methods used by the artist in creating his bronzes. The emphasis is on technique rather than style.

RICHARDS, WILLIAM TROST 1833-1905

1066 Ferber, Linda S. WILLIAM TROST RICHARDS: AMERICAN LANDSCAPE AND MARINE PAINTER, 1833-1905. New York: Brooklyn Museum, 1973. 105 p. Illus. Bibliog. pp. 104-5.

The catalog of the first major exhibition of Richards' paintings. Biographical information covers his travels abroad and analyzes his place in the history of American landscape painting.

1067 Morris, Harrison S. WILLIAM T. RICHARDS: MASTERPIECES OF THE SEA. Philadelphia: J.B. Lippincott Co., 1912. 61 p. 18 illus.

A generally complimentary biography based on personal acquaintanceship and the artist's letters.

RIMMER, WILLIAM 1816-79

1068 Bartlett, Truman Howe. THE ART LIFE OF WILLIAM RIMMER: SCULPTOR, PAINTER, AND PHYSICIAN. 1882. Reprint. New York: Da Capo Press, 1970. xii, 147 p. 31 illus.

General biography that remains an important source although outdated. Should be used with caution.

1069 Sarnoff, Charles A. "The Meaning of William Rimmer's Flight and Pursuit." THE AMERICAN ART JOURNAL 5 (May 1973): 18-19.

A short analysis of the well-known painting which provides the thesis that an attempt at sanctuary, reaching for the horns of the altar, is the actual subject of the painting. Draws upon Old Testament text.

1070 Whitney Museum of American Art. WILLIAM RIMMER, 1816-1879.
November 5-27, 1946. New York: 1946. 42 p. 12 illus. Bibliog.
pp. 33-34.

> Contains a perceptive biographical essay by Lincoln Kirstein.
> He discusses the reasons for the general rejection of Rimmer's
> work.

RIVERS, LARRY 1923-

1071 Alloway, Lawrence. "Derealized Opie." ARTFORUM 10 (June 1972):
35-41. Illus., some in color. Bibliog. p. 41.

> Discussion and analysis of Rivers' abstract pop style seen in
> its cultural context.

3rd floor

1072 Hunter, Sam. LARRY RIVERS. New York: Harry N. Abrams, 1969.
261 p. 220 illus., 52 in color. Bibliog. pp. 257-61.

759.13 R622h

> Biographical and bibliographical data and a serious analysis
> of the development of his painting style and sttitudes. Major
> source of illustrations of his work.

ROBINSON, BOARDMAN 1876-1952

1073 Christ-Janer, Albert. BOARDMAN ROBINSON. Chicago: University
of Chicago Press, 1946. 132 p. 126 illus., some in color. Bibliog.
pp. 79-80.

759.1 R65c

> The only full study of this caricaturist and painter whose work
> evolved from an uneasy cubism into a strong social realism.

ROBINSON, THEODORE 1852-96

1074 Baltimore Museum of Art. THEODORE ROBINSON: 1852-1896. Intro-
duction and essay by Sona Johnston. Baltimore: 1973. xxv, 78 p.
66 black and white illus., 4 in color. Bibliog. pp. 75-78.

> The biography draws heavily on earlier writers, but the writer
> has a critical view of Robinson's impressionism all her own.
> The catalog, while smaller than that of the earlier Brooklyn
> show, is quite up to date and useful.

1075 Baur, John I.H. THEODORE ROBINSON, 1852-1896. Brooklyn:
Brooklyn Museum, 1946. 95 p. 46 illus. Reprinted in THREE NINE-
TEENTH CENTURY AMERICAN ARTISTS. New York: Arno Press, 1969.
95 p.

A short biography draws upon the painter's letters and diary. Good critical analysis of the work and influences on the artist, and a very complete catalog of 377 portraits and landscapes.

ROESEN, SEVERIN ?-1871

1076 Stone, Richard B. NOT QUITE FORGOTTEN: A STUDY OF THE WILLIAMSPORT PAINTER, S. ROESEN. Proceedings and Papers of the Lycoming Historical Society. Williamsport, Pa.: Lycoming Historical Society, 1951. 40 p. 4 illus.

A brief attempt at sorting out the various legends surrounding Roesen's life. Primary sources and oral tradition are both used for documentation. The catalog identifies more than 130 paintings by the artist. Little on the origins of his style.

ROSENQUIST, JAMES 1933-

1077 Tucker, Marcia. JAMES ROSENQUIST. New York: Whitney Museum of American Art, 1972. 135 p. Illus., some in color. Bibliog. pp. 123-25.

759.13
R81 j

The catalog of a major exhibition of his pop art work. Traces his career and discusses the influence of his commercial art experience on his paintings.

ROTHKO, MARK 1903-70

1078 Hess, Thomas B. "The Rothko Donnybrook." ART NEWS 71 (November 1972): 24-25.

3rd
floor

A brief, illustrated article that discusses the lawsuit and conflicting claims over the painter's estate.

1079 Selz, Peter. MARK ROTHKO. Garden City, N.Y.: Distributed by Doubleday for Museum of Modern Art, 1961. Reprint. New York: Arno Press, 1973. 44 p. Illus., some in color. Bibliog. pp. 40-41.

759.13
R84 n

A brief biography in an exhibition catalog that explores the color-rich abstractions of this older member of the New York School. Good documentation on the cataloged works.

RUSSELL, CHARLES MARION 1864-1926

1080 Linderman, Frank Bird. RECOLLECTIONS OF CHARLEY RUSSELL. Edited by H.G. Merriam. Norman: University of Oklahoma Press, 1963.

xxxii, 148 p. 19 illus.

Linderman was a close friend of the artist and the book is full
of anecdotal material concerning his life. Anecdotal memories
of Linderman's children are also included.

1081 Renner, Frederic G. CHARLES M. RUSSELL: PAINTINGS, DRAWINGS
AND SCULPTURE IN THE AMON G. CARTER COLLECTION. Austin:
University of Texas Press, 1966. xvi, 148 p. 223 black and white illus.,
36 in color. Bibliog. pp. 143-44.

An excellent annotated catalog of the works in the museum.
All are illustrated and discussed. Includes a useful biography
of his unusual life.

1082 Russell, Charles Marion. PAPER TALK: ILLUSTRATED LETTERS OF
CHARLES M. RUSSELL. Introduction and commentary by Frederic G.
Renner. Fort Worth, Texas: Amon Carter Museum of Western Art, 1962.
120 p. Illus.

Russells' sharp, witty letters, which discuss matters personal
and artistic.

1083 Yost, Karl. CHARLES M. RUSSELL: THE COWBOY ARTIST, A BIBLIOG-
RAPHY. Pasadena, Calif.: Trail's End Publishing Co., 1948. 218 p.

A bibliography of all sources known to carry illustrations by
the artist, more than 3,000 in total. Useful for the scholar
or collector.

RYDER, ALBERT PINKHAM 1847-1917

1084 Dorra, Henri. "Ryder and Romantic Painting." ART IN AMERICA 48
(1960): 23-33.

Traces the phases of the Romantic Revolution which swept over
Europe and the United States in the nineteenth century and
concludes that Ryder must be associated with Romantic Symbolism.
Comparisons with Baudelaire and various painters.

1085 Goodrich, Lloyd. ALBERT P. RYDER. Great American Artists Series.
New York: George Braziller, 1959. 128 p. Illus., some in color.
Bibliog. pp. 123-26.

One of a series of monographs on American painters. As an
introduction to the artist, it contains basic biographical ma-
terial and an analysis of his style. Discusses his poetic vision.

1086 _____. "Ryder Rediscovered." ART IN AMERICA 56 (November–Decem-
ber 1968): 32-45.

Discusses the major collection of Ryder in The National Collection of Fine Arts, as well as providing an analysis of his creative processes.

1087 Metropolitan Museum of Art. ALBERT P. RYDER: MEMORIAL EXHIBITION. New York: 1918. viii, 12 p. 48 illus.

A catalog with all forty-eight works illustrated.

1088 Museum of Modern Art. SIXTH LOAN EXHIBITION: HOMER, RYDER, EAKINS. New York: 1930. 31 p. Illus.

The essay on Ryder, by B. Burroughs, serves as a general introduction for the general reader. It deals more with personal eccentricities than with formal analysis.

1089 Price, Frederic Newlin. RYDER: A STUDY OF APPRECIATION. New York: William E. Rudge, 1932. xxiv, 202 p. 71 illus.

The essay attempts to grasp the poetic attitude of the painter. It presents us with anecdotes that show him as a naive and childlike mystic. The catalog, which includes the names of collectors, numbers more than 200 items.

1090 Sherman, Frederic Fairchild. ALBERT PINKHAM RYDER. New York: privately printed, 1920. 78 p. 33 illus.

This appreciative author provides a biographical sketch of the artist, compares his poetry to his painting in terms of great meaning and poor technical expression, and concludes with critical analysis of the paintings themselves. Exhibition checklists are supplied.

SAINT MEMIN, C.B.J. 1770-1852

1091 Norfleet, Fillmore. SAINT MEMIN IN VIRGINIA: PORTRAITS AND BIOGRAPHIES. Richmond, Va.: The Dietz Press, 1942. xix, 235 p. Illus. Bibliog. pp. 227-35.

Standard volume on the artist's years in the new world. The author is as much concerned with the subjects of the painting as with the transplanted artist.

1092 Pleasants, J. Hall. SAINT MEMIN: WATERCOLOR MINIATURES. Portland, Me.: Anthoenson Press, 1947. 29 p. 19 plates.

Concentrates on the small body of watercolor miniatures painted in 1803-4 in Maryland and a few executed in Charleston in 1808-9. Documentary discussion of subjects rather than artistic criticism.

SARGENT, JOHN SINGER 1856-1925

1093 Charteris, Evan. JOHN SARGENT. New York: Charles Scribner's Sons,
759.13 1927. xii, 308 p. 50 illus.
S 24c
> An early "standard" biography and detailed year-by-year list
> of paintings. Uses his letters as basic source.

1094 Downes, William Howe. JOHN S. SARGENT: HIS LIFE AND WORK.
Boston: Little, Brown and Co., 1925. xiii, 313 p. 42 illus. Bibliog.
pp. 311-13.
> The early standard biography of Sargent, it makes use of letters
> to and from the painter. The second part of the book is a
> well-documented catalog of the oil paintings, sketches, and
> water colors.

1095 Hoopes, Donelson F. THE PRIVATE WORLD OF JOHN SINGER SARGENT.
Washington, D.C.: Corcoran Gallery of Art, 1964. Unpaged. 58 illus.,
8 in color. Bibliog.
> The author attempts to portray Sargent's own feelings toward
> his career and work rather than presenting a strictly factual
> biography. It is a supplement to the Downes or Mount bi-
> ographies. Good illustrations.

1096 _____. SARGENT WATERCOLORS. New York: Watson-Guptill, 1970.
87 p. 32 color illus. Bibliog. p. 10.
> A valuable critical essay on Sargent's watercolor style and a
> descriptive text for each painting. The development of his
> vigorous late technique is explored.

1097 Metropolitan Museum of Art. MEMORIAL EXHIBITION OF THE WORK
OF JOHN SINGER SARGENT. January 4-February 14, 1926. New York:
1926. xxiii, 14 p. Illus.
> A brief essay by the critic, Mariana Van Rensselaer, and a
> representative catalog of oils and watercolors.

1098 Meynell, A. THE WORK OF JOHN S. SARGENT, R.A. London:
William Heinemann; New York: Charles Scribner's Sons, 1903. Unpaged.
62 plates.
> Valuable for its excellent gravure plates.

1099 Mount, Charles Merrill. JOHN SINGER SARGENT: A BIOGRAPHY.
New York: W.W. Norton & Co., 1955. xv, 464 p. 48 illus.
> A detailed biography based on diaries, the painter's letters,
> archives, and interviews. A convincing picture of the daily
> life and cultural milieu in which the artist worked. A check-
> list of hundreds of works is included.

1100 Museum of Fine Arts. Boston. DECORATIONS OF THE DOME OF THE ROTUNDA: BY JOHN SINGER SARGENT. Boston: 1921. 19 p. Illus.

> Describes the history and subjects of the murals by Sargent.

1101 _____. DECORATIONS OVER THE MAIN STAIRWAY AND LIBRARY: JOHN SINGER SARGENT. Boston: 1926. 23 p. Illus.

> Describes the history, style, and subject matter of these murals by Sargent.

1102 Ormond, Richard. JOHN SINGER SARGENT. New York: Harper & Row, Publishers, 1970. 264 p. 134 plates, many in color. 52 figures.

> An abbreviated biography that contains little new information. The catalog documents each work thoroughly, and the illustrations are large and usually clear.

SCHAMBERG, MORTON LIVINGSTON 1882-1918

1103 Wolf, Ben. MORTON LIVINGSTON SCHAMBERG: A MONOGRAPH. Philadelphia: University of Pennsylvania Press, 1963. 125 p. Illus. Bibliog. p. 125.

> The single valuable source of biographical information on this early dadaist/precisionist.

1104 _____. "Rediscovery: Morton L. Schamberg." ART IN AMERICA 52 (February 1964): 76-80.

> Provides biographical information on the artist's short life and discusses his work as a pioneer abstractionist after his split with the Chase style. Explains lack of popularity by reason of scarcity of his work.

SHAHN, BEN 1898-1969

1105 Bush, Martin H. BEN SHAHN: THE PASSION OF SACCO AND VAN-ZETTI; WITH AN ESSAY AND COMMENTARY BY BEN SHAHN. Syracuse, N.Y.: Syracuse University Press, 1968. 87 p. Illus., some in color. Bibliog. pp. 78-85.

> The infamous trial is well known as a major subject for the artist, and this study traces his various works, in all media, that are based on it. An essay by Shahn helps convey his feelings on art as a form of social expression.

1106 Morse, John D., ed. BEN SHAHN. New York: Frederick A. Praeger, 1972. 228 p. 81 illus., 6 in color. Bibliog. pp. 219-26.

The editor provides a brief essay on Shahn's life and work as well as a chronology. Shahn was not shy about discussing his work and attitudes, and many of his writings are edited for inclusion in this volume.

1107 The National Museum of Modern Art. BEN SHAHN. Tokyo, Japan: 1970. 182 p. Illus., many in color.

This catalog of an exhibition held in Japan is written in both Japanese and English. Primarily valuable as a richly illustrated survey of Shahn's paintings and graphics.

1108 Prescott, Kenneth. THE COMPLETE GRAPHIC WORKS OF BEN SHAHN. New York: Quadrangle Books, 1973. 256 p. Illus.

Shahn's political works and posters are newly presented to those too young to have seen them when published and who have seen primary attention paid to the oil paintings. Many of the subjects are similar in the two media.

1109 Rodman, Selden. PORTRAIT OF THE ARTIST AS AN AMERICAN: BEN SHAHN: A BIOGRAPHY WITH PICTURES. New York: Harper and Brothers, 1951. 180 p. Illus., some in color.

759.13
S52r

A biography for the layman that emphasizes Shahn's interest in art as a form of social criticism, and the artist's personal struggle in the political and social arenas.

1110 Shahn, Ben. THE SHAPE OF CONTENT. Cambridge, Mass.: Harvard University Press, 1967. 131 p. Illus.

704.91
S52s

An autobiographical statement about art, both his own and that of the contemporary abstractionists at the time of his Harvard lecture series in 1957. Later expanded into a major philosophical statement about the meaning of modern art.

1111 Shahn, Bernarda Bryson. BEN SHAHN. New York: Harry N. Abrams, 1972. 384 p. 345 illus., 154 in color. Bibliog. pp. 357-63.

Shahn's widow has presented us with biographical and bibliographical material, a tribute to her husband, and an impressive selection of his major works in color illustrations.

1112 Soby, James Thrall. BEN SHAHN: HIS GRAPHIC ART. New York: George Braziller, 1957. 142 p. Illus.

741.91
S52s

Presents the individual and series of works in the various graphic media. Many of the better-known social commentaries are illustrated and documented as well as some which are not often seen.

1113 _____. BEN SHAHN: PAINTINGS. New York: George Braziller,

759.13
S52s

1963. Illus., some in color. Bibliog. pp. 139-44.

A brief biography and some analysis of Shahn's work, a chronology, and detailed bibliography. Complements the Soby volume on the artist's graphics.

1114 Weiss, Margaret R., ed. BEN SHAHN: PHOTOGRAPHER. New York: Da Capo Press, 1973. 82 illus.

Discusses and illustrates the interest Shahn had in this medium, and examines the relationship between his photographs and his other creative work.

SHEELER, CHARLES 1883-1965

1115 Craven, G.M. "Sheeler at Seventy-Five." COLLEGE ART JOURNAL 18 (Winter 1959): 136-93.

Nominal biographical information. The emphasis is upon Sheeler's development of the hard-edged precisionist style for which he became famous and his later interest in fractionalizing the forms.

1116 Dochteman, Lillian. THE QUEST OF CHARLES SHEELER: 83 WORKS HONORING HIS 80th YEAR. Iowa City: The University of Iowa Press, 1963. 53 p. Illus., some in color. Bibliog. pp. 45-46.

An exhibition catalog that illustrates his work, discusses the development of his style, and contains essays on his contact with cubism, the creation of his mature style, and the relationship of his photography to his painting.

1117 Friedman, Martin; Hayes, Bartlett; and Millard, Charles. CHARLES SHEELER 1883-1965. Washington, D.C.: Smithsonian Institution Press, for National Collection of Fine Arts, 1968. 156 p. 151 black and white illus., 4 in color. Bibliog. pp. 106-7.

Biographical coverage, discussion of his style and photography within a context of Americana. Catalog and index of exhibition.

1118 Kramer, Hilton. "Charles Sheeler, American Pastoral." ARTFORUM 7 (January 1969): 36-39. 10 illus.

Author presents different point of view of Sheeler: that of declining quality after the 1920s, as he moves away form cubism.

1119 Rourke, Constance. CHARLES SHEELER: ARTIST IN THE AMERICAN TRADITION. New York: Harcourt, Brace and Co., 1938. Reprint. New York: Da Capo Press, 1969. 203 p. 48 illus.

An early yet still important biography which brings out the
important studies and influences on the development of Sheeler's
thinking and style. Discusses his associations with artist friends.

1120 Wight, Frederick [S.]. "Charles Sheeler." ART IN AMERICA 42 (October 1954): 180-213. 27 illus.

3rd floor

The biographical information is excellent and used ably in
discussion of the influences upon Sheeler.

SHINN, EVERETT 1876-1953

1121 DeShazo, Edith. "Everett Shinn." AMERICAN ART REVIEW 1 (January-February 1974): 107-14. 7 illus in color.

3rd floor

Biographical material distilled by the author of the Shinn
catalog of 1973.

1122 New Jersey State Museum. EVERETT SHINN, 1876-1953. Trenton:
1973. 61 p. 78 illus.

A catalog of the first comprehensive survey of Shinn's work.
Attention is drawn to his theatrical involvement beyond set
design. He is presented as the tragic figure with too many
interests.

SLOAN, JOHN 1871-1951

1123 Brooks, Van Wyck. JOHN SLOAN: A PAINTER'S LIFE. New York:
E.P. Dutton & Co., 1955. 246 p. Illus.

A biography by a close friend of Sloan and the Ashcan group.
Valuable anecdotes about the interactions of these early social
realists.

1124 DuBois, Guy Pene. JOHN SLOAN. American Artists Series. New
York: Whitney Museum of American Art, 1931. 57 p. 20 illus.
Bibliog. pp. 15-16.

759.1 W62sL

Typical brief biography of the American Artists Series, with
a good selection of illustrations by a friend of the artist.

1125 Goodrich, Lloyd. JOHN SLOAN. New York: Macmillan Publishing
Co., 1952. 80 p. 227 illus., some in color. Bibliog. pp. 78-80.

Brief biography and information about the early New York
School of social realists. Basic discussion of style and catalog
of works.

1126 Roberts, Mary Fantan. "John Sloan: His Art and Its Inspiration."
TOUCHSTONE 4 (February 1919): 362-70.

> An intimate discussion of the man and his work by a good
> friend and figure in the rich cultural scene of which he was
> a part.

1127 St. John, Bruce. JOHN SLOAN. New York: Frederick A. Praeger,
1971. 156 p. 100 black and white illus., 10 in color. Bibliog.
pp. 150-52.

759.1
S632S

> A biography that places Sloan in regard to the art world
> around him. A good selection of graphics and drawings to
> complement the illustrated paintings.

1128 _____, ed. JOHN SLOAN'S NEW YORK SCENE. New York: Harper
& Row, Publishers, 1965. xxvi, 658 p. 54 illus.

> This is Sloan's diary from 1906-13. Provides us with a great
> deal of insight into the man, his thinking and manner of work-
> ing, and interpersonal relationships with the New York cultural
> world.

1129 Scott, David, and Bullard, E. John. JOHN SLOAN: HIS LIFE AND
PAINTINGS BY DAVID W. SCOTT, HIS GRAPHICS BY E. JOHN BULLARD.
Washington, D.C.: National Gallery of Art, 1971. 215 p. Illus.,
some in color. Bibliog. pp. 211-13.

> The catalog of a major exhibition. Important documentation
> of his work in the catalog and selected comments on various
> works culled from the writings of the painter.

SMIBERT, JOHN 1688-1751

1130 Foote, Henry Wilder. JOHN SMIBERT, PAINTER; WITH A DESCRIPTIVE
CATALOGUE OF PORTRAITS, AND NOTES ON THE WORK OF NATHAN-
IEL SMIBERT. Cambridge, Mass.: Harvard University Press, 1950. Re-
print. New York: Da Capo Press, 1969. vii, 292 p. Bibliog. pp. 275-
78. 9 black and white illus.

759.1
S639f

> A valuable catalog of the portraits of the English painter who
> arrived here in the retinue of Berkely and who remained to
> influence painting in Boston for many years. Well-written
> biography.

1131 Smibert, John. THE NOTEBOOK OF JOHN SMIBERT. With essays by
Sir David Evave, John Kers-lake, and Andrew Oliver. Boston: Massa-
chusetts Historical Society, 1969. vi, 131 p.

> Smibert's notebooks suddenly appeared and give us important
> information as to pricing and a number of his previously unre-
> corded patrons.

SOYER, MOSES 1899-1974

1132 Smith, Bernard. MOSES SOYER. New York: A.C.A. Gallery, 1944.
58 p. 44 illus.

> Brief biography and many of the artist's ideas on painting.

1133 Soyer, David. MOSES SOYER. South Brunswick, N.J.: A.S. Barnes
and Co., 1970. 47 p. 127 illus., some in color.

> A personal anecdotal biography by the painter's son in which
> he is identified with the New York realists. Illustrations
> survey his work over a period of almost fifty years.

SOYER, RAPHAEL 1899-

1134 Cole, Sylvan, Jr. RAPHAEL SOYER: 50 YEARS OF PRINTMAKING,
1917-1967. New York: Da Capo Press, 1967. xiii, 257 p. Illus.

> The major source of both information and illustrations of Soyer's
> less-known work in the graphic medium. Many of the prints
> parallel the subjects of the paintings.

1135 Foster, Joseph K. RAPHAEL SOYER: DRAWINGS AND WATERCOLORS.
New York: Crown Publishers, 1968. 26 p. 124 illus., some in color.

> Concentrates on these forms rather than the oil paintings.
> Drawings and watercolors are often translated into his figure
> studies and portraits.

1136 Goodrich, Lloyd. RAPHAEL SOYER. New York: Whitney Museum of
American Art, 1967. 77 p. Illus., some in color. Bibliog. pp. 72-74.

759.1
S72g

> The catalog of a major retrospective exhibition. Biographical
> information plus discussion of the formation and meaning of
> Soyer's style.

1137 _____. RAPHAEL SOYER. New York: Harry N. Abrams, 1972. 349 p.
290 illus., 77 in color. Bibliog. pp. 339-42.

> An extremely well-illustrated volume in which the artist's life
> and work are documented. Research is based on Goodrich's
> previous exhibition catalog.

SPENCER, LILY MARTIN 1822-1902

1138 Bolton-Smith, Robin, and Truettner, William H. LILY MARTIN SPENCER,
1822-1902: THE JOYS OF SENTIMENT. Washington, D.C.: National
Collection of Fine Arts, 1973. 253 p. Illus., some in color. Bibliog.

pp. 240-46.

The catalog of an exhibition which reintroduced the anecdotal genre painting of this once popular artist. Biographical and bibliographical data included.

SPENCER, NILES 1859-1952

1139 Cahill, H[olger]. "Niles Spencer." MAGAZINE OF ART 45 (November 1952): 313-15.

Good discussion of Spencer's style but no biographical information. Discusses the evolution of his use of color as an element in his geometric studies.

1140 Freeman, Richard B. NILES SPENCER. Lexington: University of Kentucky Art Gallery, 1965. 79 p. Illus. Bibliog. p. 43.

Exhibition catalog of the paintings and graphics of one of the early precisionist painters. Spencer was known for his architectural views and strong crisp lines.

STELLA, FRANK 1936-

1141 Rubin, William S. FRANK STELLA. Greenwich, Conn.: New York Graphic Society, 1970. 176 p. 83 illus., some in color. Bibliog. pp. 161-70.

Written as a catalog of a major exhibition of the works of this young painter of large, shaped striped canvases. Explores his feeling for geometric form and color.

STELLA, JOSEPH 1877-1946

1142 Baur, John I.H. JOSEPH STELLA. New York: Frederick A. Praeger, 1971. 154 p. 97 illus., 10 in color. Bibliog. pp. 145-49.

The book is valuable for combining the painstaking and excellent research of Irma Jaffe with the sharp, pointed criticism of Baur. Discusses Stella's place in the area of geometric abstraction and his relationship to the Italian futurists' works.

1143 Jaffe, Irma B. JOSEPH STELLA. Cambridge, Mass.: Harvard University Press, 1970. 262 p. 114 black and white illus., 2 in color. Bibliog. pp. 231-36.

A well-documented and exhaustive biography and catalog of Stella's works in all media. Explores his Italian background

and connections and discusses the problems of defining influences. Includes Stella's writings in Italian.

STERNE, MAURICE 1878-1957

1144 Kallen, H.M. MAURICE STERNE: RETROSPECTIVE EXHIBITION, 1902-1932; PAINTINGS, SCULPTURE, DRAWING. New York: Museum of Modern Art, 1933. 39 p. Illus. Bibliog. pp. 19-20.

>This catalog of an early exhibition provides us with some biographical information and a discussion of his style.

1145 Sterne, Maurice. SHADOW AND LIGHT: THE LIFE, FRIENDS AND OPINIONS OF MAURICE STERNE. New York: Harcourt, Brace and World, 1965. 260 p. 19 illus., 3 in color.

>An easy to read and informative autobiography. The editor filled gaps with comments by friends of the artist. Lacks stylistic analysis.

STILL, CLIFFORD 1904-

1146 McCaughey, Patrick. "Clifford Still and the Gothic Imagination." ARTFORUM 8 (April 1970): 56-61.

>An illustrated article which presents Still's rich, colorful canvases as making up a gothic and mystical whole.

3rd
floor

STUART, GILBERT 1755-1828

1147 Fielding, Mantle. GILBERT STUART'S PORTRAITS OF GEORGE WASHINGTON. Lancaster, Pa.: Wickershon Printing Co., 1923. 264 p. 34 illus.

>Stuart is best known for his many portraits of the first president and, although others have surfaced since this book appeared, the various major "types" are here defined.

1148 Mason, George Chomplin. THE LIFE AND WORK OF GILBERT STUART. New York: Charles Scribner's Sons, 1879. x, 288 p. Illus. with 13 portraits.

>An early but still useful biography of Stuart. The aesthetic values of the time are reflected in the writer's judgments on Stuart's painting.

1149 Morgan, John Hill. GILBERT STUART AND HIS PUPILS. New York:

New York Historical Society, 1939. vii, 102 p. 12 illus.

> Gilbert Stuart is presented as the heir to West in the training of a generation of American painters. A valuable addition to the historical presentation is the "Notes on Painting" reported by Matthew Jouett, based on conversations with Stuart in 1816.

1150 Mount, Charles Merrill. GILBERT STUART: A BIOGRAPHY. New York: W.W. Norton & Co., 1964. 384 p. 56 illus.

> An objective biography that presents both Stuart, the competent and sometimes brilliant artist, and Stuart, the all too human being.

1151 National Gallery of Art. GILBERT STUART: PORTRAITIST OF THE YOUNG REPUBLIC 1755-1828. Meriden, Conn.: Meriden Gravure Co., 1967. 115 p. 58 illus. Bibliog. p. 114.

> This volume is an exhibition catalog and the result of collaboration between John Walker and Daniel Robbins. Authoritative biography and excellent analysis.

1152 Park, Lawrence. GILBERT STUART: AN ILLUSTRATED DESCRIPTIVE CHECKLIST OF HIS WORKS. 4 vols. New York: William E. Rudge, 1926. Illus.

> An important study of the painter with a complete catalog of his portraits. A biography by J. Morgan is thorough, and the two volumes of illustrations are valuable for a study of Stuart's style and clients.

1153 Rhode Island School of Design. Rhode Island Tercentennial Celebration. A CATALOG OF AN EXHIBITION OF PAINTINGS BY GILBERT STUART, FURNITURE BY THE GODDARDS AND TOWNSENDS, SILVER BY RHODE ISLAND SILVERSMITHS. February 6-March 31, 1936. Providence: Ackerman-Standard Co., 1956. 48 p. 8 illus.

1154 Whitley, William Thomas. GILBERT STUART. Cambridge, Mass.: Harvard University Press, 1932. Reprint. New York: Da Capo Press, 1969. xiv, 240 p. 7 illus. Bibliog. pp. 227-28.

759.13
S92w

> A reprint of a good standard monograph on the life of Stuart. Many libraries will have the original edition.

SULLY, THOMAS 1783-1872

1155 Biddle, Edward, and Fielding, Mantle. THE LIFE AND WORKS OF THOMAS SULLY. Philadelphia: Wickersham Press, 1921. viii, 410 p. 15 illus.

> A standard biography based on letters, family papers, etc.

The massive catalog of 2,631 paintings is essential for any study of Sully's work. The appendix contains letters pertaining to his activities with the Pennsylvania Academy of Fine Arts.

1156 Hart, Charles Henry. A REGISTER OF PORTRAITS PAINTED BY THOMAS SULLY. Philadelphia: privately printed, 1909. 202 p.

A brief biographical introduction and the register of almost 2,000 Sully portraits and their present owners.

1157 Pennsylvania Academy of the Fine Arts. MEMORIAL EXHIBITION OF POR-TRAITS BY THOMAS SULLY. April 9-May 10, 1922. Philadelphia: 1922. 186 p. Illus.

A carefully compiled and documented selection of paintings in the exhibition.

1158 Sully, Thomas. HINTS TO YOUNG PAINTERS. 1873. Reprint. New York: Reinhold Publishing, 1965. xxiii, 46 p. Illus.

His early and important book on painting techniques.

TANNER, HENRY OSSAWA 1859-1937

1159 THE ART OF HENRY OSSAWA TANNER, 1859-1937; FROM THE COL-LECTION OF THE MUSEUM OF AFRICAN ART, FREDERICK DOUGLASS INSTITUTE, WASHINGTON, D.C. Glens Falls, N.Y.: Hyde Collection, 1972. 32 p. Illus. Bibliog. pp. 30-32.

Catalog of an exhibition of the paintings of this important realist artist. Cosponsored by several museums devoted to the black community. Discusses his work.

1160 Mathews, Marcia M. HENRY OSSAWA TANNER, AMERICAN ARTIST. Chicago: University of Chicago Press, 1969. xvii, 261 p. Illus., some in color. Bibliographical footnotes in annotations.

A substantial biography of this American realist. Describes his background, studies with Eakins, travels abroad, and election as the first black member of the National Academy. Important documentation and collateral material.

THAYER, ABBOTT 1849-1921

1161 Carnegie Institute. EXHIBITION OF PAINTINGS BY ABBOTT H. THAYER. Pittsburgh: 1919. 41 p.

Early checklist of paintings is valuable for research purposes.

1162 Pousette-Dart, Nathaniel. ABBOTT H. THAYER. Distinguished American
Artists Series. New York: Frederick A. Stokes Co., 1923. xii, 68 p.
64 illus.

> The brief introduction was written by the painter's close friend,
> Royal Cortissoz. Good illustrations.

1163 White, Nelson C. ABBOTT H. THAYER: PAINTER AND NATURALIST.
Hartford: Connecticut Printers, 1951. xxi, 277 p. 69 illus. Bibliog.
pp. 265-69.

> Based on letters and manuscripts collected by Thayer's widow
> and conversations with the critic and friend of the painter,
> Royal Cortissoz. This is an avowed attempt at presenting a
> biography of the individual. The appendix includes letters
> and an essay by the painter.

THEUS, JEREMIAH 1719?-74

1164 Middleton, Margaret. JEREMIAH THEUS: COLONIAL ARTIST OF
CHARLESTOWN. Columbia: University of South Carolina Press, 1953.
xviii, 218 p. 51 illus. Bibliog. pp. 187-89.

> A biography of the Swiss-born painter who became portraitist
> to the colonial South. Discusses his work and contains a
> checklist of paintings.

TOBEY, MARK 1890-

1165 Seitz, William C. MARK TOBEY. New York: Doubleday & Co.,
1962. 112 p. Illus., some in color. Bibliog. pp. 100-106.

759.13
T62se
> The catalog of a major retrospective exhibition of the painter's
> surrealist canvases. It is the best documented study including
> both biographical and stylistic information.

TOMLIN, BRADLEY WALKER 1899-1953

1166 Baur, John I.H. BRADLEY WALKER TOMLIN. New York: Macmillan
Publishing Co., 1957. 62 p. Illus., some in color. Bibliog. pp. 60-61.

759.13
T65 b
> The only substantial study of the painter, it includes essays
> by artist friends, a collector, and a critic. Provides biographi-
> cal information and stylistic analysis.

TOOKER, GEORGE 1920-

1167 Garver, Thomas H. GEORGE TOOKER. San Francisco: The Fine Arts
Museums of San Francisco, 1974. Unpaged. Illus., 14 in color. Bibliog.

759.13
T66g

The catalog of a travelling exhibition of this unusual painter
of realist figure studies often studded with emotional connota-
tions. Biographical data, a chronology, an exhibition record,
and a bibliography.

TRUMBULL, JOHN 1756-1843

1168 Connecticut Tercentenary Commission. PAINTINGS BY JOHN TRUMBULL
AND SAMUEL FINLEY BREESE MORSE. Gallery of Fine Arts, Yale Uni-
versity. New Haven, Conn.: Yale University Press, 1935. 24 p.
3 illus.

The Yale Gallery has the great collection of Trumbull's work,
dating back to his own lifetime. Morse, as a Yale student,
was also regarded as one of its great artistic sons.

1169 Sizer, Theodore. THE WORKS OF COLONEL JOHN TRUMBULL: ARTIST
OF THE AMERICAN REVOLUTION. Rev. ed. New Haven: Yale Uni-
versity Press, 1967. xxiii, 181 p. 276 illus, 1 in color. Bibliog.
pp. 9-10.

759.1
T86s

Concentrates on documenting the paintings of the Revolutionary
period. The important sketches of these paintings are in the
Yale Gallery.

1170 Trumbull, John. THE AUTOBIOGRAPHY OF COLONEL JOHN TRUMBULL,
PATRIOT-ARTIST, 1756-1843. Edited by Theodore Sizer. New Haven:
Yale University Press, 1953. xxiii, 404 p. 4 illus.

The crusty old president of the American Academy and son and
brother of Connecticut governors presents his view of American
history and art.

1171 Weir, John F. JOHN TRUMBULL: A BRIEF SKETCH OF HIS LIFE.
New York: Charles Scribner's Sons, 1901. 80 p. 21 illus.

Trumbull is presented in his role of patriot-artist, the way he
appears to have wished to be seen by posterity. No real criti-
cism.

TYRON, DWIGHT W. 1849-1925

1172 Caffin, Charles H[enry]. THE ART OF DWIGHT W TRYON: AN APPRE-
CIATION. N.p., 1909. 77 p. Illus.

The author presents some biographical information, but primarily an analysis of the paintings in terms of the spiritual force of the artist. Contains a checklist of works painted prior to the date of publication.

TWACHTMAN, JOHN HENRY 1853-1902

1173 Brooklyn Museum. LEADERS OF IMPRESSIONISM: MARY CASSATT, CHILDE HASSAM, JOHN H. TWACHTMAN, J. ALDEN WEIR.

> For main entry, see 1192.

1174 Clark, Eliot. JOHN TWACHTMAN. New York: privately printed, 1924. 76 p. 12 illus. Bibliog. p. 75.

> Good biography and discussion of his style from the early Munich-influenced work through the late impressionism.

1175 Tucker, Allen. JOHN H. TWACHTMAN. American Artists Series. New York: Whitney Museum of American Art, 1931. 56 p. Illus. Bibliog. pp. 14-15.

> Brief biographical note and a valuable catalog of his works.

759.1
W62t

TWORKOV, JACK 1900-

1176 Bryant, Edward. JACK TWORKOV. New York: Frederick A. Praeger, 1964. 56 p. Illus., some in color. Bibliog. pp. 54-56.

> Printed as the catalog of an exhibition at the Whitney Museum, it provides biographical information and discusses his paintings as part of the development of abstract expressionism.

759.13
T97b

VANDERLYN, JOHN 1755-1852

1177 Lindsay, Kenneth C. THE WORKS OF JOHN VANDERLYN: FROM TAMMANY TO THE CAPITOL. October 11-November 9, 1970. Binghamton: State University of New York at Binghamton, 1970. xiii, 153 p. Illus.

> Biographical information, a discussion of the panoramas, and questions of attribution of several works. An important documented catalog is the major source of information concerning his paintings. Includes portraits and landscapes in addition to his well-known historical works.

VEDDER, ELIHU 1836-1923

1178 Reich, Marjorie. "The Imagination of Elihu Vedder as Revealed in His Book Illustrations." THE AMERICAN ART JOURNAL 6 (May 1974): 39-53.

3rd
floor

> Discussion of his interest in mysticism and vision as found in both his paintings and illustrations. His work is compared to that of the English painter, George Watts.

1179 Soria, Regina. ELIHU VEDDER: AMERICAN VISIONARY ARTIST IN ROME. Cranbury, N.J.: Fairleigh Dickinson University Press, 1970. 413 p. 85 illus. Bibliog. pp. 389-401.

> A well-documented biography drawing upon letters and archival material from both Italy and the United States. The author presents both a biography and a study in the taste of the times. For the first time a significant statement about Vedder's role in the decorative arts is presented in the overall view of his work. Contains an important catalog of his paintings and drawings.

1180 Vedder, Elihu. THE DIGRESSIONS OF V. Boston and New York: Houghton Mifflin Co., 1910. xxvi, 521 p. Illus.

> Autobiography of Vedder, meant to be read by friends and associates.

WALKOWITZ, ABRAHAM 1880-1965

1181 Reich, Sheldon. "Abraham Walkowitz: Pioneer of American Modernism." THE AMERICAN ART JOURNAL 3 (September 1971): 72-82.

3rd
floor

> A serious attempt to redefine the importance of Walkowitz, long considered to be the man who drew Isadora Duncan. Provides us with biographical information and discussion as well as illustrations of the evolution of his style.

WARHOL, ANDY 1930-

1182 Coplans, John. ANDY WARHOL. Greenwich, Conn.: New York Graphic Society, 1970. 160 p. Illus., some in color. Bibliog. pp. 157-60.

759.13
W27c

> An introduction to the artist for the layman. Discusses and illustrates both graphics and paintings of this pop artist.

1183 Crone, Rainer. ANDY WARHOL. New York: Frederick A. Praeger, 1970. 332 p. Illus., some in color. Bibliog. pp. 318-31.

759.13
W27cr

A well-documented attempt to present the artist as a major figure in the contemporary art world. Includes a catalog raisonne of more than twenty-five pages, but it might not be complete. Discusses both the traditional arts and Warhol's work in film.

WATSON, JOHN 1685-1768

1184 Morgan, John Hill. JOHN WATSON: PAINTER, MERCHANT AND CAPITALIST OF NEW JERSEY, 1685-1768. Worcester, Mass.: American Antiquarian Society, 1941. 101 p. 12 illus.

An important source of data on an elusive figure in eighteenth-century portrait painting. Many biographical gaps and a small selection of illustrations.

WAUGH, FREDERICK J. 1861-1940

1185 Havens, George R. FREDERICK J. WAUGH: AMERICAN MARINE PAINTER. Orono: University of Maine Press, 1969. 361 p. Illus., 2 in color. Bibliog. pp. 261-81.

A well-researched and documented study of the painter's life and his paintings of the ocean. Gives us some idea of the extent of his ouvre and provides a detailed bibliography.

WEBER, MAX 1881-1961

1186 Barr, Alfred [H., Jr.]. MAX WEBER: A RETROSPECTIVE EXHIBITION. New York: Plandome Press, for the Museum of Modern Art, 1930. 22 p. 17 illus.

Barr's introduction contains biographical data based on the writing of Cahill. Traces Weber's entry into the various European modern movements.

1187 Cahill, Holger. MAX WEBER. New York: The Downtown Gallery, 1930. 45 p. 32 plates.

Adequate discussion of influences, yet statements by Weber on his work and art are the success of the catalog.

1188 Story, Ala. FIRST COMPREHENSIVE RETROSPECTIVE EXHIBITION IN THE WEST OF OILS, GOUACHES, PASTELS, DRAWINGS AND GRAPHIC WORKS BY MAX WEBER, 1881-1961. Santa Barbara: The Art Galleries, University of California at Santa Barbara, 1968. 86 p. Illus. Bibliog. pp. 24-27.

709.73
W 37f

The catalog of an important retrospective exhibition which covered works done over a half century by this pioneer member of the Stieglitz Circle.

1189 Werner, Alfred. "Max Weber at Seventy-Five." ARTS 32 (September 1958): 10.

3rd floor

Excellent article that discusses Weber's involvement in Paris with the Steins and also in America during the days of Stieglitz's "291" after the Armory Show.

WEIR, JOHN FERGUSON 1841-1926

1190 Sizer, Theodore, ed. THE RECOLLECTIONS OF JOHN FERGUSON WEIR. New York: Historical Society, 1957. 93 p. 10 illus.

Chapters on the years at West Point, his life in New York in the 1860s, and his first eight years as a Yale professor. Edited from autobiographical fragments.

1191 Weir, John F. "American Art, Its Progress and Prospects." THE PRINCETON REVIEW 1 (May 1878): 815-29.

Discusses the diversity of American art and counsels the reader to seek nature rather than the past.

WEIR, JULIAN ALDEN 1852-1919

1192 Brooklyn Museum. LEADERS OF IMPRESSIONISM: MARY CASSATT, CHILDE HASSAM, JOHN H. TWACHTMAN, J. ALDEN WEIR. Brooklyn, N.Y.: 1937. 43 p. 12 illus.

An exhibition catalog of the works of the four painters. Discusses Weir's work within the specific context of impressionism.

1193 Century Club. JULIAN ALDEN WEIR: AN APPRECIATION OF HIS LIFE AND WORKS. New York: 1921. x, 141 p. 25 illus.

Includes essays by the collector Duncan Phillips, the critic Royal Cortissoz, and fellow artists Childe Hassam, J.B. Millet, and others. Primarily personal anecdotes and some important information about the Tile Club and Weir's participation in that organization.

1194 Metropolitan Museum of Art. MEMORIAL EXHIBITION OF THE WORKS OF JULIAN ALDEN WEIR. March 17-April 20, 1924. New York: 1924. xxii, 18 p. 40 illus.

Catalogs the oils, water-colors, drawings, and prints in

chronological order.

1195 University of Nebraska Art Galleries. THE ETCHINGS OF J. ALDEN WEIR. November 7-December 3, 1967. Lincoln: 1967. Unpaged. 18 illus.

Contains a catalog of 128 known etchings by Weir and provides documentary information and a list of collections in which each is to be found.

1196 Young, Dorothy Weir. THE LIFE AND LETTERS OF J. ALDEN WEIR. Edited by Lawrence W. Chisolm. New Haven: Yale University Press, 1960. Reprint. New York: Da Capo Press, 1971. xxxii, 277 p. 37 illus.

The letters of and to the painter. Of particular importance are those from his European travels and to other American artists such as Ryder and Hassam. Includes biographical information by his daughter.

WEST, BENJAMIN 1738-1820

1197 Brinton, Ellen Starr. "Benjamin West's Painting of Penn's Treaty with the Indians." BULLETIN OF FRIENDS' HISTORICAL ASSOCIATION 30 (Autumn 1941): 99-189. 35 illus.

A discussion of the history and influence of this important painting by West.

1198 Evans, Grose. BENJAMIN WEST AND THE TASTE OF HIS TIMES. Carbondale: Southern Illinois University Press, 1959. 144 p. 73 illus., 1 in color. Bibliog. pp. 129-38.

The contributions of West are placed within the context of cultural history both here and in England. The position is documented by reference to a great deal of primary and secondary material.

1199 Galt, John. THE LIFE, STUDIES AND WORKS OF BENJAMIN WEST, ESQUIRE. London: T. Cadell & W. Davies, 1820. 251 p.

This is the standard early biography written by a source close to the subject. Galt's opinion was colored by the relationship and, while providing many important biographical insights, is weak in analysis of the works themselves.

1200 Jackson, Henry Ezekiel. BENJAMIN WEST: HIS LIFE AND WORK. Philadelphia: The J.C. Winston Co., 1900. 115 p. 12 illus.

Biography based on the life of West by Galt. The critical evaluation is too scant.

1201 Pennsylvania Art Museum. THE WORLD OF BENJAMIN WEST. Allentown: 1962. 96 p. 95 illus.

 Exhibition of the works of West and his contemporaries.

1202 Philadelphia Museum of Art. BENJAMIN WEST, 1738-1820. Philadelphia: 1938. 58 p. 20 illus.

 Written in conjunction with an exhibition commemorating the two hundredth-anniversary of West's birth. A brief biography and selection of paintings.

1203 Sawitzky, William. "The American Work of Benjamin West." PENNSYL-VANIA MAGAZINE OF HISTORY AND BIOGRAPHY 62 (October 1938): 433-62. 35 illus.

 This article is concerned with the small number of authenticated works painted by West while in the United States, or for an American patron.

WHISTLER, JAMES ABBOTT McNEILL 1834-1903

Although Whistler is an extremely important artist of the nineteenth century, he left the country so early and, unlike West, had so little to do with it that he can hardly be thought of as an American. One representative study is included to illustrate his importance in the history of art.

1204 Sweet, Frederick A. JAMES McNEILL WHISTLER. Chicago: Art Insti-tute of Chicago, 1968. 131 p. Illus., some in color. Bibliog. pp. 49-51.

759.1
W 57sw

 The catalog of an important exhibition with essays on his life, importance of his work, and his relationship with important European artists.

WHITTREDGE, THOMAS WORTHINGTON 1820-1910

1205 Baur, John I.H., ed. THE AUTOBIOGRAPHY OF WORTHINGTON WHITTREDGE, 1820-1910. New York: Arno Press, 1973. 68 p. Illus.

 The autobiography of an important Dusseldorf-trained landscape painter whose long career resulted in a growing freedom of execution and departure from topography. This is a reprint of an article that appeared in BROOKLYN MUSEUM JOURNAL 1 (1942): 1-68.

1206 Dwight, Edward H. RETROSPECTIVE EXHIBITION OF AN AMERICAN ARTIST. Utica, N.Y.: Munson-Williams-Proctor Institute, 1969. 72 p. 44 illus.

The catalog of the major exhibition of paintings in recent years.
Biographical information, a discussion of the sources of his style,
and an analysis of his landscapes.

WILLIAMS, WILLIAM ?-1790

1207 Richardson, Edgar Preston. "William Williams: A Dissenting Opinion."
THE AMERICAN ART JOURNAL 4 (Spring 1972): 5-23.

Proposes the idea that there were really several William
Williamses and attempts to establish a body of work for
each.

1208 Williams, John Francis. THE ANCESTOR: THE WORLD OF WILLIAM
WILLIAMS. Philadelphia: Dorrance, 1973. 184 p. Illus.

Discusses the life of the elusive painter and tries to sort out
his work. Mentions his influence on West.

WIMAR, CHARLES 1828-62

1209 Hodges, William Romaine. CARL WIMAR: A BIOGRAPHY. Galveston,
Tex.: Charles Reymershoffer, 1908. 87 p. 12 illus.

Contains a biography and a list of Wimar's works and their
owners. Much of the information on his western journeys of
1858 is provided in his own letters. Illustrates his concern
for the dramatic in the life of the Indians.

WOOD, GRANT 1891-1942

1210 Baigell, Matthew. "Grant Wood Revisited." ART JOURNAL 26 (Winter
1966): 116-22.

An attempt to reevaluate the importance of this painter and
to explain the popularity of "American Gothic" as a monument
in the history of art.

1211 Brown, Hazel E. GRANT WOOD AND MARVIN CONE: ARTISTS OF
AN ERA. Ames: Iowa State University Press, 1972. 150 p. Illus.,
some in color.

A biography of two of the author's friends. Concerned with
Wood's life and the realism of his regionalist paintings.

1212 Garwood, Darrell. ARTIST IN IOWA: A LIFE OF GRANT WOOD.
New York: Norton, 1944. Reprint. New York: Greenwood, 1971.

213

259 p. 10 illus.

A journalistic biography with undocumented quotations from
the artist.

WOOD, THOMAS WATERMAN 1823-1903

1213 Wood Gallery of Art. CATALOG OF THE PICTURES IN THE ART GAL-
LERY IN MONTPELIER. Montpelier, Vt.: Capital City Press, 1913.
80 p. Illus.

Contains a biography of the artist and descriptions of the art
of Wood and others located in the gallery that bears his name.
Includes a list of some 170 sketches.

WYANT, ALEXANDER HELWIG 1836-72

1214 Clark, Eliot. ALEXANDER WYANT. New York: Frederic F. Sherman,
1916. 69 p. 15 illus.

A biography and analysis of the painter's landscapes. His
activity in Dusseldorf and how his education there affected
his style are discussed.

1215 _____. SIXTY PAINTINGS BY ALEXANDER H. WYANT. New York:
Frederic F. Sherman, 1920. 144 p. 60 illus.

Each painting is described in terms of subject matter, composi-
tion, and form.

WYETH, ANDREW 1917-

1216 Corn, Wanda M., ed. THE ART OF ANDREW WYETH. Greenwich,
Conn.: New York Graphic Society, 1973. 176 p. 121 illus.

759.13
W97c

Although there have been many picture books on Wyeth, this
volume attempts to provide some information on his painting
technique and style.

1217 Meryman, Richard. ANDREW WYETH. Boston: Houghton Mifflin Co.,
1968. 174 p. Illus., some in color.

759.13
W97m

A well-designed picture book with unusually good illustrations.
Surveys the artist's paintings over his long career.

1218 Richardson, Edgar P. ANDREW WYETH: TEMPERAS, WATERCOLORS,
DRY BRUSH DRAWINGS, 1938 INTO 1966. Philadelphia: Pennsylvania
Academy of the Fine Arts, 1966. 111 p. Illus., some in color.

The catalog of an exhibition. It contains solid biographical information and an analysis of the style.

ZORACH, MARGUERITE THOMPSON 1887-1968

1219 Tarbell, Roberta K. "Early Paintings by Marguerite Thompson Zorach." AMERICAN ART REVIEW 1 (March-April 1974): 43-57.

3rd
floor

A discussion of her early Fauve paintings, her training and biographical material. Quotes from her letters to Zorach.

Chapter 9

AMERICAN SCULPTURE

Compared to the amount of writing on architecture and painting, there has been very little published on the subject of American sculpture. Whether for reasons related to portability or a strong iconoclastic tradition from the time of the Puritans onward, other than decorative carving, work has been minimal. The decorative work will be covered in another chapter, so the small number of studies below represents the bulk of useful materials in the field. There being such a paucity of references, there has been no attempt to divide them either by genre or period.

1220 Adams, Adeline. THE SPIRIT OF AMERICAN SCULPTURE. New York: The Gilliss Press, 1923. xx, 234 p. 21 illus.

> A philosophical treatise that emphasizes the types of sculpture and attempts to define the American point of view about it. The author explains what was appreciated and why.

1221 "American Sculpture." ARTFORUM 5 (Summer 1967): entire issue.

> Essays on the various developments in American sculpture in the late 1950s and early 60s. Work in various media, including mixed media, is examined in this special issue of ART-FORUM.

1222 Ashton, Dore. MODERN AMERICAN SCULPTURE. New York: Harry N. Abrams, 1968. 54 p. 28 black and white illus., 80 color plates.

> Presents ideas on the meaning and development of an interest in abstraction in the work of American sculptors. Stylistic influences on the younger generation are explored, and an exposition of how each one uses materials and techniques in a search for form is presented. Excellent illustrations are oversize.

1223 Baro, Gene. "American Sculpture: A New Scene." STUDIO INTER-NATIONAL 175 (January 1968): 9-19.

> An illustrated article that discusses postabstract developments in which plastics play an important part, as does realism of

the surface.

1224 Berry, Rose V.S. AMERICAN SCULPTURE AT THE PALACE OF THE LEGION OF HONOR. Los Angeles: University of California, 1939. 47 p. Illus.

> Discusses the work exhibited for three months in 1929 and provides biographical data and stylistic information on many important American sculptors of the early years of this century. The selection is somewhat conservative. First appeared as an article in the UNIVERSITY OF CALIFORNIA CHRONICLE, October 1929.

1225 Bolton, Ethel. AMERICAN WAX PORTRAITS. Boston and New York: Houghton Mifflin Co., 1929. vii, 68 p. 15 illus.

> A history of the technique in America emphasizing the work of Patience Wright. In addition, there is a register of those works surviving at the date of writing.

1226 Brewington, Marion Vernon. SHIPCARVERS OF NORTH AMERICA. Barre, Mass.: Barre Publishing Co., 1962. xiv, 173 p. 134 black and white illus. Bibliog. pp. 147-53.

> Illustrations of figureheads and other carvings from the eighteenth century through the end of the nineteenth. Biographical information about the carvers and history of the ships for which the carvings were done.

1227 Broder, Patricia Janis. BRONZES OF THE AMERICAN WEST. New York: Harry N. Abrams, 1974. 431 p. 511 illus., some in color. Bibliog. pp. 393-96.

> Chapters on the work of individually well-known sculptors such as Solon Borglum, Frederic Remington, and Charles M. Russell, and subject chapters that cover the various sculptors who worked in an area. Certainly contains the widest selection of illustrations assembled on the subject and a scholarly and useful bibliography.

1228 Brooklyn Museum. RECENT WORK BY DISTINGUISHED SCULPTORS. New York: 1930. Unpaged. Illus.

> This is essentially a small catalog of illustrations. Its value is in the pictured works that are so seldom seen. Figurative sculpture of the 1910s through the 20s.

1229 Brumme, C. Ludwig. CONTEMPORARY AMERICAN SCULPTURE. New York: Crown Publishers, 1948. 156 p. 130 illus. Bibliog. pp. 150-56.

> No real text; full page illustrations, biographical note and a

good (though out-of-date) bibliography.

1230 Bullard, F. Lauriston. LINCOLN IN MARBLE AND BRONZE. New
Brunswick, N.J.: Rutgers University Press, 1952. xiii, 353 p. 69 illus.

Contains fifty-six short chapters on individual Lincoln projects
or on the work of one sculptor. The problems involved in
dealing with such a well-known and unusual looking figure
are presented with extensive quotations from the sculptors
themselves.

1231 Caffin, Charles [Henry]. AMERICAN MASTERS OF SCULPTURE. New
York: Doubleday, Page and Co., 1903. xiii, 230 p. 31 plates.

735.73
C 12

Biographical essays on various nineteenth-century American
sculptors: Saint-Gaudens, J.Q.W. Ward, French, Macmonnies,
and others.

1232 Christensen, Edwin. EARLY AMERICAN WOOD CARVING. Cleveland
and New York: World Publishing Co., 1952. 149 p. 52 black and
white illus., 12 in color. Bibliog. pp. 139-43.

A picture of wood carving from colonial days through 1900.
Chapters on figureheads and sternboards, amusement props,
portraits, monuments, architectural decoration, and other areas.
Includes a valuable list of museums and historical societies
which own such works.

1233 Clark, William J. GREAT AMERICAN SCULPTURES. Philadelphia:
Gebbie & Barrie Co., 1878. 144 p. 12 illus.

Not a very good attempt at distinguishing between the impor-
tance of the subject and the quality of the sculpture.

1234 Coplans, John. FIVE LOS ANGELES SCULPTORS. Irvine: University
of California at Irvine, 1966. 36 p. Illus., some in color.

The catalog of an exhibition of five sculptors interested in
freedom to develop the potential of their materials. Both
hard-edged and biomorphic forms are found, and a section on
the drawings of sculptors is included.

1235 Crane, Sylvia. WHITE SILENCE: GREENOUGH, POWERS, AND CRAW-
FORD. AMERICAN SCULPTORS IN NINETEENTH CENTURY ITALY.
Coral Gables, Fla.: University of Miami Press, 1972. xviii, 499 p.
Illus. Bibliog. pp. 459-89.

Monograph type treatment of each of the three important
figures in (neoclassical) nineteenth-century American sculp-
ture. Biographical studies integrated with information on and
illustrations of their work. Emphasizes their dependence on
and interest in European associations.

1236 Craven, Wayne. SCULPTURE IN AMERICA. New York: Thomas Y. Crowell, 1968. xx, 722 p. Illus. Bibliog. pp. 675-90.

The most complete and thorough history of American sculpture, from the early views of the seventeenth century to the middle of the twentieth. Profusely illustrated.

1237 _____. "1776--How America Really Looked: Sculpture." THE AMERICAN ART JOURNAL 7 (May 1975): 34-42.

A general survey of the varieties of sculpture and sculptural decoration being executed at the time of the Revolution. Gravestones, portrait busts, and ship carvings are included, along with a discussion of sources of style.

3rd floor

1238 Crawford, John Stephens. "The Classical Orator in Nineteenth Century American Sculpture." THE AMERICAN ART JOURNAL 6 (November 1974): 56-72.

3rd floor

Interesting discussion of the reasons for orators' representations in specific poses, based on literary sources. Many illustrations comparing sculpture of the nineteenth century to that of similar subjects in classical antiquity.

1239 Forbes, Harriet Merrifield. GRAVE STONES OF EARLY NEW ENGLAND. Boston: Houghton Mifflin Co., 1927. Reprint. Princeton, N.J.: Pyne Press, 1973. 252 p. 192 illus.

731.54 F69g

A survey of the gravestones, their location, symbolism, and an attempt to place them in a cultural context.

1240 Fried, Frederick. ARTISTS IN WOOD. New York: Clarkson N. Potter, 1970. 320 p. 234 illus., 26 in color.

A well-illustrated survey of a wide range of wooden sculpture from the folk tradition to the work of highly trained professionals.

1241 Gardner, Albert T[en] E[yck]. AMERICAN SCULPTURE: A CATALOGUE OF THE COLLECTION OF THE METROPOLITAN MUSEUM OF ART. Greenwich, Conn.: New York Graphic Society, 1965. xii, 192 p. Illus.

735 N532a Ref. shelf

Provides a brief history of each sculptor represented. Each work is then discussed. Background information is provided, and a catalog entry is made. Heavy emphasis on the nineteenth century.

1242 _____. YANKEE STONECUTTERS: THE FIRST AMERICAN SCHOOL OF SCULPTURE, 1800-1850. New York: Columbia University Press, 1944.

735 G-22

84 p. 12 plates. Bibliog. pp. 76-80.

The volume is divided into two parts: the first deals with types and categories of sculpture; the second with the lives and work of specific sculptors born before 1850.

1243 Gerdts, William H. AMERICAN NEO-CLASSIC SCULPTURE: THE MARBLE RESURRECTION. New York: Viking Press, 1973. 160 p. 179 illus. Bibliog. pp. 149-60.

735.73
G36a

Discusses the history and critical reaction to neoclassic sculpture from the mid-nineteenth century through the present. Categories of work are presented, such as angels, funeral monuments, the female nude, Christ and Satan, etc., and several illustrations are provided for each category. Includes highly detailed bibliography.

1244 _____. "Marble and Nudity." ART IN AMERICA 59 (May-June 1971): 60-67.

3rd
floor

Presents the point of view that neoclassic sculpture was the vehicle for repressed sexual expression in nineteenth-century America. Illustrates the work of many figures and discusses poses, drapery, and other ways that permitted sensuality to break through conventions.

1245 _____. A SURVEY OF AMERICAN SCULPTURE: LATE 18th CENTURY TO 1962. Newark, N.J.: The Newark Museum, 1962. 44 p. Illus.

Traces the history of styles, materials, and techniques of our sculptors who trained both here and abroad. Discusses academic successes and the various revolts against the academy, and compares the work of sculpture to developments in painting in each era.

1246 Giedion-Welcker, Carola. CONTEMPORARY SCULPTURE: AN EVOLUTION IN VOLUME AND SPACE. 3rd rev. ed. New York: Wittenborn and Co., 1960. xxxi, 400 p. Illus.

735.
G45c3

A general survey of twentieth-century sculpture, with adequate coverage of major American figures. Discusses both figurative and abstract sculptors.

1247 Gridley, Marion E. AMERICA'S INDIAN STATUES. Chicago: The Ameridian, 1966. 104 p. Illus.

A catalog of the major statues of American Indians in the United States. The sculptor, medium, date, size, and location are provided for each, as is a photograph and information about the subject. A guide for the general reader.

1248 Ludwig, Allan I. GRAVEN IMAGES. Middletown, Conn.: Wesleyan University Press, 1966. xxxi, 482 p. Illus. and maps.

731.76
L94g

Important for iconographic interpretations of the gravestones of early New England. Covers the period from 1650 to 1815.

1249 McSpadden, Joseph. FAMOUS SCULPTORS OF AMERICA. New York: Dodd, Mead and Co., 1924. xv, 377 p. Illus. Bibliog. pp. 369–77.

Chapters on the usual major nineteenth-century American sculptors. Especially singles out a group of women sculptors for separate discussion.

1250 Metropolitan Museum of Art. AMERICAN SCULPTURE, 1951. December 7, 1951–February 24, 1952. New York: 1951. 13 p. 49 plates.

735
N532a
REF
SHELF

The catalog of one of the large exhibitions held by the Metropolitan in an attempt to get involved in the contemporary art scene. This one, devoted to sculpture, presents an interesting cross sample, although almost exclusively in illustrations of the work valued by the jury of sculptors.

1251 National Sculpture Society. AMERICAN SCULPTURE: EXHIBITION CATALOGUE. April 4–August 1, 1923. New York: 1923. xiv, 372 p. Illus.

Biographical entries on hundreds of sculptors, their background, training, and exhibitions. Illustrations of both monumental sculpture and medals and plaques.

1252 New Jersey Cultural Council. SCULPTURE IN THE PARK: AN EXHIBITION OF AMERICAN SCULPTURE. Paramus, N.J.: Van Saan Park, 1974. 118 p. Illus.

A survey of the sculptural forms in American history presented in this exhibition catalog. Some biographical information on each sculptor.

1253 Pinckney, Pauline. AMERICAN FIGUREHEADS AND THEIR CARVERS. New York: W.W. Norton & Co., 1940. 223 p. 32 plates. Bibliog. pp. 204–10.

Describes the figureheads on some of the most famous American ships as well as discusses the different types of subjects—politicians, mythological figures, etc.—favored by the American public. Primarily a record of the nineteenth century.

1254 Proske, Beatrice. BROOKGREEN GARDENS SCULPTURE. Rev. ed. Brookgreen, S.C.: Brookgreen Gardens, 1964. xxxiii, 574 p. Illus. Bibliog. pp. 513–44.

Biographies of all the sculptors whose work is in Brookgreen Gardens, an unusual botanical gardens with sculpture. All

works in the collection are illustrated.

1255 Read, Herbert. A CONCISE HISTORY OF MODERN SCULPTURE. New York: Frederick A. Praeger, 1964. 310 p. Illus., some in color. Bibliog. pp. 283-85.

735
R28c

> A good general history of modern sculpture that includes important Americans of the mid-twentieth century and places them them in historical perspective. Both the early figurative and the later nonobjective works are covered.

1256 Rickey, George. "The New Tendency." ART JOURNAL 23 (Summer 1964): 272-79.

3rd
floor

> Written by a strong proponent of constructivism and geometric abstraction, the article gives a picture of certain directions in sculpture but ignores others.

1257 Rose, Barbara. "Blowup-The Problem of Scale in Sculpture." ART IN AMERICA 56 (July-August 1968): 80-91.

3rd
floor

> In both traditional abstract, but more important, in minimalist statements, the work is getting bigger and bigger. Need it be to make the point?

1258 Rusk, William Sener. ART IN BALTIMORE: MONUMENTS AND MEMORIALS. Baltimore: The Norman, Remington Co., 1924. xviii, 141 p. Illus. Bibliog. p. 129.

> Tells the reader about the location, historical particulars, and importance of each notable piece of public sculpture in Baltimore. When the sculptor is known, information about him is provided.

1259 San Francisco. Panama-Pacific International Exposition, 1915. SCULPTURE AT THE EXPOSITION. San Francisco: H.S. Crocker Co., 1915. xii, 96 p.

> Descriptive notes on the statuary of the exhibition. A.S. Calder supervised the planning, placement, and naming of the sculpture at the exposition.

1260 Schnier, Jacques. SCULPTURE IN MODERN AMERICA. Berkeley: University of California Press, 1948. ix, 224 p. 139 illus. Bibliog. pp. 65-67.

735.73
S36

> The author discusses and illustrates a great number of sculptors known today only to the specialist. The photos of the less-known works are of great value.

1261 Sculptors Guild. SCULPTURE, 1955: OUTDOOR EXHIBITION. June-September 1955. New York: 1955. 62 p. 54 illus.

A picture book of the works of this loose association of American sculptors. Much of the work shows the direct influence of such well-known sculptors as Henry Moore and David Smith.

1262 SCULPTORS' GUILD TRAVELLING EXHIBITION, 1940-1941. New York: 1940. Unpaged. 112 illus.

Information on the background, preferred medium, and exhibition record of fifty-six sculptors in the guild. Also illustrates each one at work and one completed piece of each sculptor. Many of the artists are unknown today, and a few are highly successful.

1263 Seymour, Charles, Jr. TRADITION AND EXPERIMENT IN AMERICAN SCULPTURE. Washington, D.C.: American University Press, 1949. viii, 86 p. Illus.

735
S 52

A history of sculpture that compares academic and avant-garde developments.

1264 Sharp, Lewis I. NEW YORK CITY PUBLIC SCULPTURE: BY 19th CENTURY AMERICAN ARTISTS. New York: Metropolitan Museum of Art, 1974. 68 p. 22 illus. Bibliog. p. 68.

A brief introduction to public sculpture in New York is followed by studies and illustrations of individual works, information about the artist and subject, and details about the commission. Suggested walking tours are provided.

1265 Taft, Lorado. THE HISTORY OF AMERICAN SCULPTURE. 2nd ed. New York: Macmillan Publishing Co., 1924. xii, 600 p. 116 illus.

735.73
T12

An early history of American sculpture by one of the best-known sculptors of his time. Separate chapters on sculptors of animals and decorative sculptors.

1266 Tashjian, Dickran, and Tashjian, Ann. MEMORIALS FOR CHILDREN OF CHANGE: THE ART OF EARLY NEW ENGLAND STONECARVING. Middletown, Conn.: Wesleyan University Press, 1974. 309 p. 162 illus. Bibliog. pp. 297-99.

736.5
T19m

A complete and detailed study of seventeenth and eighteenth-century gravestones, within a framework of the culture which produced them. The design of the stones is compared to that of the other decorative arts of the era.

1267 Thorp, Margaret. THE LITERARY SCULPTORS. Durham, N.C.: Duke University Press, 1965. x, 206 p. 24 illus. Bibliog. pp. 198-202.

A study of what would usually be called the neoclassic sculptors. Discusses the work and lives of both those who lived in Italy and those who remained here. In addition, there is a good

short chapter on patrons.

1268 Tuchman, Maurice, ed. AMERICAN SCULPTURE OF THE SIXTIES. Los Angeles: Los Angeles County Museum of Art, 1967. 258 p. 165 illus., some in color. Bibliog. pp. 236-56.

735.73
T88a
The catalog of a major exhibition of American twentieth-century sculpture. Critical essays on the movements and important individuals in the contemporary scene, artists' statements, very good illustrations, and biographical/biblio-graphical entries on all the artists included in the exhibition.

1269 Walker Art Center. TEN AMERICAN SCULPTORS. Minneapolis, Minn.: 1964. Unpaged. Illus.

w
735.73
w17t
The small catalog of the exhibition of American sculpture which appeared at the biennial in Sao Paolo and travelled to various American cities. The work of both figural and abstract form sculptors is illustrated and biographical infor-mation is provided.

1270 Whitney Museum of American Art. ANNUAL EXHIBITION OF SCULPTURE. 1968- . Biannual.

Each biannual catalog provides illustrations and data on the work of contemporary American sculptors. No real text, but good documentation as to taste in the museum art establish-ment.

1271 _____. CONTEMPORARY AMERICAN SCULPTURE. New York: 1966. 63 p. Illus.

Biographical entries on each sculptor and illustrations of his work. Contemporary figures working in a variety of media and styles.

1272 Whittemore, Frances Davis. GEORGE WASHINGTON IN SCULPTURE. Boston: Marshall Jones Co., 1933. xv, 203 p. 47 illus.

Discusses the major works and projects of the figure of Washing-ton, including several by Europeans. The circumstances surround-ing each commission and the details of the work are provided. Small but clear illustrations.

Chapter 10

INDIVIDUAL SCULPTORS

Individual American sculptors have not been written about nearly as much as painters have been. In addition, very little has been written about nineteenth-century figures in the past fifty years, and our only sources of information are often books and articles written as much as 100 years ago. The one volume that is indispensable as a source of biographical data on the entire history of American sculpture is Wayne Craven's SCULPTURE IN AMERICA (see 1236).

ADAMS, HERBERT 1858-1945

1273 Peixotto, Ernest. "The Sculpture of Herbert Adams." AMERICAN MAGA-ZINE OF ART 12 (May 1921): 151-59.

> Discusses the work of this academic portrait sculptor who worked in a realist/idealized style. Mention of his monumental statues as well.

AUGUR, HEZEKIAH 1791-1858

1274 Baldwin, Ebenezer. "Auger." AMERICAN HISTORICAL MAGAZINE AND LITERARY RECORD 1 (February 1836): 44-53.

> Although extremely old, this is the only published source to concentrate on the work of this native born self-taught pioneer carver of wood and marble. Mentions his more famous neo-classical ideal figures.

BALL, THOMAS 1819-1911

1275 Ball, Thomas. MY THREE SCORE YEARS AND TEN: AN AUTOBIOG-RAPHY. Boston: Roberts Brothers, 1892. xi, 379 p. Illus.

> Discusses his familial relationships, his childhood, education, and years of work in both New England and Italy. Explains his interest in naturalism rather than in traditional classicism.

BARNARD, GEORGE GREY 1863-1938

1276 Dickson, Harold E. "Barnard's Sculptures for the Pennsylvania Capitol." ART QUARTERLY 22 (1959): 127–47.

Discusses the sculptural decorations which took ten years to complete (1903-13) and their general relationship to his other realistic work.

3rd floor

1277 _____. "The Other Orphan." THE AMERICAN ART JOURNAL 1 (Fall 1969): 108-18.

A well-illustrated article on the origins, planning, execution, and subsequent career of George Grey Barnard's statue of Pan, finally at home at Columbia University.

3rd floor

BARTHOLOMEW, EDWARD SHEFFIELD 1822-58

1278 Wendell, William. "Edward Sheffield Bartholomew, Sculptor." WADSWORTH ATHENEUM BULLETIN 12 (Winter 1962): 1-8.

Discusses the life and brief career of the sculptor who had served as curator of the Wadsworth Atheneum, which received the bulk of his neoclassically influenced works at his death.

BARTLETT, PAUL WAYLAND 1865-1925

1279 Wheeler, Charles. "Bartlett." AMERICAN MAGAZINE OF ART 16 (November 1925): 573-85.

Written to commemorate the death of the artist that year, it discusses his long career in Paris, his well-known animal sculptures, and his figures of historical personalities.

3rd Floor

BASKIN, LEONARD 1922-

1280 Baskin, Leonard. BASKIN: SCULPTURE, DRAWINGS, PRINTS. New York: George Braziller, 1970. 176 p. 130 illus. Bibliog. pp. 167-70.

Autobiographical statement about his work in the two media of printing and sculpture. The illustrations show the development in his sculptural work in wood and bronze toward increasingly simplified and abstract forms.

709.73 B31b

1281 Bowdoin College Museum of Art. LEONARD BASKIN. Brunswick, Me.: 1962. Unpaged. 85 illus. Bibliog. last page.

A catalog of an exhibition of the artist's sculpture, and also

his prints and drawings. Complete catalog entries for all illustrated works, and short introductions to the work in each medium.

1282 Fern, Alan. LEONARD BASKIN. Washington, D.C.: National Collection of Fine Arts, Smithsonian Institution, 1970. 76 p. 62 illus.

Concerned with the graphic output of the versatile sculptor and draughtsman.

BITTER, KARL 1867-1915

1283 Dennis, James M. KARL BITTER, ARCHITECTURAL SCULPTOR, 1867-1915. Madison: University of Wisconsin Press, 1967. xiv, 302 p. 110 illus.

A good biography of the Austro-American sculptor and a description of his changing style. Many of his major works are discussed.

1284 Greer, H.H. "The Work of Karl Bitter." BRUSH AND PENCIL 13 (March 1904): 466-78.

An appreciation of the work of the decorative sculptor written during his own lifetime. Dwells on several major commissions.

1285 Schevill, Ferdinand. KARL BITTER: A BIOGRAPHY. Chicago: University of Chicago Press, 1917. xiii, 68 p. 41 illus.

The first biography of the decorative sculptor who worked on many of the great American mansions.

BOCK, RICHARD WALTER 1865-1949

1286 Hallmark, Donald P. "Richard W. Bock, Sculptor." THE PRAIRIE SCHOOL REVIEW 8 (1971): part 1, 5-18; part 2, 5-29.

A two-part series on the work of the sculptor so identified with the Prairie School architects. His early work was influenced by the example of Sullivan, with whom the collaboration on the Schiller Theater is discussed. His fountains and other late decorative work are discussed in the second part of the series.

BORGLUM, JOHN GUTZON 1867-1941

1287 Dean, Robert J. LIVING GRANITE: THE STORY OF BORGLUM AND THE MOUNT RUSHMORE MEMORIAL. New York: Viking Press, 1949. 128 p. 4 illus.

> Extremely flowery tribute to both the sculptor and the Mount Rushmore memorial. We are doused in statistics while being given the history of this huge sculptural project.

BORGLUM, SOLON HANNIBAL 1868-1922

1288 Eberle, Louise. "In Recognition of an American Sculptor." SCRIBNER'S MAGAZINE 72 (September 1922): 379-84.

> Written soon after the sculptor's death, it gives biographical background and discusses both his works celebrating the life of the West and his large equestrian monuments.

1289 Sewell, Frank. "A Sculptor of the Prairie." CENTURY MAGAZINE 68 (June 1904): 247-51.

> Provides some biographical information and discusses his bronzes of the life of the cowboy and the American Indian.

BROWERE, JOHN HENRI ISAAC 1792-1834

1290 Hart, Charles Henry. BROWERE'S LIFE MASKS OF GREAT AMERICANS. New York: Doubleday and McClure Company, 1899. xiv, 123 p. 21 illus.

> A brief biography of the sculptor and information about the circumstances surrounding many of the life masks he executed.

1291 New York State Historical Association. LIFE MASKS OF NOTED AMERICANS OF 1825, BY JOHN H.I. BROWERE. New York: M. Knoedler and Co., 1940. Unpaged. Illus.

> The catalog of an exhibition of Browere's life masks sponsored by the New York State Historical Association.

BROWN, HENRY KIRKE 1814-86

1292 Craven, Wayne. "Henry Kirke Brown: His Search for an American Art in the 1840's." THE AMERICAN ART JOURNAL 4 (November 1972): 44-58. Illus.

> Discusses the sculptor's decision to turn against the popular neoclassical subjects in favor of a return to American inspiration.

Illustrated with his portraits and subjects from American history.

1293 . "Henry Kirke Brown in Italy, 1842-1846." THE AMERICAN
ART JOURNAL 1 (Spring 1969): 65-77.

3rd
floor

> A reintroduction of the American public to a long out-of-
> fashion sculptor of the mid-nineteenth century. Illustrated
> with his early classical subjects, it describes his life and
> manner of working in Italy.

CALDER, ALEXANDER 1898-

1294 Arnason, H.H. CALDER. Princeton, N.J.: D. Van Nostrand Co.,
1966. xi, 192 p. 127 illus. Bibliog. pp. 184-85.

731
c14ar

> The volume's chapters are each centered on an artistic develop-
> ment: the birth of the mobile, stabiles, etc. Important bib-
> liography and chronology of works.

1295 Calder, Alexander. CALDER: AN AUTOBIOGRAPHY WITH PICTURES.
New York: Pantheon, 1966. 288 p. Illus., some in color.

731
C14c

> An autobiography written in the form of a diary. Discusses
> his life, interests, and art. Illustrations of his sculptures,
> drawings, and ideas are included.

1296 Lipman, Jean, ed. CALDER'S CIRCUS. New York: Whitney Museum
of American Art, 1972. 172 p. 115 illus. Bibliog. pp. 170-71.

> Illustrations of Calder's wire sculpture forms, his drawings,
> photographs of the circus as his inspiration, and his comments
> on the pieces.

1297 Sweeney, James Johnson. ALEXANDER CALDER. New York: Museum
of Modern Art, 1951. 80 p. Illus. Bibliog. pp. 77-80.

731
C14s

> Biography and artistic analysis of his painting, sculpture, and
> jewelry. Plates of many works not usually illustrated.

CALDER, ALEXANDER STIRLING 1870-1945

1298 Bowes, Julian. "The Sculpture of Stirling Calder." AMERICAN MAGA-
ZINE OF ART 16 (May 1925): 229-37.

> Some biographical information and discussion of his bronze
> figure pieces and monumental sculpture, his role in several
> major expositions, and his activities as a teacher.

CERACCHI, GIUSEPPE c.1740-1801

1299 Desportes, Ulysses. "Giuseppe Ceracchi in America and His Busts of
George Washington." ART QUARTERLY 26 (1963): 140-79.

3rd Floor

> Discusses the work of this imported sculptor and his carvings
> and statuary for the capitol building in Washington, D.C.

CLEVENGER, SHOBAL VAIL 1812-43

1300 Brumbaugh, Thomas [B.]. "Shobal Clevenger: An Ohio Stonecutter in
Search of Fame." ART QUARTERLY 29 (1966): 29-45.

3rd Floor

> The Cincinnati stonecutter who travelled to Italy to work his
> portrait busts into marble and died at the age of thirty-one.
> Combined realistic modelling and classical form.

COFFEE, WILLIAM JOHN 1774-c.1846

1301 Croce, George [C., Jr.]. "William John Coffee, Long-Lost Sculptor."
AMERICAN COLLECTOR 15 (May 1946): 14-15, 19-20.

3rd Floor

> Basic biographical information and discussion of the work in
> plaster of this English-born sculptor.

1302 Rutledge, Anna W. "William John Coffee as a Portrait Sculptor."
GAZETTE DES BEAUX ARTS 28 (November 1945): 297-312.

3rd floor

> Discusses the portrait bust, primarily in plaster, executed in
> the 1820s and 30s and mentions his training and earlier work
> in terra cotta.

CORNELL, JOSEPH 1903-72

1303 Waldman, Diane. JOSEPH CORNELL. New York: Solomon R. Guggen-
heim Museum, 1967. 55 p. Illus.

> The catalog of an exhibition of his sculptural forms: boxes of
> space with surrealistic figures in them. Discusses the place of
> his work in modern art.

CRAWFORD, THOMAS 1813-57

1304 Brumbaugh, Thomas B. "The Evolution of Crawford's Washington." THE
VIRGINIA MAGAZINE OF HISTORY AND BIOGRAPHY 70 (January
1962): 3-29.

3rd Floor

Discusses the competition for the commission, Crawford's plans and designs, describes what was created by him before his death, and how final figures were completed by Randolph Rogers.

1305 Gale, Robert. THOMAS CRAWFORD, AMERICAN SCULPTOR. Pittsburgh: University of Pittsburgh Press, 1964. viii, 241 p. 9 illus. Bibliog. pp. 199-229.

A chronologically divided biography of Crawford. Based on letters to and from him. Scholarly and effective in describing his life both here and in Europe.

DALLIN, CYRUS E. 1861-1944

1306 Seaton-Schmidt, Anna. "An American Sculptor: Cyrus E. Dallin." INTERNATIONAL STUDIO 58 (April 1916): 109-14.

Provides information on the training and work of this Parisian-trained son of pioneers who achieved fame as a monumental portrayer of the American Indian. His major equestrian groups are discussed.

DAVIDSON, JO 1883-1952

1307 Davidson, Jo. BETWEEN SITTINGS. New York: Dial Press, 1951. vii, 369 p. Illus.

735
D 25d

Autobiography of one American sculptor who is noted for busts of the well known of all countries.

1308 Du Bois, Rene. "Jo Davidson." INTERNATIONAL STUDIO 76 (November 1922): 177-81.

Discusses his training in New York and in Paris and comments on the naturalistic quality of his portraits.

DE CREEFT, JOSE 1884-

1309 Campos, Jules. THE WORKS OF JOSE DE CREEFT. Preface by the artist. New York: Da Capo Press, 1971. 230 p. Illus.

A study of this abstract lyrical sculptor who joined with other pioneers to produce an acceptance of modernism in the 1930s. Emphasizes his figural compositions in stone. Catalog of his work.

DE RIVERA, JOSE 1904-

1310 Ashton, Dore. "The Sculpture of Jose de Rivera." ARTS 30 (April 1956): 38-41.

3rd
Floor

> Discusses the sculptor's work as part of the development of abstract form and ideas and points out European influence.

1311 Gordon, John. JOSE DE RIVERA. New York: American Federation of Arts, 1961. 33 p. 15 illus.

> Short critical study of the sculptor and his abstract forms in chrome and steel.

FERBER, HERBERT 1906-

1312 Dennison, George. "Sculpture as Environment: The New Work of Herbert Ferber." ARTS 37 (May 1963): 86-91.

3rd
floor

> Discusses the transition of the early sculpture into new monumental forms, several times larger than life-size, into which the observer can walk and experience the work from many points of view.

1313 Ferber, Herbert. "On Sculpture." ARTS IN AMERICA 42 (December 1954): 262 ff.

3rd
floor

> The artist sets forth his thinking on the role of technique and materials in the development of form, maintaining that form and content are the ends of great art and technique merely a means.

1314 Goosen, E.C.; Goldwater, Robert; and Sandler, Irving. THREE AMERICAN SCULPTORS: FERBER, HARE, LASSAW. New York: Grove Press, 1959. 75 p. 30 illus., some in color.

> Individual chapters on each sculptor by three noted critics. Each artist is presented as an important figure in the development of modern sculpture, with Hare linked closer to surrealism and Ferber and Lassau to abstract expressionism.

FLANNAGAN, JOHN 1895-1942

1315 Arnason, H.H. "John Flannagan." ART IN AMERICA 48 (1960): 64-69.

3rd
floor

> A reappraisal of Flannagan's work in which the author provides background information on the whole American art scene of the 1920s and 30s. He feels that the animals and heads will remain the most important contribution of the artist whose

sources are so difficult to trace.

1316 Flannagan, John B. LETTERS OF JOHN B. FLANNAGAN. New York: Curt Valentin, 1942. 100 p. 7 illus.

Letters to friends, relatives, and his dealer, discussing his work, his fears, and problems of daily life. Included are the texts of his applications for Guggenheim Fellowships.

1317 Miller, Dorothy C., ed. THE SCULPTURE OF JOHN B. FLANNAGAN. New York: Museum of Modern Art, 1942. 40 p. Illus.

This volume contains a brief discussion of his art, a chronology, checklist of work in museum collections, and illustrations of seldom seen sculptures.

1318 Weyhe Gallery. JOHN B. FLANNAGAN: SCULPTURE/DRAWINGS, 1924-1938. New York: 1973. 32 p. Illus.

A retrospective exhibition's catalog that reasserts the importance and uniqueness of the sculptor's work.

FOLEY, MARGARET c.1820-77

1319 Chatterton, E.B. "A Vermont Sculptor." NEWS AND NOTES (Vermont Historical Society) 7 (October 1955): 10-14.

3rd floor

Provides biographical information and describes her entry to the profession through cameo carving. Details her move to Rome and her busts and large scale figures of famous Americans.

FRASER, JAMES EARLE 1876-1953

1320 "James Earle Fraser." PAN-AMERICAN UNION BULLETIN 46 (May 1918): 648-55.

Some biographical information and discussion of his French training and work with St. Gaudens. Concentrates on his portrait busts and full-scale statues in both bronze and marble.

FRAZEE, JOHN 1790-1852

1321 "The Autobiography of John Frazee." AMERICAN COLLECTOR 15 (September 1946): 15 ff.; (October): 10 ff.; (November): 12 ff.

3rd floor

This three-part series is based on autobiographical manuscripts which describe his early years and upbringing, his venture into the use of the chisel, his work on monuments, and successes in sculpture.

FRENCH, DANIEL CHESTER 1850-1931

1322 Adams, Adeline. DANIEL CHESTER FRENCH, SCULPTOR. Boston: Houghton Mifflin Co., 1932. xi, 90 p. 32 illus.

> A romantic and sentimentalized biography of the sculptor that contains some biographical information of importance.

1323 Cresson, Margaret French. THE LIFE OF DANIEL CHESTER FRENCH: JOURNEY INTO FAME. Cambridge, Mass.: Harvard University Press, 1947. xv, 316 p. Illus. Bibliog. pp. 315-16.

> A very complete biography that reads like an historical novel. Very little stylistic analysis or criticism from the author, the sculptor's daughter, but much information about the man, his ideas, and values.

1324 Richman, Michael. "The Early Public Sculpture of Daniel Chester French." THE AMERICAN ART JOURNAL 4 (November 1972): 97-116.

3rd floor

> Biographical background and an examination of the small output of the first twenty years of his career. Particular attention is paid to the history of the "Minute Man" monument.

GABO, NAUM 1890-

1325 Olson, Ruth, and Chanin, Abraham. PEVSNER GABO. New York: Museum of Modern Art, 1948. 83 p. Illus.

735 N53

> The catalog of an exhibition held two years after Gabo came to the states. His nonobjective forms in metal and plastic are clearly part of the Russian constructivist movement, but had tremendous influence on two generations of American sculpture.

GREENOUGH, HORATIO 1805-52

1326 Greenough, Frances, ed. LETTERS OF HORATIO GREENOUGH TO HIS BROTHER, HENRY GREENOUGH. 1887. Reprint. New York: Da Capo Press, 1970. x, 250 p.

> As many of these letters describe his life and work in Italy, they are a valuable source of information not only on Greenough, but also on the whole colony of expatriate Americans.

1327 Tuckeman, Henry [T.]. A MEMORIAL TO HORATIO GREENOUGH. New York: G.P. Putnam & Son, 1853. vi, 245 p.

735.73 G81t

> Contains a memoir by Tuckerman, a list of Greenough's known works, essays by the sculptor, and tributes by friends of the

artist.

1328 Wright, Nathalia. HORATIO GREENOUGH: THE FIRST AMERICAN
SCULPTOR. Philadelphia: University of Pennsylvania Press, 1963. 382 p.
61 illus.

> A well-documented biography that draws upon Greenough's
> letters and contemporary sources. Describes his life here and
> in Italy and the history of his famous commissions for the fed-
> eral government.

1329 _____, ed. LETTERS OF HORATIO GREENOUGH: AMERICAN SCULP-
TOR. Madison: University of Wisconsin Press, 1972. 456 p.

> This expatriate sculptor was extremely well educated and
> literate and wrote extensively. The letters provide us with
> information on his life in Italy and his views on art.

GREENOUGH, RICHARD SALTONSTALL 1819-1904

1330 Brumbaugh, Thomas [B.]. "The Art of Richard Greenough." OLD TIME
NEW ENGLAND 53 (January-March 1963): 61-78.

> As well as discussion of the ideal figures in neoclassical style
> and the major portrait commissions in bronze, biographical in-
> formation on his training and years in Rome is provided.

GROSS, CHAIM 1904-

1331 Lombardo, Josef. CHAIM GROSS, SCULPTOR. New York: Dalton
House, 1949. vii, 247 p. Illus. Bibliog. pp. 237-42.

735.73
G-87L

> A biographical and stylistic study of the sculptor. Discusses
> his direct carving in wood of circus and gymnast figures.

HARE, DAVID 1917-

1332 Goosen, E.C.; Goldwater, Robert; and Sandler, Irving. THREE AMERI-
CAN SCULPTORS: FERBER, HARE, LASSAW.

> For main entry, see 1314.

1333 Hare, David. "The Spaces of the Mind." MAGAZINE OF ART 43
(February 1950): 48-53.

3rd
floor

> Discusses how his concepts for major cast sculpture came from
> free floating ideas. Rejects doctrinaire surrealism.

Individual Sculptors

HOFFMAN, MALVINA 1887-1966

1334 Alexandre, Arsene. MALVINA. Paris: J.E. Pouterman, 1930. 104 p.
Illus.

> The text is in French, but the valuable chronological catalog
> of works is in English. Illustrations of sculpture in wax, marble,
> bronze, and polychromed plaster.

1335 Hoffman, Malvina. HEADS AND TALES. New York: Charles Scribner's
Sons, 1936. xx, 416 p. Illus.

> An autobiography by this American student of Rodin. She
> discusses her work for the Hall of Man at the Field Museum,
> and her contacts with the artistic and musical circles of the
> United States and Europe.

HOSMER, HARRIET 1830-1908

1336 Carr, Cornelia. HARRIET HOSMER: LETTERS AND MEMORIES. New
York: Moffat, Yard and Company, 1912. xiii, 386 p. Illus.

> The life, here and abroad, of one of our early woman sculptors
> of the neoclassic persuasion, her involvement in the world of
> sculpture, and her thoughts on art.

1337 Van Rennselaer, Susan. "Harriet Hosmer." ANTIQUES 84 (October
1963): 424-28.

> Biographical information on a strong-willed, independent woman
> sculptor, discussion of her life in Italy, and comments on the
> neoclassical style in which she worked.

HUGHES, ROBERT BALL 1806-68

1338 Chamberlain, Georgia. "Portrait Busts of Robert Ball Hughes." ART
QUARTERLY 20 (Winter 1957): 383-86.

> Discusses the portrait busts, from those created in England, to
> those in New York and later in Massachusetts, of which he
> sold multiple copies. An important early figure in professional
> sculptured work.

HUNT, RICHARD 1935-

1339 Museum of Modern Art. THE SCULPTURE OF RICHARD HUNT. New
York: 1971. 24 p. Illus. Bibliog. pp. 21-22.

Contains a catalog of the sculpture, drawings, and prints, a
chronology, a list of exhibitions, and statements by the artist
on his work.

HUNTINGTON, ANNA HYATT VAUGHN 1876-

1340 Cortissoz, Royal. EXHIBITION OF SCULPTURE BY ANNA HYATT HUNT-
INGTON. New York: American Academy of Arts and Letters, 1936.
38 p. Plus illus.

Introductory essay by Cortissoz comments on the expressive
quality in her sculpture. An essay, in French, is included,
as well as a chronological catalog of 171 pieces of sculpture.

1341 Evans, Cerinda W. ANNA HYATT HUNTINGTON. Newport News,
Va.: The Mariners Museum, 1965. 87 p. 22 illus.

An anecdotal and biographical text that fails to make any
serious comment on the work, but is useful for the illustra-
tions, and for those interested in illustrations and locations
of her statues.

1342 Price, Frederick [Newlin]. "Anna Hyatt Huntington." INTERNATIONAL
STUDIO 79 (August 1924): 319-23.

Essentially known for her bronze cast figures of animals moving,
fighting, or resting, her major equestrian monuments are also
briefly discussed.

IANNELLI, ALFONSO 1888-1965

1343 Griggs, Joseph. "Alfonso Iannelli: The Prairie Spirit in Sculpture."
THE PRAIRIE SCHOOL REVIEW 2 (1965): 5-23.

An examination of a major decorative sculptor and designer,
best known for his collaboration with Wright on Midway Gardens,
and with Purcell and Elmslie and the younger Barry Byrne. His
life is sketched in brief and his relationships with the Prairie
School architects are explored.

IVES, CHAUNCEY BRADLEY 1810-94

1344 Gerdts, William H. "Chauncey Bradley Ives, American Sculptor." AN-
TIQUES 94 (November 1968): 714-18.

A general introduction to the life and work of an American
sculptor who worked in Boston, Florence, and later, Rome.
His major work of ideal figures and parlor pieces is discussed,

and the change from literalism to neoclassicism is illustrated.

JENNEWEIN, CARL PAUL 1890-

1345 Cunningham, John J., ed. PAUL JENNEWEIN. Athens: University of
Georgia Press, 1950. 61 p. Illus.

> Brief text. Primarily illustrations of the graceful, rhythmic,
> and highly polished metal classical figures and architectural
> decoration.

1346 Parkes, Kineton. "Plastic Form and Color: The Work of Paul Jennewein."
APPOLLO 17 (April 1933): 130-34.

> Concerned with the work of the early 1930s, in polychromed
> terra cotta, especially those for the Philadelphia Museum of
> Art. For these he derived his inspiration from preclassical
> Greek sculpture.

JUDD, DON 1928-

1347 Agee, William C. DON JUDD. February 27-March 24, 1968.
New York: Whitney Museum of American Art, 1968. 40 p. Illus.
Bibliog. p. 40.

> Includes a descriptive introduction, selections from the sculp-
> tor's own writings, illustrations, and a chronology.

1348 Coplans, John. DON JUDD. Pasadena, Calif.: Pasadena Art Museum,
1971. 72 p. 44 illus., some in color. Bibliog. pp. 70-72.

> Contains an analytical essay and an interview with the sculptor
> in which his style, technique, and philosophy of art are ex-
> plored.

KIENHOLZ, EDWARD 1927-

1349 Tuchman, Maurice. EDWARD KIENHOLZ. Los Angeles: Los Angeles
County Museum of Art, 1966. 52 p. Illus. Bibliog. pp. 12-13.

> The catalog of a major exhibition of the pop realism sculpture
> of the artist. Discusses the evolution of his work and the way
> he created his tableaux in the 1960s.

LACHAISE, GASTON 1882-1935

1350 Kirstein, Lincoln. GASTON LACHAISE: RETROSPECTIVE EXHIBITION. New York: Museum of Modern Art, 1935. 29 p. 32 p. of illus. Bibliog. p. 22.

> The catalog of a retrospective exhibition held a few months before his death. His role as a classic portrayer of earth-bound sexuality is discussed as is the quality of his bronzes and drawings. Catalog documents eighty-seven works.

1351 Kramer, Hilton. THE SCULPTURE OF GASTON LACHAISE. New York: Eakins Press, 1967. 49 p. 86 illus. Bibliog. pp. 43-44.

735.44

L13L

> A major monograph on the sculptor who came to this country at the age of twenty-four to become an important influence in modern sculptural development. A catalog of his works, and appreciation essays by L. Kirstein, H. McBride, and A. Hyatt Mayor.

LASSAW, IBRAM 1913-

1352 Campbell, Lawrence. "Lassaw Makes a Sculpture." ART NEWS 53 (March 1954): 24 ff.

3rd
floor

> Discusses the sculptor's method of building pieces of wire welded together and adding other metals to bronze to achieve his color and texture effects.

1353 Goosen, E.C.; Goldwater, Robert; and Sandler, Irving. THREE AMERI-CAN SCULPTORS: FERBER, HARE, LASSAW.

> For main entry, see 1314.

1354 Sawin, Martica. "Ibram Lassaw." ARTS 30 (December 1955): 22-26.

3rd
floor

> Discusses the various hued metal abstract sculptures which suggest, both in form and title, cosmic interaction and form.

LAURENT, ROBERT 1890-1970

1355 Frost, Rosamund. "Laurent: Frames to Figures, Brittany to Brooklyn." ART NEWS 40 (April 1941): 10 ff.

3rd
floor

> Provides some biographical information and discusses the evolution of his forms into simplified bold masses. Marks him as one of the pioneers of direct carving.

LEE, ARTHUR 1881-1961

1356 Slusser, J[ean] P. "A Note on Arthur Lee." INTERNATIONAL STUDIO 79 (June 1924): 171–76.

> Discusses both his search for beauty in the natural human figure and his marbles and bronzes.

LEWIS, MARY EDMONIA 1845-90

1357 Dannett, Sylvia G.L. "Mary Edmonia Lewis, 1846–1890: The First American Negro to Achieve Recognition in the Field of Sculpture." PROFILES OF NEGRO WOMANHOOD 1 (1965): 118–23.

> Biographical and historical material on the sculptor and an introduction to her work both here and in Italy. Points out the importance of her bust of Colonel Shaw, and discusses her work on both Negro and Indian subjects.

LIPCHITZ, JACQUES 1891-1973

1358 Van Bork, Bert. JACQUES LIPCHITZ: THE ARTIST AT WORK. New York: Crown Publishers, 1966. 220 p. Illus.

> Includes a biographical sketch, but concentrates on his years in America and his way of working. Many illustrations of his sculptures and of him at work. Includes a critical evaluation by Alfred Werner. Although he was in America only during the last part of his life, his work had tremendous influence on American sculpture.

LIPPOLD, RICHARD 1915-

1359 Campbell, Lawrence. "Lippold Makes a Construction." ART NEWS 55 (October 1956): 31 ff.

> An analysis of the form of the wire abstractions of the sculptor and a discussion of his method of working and the development of his constructions.

LIPTON, SEYMOUR 1903-

1360 Elsen, Albert. SEYMOUR LIPTON. New York: Harry N. Abrams, 1970. 244 p. 214 illus., 54 in color.

> A major study of the life and work of the dentist turned sculptor. Traces the development of his forms from the human

figure to his representations of ideas and basic life drives and forces. Discusses his technique for work in metal.

1361 Hunter, Sam. SEYMOUR LIPTON. New York: Marlborough-Gerson Gallery, 1965. 36 p. Illus.

The catalog of an exhibition of the sculptor's abstract expressionistic forms in welded metal. His imagery is discussed.

1362 Ritchie, Andrew [Carnduff]. "Seymour Lipton." ART IN AMERICA 44 (Winter 1956): 14-17.

Discusses his larger expressive work, including his commissions for buildings in the private sector.

McINTIRE, SAMUEL 1737-1811

1363 Cousins, Frank, and Riley, Phil M. THE WOOD-CARVER OF SALEM: SAMUEL McINTIRE, HIS LIFE AND WORK.

For main entry, see 375.

MacMONNIES, FREDERICK WILLIAM 1863-1937

1364 Greer, H.H. "Frederick MacMonnies, Sculptor." BRUSH AND PENCIL 10 (April 1902): 1-15.

Discusses the indignant reception caused by his "Bacchante" and the general approval of his basically realist sculpture. Some information on his association with Saint-Gaudens.

1365 Low, Will. "Frederick MacMonnies." SCRIBNER'S MAGAZINE 18 (1895): 617-28.

Discusses his early training, his successes in France, awarding of the Prix d'Atelier in two successive years, and his early sculptural forms.

MANSHIP, PAUL 1885-1966

1366 Murtha, Edwin. PAUL MANSHIP. New York: Macmillan Publishing Co., 1957. Illus.

Biographical information on his long career in the United States, Paris, and Rome. Discusses archaic Greek and other influences on his lyrical figurative work and the many honors which he was awarded.

MARISOL [ESCOBAR] 1930-

1367 Campbell, Lawrence. "Marisol's Magic Mixtures." ART NEWS 63 (March 1964): 38 ff.

3rd floor

> Duscusses the painted wood sculptures and pop imagery of a leader of the movement and her use of other materials in gaining her desired effect.

MILLS, CLARK 1815-83

1368 Rutledge, Anna W. "Cogdell and Mills, Charleston Sculptors." ANTIQUES 41 (March 1942): 192-93, 205-7.

3rd floor

> Concentrates on the life masks of John C. Calhoun and other important figures of the South Carolina upper class.

MORRIS, ROBERT 1931-

1369 Compton, Michael, and Sylvester, David. ROBERT MORRIS. London: The Tate Gallery, 1971. 128 p. Illus.

> The catalog of a large exhibition of his sculpture and reliefs. Extensive quotes from the artist's own writing and thoughts on art. Discusses conceptual concepts.

1370 Tucker, Marcia. ROBERT MORRIS. New York: Whitney Museum of American Art, 1970. 63 p. 34 illus. Bibliog. pp. 61-63.

735.73 M87t

> The catalog of the exhibition of new works created just for the show. A critical text describes his earlier work and the development of his style and ideas; together with a chronology, detailed bibliography, and exhibition record; provides the most up-to-date reference on the artist.

NADELMAN, ELIE 1882-1946

1371 Kirstein, Lincoln. THE SCULPTURE OF ELIE NADELMAN. New York: Museum of Modern Art, 1948. 64 p. Illus. Bibliog. pp. 63-64.

735.438 N13ka

> The most complete biographical and analystic discussion of this Polish expatriate's work. His years in the United States are detailed.

1372 Murrell, William. ELIE NADELMAN. Younger Artists Series, no. 6. Woodstock, N.Y.: William M. Fisher, 1923. Unpaged. 40 black and white illus., 6 in color.

No text, but a good source of illustrations.

NAKIAN, REUBEN 1897-

1373 Arnason, H.H. "Nakian." ART INTERNATIONAL 7 (April 1963): 36-43.

3rd
Floor

Discusses the recent abstract expressionist work of the sculptor in his handling of mythological themes.

1374 O'Hara, Frank. NAKIAN. New York: Museum of Modern Art, 1966. 56 p. Illus.

735.73
N53n

This exhibition catalog contains a biographical essay and detailed information and illustrations of his work. His relationship to both Calder and Smith is examined. His bronzes, drawings, and terra cotta figures are included.

NEVELSON, LOUISE 1900-

1375 Seckler, Dorothy. "The Artist Speaks: Louise Nevelson." ART IN AMERICA 55 (January-February 1967): 33-42.

3rd
Floor

Discussion of her painted nonobjective wooden forms and the wall of space each becomes.

NOGUCHI, ISAMU 1904-

1376 Gordon, John. ISAMU NOGUCHI. New York: Whitney Museum of American Art, 1966. 68 p. Illus.

735.73
N77g

Discusses the evolution of form in the work of the sculptor and analyzes the sources for his style in his bicultural background.

1377 Noguchi, Isamu. A SCULPTOR'S WORLD. New York: Harper & Row, Publishers, 1968. 259 p. 255 black and white illus., 13 in color.

735.73
N77na

Autobiography and notes on his involvement with theater, architecture, and other aspects of design. A catalog of works and photos of activities in addition to those sculptural. Explains his conflict between East and West.

OLDENBURG, CLAES 1929-

1378 Baro, Gene. CLAES OLDENBURG. London and New York: Chelsea House, 1969. 274 p. Illus.

A biography, many illustrations of drawings, and a catalog raisonne of drawings and prints.

1379 Haskell, Barbara. CLAES OLDENBURG: OBJECT INTO MONUMENT. Pasadena, Calif.: Pasadena Art Museum, 1971. 135 p. Illus., some in color. Bibliog. p. 135.

The catalog of a major travelling exhibition which concentrates on the projects, drawings, and designs for monuments and proposed monuments in various cities of the world. Oldenburg's notes for the projects are included.

1380 Oldenburg, Claes. PROPOSALS FOR MONUMENTS AND BUILDINGS, 1965-69. Chicago: Big Table Publishing Co., 1969. 196 p. Illus.

709.73
099p

An interview with Oldenburg by Paul Carron, drawings for monuments, and explanatory material by the artist.

1381 _____. STORE DAYS. New York: Something Else Press, 1967. Unpaged. Illus.

Oldenburg's writings, drawings, and photos of "happenings" at the store.

1382 Rose, Barbara. CLAES OLDENBURG. New York: Museum of Modern Art, 1970. 221 p. Illus., many in color. Bibliog. pp. 206-14.

Major critical study of the artist's work and its significance.

OSSORIO, ALFONSO 1916-

1383 Friedman, B.H. ALFONSO OSSORIO. New York: Harry N. Abrams, 1972. 269 p. Illus., some in color. Bibliog. pp. 267-69.

Biographical and bibliographical information on this Philippines-born sculptor. This heavily documented volume includes discussion and illustrations of his collage constructions and some of his earlier paintings.

PALMER, ERASTUS DOW 1817-1904

1384 Webster, J. Carson. "A Checklist of the Works of Erastus D. Palmer." ART BULLETIN 49 (1967): 143.

3rd
floor

An exhaustive, well documented list of the various size figures and miniatures credited to the studio of Palmer.

1385 _____. "Erastus D. Palmer: Problems and Possibilities." THE AMERICAN ART JOURNAL 4 (November 1972): 34-43.

3rd
floor

Discusses the problems involved in identifying the subjects of
his small cameo carvings and provides an evaluation of his
marble statues as having moral worth beyond those of many
of his contemporaries.

PARTRIDGE, WILLIAM ORDWAY 1861-1930

1386 Langdon, William. "William Ordway Partridge, Sculptor." NEW ENG-
LAND MAGAZINE 22 (1900): 382-98.

Provides biographical material and discusses the major works
in an impressionistic naturalistic modelling technique.

1387 Partridge, William Ordway. THE WORKS IN SCULPTURE OF WILLIAM
ORDWAY PARTRIDGE. New York: John Lane Co., 1914. xii, 67 p.
Illus.

A catalog of 138 items of sculpture and sixty-seven illustra-
tions of completed statues and monuments. No text.

POWERS, HIRAM 1805-73

1388 Gardner, Albert Ten Eyck. "A Relic of the California Gold Rush."
THE METROPOLITAN MUSEUM OF ART BULLETIN 8 (December 1949):
117-22.

3rd floor

Discusses the life-size marble statue, "California," which
Powers designed in 1850 to commemorate the recent gold rush.
Describes the symbols and role of the work in Powers' output.

1389 Roberson, Samuel A., and Gerdts, William H. "The Greek Slave."
THE MUSEUM (The Newark Museum) 17 (Winter-Spring 1965): 1-32.

3rd floor

Discusses the history, travels, and importance of this several
times repeated and often illustrated monument in the history
of American sculpture.

1390 Wunder, Richard P. "The Irascible Hiram Powers." THE AMERICAN
ART JOURNAL 4 (November 1972): 10-15.

3rd floor

Discusses Powers' relationships with the other sculptors living
in Italy, and the squabbles in their lives. Quotations from
his letters document the point about attitudes.

PROCTOR, ALEXANDER PHIMISTER 1862-1950

1391 Paladin, Vivian. "A. Phimister Proctor: Master Sculptor of Horses."

MONTANA MAGAZINE OF WESTERN HISTORY 14 (Winter 1964): 10–24.

3rd Floor

> Provides biographical material on the naturalist sculptor, known for his monumental bronzes of horses, Indians, and bison. Discusses his training, years in Paris and Rome, and the quality of his work.

1392 Peixotto, Ernest. "A Sculptor of the West." SCRIBNER'S MAGAZINE 68 (September 1920): 266–77.

> Concerned with the naturalistic approach to the subject matter of the sculptor. Discusses his pieces of decorative sculpture of animals and cowboys and the American Indian.

REMINGTON, FREDERIC 1861-1909

1393 See entries 1060–65.

RICKEY, GEORGE 1907-

1394 Institute of Contemporary Art. GEORGE RICKEY: KINETIC SCULPTURES. Boston: 1964. 18 p. Illus.

> The catalog of an exhibition of the sculptor/critic's own development and interest in movement in three dimensional form. Discusses the origins of his style in European twentieth-century developments.

1395 Rickey, George. CONSTRUCTIVISM: ORIGINS AND EVOLUTION. New York: George Braziller, 1967. xi, 305 p. Illus. Bibliog. pp. 247–300.

709.04
R539c

> A history of the developments in the twentieth century: in Russia, among the De Stijl group in Holland, and in the followers of the two concerned with both painting and sculpture, with the emphasis on the latter. A good guide to understanding his own work.

RIMMER, WILLIAM 1816-79

1396 See entries 1068–70.

RINEHART, WILLIAM HENRY 1825-74

1397 Ross, Marvin C., and Rutledge, Anna W. WILLIAM HENRY RINEHART: MARYLAND SCULPTOR. Baltimore: Walters Art Gallery, 1948. 74 p. 48 illus. Bibliog. pp. 72-74.

> A brief biography and analysis of his way of working is followed by the valuable annotated and descriptive catalog of 167 works by the sculptor.

1398 Rusk, William Sener. WILLIAM HENRY RINEHART, SCULPTOR. Baltimore: Norman T.A. Munder, 1939. xiii, 143 p. 24 illus. Bibliog. pp. 107-12.

> Divided into chapters: a biography of the sculptor, information on his years both here and in Italy, a selection from his letters, criticism of his works, and classification by chronology and location. Contains a section on the "Rinehart Scholars" scholarship students.

ROGERS, JOHN 1829-1904

1399 Barck, D.C. "Rogers' Groups in the Museum of the New York Historical Society." NEW YORK HISTORICAL SOCIETY QUARTERLY 16 (1932): 67-86.

> Lists and describes the many examples of the figure groups by Rogers in their collection and comments on their importance.

1400 Wallace, David H. "The Art of John Rogers: 'So Real and So True'." THE AMERICAN ART JOURNAL 4 (November 1972): 59-70.

> Brief biographical data plus a tracing of the production of his "groups" and their critical and popular reception.

1401 _____. JOHN ROGERS: THE PEOPLE'S SCULPTOR. Middletown, Conn.: Wesleyan University Press, 1967. xv, 326 p. Illus.

> A biography based on earlier writings, it presents his familial background career and financial dealings. The extensive catalog itemizes and discusses 225 sculptures and groups by Rogers, and refutes several misattributions. Appendix I describes the process used in making the "Group" sculptures.

ROGERS, RANDOLPH 1825-1922

1402 Rogers, Millard F., Jr. "Nydia: Popular Victorian Image." ANTIQUES 97 (March 1970): 374-77.

> Discusses the popularity and importance of the most popular

figure based on a literary source of which over fifty copies were made.

1403 _____. RANDOLPH ROGERS: AMERICAN SCULPTOR IN ROME. Amherst: University of Massachusetts Press, 1971. xviii, 237 p. Illus. Bibliog. pp. 187-92.

735.73
R72ro

A biography and complete bibliography of the life of an expatriate sculptor of ideal forms. Discusses his life in Italy, his relations with other Americans there, and provides the history of his important commissions for American projects.

ROSZAK, THEODORE 1907-

1404 Arnason, H.H. THEODORE ROSZAK. Minneapolis, Minn.: The Walker Art Center, 1955. 55 p. Illus., some in color. Bibliog. p. 54.

The catalog of an exhibition of his sculptures in many media, and the drawings for his work. Included are the early paintings before he turned to the metal sculpture for which he is best known. Traces the evolution of his style and discusses recovery themes.

RUSH, WILLIAM 1756-1833

1405 Marceau, Henri. WILLIAM RUSH 1756-1833: THE FIRST NATIVE AMERICAN SCULPTOR. Philadelphia: Pennsylvania Museum of Art, 1937. 85 p. 27 illus.

735.73
R95m

In addition to the brief biography, the catalog documents eighty-six works by Rush and illustrates twenty-seven of them. Important biographical information is provided and notice of earlier documentation of missing works is included.

SAINT-GAUDENS, AUGUSTUS 1848-1907

1406 Carnegie Institute. AUGUSTUS SAINT-GAUDENS MEMORIAL EXHIBITION. Pittsburgh: 1909. 99 p. Illus. Bibliog. pp. 95-96.

Contains a short biographical essay and a catalog of 132 large-scale statues and cameos. Locations of originals as well as of the source of the cast are provided.

1407 Cortissoz, Royal. AUGUSTUS SAINT-GAUDENS. Boston and New York: Houghton Mifflin Co., 1907. 86 p. 24 illus.

A study of both the life and work of the sculptor, based, in part, on personal conversations between him and the author.

The attention paid to the medallions is important as we tend usually to see Saint-Gaudens' civic sculptures rather than the smaller works.

1408 Cox, Kenyon. "Augustus Saint-Gaudens." CENTURY MAGAZINE 35 (November 1887): 28-37.

The artist-critic praises the sculptor as a leader of the new realism rather than of the established neoclassicism.

1409 Dryfhout, John. AUGUSTUS SAINT-GAUDENS: THE PORTRAIT RELIEFS. New York: Grossman Publishers, 1971. 176 p. Illus.

Although better known today for his monumental sculpture, the artist did many portrait reliefs on commission. Illustrations of his bronzes.

1410 Hind, C. Lewis. AUGUSTUS SAINT-GAUDENS. New York: John Lane Co., 1908. xivii. 52 plates.

Divided into four sections: a biography, an essay of commentary on style and development, a chronological catalog of works, and illustrations of his sculpture in chronological order.

1411 National Portrait Gallery. AUGUSTUS SAINT-GAUDENS: THE PORTRAIT RELIEFS. Washington, D.C.: Smithsonian Institution Press, 1969. Unpaged. 56 illus. Bibliog.

735.73
S13d
Contains a very detailed catalog of the fifty-six reliefs and gives biographical data on each subject. Contains an extensive bibliography.

1412 Saint-Gaudens, Homer, ed. THE REMINISCENCES OF AUGUSTUS SAINT-GAUDENS. 2 vols. New York: The Century Co., 1913. Vol. 1, xvii, 393 p., 38 illus.; vol. 2, 381 p., 51 Illus.

The autobiography of the sculptor with biographical supplements by his son, Homer.

1413 Tharp, Louise Hall. SAINT-GAUDENS AND THE GILDED ERA. Boston: Little, Brown and Co., 1969. 419 p. 56 illus.

Detailed biography of the artist based on interviews, family documents, and archival sources. Direct quotations, taken from works of others, help to bring the events described very close to us. Particular attention is paid to the sculptor's familial relationships and the role his wife played in financial matters.

SEGAL, GEORGE 1924-

1414 Geldzahler, Henry. "An Interview With George Segal." ARTFORUM 3 (November 1964): 26-29.

> Discussion of the how and why of the silent white figures that make up the world of the sculptor.

3rd floor

1415 Kaprow, Allan. "Segal's Vital Mummies." ART NEWS 62 (February 1964): 30-35, 65.

> Discusses the way that the sculptor's forms create a mood and take on added dimensions in their settings.

3rd floor

1416 Seitz, William C. SEGAL. New York: Harry N. Abrams, 1972. 95 p. Illus., some in color. Bibliog. pp. 90-95.

> A full-length study of the sculptor, the philosophy behind his art, and an analysis of his work in relation to both traditional and contemporary sculpture. Draws on the author's own words.

SIMMONS, FRANKLIN 1834-1913

1417 Burrage, Henry. "Franklin Simmons, Sculptor." MAINE HISTORICAL MEMORIALS 1 (1922): 109-47.

> Information on the life and work of the sculptor, who lived in Rome from the age of twenty-eight until his death, but who continued to produce portrait busts, commemorative statues, and other work for the country of his birth.

SKILLIN, SIMEON 1716-78

1418 Swan, Mabel. "Simeon Skillin, Senior, The First American Sculptor." ANTIQUES 46 (July 1944): 21 ff.

> While admitting that no surviving work can be positively assigned to the sculptor, the author points out the historical record for proving that he was involved in portrait sculpture, ship figureheads, and shop signs. Certain attributions are suggested.

3rd floor

1419 Thwing, Leroy. "The Four Carving Skillins." ANTIQUES 33 (June 1938): 326-28.

> Discusses the range of carving in wood attempted by members of the family and comments on their relationship to the artisan-craftsman tradition. Concentrates on Simeon and his sons in both utilitarian and decorative arts.

3rd floor

SMITH, DAVID ROLAND 1906-65

1420 Fogg Art Museum. DAVID SMITH: A RETROSPECTIVE EXHIBITION.
Introduction by Jane Harrison Cone. Cambridge, Mass.: 1966. ix, 107 p.
83 illus. Bibliog. pp. 90-94.

735.73
S64co

> A major study of the sculptor in an exhibition catalog. Includes
> a checklist of works, a chronology of his life, a list of exhibi-
> tions, and the texts of four articles by the sculptor and an
> interview by Katherine Kuh.

1421 Fry, Edward F. DAVID SMITH. New York: Solomon R. Guggenheim
Museum, 1969. 182 p. Illus., many in color. Bibliog. pp. 170-71.

735.73
S64F

> An extremely well documented catalog of the sculptor's pro-
> duction in chronological order. Comments on ninety-seven
> works and a list of exhibitions. Biographical information in
> a chronology.

1422 Gray, Cleve, ed. DAVID SMITH BY DAVID SMITH. New York: Holt,
Rinehart and Winston, 1968. 176 p. Illus., some in color.

735.73
S64s

> Bits and pieces of conversation and notes, on his work and
> philosophy of art, interspersed with hundreds of illustrations
> of his work and of him at work.

1423 Hunter, Sam. "David Smith." MUSEUM OF MODERN ART BULLETIN
2 (1957): 3-36.

3rd
floor

> A lengthy study of this pioneering sculptor in steel. Some
> biographical information and discussion of the evolution of
> his forms from abstract figurative to geometric.

1424 Krauss, Rosland E. TERMINAL IRON WORKS: THE SCULPTURE OF
DAVID SMITH. Cambridge, Mass.: The M.I.T. Press, 1971. 232 p.
148 illus. Bibliog. pp. 189-96.

735.73
S64t

> A study of the man and his work in chapters on his career,
> imagery, movement into surrealism, and final nonobjective
> minimalist forms.

SMITH, TONY 1912-

1425 Burton, Scott. "Old Master at the New Frontier." ART NEWS 65
(December 1966): 52-55, 68-70.

3rd
floor

> Discussion of the new minimal sculptural forms of the architect
> turned sculptor. Presents his work in metal.

1426 Lippard, Lucy R. TONY SMITH. New York: Harry N. Abrams, 1972.
86 p. Illus. Bibliog. pp. 85-86.

Based on earlier articles by the same author, this work presents
biographical information, discusses the evolution of Smith's
development from architecture to sculpture, the role and mean-
ing of his work, and illustrates his major sculptural forms.

1427 _____. TONY SMITH: RECENT SCULPTURE. New York: M. Knoedler
& Co., 1971. Illus.

In a series of interviews the sculptor discusses his continued
interest in the direct expression of basic form.

STANKIEWICZ, RICHARD 1922-

1428 Walker Art Center. RICHARD STANKIEWICZ, ROBERT INDIANA.
Minneapolis, Minn.: 1963. Unpaged. Illus.

Discusses the junk sculpture of the artist and quotes him on
the philosophy behind his use of discarded materials and ma-
chine parts. Includes a checklist of exhibitions.

STORRS, JOHN 1885-1956

1429 "John Storrs." ART NEWS 64 (April 1965): 15.

3rd
floor

Discusses a recent exhibition of the work of an early experi-
menter in the cubist idiom. A man who travelled widely and
studied with Rodin, he discovered abstraction by 1917, and
in the 1920s turned to nonobjective form.

STORY, WILLIAM WETMORE 1819-95

1430 Gerdts, William H. "William Wetmore Story." THE AMERICAN ART
JOURNAL 4 (November 1972): 16-33.

3rd
floor

A well-illustrated survey of his career and output, discussing
the portrait busts and classical figures. Points out that, of
the major neoclassical sculptors, only his reputation has suf-
fered, whereas he was the most successful in his lifetime.

1431 James, Henry. WILLIAM WETMORE STORY AND HIS FRIENDS. 1903.
Reprint. New York: Da Capo Press, 1969. Vol. 1, 371 p.; vol. 2,
345 p.

A full biographical study from his early days and maturation
through his death. Much of this is flowery prose and anecdote,
but gives us a first hand impression of the expatriates' life-
style in Italy.

1432 Story, William W. CONVERSATIONS IN A STUDIO. Boston: Houghton
Mifflin Co., 1890. 578 p.

> Story's philosophies and attitudes toward art and the art world
> through the device of two artists' discussions in an Italian
> studio.

TAFT, LORADO 1860-1936

1433 Garland, Hamlin. "The Art of Lorado Taft." MENTOR 3 (October
1923): 19-34.

> Written by a well-known author and fellow Chicagoan, this
> article speaks to his simplified but still classic forms and ignores
> the fact that entirely new currents were in the air.

1434 Taft, Ada Bartlett. LORADO TAFT: SCULPTOR AND CITIZEN. Greens-
boro, N.C.: privately printed, 1946. vii, 88 p. Illus.

> A chatty biographical study. Discusses his ideas on art edu-
> cation and art for the public. Also contains a checklist of
> his major sculptural works.

TROVA, ERNEST 1927-

1435 Alloway, Lawrence. TROVA: SELECTED WORKS, 1953-1966. Cambridge,
Mass.: Hayden Gallery, Massachusetts Institute of Technology, 1967.
55 p. 30 illus. Bibliog. pp. 53-55.

> Discusses the evolution of his falling man imagery, provides
> analytical discussion of his style, and a detailed catalog of
> the works illustrated.

1436 Pace Gallery. TROVA: THE PROFILE CANTOS. New York: 1973.
Unpaged. Illus. Bibliog.

> A critical essay, illustrations of the work of the 1970s, and a
> complete exhibition record.

WARD, JOHN QUINCY ADAMS 1830-1910

1437 Adams, Adeline. JOHN QUINCY ADAMS WARD: AN APPRECIATION.
New York: National Sculpture Society, 1912. xv, 93 p. 15 illus.

> This volume was commissioned by the society in honor of
> Ward. Contains a chronological list of works, chapters on
> his early years, his work with Henry Kirke Brown, the devel-
> opment of his own work, and a final one on his professional

and artistic life.

1438 Sharp, Lewis I. "John Quincy Adams Ward: Historical and Contemporary Influences." THE AMERICAN ART JOURNAL 4 (November 1972): 71-83.

3rd
Floor

An attempt to balance our image of Ward by pointing out the influence of classical, renaissance, and the French nineteenth-century sculpture on his work. Extensive quotations from the sculptor's writing and illustrations of many of his monuments and bronzes.

WHITNEY, ANNE 1821-1915

1439 Payne, Elizabeth R. "Anne Whitney: Sculptor." ART QUARTERLY 25 (Autumn 1962): 244-61.

3rd
floor

Discusses the work and provides a brief biography of a woman sculptor who began her career in absolute naturalism and later absorbed French ideas into her work of the mid-1870s and beyond. Noted for her busts of famous women and the struggle for Negro freedom.

WHITNEY, GERTRUDE VANDERBILT 1877-1942

1440 Force, Juliana. MEMORIAL EXHIBITION: GERTRUDE VANDERBILT WHITNEY. New York: Whitney Museum of American Art, 1943. Unpaged. Illus.

Includes a biographical introduction, a catalog of sixty-two of her marble and bronze figures, and illustrations of both her monuments and small-scale figure studies.

WRIGHT, PATIENCE 1725-86

1441 Lesley, E.P. "Patience Lovell Wright, America's First Sculptor." ART IN AMERICA 24 (October 1936): 148-54.

3rd
floor

An introduction to the work of the early wax modeller who worked in New York during the early 1770s. Even her busts and reliefs done in England were often of American subjects.

YOUNG, MAHONRI 1877-1957

1442 Mather, Frank Jewett, Jr. MAHONRI M. YOUNG. Andover, Mass.: Addison Gallery of American Art, 1940. 57 p. Illus.

The catalog of a retrospective exhibition of the artist's sculpture, drawings, paintings, and prints. Although he is best remembered as a figural sculptor, it is useful to examine all the work together. Includes autobiographical notes, and a catalog of hundreds of items.

ZORACH, WILLIAM 1887-1966

1443 Baur, John I.H. WILLIAM ZORACH. New York: Frederick A. Praeger, 1959. 116 p. 90 illus. Bibliog. pp. 112-14.

735
Z89b

A biographical and artistic study of the artist that presents his early work in oils and evaluates his painting before his transition to sculpture in the 1920s. An analysis of his methods of carving and of his style is provided. The entanglements and lawsuits related to several of his commissions and entries are discussed.

1444 Hoopes, Donelson F. WILLIAM ZORACH: PAINTINGS, WATERCOLORS AND DRAWINGS, 1911-1922. New York: Brooklyn Museum, 1968. vi, 71 p. Illus., some in color.

A brief introduction to the artist's life and work before and during his years as a painter. The discussion ends in 1922, when Zorach painted his last oil and turned completely to sculpture. The catalog lists seventy-three items of painting and drawings, most of which had not been seen together.

1445 Wingert, Paul. THE SCULPTURE OF WILLIAM ZORACH. New York: Pitman Publishing Corp., 1938. 74 p. 49 illus. Bibliog. pp. 66-68.

Contains a brief biography to the date of writing, a detailed analysis of the artist's development, and an interpretation of sources and style. A catalog of the works of 1917-37 is included with brief excerpts from his writings.

1446 Zorach, William. ART IS MY LIFE. Cleveland: World Publishing Co., 1967. ix, 205 p. 85 illus.

An autobiography that provides information about the artistic milieu in the United States among the avant-garde during the years from 1912 and later.

1447 _____. "Background of Artist." MAGAZINE OF ART 34 (April 1941): 162-68; (May 1941): 237-39.

3rd
floor

Autobiographical article deals with his early migration to America and the development as an artist in America. Article has excellent examples of his water colors and sculptures.

Chapter 11

AMERICAN DECORATIVE ARTS

The field of American decorative arts has been the most fragmented of all areas of art, and very few works have dealt with it in a survey fashion. Only a fraction of the surviving furniture, glass, or metal ware can be identified as the work of a particular craftsman, and very little is known about any but the most famous of these men. Much of what has been written is by and for the collector, and most books are long out of print; but a shift in taste and values is currently causing a new burst of activity in this field.

The works below form a very small and select introduction to the literature in the field, incorporating what has been written on both the work of the highly trained craftsman and the folk artist. Much valuable information can be found in popular magazines and local history newsletters, but the most valuable source still remains the magazine ANTIQUES, published and indexed since 1922.

GENERAL SURVEYS AND PERIOD STUDIES

1448 Brazer, Esther Stevens. EARLY AMERICAN DECORATION. Springfield, Mass.: The Pond-Ekberg Co., 1940. xii, 273 p. Illus., some in color.

> Provides a brief historical chapter on decorative design and then discusses how various effects and types of decoration were created. Provides descriptive and technical information based on both written material and scientific analysis of objects.

1449 Bridenbaugh, Carl. THE COLONIAL CRAFTSMAN. New York: New York University Press, 1950. xii, 214 p. 17 illus.

> This is the text of a series of lectures under the general heading of the book. Discusses the role and activities of both rural and urban craftsmen in colonial America, and their manner of creation and sales of their work. Fine cultural background.

1450 Butler, Joseph T. AMERICAN ANTIQUES, 1800-1900: A COLLECTOR'S HISTORY AND GUIDE. New York: Odyssey Press, 1965. xxi, 203 p. 170 illus., some in color. Bibliog. pp. 187-95.

Suitable for the novice in the field of decorative arts as well as the collector, this volume treats each category—furniture, glass, ceramics, textiles, etc.—in a cultural context and provides clear, easy-to-read descriptive material.

1451 Carpenter, Ralph E., Jr. THE ARTS AND CRAFTS OF NEWPORT, RHODE ISLAND, 1640-1820. Newport, R.I.: The Preservation Society of Newport County, 1954. xiii, 218 p. 139 illus.

Discusses furniture, silver, and some painting, and provides biographical material on the known craftsmen of the region. The bulk of the book is an illustrated catalog with descriptions and commentary on the various pieces.

1452 Christensen, Edwin. THE INDEX OF AMERICAN DESIGN. New York: Macmillan Publishing Co., 1950. xviii, 229 p. 378 illus., many in color.

Information gathered from this large project of the Depression. WPA artists' watercolor renderings illustrate weathervanes, cigar store Indians, warming pans, and hundreds of other objects made by American craftsmen.

1453 Clark, Robert Judson, ed. THE ARTS AND CRAFTS MOVEMENT IN AMERICA, 1876-1916. Princeton, N.J.: Princeton University Press, 1972. 190 p. 295 illus. Bibliog. pp. 187-90.

Individual essays on the Eastern seaboard, Chicago and the Midwest, the Pacific coast, The Arts and Crafts Book, and Art Pottery. Each was written by an authority on the field, and all are well illustrated. The bibliography is very valuable for a further study of the era.

1454 Comstock, Helen. THE CONCISE ENCYCLOPEDIA OF AMERICAN ANTIQUES. 2 vols. New York: Hawthorn Books, 1958. 543 p. 352 illus. Bibliog.

Sixty-two short chapters on different aspects of the decorative and, in some cases, fine arts. Chapters on Windsor chairs, pewter, the craftsmanship of the Shakers, glass, hooked rugs, etc., by important authorities in each field. Includes short bibliographies in each section and line drawings to supplement the plates.

1455 Cummings, Abbott Lowell, ed. RURAL HOUSEHOLD INVENTORIES: ESTABLISHING THE NAMES, USES, AND FURNISHINGS OF ROOMS IN THE COLONIAL NEW ENGLAND HOME, 1675-1775. Boston: The Society for the Preservation of the New England Antiquities, 1964. xi, 306 p. 14 plates.

Divided into twenty-five-year sections, full inventories of the contents of homes are taken from auction and sales records.

1456 Davidson, Marshall B., ed. THE AMERICAN HERITAGE HISTORY OF
AMERICAN ANTIQUES FROM THE CIVIL WAR TO WORLD WAR I. New
York: American Heritage Publishing Co., 1969. 415 p. 646 illus.,
many in color.

> The third volume in this series, it contains many more "out of
> the home" objects. Discusses children's toys, greeting cards,
> etc., as well as the furniture and painting. In addition to
> the glossary of terms, there is a selection of advertisements
> of the period.

1457 _____. THE AMERICAN HERITAGE HISTORY OF AMERICAN ANTIQUES
FROM THE REVOLUTION TO THE CIVIL WAR. New York: American
Heritage Publishing Co., 1968. 416 p. 511 illus., many in color.

> Continues the survey of American decorative arts, painting,
> and early photographic attempts. Undocumented, but generally
> accurate. A glossary of terms and style charts of furniture
> are helpful tools.

1458 _____. THE AMERICAN HERITAGE HISTORY OF COLONIAL ANTIQUES.
New York: American Heritage Publishing Co., 1967. 384 p. 580 illus.,
many in color.

> A general survey of the furniture, household utensils, silver
> work, and painting of the colonial period of American history.
> Includes style charts of furniture and typical forms in silver.
> A glossary of terms is provided.

1459 DeJonge, Eric, ed. COUNTRY THINGS: FROM THE PAGES OF THE
MAGAZINE 'ANTIQUES'. Princeton, N.J.: The Pyne Press, 1973.
Var. pag. Illus.

> Reprints of articles that have appeared in ANTIQUES, dealing
> with such decorative arts subjects as southern provincial furni-
> ture, Ohio coverlets, American woodenware, and fifty-three
> others. Several articles deal with the collections at specific
> museums.

1460 Dickey, Roland F. NEW MEXICO VILLAGE ARTS. Rev. ed. Albuquer-
que: University of New Mexico Press, 1970. xii, 264 p. Illus. with
drawings. Bibliog. pp. 254-58.

> A sympathetic social and cultural history with description of
> the crafts found in the homes of the villagers.

1461 Eberlein, Harold Donaldson, and McClure, Abbott. THE PRACTICAL
BOOK OF AMERICAN ANTIQUES. Philadelphia: J.B. Lippincott Co.,
1927. iv, 390 p. Illus.

> An early but well-written general introduction to the decora-
> tive arts of the colonial and early national period. Discusses
> and illustrates the types and stylistic evolution of glassware,

pottery, silver, textiles, metalwork, and painted objects.

1462 Harvard University. HARVARD TERCENTENARY EXHIBITION: FURNI-
TURE AND DECORATIVE ARTS OF THE PERIOD 1636-1836. Cambridge,
Mass.: 1936. ix, 114 p. 70 illus.

An illustrated exhibition catalog which provides a descriptive
and historical note on 472 items catalogued. Also included is
a biographical index of the craftsmen and original owners of
the work. Covers a variety of early decorative arts.

1463 Hill, Ralph Nading, and Carlisle, Lilian Baker. THE STORY OF THE
SHELBURNE MUSEUM. Shelburne, Vt.: The Shelburne Museum, 1960.
113 p. Illus., some in color.

Although this serves as a history and guidebook to this large
museum collection, it provides sufficient information on the
types of objects illustrated to be useful to the general student
of American decorative arts.

1464 Hornung, Clarence P. TREASURY OF AMERICAN DESIGN. 2 vols.
New York: Harry N. Abrams, 1972. xxvii, 846 p. 2901 illus., more
than 800 in color.

The author has taken the Depression-born Index of American
Design project and has provided both a text and inclusion of
all the renderings involved in the project. Includes H. Cahill's
original introduction to the project. Although the project was
never completed in some parts of the country, this remains as
an indispensable guide to the design traditions in American
history.

1465 Lipman, Jean, and Winchester, Alice. THE FLOWERING OF AMERICAN
FOLK ART, 1776-1876. New York: Viking Press, 1974. 288 p.
410 illus., 110 in color. Bibliog. pp. 284-87.

The catalog of an important travelling exhibition of American
decorative and functional arts in the folk tradition. The text
describes the general conditions which helped produce the work
and describes the role of the individual artists, when known.

1466 Little, Nina Fletcher. THE ABBY ALDRICH ROCKEFELLER FOLK ART
COLLECTION. Williamsburg, Va.: Colonial Williamsburg, 1957.
xvi, 402 p. 105 color illus. Bibliog. pp. 393-94.

The catalog of a major collection of both painting and useful
objects made in the folk tradition. An excellent source of
color illustrations of fine examples of work in each genre.

1467 Lord, Priscilla Sawyer, and Foley, Daniel J. THE FOLK ARTS AND
CRAFTS OF NEW ENGLAND. Philadelphia: Chilton Books, 1965.
xix, 282 p. Illus. Bibliog. pp. 253-65.

A very general cultural history of the development of decorative arts in New England, covering both the work of the trained craftsman and the amateur. Discusses technical matters in a way that the general reader can absorb and provides an extensive bibliography for the serious student of the material.

1468 McClinton, Katharine Morrison. A HANDBOOK OF POPULAR ANTIQUES. New York: Random House, 1946. xii, 244 p. Bibliog.

One of the best of the books for collectors, it provides a reasonable introduction to the various antique objects of colonial and early federal America. Provides information of use to the connoisseur.

1469 Metropolitan Museum of Art. 19th CENTURY AMERICA: FURNITURE AND OTHER DECORATIVE ARTS. New York: 1970. xxxii, unpaged. 298 illus., 67 in color. Bibliog.

This is the catalog of the exhibition marking the 100th birthday of the Met. The general introduction is an historical text on decorative arts in America. The bulk of the book is a descriptive and critical statement on each of the 298 objects illustrated. Furniture, glassware, ceramics, and metalwork are covered.

1470 Naylor, Gillian. THE ARTS AND CRAFTS MOVEMENT. Cambridge, Mass.: The M.I.T. Press, 1971. 208 p. 101 illus., some in color. Bibliog. pp. 195-98.

A study of the European movement that includes references to its influence in the United States. Particular attention is called to the meeting of Charles R. Ashbee with Frank Lloyd Wright.

1471 Nordness, Lee. OBJECTS: U.S.A. New York: Viking Press, 1970. 360 p. Illus.

Contemporary craftsmen in enamel, ceramics, glass, metal, plastic, mosaic, wood, and textiles, and their work. Covers the range of decorative arts in mid-twentieth-century America and provides quotes by the artisans of their thoughts on their work.

1472 Polley, Robert L., ed. AMERICA'S FOLK ART. New York: G.P. Putnam's Sons and Country Beautiful Foundation, 1968. 192 p. Illus., 62 in color.

A good introduction to the range of objects for daily living which were often created by the folk artist as well as the trained craftsman. This volume concentrates on the work of the former group.

1473 Quimby, Ian M.G. WINTERTHUR CONFERENCE REPORT 1973:
TECHNOLOGICAL INNOVATION AND THE DECORATIVE ARTS. Char-
lottesville: University Press of Virginia, 1974. xiv, 373 p. Illus.

These published papers discuss various technological processes
and their effect on decorative arts: iron castings, pressed
glass, calico cylinder printing, etc.

1474 Schwartz, Marvin D. AMERICAN INTERIORS, 1675-1885: A GUIDE
TO THE PERIOD ROOMS IN THE BROOKLYN MUSEUM. New York:
Brooklyn Museum, 1968. vi, 114 p. 83 illus., 19 in color.

Discusses the use of the objects and arrangement and design
of objects in each of the rooms, with information on materials,
techniques, and style.

1475 Stillinger, Elizabeth. THE "ANTIQUES" GUIDE TO DECORATIVE ARTS
IN AMERICA, 1600-1875. New York: E.P. Dutton & Co., 1972.
xv, 463 p. 626 illus. Bibliog. pp. 459-63.

A comprehensive but general introduction to both English and
American decorative arts in this country. Photographs of
significant examples of work and line drawings highlighting
the features described in each period. Arranged by genres
within each historical period.

1476 Stoudt, John Joseph. EARLY PENNSYLVANIA ARTS AND CRAFTS.
New York: A.S. Barnes & Co., 1964. 364 p. 344 illus.

Covers some early painting and architecture but is essentially
a cultural study of the society and the objects in use in daily
life. Many of the illustrations show furniture and other crafts
within the setting of the architecture of the period.

1477 Tracy, Berry B., and Gerdts, William H. CLASSICAL AMERICA, 1815-
1845. Newark, N.J.: Newark Museum, 1963. 212 p. Illus. Bibliog.
pp. 161-63.

Catalog of an exhibition of fine and decorative arts in the
classical period is divided into two parts. The decorative
arts portion provides information on the European background
and discusses furniture, silver, ceramics, glass, wallpaper,
textiles, lamps, stoves, and clocks. A fine documentation of
a small but important period in our decorative arts history.

1478 Triggs, Oscar Lovell. CHAPTERS IN THE HISTORY OF THE ARTS AND
CRAFTS MOVEMENT. Chicago: Bohemia Guild of the Industrial Art
League, 1902. 198 p. Illus.

Primarily a discussion of the European development of the
movement, but directed toward the reactivation of guild handi-
craft in this country.

1479 Welsh, Peter C. AMERICAN FOLK ART: THE ART AND SPIRIT OF A PEOPLE. Washington, D.C.: Smithsonian Institution Press, 1965. Unpaged. 65 illus., some in color. Bibliog.

> A catalog of the collections of paintings, sculpture, and useful objects from the important Eleanor and Mabel Van Alstyne collection.

FURNITURE

1480 Andrews, Edward Deming, and Andrews, Faith. THE SHAKER FURNITURE: THE CRAFTSMANSHIP OF AN AMERICAN COMMUNAL SECT. New Haven, Conn.: Yale University Press, 1937. xi, 133 p. 48 illus. Bibliog. pp. 121-26.

> Chapters discuss the cultural background of Shaker craftsmanship, the purposes of the furniture, information about the craftsmen and descriptions of the houses and shops. The appendices cover the chair industry of the group, and notes on the construction of the pieces.

1481 Bjerkoe, Ethel Hall. THE CABINET MAKERS OF AMERICA. Garden City, N.Y.: Doubleday & Co., 1957. xvii, 252 p. 32 illus. and line drawings. Bibliog. pp. 249-52.

> A brief essay on the development of style and technique in furniture construction is followed by biographical entries on hundreds of known craftsmen. Discusses their work, when identified. Includes a useful glossary.

1482 Burton, E. Milby. CHARLESTON FURNITURE, 1700-1825. Charleston, S.C.: Charleston Museum, 1955. ix, 150 p. 149 illus. Bibliog. pp. 143-45.

> Some background history on the city precedes discussion of the various types of furniture made there, by schools and on plantations. The bulk of the volume is a biographical dictionary of the individual craftsmen. Regional variations from traditional models are discussed.

1483 Comstock, Helen. AMERICAN FURNITURE: SEVENTEENTH, EIGHTEENTH, AND NINETEENTH CENTURY STYLES. New York: Viking Press, 1962. 366 p. 655 illus. Bibliog. pp. 319-24.

> The history of style in American furniture. Each chronological period has an introduction, charts summing up distinctive and new forms, characteristic designs, and new techniques. Many examples of work in each period are illustrated.

1484 Cornelius, Charles Over. FURNITURE MASTERPIECES OF DUNCAN PHYFE. Garden City, N.Y.: Doubleday, Page and Co., 1923. Reprint.

New York: Dover, 1970. xii, 86 p. 66 illus.

Biography and cultural history of his era, followed by a de-
scription of his work, a detailed analysis of his style, and
illustrations of his work in various forms.

1485 Downs, Joseph. AMERICAN FURNITURE: QUEENE ANNE AND CHIP-
PENDALE PERIODS, IN THE HENRY FRANCIS DUPONT WINTERTHUR
MUSEUM. New York: Macmillan Publishing Co., 1952. xl, unpaged.
401 illus., many in color.

A descriptive catalog which provides stylistic, historical, and
provenance material on almost 400 items of early American
furniture. When known, the name of the craftsman and exact
date are also provided.

1486 Fales, Dean A. AMERICAN PAINTED FURNITURE, 1660-1880. New
York: E.P. Dutton & Co., 1972. 298 p. 577 illus., 148 in color.
Bibliog. pp. 289-93.

The only useful source on the history and development of this
form. Divides painted furniture into three groups: plain
painted furniture; painting used to imitate wood, marble, or
other materials; and imaginative and fanciful painting.

1487 Freeman, John Crosby. THE FORGOTTEN REBEL: GUSTAV STICKLEY
AND HIS CRAFTSMAN MISSION FURNITURE. Watkins Glen, N.Y.:
Century House, 1966. 112 p. Illus. Bibliog. pp. 110-11.

Several articles gathered to present a history of the work and
a biography of the man who designed and originated the "mis-
sion" furniture of the early twentieth century. The relation-
ship of Stickley to the general craftsman movement and to
worldwide Art Nouveau is discussed in some detail.

1488 Greenlaw, Barry A. NEW ENGLAND FURNITURE AT WILLIAMSBURG.
Williamsburg, Va.: Williamsburg Foundation, 1974. viii, 195 p.
172 illus., 8 in color.

The well-illustrated and documented catalog of the important
collection at Williamsburg. Style, quality, and provenance
are discussed, and bibliographical references are provided.

1489 Halsey, R.T.H., and Cornelius, Charles O[ver]. A HANDBOOK OF THE
AMERICAN WING. Rev. ed. New York: Metropolitan Museum of Art,
1938. xxiv, 312 p. Illus.

A discussion and description of the furniture in this important
collection. Provides history of the works and discussion as to
the probable craftsman creator.

1490 Horton, Frank L., and Weekley, Carolyn J. THE SWISEGOOD SCHOOL

OF CABINETMAKING. Winston-Salem, N.C.: Museum of Early Southern Decorative Arts, 1973. 50 p. 20 illus.

A discussion of an important southern regional school of furniture making and a description and illustrations of the work of the various craftsmen.

1491 Kalec, Donald. "The Prairie School Furniture." THE PRAIRIE SCHOOL REVIEW I (1964): 5-15.

Shows how Prairie School architects supervised the furniture selection and designed pieces in the spirit of their buildings. Gives Wright a major place in the development of their "total design" concept.

1492 Kettell, Rusell Hawes. THE PINE FURNITURE OF EARLY NEW ENGLAND. Garden City, N.Y.: Doubleday, Doran & Co., 1929. xxiii, 618 p. Illus.

Hundreds of illustrations of furniture built in this particular softwood. Includes a chapter on pine and one on construction techniques. The illustrated entries are divided into chapters on chests, tables, chairs, etc.

1493 Kovel, Ralph [M.], and Kovel, Terry [H.]. AMERICAN COUNTRY FURNITURE, 1780-1875. New York: Crown Publishers, 1965. vii, 248 p. 691 illus.

Illustrates the various developments and variations from the standard high styles in most of the basic furniture forms of the era. Short introductions to each section give a brief history of each form.

1494 Lea, Zilla Rider, ed. THE ORNAMENTED CHAIR: ITS DEVELOPMENT IN AMERICA 1700-1890. Rutland, Vt.: Charles E. Tuttle Co., 1960. 173 p. Illus., 7 in color. Bibliog. pp. 165-67.

Various authors in seven chapters on the different periods in the history of this genre. Each section, on such topics as the Windsor chair and the rocking chair, is illustrated with several examples of such work. Although photos are merely adequate, the details of important objects are very valuable.

1495 Lockwood, Luke Vincent. COLONIAL FURNITURE IN AMERICA. 2 vols. New York: Charles Scribner's Sons, 1926. Vol. 1, xxiv, 398 p.; vol. 2, xx, 354 p. 1003 illus.

Chapters on each type of colonial furniture: tables, chairs, cupboards, sideboards, etc. General discussion of each type, technical considerations, and many illustrations of varieties of each form. An extremely old yet still valuable resource.

1496 Madigan, Mary Jean Smith. EASTLAKE-INFLUENCED AMERICAN FURNI-
TURE, 1870-1890. Yonkers, N.Y.: The Hudson River Museum, 1973.
66 p. Illus. Bibliog. pp. 64-65.

Discusses the work of Charles L. Eastlake (1833-1906) and his
influence on American Victorian furniture. A well-researched
and illustrated exhibition catalog.

1497 Margon, Lester. MASTERPIECES OF AMERICAN FURNITURE, 1620-1840.
New York: Architectural Book Publishing Co., 1965. 256 p. Illus.

Individual quality works are illustrated and discussed, covering
the range of American furniture from the colonial through the
federal periods.

1498 Miller, V. Isabelle. FURNITURE BY NEW YORK CABINETMAKERS,
1650-1860. New York: Museum of the City of New York, 1956. 84 p.
Illus.

The catalog of an important exhibition of the work of New
York craftsmen. Descriptive entries, including the identity
of the maker when known, and illustrations of many of the
pieces. Bibliographical sources on well-known pieces are in-
cluded.

1499 Montgomery, Charles F. AMERICAN FURNITURE: THE FEDERAL PERIOD,
IN THE HENRY FRANCIS DUPONT WINTERTHUR MUSEUM. New York:
Viking Press, 1966. 497 p.

Discusses the development of the furniture styles, concentrating
on the norm developed by skilled craftsmen in the cities.
Each work is described, variations that cause a local identifi-
cation are pointed out, and a provenance is provided.

1500 Morse, John D., ed. COUNTRY CABINETWORK AND SIMPLE CITY
FURNITURE. Charlottesville: University Press of Virginia, for the Henry
Francis du Pont Winterthur Museum, 1970. xiv, 311 p. 57 illus.
Bibliog.

A series of papers including two on specific families of furni-
ture makers, the Dunlaps and Dominys, one on consumer taste,
urban Massachusetts furniture, and others on topics related to
technique and history for the scholar.

1501 Ormsbee, Thomas Hamilton. EARLY AMERICAN FURNITURE MAKERS: A
SOCIAL AND BIOGRAPHICAL STUDY. New York: Thomas Y. Crowell
Co., 1930. xviii, 183 p. 67 illus. Bibliog. pp. 177-79.

Chapters on the work and activity of the craftsmen during the
seventeenth century: American Chippendales, Duncan Phyfe
and his followers, and craftsmen who became involved in
government and politics. A popular social history.

1502 _____. FIELD GUIDE TO AMERICAN VICTORIAN FURNITURE. Boston: Little, Brown and Co., 1952. xxxii, 429 p. 283 illus. Bibliog. p. 429.

This is a guide for the collector. Line drawings of 283 different items show the range and depth of Victorian pieces. Chapters on the substyles of Victorian furniture, a discussion of woods and of specialty items like cast-iron papier-mache furniture.

1503 _____. THE WINDSOR CHAIR. New York: Deerfield Books, 1962. 223 p. 80 illus.

Although pointing out the English origins of the Windsor chair and including a small section on the English product, this is a study of the development of the type in America, a discussion of regional variations, and a checklist of American Windsor chair makers.

1504 Otto, Celia Jackson. AMERICAN FURNITURE OF THE NINETEENTH CENTURY. New York: Viking Press, 1965. 229 p. 481 illus.

Chronological treatment of styles and of classes of objects: chairs, tables, mirrors, etc., within chronology. A general encyclopedia of works.

1505 Randall, Richard H., Jr. AMERICAN FURNITURE IN THE MUSEUM OF FINE ARTS, BOSTON. Boston: Museum of Fine Arts, 1965. 273 p. 218 illus.

The catalog of one of the major collections of American furniture from the colonial period through the nineteenth century. Each entry is described, documented, and illustrated.

1506 _____. THE FURNITURE OF H.H. RICHARDSON. BOSTON: Museum of Fine Arts, 1962. 4 p. Illus.

The catalog of an exhibition of the furniture designed for his buildings.

1507 Renwick Gallery. SHAKER: FURNITURE AND OBJECTS FROM THE FAITH AND EDWARD DEMING ANDREWS COLLECTIONS. Washington, D.C.: Smithsonian Institution Press, 1973. 88 p. 40 illus.

An essay on the Shakers, a discussion of design in Shaker furniture, a conversation with Faith Andrews, the compiled writings of the Andrewses, and an exhibition catalog make up this volume for and by the family who are so closely identified with Shaker art and life.

1508 Sack, Albert. FINE POINTS OF FURNITURE: EARLY AMERICAN. New York: Crown Publishers, 1950. xvi, 303 p. Illus.

An interesting guide for the collector and connoisseur. Various

genres of furniture are examined and typical, better, and excellent examples of each are illustrated. The author explains why proportions, woods, etc., cause the selection of pieces in each category.

1509 Schiffer, Margaret Berwind. FURNITURE AND ITS MAKERS OF CHESTER COUNTY, PENNSYLVANIA. Philadelphia: University of Pennsylvania Press, 1966. 280 p. 168 illus. Bibliog. pp. 279-80.

A carefully researched and documented biographical survey of the furniture makers. Includes inventories of many of their shops and provides any information available on their work. Illustrations are also well documented and attributed.

1510 Stoneman, Vernon C. JOHN AND THOMAS SEYMOUR: CABINETMAKERS IN BOSTON, 1794-1816. Boston: Special Publications, 1959. 393 p. 291 illus. Bibliog. pp. 392-93.

A major attempt to provide the history and analysis of the work of the father and son, to place their work in a perspective relating to their contemporaries, and to produce a catalog of their works. Each piece is described and illustrated.

METALWORK

1511 Avery, C. Louise. EARLY AMERICAN SILVER. New York: The Century Co., 1930. Reprint. New York: Russell and Russell, 1968. xliv, 378 p. 63 illus. Bibliog. pp. 361-64.

A standard well illustrated and carefully documented study of the stylistic development and history of types in the colonial and early national periods of our history.

1512 Bedinger, Margery. INDIAN SILVER: NAVAJO AND PUEBLO JEWELERS. Alburquerque: University of New Mexico Press, 1973. xiv, 264 p. 100 illus., 8 in color. Bibliog. pp. 243-55.

1513 Bigelow, Francis Hill. HISTORIC SILVER OF THE COLONIES AND ITS MAKERS. 1917. Reprint. New York: Tudor Publishing Co., 1948. xxiv, 476 p. Illus.

Concentrates on the work of the better-known smiths and those who signed or marked their work. The illustrated objects have historical as well as aesthetic value.

1514 Bohan, Peter J., and Hammerslough, Philip. EARLY CONNECTICUT SILVER, 1700-1840. Middleton, Conn.: Wesleyan University Press, 1970. xi, 288 p. 184 illus. Bibliog. pp. 279-83.

Contains a history of the silversmith, a chapter on technique, biographies of the smiths, a detailed catalog, and an index

of marks. The illustrated catalog is especially useful in developing an idea as to the particular forms.

1515 Buhler, Kathryn C. AMERICAN SILVER 1655-1825 IN THE MUSEUM OF FINE ARTS, BOSTON. 2 vols. Greenwich, Conn.: New York Graphic Society, 1972. xx, 740 p. 650 illus. Bibliog. pp. xv-xx.

A well-documented study and survey of the fine collection in the museum. Information on each piece, its type, maker, and provenance is provided. Good illustrations.

1516 _____. PAUL REVERE: GOLDSMITH, 1735-1818. Boston: Museum of Fine Arts, 1956. 44 p. Illus.

Discusses the man, his general involvement in American life, and his work as a smith. Documents particular Revere works.

1517 Buhler, Kathryn C., and Hood, Graham. AMERICAN SILVER IN THE YALE UNIVERSITY ART GALLERY. Vol. 1. New Haven: Yale University Press, 1970. xviii, 344 p. Illus.

Each craftsman represented has his works consecutively listed. The catalog entries are fully documented, including the provenance for each object.

1518 Burton, E. Milby. SOUTH CAROLINA SILVERSMITHS, 1690-1860. Charleston, S.C.: Charleston Museum, 1942. xvii, 311 p. Illus. Bibliog. pp. 291-302.

A biographical dictionary of craftsmen working in metal in the state, arranged by geographic area. Included is a lengthy table of the initials stamped on the metal by the smith, and a detailed bibliography of primary and secondary sources.

1519 Clarke, Herman Frederick, and Foote, Henry Wilder. JEREMIAH DUMMER: COLONIAL CRAFTSMAN AND MERCHANT. Boston: Houghton Mifflin Co., 1935. Reprint. New York: Da Capo Press, 1970. xix, 205 p. 23 plates.

The life and work of this silversmith is presented as completely as possible. Contains the hypothesis that Dummer may have painted portraits as well.

1520 Currier, Ernest M. MARKS OF EARLY AMERICAN SILVERSMITHS. Harrison, N.Y.: R. A. Green, 1970. 179 p. Illus. Bibliog. pp. 172-76.

Includes notes on silver, discusses and illustrates spoon types. The various smiths' marks are documented and illustrated, and a list of New York City silversmiths of the early nineteenth century is provided.

1521 Cutten, George Barton. THE SILVERSMITHS OF VIRGINIA. Richmond, Va.: The Dietz Press, 1952. xxiv, 259 p. Illus.

A brief history of silver and silversmithing in Virginia is followed by a biographical survey by city of the known figures working at the craft. Illustrations of the available surviving works are provided and show the high quality of native work.

1522 Fales, Martha Gandy. EARLY AMERICAN SILVER, FOR THE CAUTIOUS COLLECTOR. New York: Funk & Wagnalls, 1970. x, 329 p. 226 illus. Bibliog. pp. 303-13.

Written for the collector rather than the scholar, this volume provides sections on stylistic development, both in general and for the specific forms, discusses regional variations, design sources, and concentrates on connoisseurship features.

1523 French, Hollis. JACOB HURD AND HIS SONS NATHANIEL AND BENJAMIN, SILVERSMITHS 1702-1781. Cambridge, Mass.: Riverside Press, 1939. Reprint. New York: Da Capo Press, 1972. 154 p. 27 illus.

Presents biographical information, a discussion of the type and quality of the Hurd silverwork, and its place in America's craftsmanship.

1524 Gourley, Hugh J. THE NEW ENGLAND SILVERSMITH: AN EXHIBITION OF NEW ENGLAND SILVER FROM THE MID-SEVENTEENTH CENTURY TO THE PRESENT. Providence: Rhode Island School of Design, 1965. Unpaged. 84 illus.

The catalog of an important exhibition of a cross section of silverwork from the colonial period to the present. Each of the 327 catalog entries is described in physical detail.

1525 Henry Francis du Pont Winterthur Museum. SPANISH, FRENCH, AND ENGLISH TRADITIONS IN THE COLONIAL SILVER OF NORTH AMERICA. Winterthur, Del.: 1968. 109 p. Illus.

A series of papers on the various influences of what is now primarily the area of the United States. Of particular importance are the papers dealing with American church silver.

1526 Hood, Graham. AMERICAN SILVER: A HISTORY OF STYLE, 1650-1900. New York: Frederick A. Praeger, 1971. 256 p. 286 illus. Bibliog. pp. 247-50.

The introduction discusses the origins and practice of the crafts, problems of dating, and manufacturing techniques. The history of style in American silver is traced from the seventeenth-century cups and beakers through the varied products of the end of the nineteenth century. Stylistic considerations and changes include discussion of political, social, and economic

factors.

1527 Kauffman, Henry J. AMERICAN COPPER AND BRASS. Camden, N.J.: Thomas Nelson & Sons, 1968. 288 p. Illus. Bibliog. pp. 282-83.

Two main sections, one on the products of the coppersmith and one on the products of the Brass Founder. Lists of craftsmen are included with locations and active dates.

1528 _____. THE COLONIAL SILVERSMITH: HIS TECHNIQUES AND HIS PRODUCTS. Camden, N.J.: Thomas Nelson & Sons, 1969. 176 p. Illus. Bibliog. p. 173.

Chapters on the metal and its general usage, the process of the workshop, and on the various products made by the silversmith of the colonial period.

1529 Kerfoot, J.B. AMERICAN PEWTER. New York: Bonanza Books, 1924. xxii, 236 p. 500 illus.

An account of every known American pewterer, with dates, type of work, marks, and scarcity factors. Very old but useful source for research on pewter.

1530 Kovel, Ralph M., and Kovel, Terry H. A DICTIONARY OF AMERICAN SILVER, PEWTER, AND SILVER PLATE. New York: Crown Publishers, 1961. 352 p. Bibliog. pp. 345-47.

An exhaustive dictionary of known silversmiths and pewterers in this country since colonial times. A basic source. Smiths' marks and initials used as marking devices are provided through line drawings.

1531 Laughlin, Ledlie Irwin. PEWTER IN AMERICA: ITS MAKERS AND THEIR MARKS. New ed. Barre, Mass.: Barre Publishers, 1969. Vol. 1, xix, 242 p. Illus. Bibliog. pp. 163-92. Vol. 2, xiv, 276 p. Illus.

A major study of the work in a once major craft form. As well as historical documentation, a checklist of American makers of pewter and an inventory of pewter shops are provided. The bibliography is both extensive and exhaustive.

1532 McClinton, Katharine Morrison. COLLECTING AMERICAN 19th CENTURY SILVER. New York: Charles Scribner's Sons, 1968. viii, 280 p. Illus. Bibliog. pp. 274-76.

Of greatest use to the collector and connoisseur, this volume is divided into chapters on the chronological periods and major creations within those periods, and a series of chapters on special collectables, presentation pieces, swords, church silver, Masonic jewels, etc. Helps any reader become familiar with basic styles and designs.

1533 Miller, V. Isabelle. SILVER BY NEW YORK MAKERS: LATE 17th CEN-
TURY TO 1906. New York: Museum of the City of New York, 1937.
xvi, 71 p. Illus.

> A catalog of 383 items by New York craftsmen, listed alpha-
> betically. Each work is described, markings are indicated,
> and weight is given. The illustrations cover a wide variety
> of objects, and the original owners, when known, are listed.

1534 Montgomery, Charles F. A HISTORY OF AMERICAN PEWTER. New
York: Frederick A. Praeger, 1973. 246 p. Illus. Bibliog. pp. 241–42.

> An excellent and concise survey and history of the use of this
> material in America. Chapters on pewter in everyday life, the
> craft of the pewterer, and connoisseurship are followed by sections
> on the varieties of objects made from pewter. Well illustrated.

1535 Museum of Fine Arts. Houston. SOUTHERN SILVER; AN EXHIBITION OF
SILVER MADE IN THE SOUTH PRIOR TO 1860. Houston: 1968. Un-
paged. Illus.

> The work of important silversmiths of the South is presented with a
> descriptive entry on each piece. The introduction describes the
> general distribution and types of silver of the South and correctly
> points to the need for a great deal of research in the field.

1536 Pleasants, J. Hall. MARYLAND SILVERSMITHS, 1715–1830. Baltimore:
Lord Baltimore Press, 1930. xiv, 320 p. 67 illus.

> Discusses the individual smiths and their work, and illustrates not
> only the fine examples of silver, but the marks and a design book.

1537 Rainwater, Dorothy T., and Rainwater, H. Ivan. AMERICAN SILVER-
PLATE. Nashville, Tenn.: Thomas Nelson & Sons, 1968. 480 p.
Illus. Bibliog. pp. 461–65.

> Provides the historical background of silverplate, discusses the
> development of electroplating and the methods of manufacturing.
> The various objects created of this material are discussed and
> illustrated, and a final chapter is devoted to care and restoration.

1538 Rosenbaum, Jeanette W. MYER MYERS: GOLDSMITH, 1723–1795.
Philadelphia: The Jewish Publication Society of America, 1954. 141 p.
30 illus. Bibliog. pp. 139–41.

> A biographical study of the smith and patriot. Illustrations of
> his work, identification of his marks, and a technical discussion
> of the various works are provided.

1539 Williams, Carl M. SILVERSMITHS OF NEW JERSEY, 1700–1825. Phila-
delphia: George S. MacManus Co., 1949. xii, 164 p. 46 illus.
Bibliog. pp. 153–57.

A geographical division of the locations where smiths were active in the period under discussion. Lengthy biographical entries on the individual craftsmen and illustrations of their work.

CERAMICS

1540 Barber, Edwin Atlee. MARKS OF AMERICAN POTTERS. 1904. Reprint. Southhampton, N.Y.: Cracker Barrel Press, 1971. 174 p. Illus.

A geographically divided catalog of American potters with more than 1,000 different marks, including different ones used by a firm over the years. A useful aid to scholar and connoisseur alike.

1541 _____. THE POTTERY AND PORCELAIN OF THE UNITED STATES. New rev. ed. Watkins Glen, N.Y.: Century House, 1971. ix, 450 p. 222 illus. Bibliog. pp. 407-35.

Discussion of operations of American individuals and companies in terms of both geography and style. Particular attention is paid to the Tucker porcelain, the first manufactured in this country. The section on ornamental tiles is valuable, as is the extensive updated bibliography.

1542 _____. TULIP WARE OF THE PENNSYLVANIA-GERMAN POTTERS: AN HISTORICAL SKETCH OF THE ART OF SLIP-DECORATION IN THE UNITED STATES. Philadelphia: Pennsylvania Museum, 1903. 233 p. 94 illus.

The history of the manufacture and style of the tulip ware of this group, with attention paid to the methods and processes. A final chapter deals with non-Pennsylvania-Dutch workers in this medium.

1543 Bivins, John. THE MORAVIAN POTTERS IN NORTH CAROLINA. Chapel Hill: University of North Carolina Press, 1972. xiii, 300 p. 276 illus. Bibliog. pp. 289-90.

A detailed study of the history and output of the Moravian pottery work in North Carolina. The activities and leadership roles of the various masters are presented, and the different products—candlesticks, pots and Queensware—are discussed and illustrated. Contains a good working glossary of terms.

1544 Chapman, Kenneth Milton. THE POTTERY OF SAN ILDEFONSO PUEBLO. Albuquerque: University of New Mexico Press, 1971. xvi, 260 p. Illus., some in color. Bibliog. pp. 259-60.

A careful study of the pottery of an important settled Indian village. Discusses style, technique, and the place of the pottery in the life of the individual and the community.

1545 FORMS FROM THE EARTH: 1,000 YEARS OF POTTERY IN AMERICA.
New York: Museum of Contemporary Crafts, 1962. 21 p. 25 illus.

> Exhibition catalog of 299 items of the pre-Columbian period,
> the colonial years, and up through the first half of the twen-
> tieth century. Very little text.

1546 Hawes, Lloyd E. DEDHAM POTTERY AND THE EARLIER ROBERTSON'S
CHELSEA POTTERIES. Dedham, Mass.: Dedham Historical Society, 1968.
52 p. 51 illus. Bibliog. p. 52.

> Brief history of this important pottery center, and illustrations
> of not only the major work, but of the factory and process as
> well. Registration and potters' marks are illustrated.

1547 Henzke, Lucile. AMERICAN ART POTTERY. Camden, N.J.: Thomas
Nelson & Sons, 1970. 336 p. Illus., some in color.

> Traces the art potteries in this country from the Fulper work
> of 1805 through those founded in the twentieth century. The
> work of Rookwood Pottery (1880-1960), Roseville Pottery (1892-
> 1954), and Newcomb Pottery (1897-1940) is discussed in
> somewhat greater detail.

1548 Ketchum, William C., Jr. EARLY POTTERS AND POTTERIES OF NEW
YORK STATE. New York: Funk & Wagnalls, 1970. x, 278 p. Illus.
Bibliog. pp. 254-69.

> After an introduction to the art of the potter, a geographical
> survey is the main body of the book. The work of potteries
> in various parts of the state is examined and a checklist of
> New York State potters and their marks is provided. Bibliog-
> raphy is detailed and divided by region.

1549 _____. THE POTTERY AND PORCELAIN COLLECTOR'S HANDBOOK:
A GUIDE TO EARLY AMERICAN CERAMICS FROM MAINE TO CALI-
FORNIA. New York: Funk & Wagnalls, 1974. xx, 204 p. Illus.

> Although designated a handbook for the collector, it serves
> quite well as an introduction to the techniques, stylistic
> changes, and history of ceramic work in this country. The
> appendix is a carefully selected list of potters, their period
> of activity, location, and type of ware produced.

1550 Klamkin, Marian. AMERICAN PATRIOTIC AND POLITICAL CHINA.
New York: Charles Scribner's Sons, 1972. 256 p. 342 illus.

> The commemorative and contemporary designs and mottos that
> have been placed on ceramic ware have a long tradition that
> is explored in this study. Examples of propaganda, both se-
> rious and humorous, are illustrated.

1551 Nelson, Marion J. "Art Nouveau in American Ceramic." ART QUAR-
TERLY 26 (1963): 441-59.

Discusses the influence of European art nouveau, and its Ameri-
can manifestations in the mainstream of both the freehand and
manufactured pottery of this country.

1552 Peck, Herbert. THE BOOK OF ROOKWOOD POTTERY. New York:
Crown Publishers, 1968. viii, 184 p. Illus., 6 in color. Bibliog.
p. 177.

A history of the Rookwood firm and its successors. The impor-
tant managers are discussed and the changes in direction of
pottery manufacturing are described. Additional material on
Rookwood marks, Rookwood in museum collections, and a note
on the Zanesville competitors.

1553 Purviance, Louise; Purviance, Evan; and Schneider, Norris F. ZANES-
VILLE ART POTTERY. Leon, Iowa: Mid-American Book Co., 1968.
Unpaged. 23 color plates.

Illustrations and discussion of the work of the major Zanesville
potteries: S.A. Weller, J.B. Owens, and the important Roseville
Pottery Co.

1554 Quimby, Ian M.G., ed. WINTERTHUR CONFERENCE REPORT 1972:
CERAMICS IN AMERICA. Charlottesville: University Press of Virginia,
1973. ix, 374 p. Illus.

A series of papers that explore American ceramics in light of
archeological and connoisseurship evidence.

1555 Ramsay, John. AMERICAN POTTERS AND POTTERY. New York: Tudor
Publishing Co., 1947. xx, 304 p. 100 illus. Bibliog. pp. 244-51.

A good general survey of the field which includes a chart and
key to pottery forms; technical notes; an index of potters' marks;
a checklist of potters, by location; and a study of developments
in the history of style and taste.

1556 Schwartz, Marvin D., and Wolfe, Richard. HISTORY OF AMERICAN ART
PORCELAIN. New York: Renaissance Editions, 1967. 93 p. 75 illus.,
some in color. Bibliog. p. 93.

A background chapter on the history of porcelain is followed
by a chronological study of developments in technique and,
increasingly more important, taste, and style. Information on
the illustrations is very specific.

1557 Stiles, Helen E. POTTERY IN THE UNITED STATES. New York: E.P.
Dutton & Co., 1942. 329 p. Illus. Bibliog. pp. 317-24.

A somewhat chatty but useful survey of pottery, starting with

an examination of early imports. The major pottery centers are examined and the various art ware sources are discussed. Separate chapters on brick and tile work.

1558 _____. POTTERY OF THE AMERICAN INDIANS. New York: E.P. Dutton & Co., 1939. 169 p. Illus. Bibliog. pp. 161-65.

A study of the Indian work in all of North America, it includes a section on the work found, for the most part, in the southwest United States. Technical and stylistic material is presented in a journalistic fashion.

1559 Watkins, Lura Woodside. EARLY NEW ENGLAND POTTERS AND THEIR WARES. Cambridge, Mass.: Harvard University Press, 1950. x, 291 p. 136 illus. Bibliog. pp. 271-76.

A carefully written scholarly study of the techniques and history of the potters, by location, and the work they produced. The peculiarities and distinctive characteristics of different potters are discussed and used as an aid in research.

GLASS

1560 Barber, Edwin Atlee. AMERICAN GLASSWARE. Philadelphia: David McKay Co., 1900. 112 p. Illus.

Chapters on early glass works, on the identification of old glassware, descriptions of some of the old firms, representative designs, etc.

1561 Bing, Samuel. ARTISTIC AMERICA: TIFFANY GLASS, AND ART NOUVEAU. Cambridge, Mass.: The M.I.T. Press, 1970. xiv, 260 p. Illus., some in color.

The greatest part of this work is translation from LA CULTURE ARTISTIQUE EN AMERIQUE. Individual essays on the three subjects in the title.

1562 Cloak, Evelyn Campbell. GLASS PAPERWEIGHTS OF THE BERGSTROM ART CENTER. New York: Crown Publishers, 1969. 196 p. Illus. in color. Bibliog. pp. 173-90.

A catalog of the glass paperweights of many countries; the section of American work is particularly well illustrated. Contains an extremely detailed bibliography.

1563 Freeman, Larry. IRIDESCENT GLASS. Watkins Glen, N.Y.: Century House, 1956. 128 p. Illus.

After a brief introduction to the method of producing iridescent glass, chapters are devoted to several major firms associated

with its manufacture. Discusses stylistic and technical differences and contains some information of interest to collectors.

1564 Hunter, Frederick W. STIEGEL GLASS. New York: Dover, 1950. xxii, 308 p. 169 illus., 16 in color.

Includes biographical material on Stiegel (1729-85), a description and discussion of his work and techniques, and illustrations of his pitchers, glasses, bottles, and other forms.

1565 JOURNAL OF GLASS STUDIES. Corning, N.Y.: Corning Museum of Glass, 1959- . Annual.

Although this journal treats the subject of glass throughout the world and historically, many of its articles are concerned with developments in the United States.

1566 Keefe, John Webster. LIBBEY GLASS: A TRADITION OF 250 YEARS, 1818-1968. Toledo: The Toledo Museum of Art, 1968. 69 p. Illus. Bibliog. p. 69.

The catalog of an exhibition of 224 items of the New England Glass Company and its successors. A history of the firm is given, followed by a chapter on techniques of creating blown, pressed, cut, and engraved glass. A well-documented and beautifully photographed exhibition catalog.

1567 Klamkin, Marian. THE COLLECTORS GUIDE TO DEPRESSION GLASS. New York: Hawthorn Books, 1973. 225 p. Illus. Bibliog. p. 214.

Essentially for the collector and interested layman, this volume documents the history and manufacture of machine-made inexpensive table and gift ware of the 1920s through World War II. Discussion on the work of several major firms, varieties of products, and various collector-related chapters.

1568 Koch, Robert. LOUIS C. TIFFANY, REBEL IN GLASS. New York: Crown Publishers, 1964. 246 p. Illus., some in color. Bibliog. pp. 222-33.

The standard modern biography of the artist/designer. Supersedes the one DeKay wrote during Tiffany's lifetime. The development of his career and study of his work is combined with the biographical narrative. Contains many photographs and documentary evidence of his career.

1569 Lee, Ruth Webb. EARLY AMERICAN PRESSED GLASS. 19th ed. Northboro, Mass.: privately printed, 1946. xxix, 666 p. 190 illus.

An old volume, with some omissions, but the most encyclopedic coverage of the subject. Every conceivable type of object or set has been included and most are illustrated. Provides stan-

dardized names for the available pressed glass patterns in the era, 1840-80, and the means of identifying them.

1570 McKearin, George S., and McKearin, Helen. AMERICAN GLASS. New York: Crown Publishers, 1941. xvi, 622 p. 262 illus., 1,000 drawings. Bibliog. pp. 615-17.

Although old and out of date, this remains the major one-volume study of the subject. Chapters 1 through 3 provide an historical overview of the field and its early history in this country. Other chapters are devoted to the history and products of major glass producing companies, and a few deal with specific products: pictorial and historical flasks, pattern molded bottles, fancy wares, etc.

1571 _____. TWO HUNDRED YEARS OF AMERICAN BLOWN GLASS. Garden City, N.Y.: Doubleday & Co., 1950. xvi, 382 p. 114 illus., 10 in color. Bibliog. pp. 361-66.

Carefully researched chapters on the periods in the history of American blown glass, through the middle of the twentieth century. The plates are fully described, the important generic qualities are discussed, and its provenance, when known, is provided.

1572 Papert, Emma. THE ILLUSTRATED GUIDE TO AMERICAN GLASS. New York: Hawthorn Books, 1972. ix, 289 p. 266 illus. Bibliog. pp. 267-71.

Provides a history of the American glass craft, European influences, and cultural forces that shaped it. Changes in forms, styles, and technology are discussed and examples of work in each era are illustrated. Of interest to the general reader and collector.

1573 Pepper, Adeline. THE GLASS GUFFERS OF NEW JERSEY AND THEIR CREATIONS 1739-1970. New York: Charles Scribner's Sons, 1971. 320 p. 237 illus., 19 in color. Bibliog. pp. 316-20.

Discusses the history of glass blowing in New Jersey, a major center for that form, and provides information on individual companies and the various types of glass products. Some data on cut glass are included.

1574 Revi, Albert Christian. AMERICAN ART NOUVEAU GLASS. Camden, N.J.: Thomas Nelson & Sons, 1968. 476 p. 561 illus., some in color. Bibliog. pp. 463-64.

The introduction provides a brief overview of the influences and sources of Art Nouveau. Individual chapters cover the history, work, and specific qualities of the major firms of Tiffany Glass Co., Douglas Nash Corp., Steuben Glass Works,

and others. Each appendix is a catalog of a major manufacturer of glass. Excellent descriptive entries for the many illustrations.

1575 _____. AMERICAN CUT AND ENGRAVED GLASS. Camden, N.J.: Thomas Nelson & Sons, 1965. xix, 497 p. 205 illus. Bibliog. p. 471.

Traces the history of cut glassware in America, describing the products of the known companies. Explores stylistic developments from early imitative work, through the great era of the end of the nineteenth century to the decline in the second quarter of the twentieth. Chapters are devoted to each cut glass manufacturing region. Line drawings supplement photos of actual works.

1576 _____. AMERICAN PRESSED GLASS AND FIGURE BOTTLES. New York: Thomas Nelson & Sons, 1964. xi, 446 p. Illus. Bibliog. p. 413.

Historical material on the development of the pressed glass industry in this country is followed by sections on each documented glass company active in the field. The varieties of each firm's work are outlined and illustrated. Documentation on designs and patents is provided and a special chapter is concerned with figure bottles in America.

1577 Schwartz, Marvin D., ed. AMERICAN GLASS. New York: Charles Scribner's Sons, 1974. 224 p. More than 200 illus.

Selected articles on American glass taken from the magazine ANTIQUES.

1578 Wilson, Kenneth N. NEW ENGLAND GLASS AND GLASSMAKING. New York: Thomas Y. Crowell Co., 1972. 401 p. 365 illus. Bibliog. pp. 385-86.

A detailed scholarly study of the history and development of the glass industry in New England. Historical roots are traced and individual chapters on window, bottle, and flint glasshouses provide documentation on developments in each area. Individual firms are covered. A chronological list of New England glasshouses and products is also provided.

TEXTILES

1579 Carlisle, Lilian Baker. PIECED WORK AND APPLIQUE QUILTS AT SHELBURNE MUSEUM. Shelburne, Vt.: Shelburne Museum, 1957. 95 p. Illus.

A handbook and guide to the collection of such work in a major museum of Americana. Some background and historical information.

1580 Davison, Mildred, and Mayer-Thurman, Christa C. COVERLETS: A HANDBOOK ON THE COLLECTION OF WOVEN COVERLETS IN THE ART INSTITUTE OF CHICAGO. Chicago: Art Institute of Chicago, 1973. 228 p. Illus., some in color. Bibliog. pp. 227-28.

1581 Hall, Carrie A., and Kretsinger, Rose. THE ROMANCE OF THE PATCH-WORK QUILT IN AMERICA. Coldwell, Idaho: Coxton Printers, 1935. Reprint. New York: Bonanza Books, 1972. 299 p. Illus.

The history of the development of the genre and the techniques and personal tricks used in the making thereof. Examples from all over the country, and some accounts of the personal reasons many were created.

1582 Harbeson, Georgiana Brown. AMERICAN NEEDLEWORK. New York: Coward-McCann, 1938. Reprint. New York: Bonanza Books, 1972. xxxviii, 232 p. Illus. Bibliog. pp. 225-26.

Chapters on the various forms of embroidery and religious and secular samplers, of both the Native American and the European settlers and their descendants. Explains how work was used and methods of creation.

1583 Holstein, Jonathan. THE PIECED QUILT: AN AMERICAN DESIGN TRADITION. Greenwich, Conn.: New York Graphic Society, 1973. 192 p. 155 illus., some in color. Bibliog. pp. 188-89.

The pieced quilt is presented as one of the great folk art forms of American art. The types of patterns and decoration are amply illustrated.

1584 Kahlenberg, Mary Hunt, and Berlant, Anthony. THE NAVAJO BLANKET. New York: Frederick A. Praeger; Los Angeles: Los Angeles County Museum of Art, 1972. 112 p. 97 illus., 16 in color. Bibliog. p. 111.

A history of the techniques and style of the blanket and its place in the life of the Navajo is followed by a discussion of more recent changes and the impact of cultural change. The catalog of the exhibition has well-documented entries.

1585 Little, Frances. EARLY AMERICAN TEXTILES. New York: The Century Co., 1931. xvi, 267 p. 62 illus. Bibliog. pp. 249-53.

Discusses the early colonial history of hand and wheel work, the development of an industry, and the types of materials produced. Other chapters cover the rise of the machine age, American silk manufacture, and a discussion of early cotton printing. An old, but still useful, source.

1586 Peto, Florence. AMERICAN QUILTS AND COVERLETS. New York: Chanticleer Press, 1949. 63 p. Illus., some in color. Bibliog.

A history of this form of American craft endeavor and a section for the layman on how quilts and coverlets can be made today.

1587 Pettit, Florence H. AMERICA'S PRINTED PAINTED FABRICS, 1600-1900. New York: Hastings House, 1970. 256 p. 175 illus., 6 in color. Bibliog. pp. 245-47.

The first section discusses and illustrates the different methods of hand and machine printing, another is concerned with technical and stylistic developments in the colonial period, and the last traces developments to 1900.

1588 Rabb, Kate. INDIANA COVERLETS AND COVERLET WEAVERS. Indianapolis: Indiana Historical Society, 1928. 433 p. Illus.

An exhaustive study of the regional work from the earliest days of settlement. Specific information on those specialists in the coverlet, and careful documentation.

1589 Safford, Carleton L., and Bishop, Robert. AMERICA'S QUILTS AND COVERLETS. New York: Weathervane Books, 1974. 313 p. 462 illus., some in color. Bibliog. p. 310.

Provides a history of both the technical changes and varieties of the genre, and discusses the changes in taste. Various types are documented and illustrated, including the crazy quilt, candlewick spread, and the applique quilt.

1590 Smithsonian Institution. AMERICAN PIECED QUILTS. Washington, D.C.: 1972. 95 p. 15 in color. Illus.

The catalog of an exhibition of this important form of American decorative arts. Although occasionally made by the specialist, it is a genre that was widely developed with interesting regional variations.

AUTHOR INDEX

This index includes all authors and editors of books and articles cited in the text.

References are to entry numbers.

A

Abrahams, Evelyn 661
Adams, Adeline 831, 1220, 1322, 1437
Adams, Alexander B. 614
Adams, Philip Rhays 913
Addison Gallery of American Art 759
Agee, William C. 80, 549, 948, 1347
Albany Institute of History and Art 698
Albers, Josef 600
Albright-Knox Art Gallery 800
Alexandre, Arsene 1334
Allcott, John V. 190
Allen, Douglas 1060
Allen, Edward B. 480
Alloway, Lawrence 623, 995, 1071, 1435
Allston, Washington 603
American Watercolor Society 481
Ames, (Polly) Scribner 824
Amory, Martha Bobcock 704
Andrew, David S. 236
Andrew Crispo Gallery 550
Andrews, Edward Deming 1480
Andrews, Faith 1480
Andrews, Wayne 128, 182, 323
Arizona, University of, Art Gallery.
See University of Arizona Art Gallery

Arkus, Leon Anthony 898
Armes, Kenneth 387
Arnason, H.H. 62, 821, 949, 981, 1294, 1315, 1373, 1404
Arthur, Eric 167
Arthur, Stanley Clisby 191
Art Institute of Chicago 7, 551, 625
Ashton, Dore 552, 820, 940, 1222, 1310
Audubon, John James 615, 616, 617
Auer, May Hale 1035
Avery, C. Louise 1511

B

Bacon, Leonard 192
Baer, Kurt 168
Baigell, Matthew 472, 553, 554, 630, 633, 717, 1210
Baker, Paul R. 95
Baldwin, Charles Crittenton 438
Baldwin, Ebenezer 1274
Baldwin, Frank Conger 193
Baley, Frank William 622
Ball, Thomas 1275
Baltimore, Municipal Museum of. See Municipal Museum of Baltimore
Baltimore Museum of Art 699, 1074
Bangs, Jean Murray 341, 381
Banham, Reyner 283
Bannister, Turpin Chambers 311
Barber, Edwin A. 1560
Barck, D.C. 1399
Barker, Virgil 473, 555

Author Index

Barlow, Elizabeth 389
Baro, Gene 1223, 1378
Barr, Alfred H., Jr. 53, 83, 1186
Bartlett, Truman Howe 1068
Baskin, Leonard 1280
Bassford, Amy O. 970
Battcock, Gregory 81, 82
Baur, John I.H. 513, 556, 557,
 668, 671, 789, 894, 925, 1046,
 1075, 1142, 1166, 1205, 1443
Bayley, Frank William 33, 648, 705,
 795
Beal, Rebecca J. 786
Beam, Phillip C. 855
Bear, James A., Jr. 217
Bearden, Romare 558
Becker, Felix 47
Bedinger, Margery 1512
Beirne, Rosamond R. 315
Belknap, Waldron V., Jr. 504
Benezit, Emmanuel 27
Bennett, Edward H. 286
Benson, E.M. 950
Benton, Thomas Hart 631, 632, 633
Berlant, Anthony 1584
Berman, Eugene 635
Bermingham, Peter 715
Berry, Rose V.S. 1224
Berry-Hill, Sidney 930
Biddle, Edward 1155
Bigelow, Francis Hill 1513
Bigot, Marie (Healy) 837
Bing, Samuel 1561
Birrell, James 345
Bishop, Robert 1589
Bivins, John 1543
Bjerkoe, Ethel Hall 1481
Blake, Peter 442
Blank, Laurel B. 236
Blashfield, Edwin H. 655
Blesh, Rudi 729
Bloch, E. Maurice 514, 639
Bogardus, James 312
Bohan, Peter J. 1514
Bolton, Ethel 1225
Bolton, Theodore 610, 887
Bolton-Smith, Robin 1138
Born, Wolfgang 482
Boston, Museum of Fine Arts. See
 Museum of Fine Arts. Boston
Boswell, Peyton, Jr. 626, 1034
Bouche, Louis 847

Bowditch, Nancy Douglas 670
Bowdoin College Museum of Art 1281
Bowes, Julian 1298
Bowly, Devereux, Jr. 470
Bowman, Ruth 611
Bracken, Dorothy K. 237
Bragdon, Claude 327
Braider, Donald 627
Brazer, Esther Stevens 1448
Breeskin, Adelyn 619, 665, 679
Breuning, Margaret 1041
Brewington, Marion Vernon 1226
Bridenbaugh, Carl 349, 1449
Briggs, Berta N. 1006
Brinton, Ellen Starr 1197
Broder, Patricia Janis 1227
Brody, J.J. 63
Brooklyn Museum 983, 1021, 1173,
 1192, 1228
Brooks, H. Allen 284
Brooks, Van Wyck 96, 1042, 1123
Brown, Albert F. 208
Brown, Hazel E. 1211
Brown, Milton Wolf 97, 559, 560,
 928
Brown, Sheldon S. 183
Bruce, Edward 561
Bruening, Margaret 718
Brumbaugh, Thomas B. 1300, 1304,
 1330
Brumme, C. Ludwig 1229
Bryant, Edward 1176
Bryant, William Cullen 700
Buckley, Charles 659
Buhler, Kathryn C. 1515, 1516,
 1517
Bullard, E. John 1129
Bullard, F. Lauriston 1230
Burchard, John 129
Burchfield, Charles 672
Burke, Russell 488
Burnham, Alan 146, 352
Burnham, Daniel H. 285, 286
Burrage, Henry 1417
Burroughs, Alan 474, 818, 969
Burroughs, Bryson 721
Burrows, John A. 233
Burton, E. Milby 1482, 1518
Burton, Scott 1425
Bush, Martin H. 1105
Bush-Brown, Albert 129, 417

Author Index

Author Index

L

Labaree, Benjamin W. 377
La Farge, John 919, 920, 921, 922
Lancaster, Clay 101, 185, 264, 265
Landgren, Marchal E. 115
Landman, Hedy 116
Lanes, Jerrold 873
Langdon, William 1386
Langsner, Jules 1055
Laning, Edward 957, 958
Lanning, John Tate 212
Larkin, Lew 641
Larkin, Oliver W. 56, 790, 974
Laughlin, Clarence John 266, 336
Laughlin, Ledlie Irwin 1531
Lea, Zilla Rider 1494
Lee, Cuthbert 509
Lee, Ruth Webb 1569
Lee, Sherman 743
Leiding, Harriette Kershaw 267
Lesley, E.P. 1441
Levy, Julien 636, 811
Linderman, Frank Bird 1080
Lindquist-Cock, Elizabeth 696
Lindsay, Kenneth C. 1177
Lipman, Jean 102, 489, 490, 1036, 1037, 1296, 1465
Lippard, Lucy R. 575, 1057, 1058, 1426, 1427
Little, Frances 1585
Little, Nina Fletcher 491, 1466
Lock, Alain 73
Lockwood, Charles 158
Lockwood, Luke Vincent 1495
Lombardo, Josef 1311
Lord, Priscilla Sawyer 1467
Low, Will 1365
Lowe Art Museum 532
Lucas, Edward Verrall 598
Lucas, E. Louise 15
Luck, Robert H. 533
Ludwig, Allan I. 1248
Lynes, Russell 103, 104

M

Maass, John 105
Mabee, Carleton 975
McCallum, Ian 303
McCaughey, Patrick 1146

McCausland, Elizabeth 750, 824, 829, 848, 885, 963
McClinton, Katharine Morrison 1468, 1532
McClure, Abbott 1461
McCoubrey, John W. 57, 492
McCoy, Esther 304, 337
McCoy, Garnett 16
McCoy, Robert E. 305
McCracken, Harold 688, 1063, 1064
McDermott, John Francis 642, 782, 783
Macdonald-Wright, Stanton 945
McFaddon, Elizabeth 117
McGrath, Robert L. 534
McHale, John 332
McIntyre, Robert George 835
McKearin, George S. 1570, 1571
McKearin, Helen 1570, 1571
McKenna, Rosalie Thorne 396
McKinney, Roland Joseph 774
McKinzie, Richard D. 118
McLanathan, Richard 58, 576
McNay, Marion Koogler, Art Institute. See Marion Koogler McNay Art Institute
McQuade, Walter 439
McSpadden, Joseph 1249
Madigan, Mary Jean Smith 1496
Mahey, John A. 1015
Major, Howard 268
Mallett, Daniel Trowbridge 41
Mann, Maybelle 785
Manson, Grant C. 454
Marceau, Henri 1405
Margon, Lester 1497
Marion Koogler McNay Art Institute 784
Marks, Robert W. 333
Marlborough Gallery 910
Marlor, Clark S. 119
Marlowe, George Francis 213
Martin, Elizabeth Gilber 961
Mason, George Chomplin 1148
Mather, Frank Jewett, Jr. 477, 962, 1442
Mathews, Marcia M. 1160
Mayer-Thurman, Christa C. 1580
Meeks, Carroll L.V. 171
Meixner, Esther Chilstrom 214
Mellorio, J.R. 964
Memorial Art Gallery 701

Author Index

Author Index

Witney, Dudley 167
Wolf, Ben 1103, 1104
Wolf, T.M. 669
Wolfe, Richard 1556
Wood Gallery of Art 1213
Woodward, Christopher 310
Wright, Frank Lloyd 463, 464, 465,
 466, 467
Wright, Louis 60, 61
Wright, Nathalia 1328, 1329
Wright, Olgivanna Lloyd 468, 469
Wunder, Richard P. 1390
Wunderlich, Rudolf 548
Wyckoff, Alexander 33

Y

Yale University 599
Yarrow, William 847
Yost, Karl 1083
Yost, L. Morgan 343
Young, Dorothy Weir 1196
Young, J.W. 654
Young, Mahonri Sharp 596, 768
Young, William 51

Z

Zimiles, Martha 175
Zimiles, Murray 175
Zorach, William 1446, 1447

SHORT-TITLE INDEX

This index includes titles of books which are cited in the text. All titles are listed in their shortened form except when full titles are necessary to distinguish among works with similar titles or when the full title is needed for a clear understanding of the subject of the text. Journals and titles of articles within journals are not listed.

References are to entry numbers.

A

Abbott H. Thayer 1162
Abbott H. Thayer: Painter and naturalist 1163
Abby Aldrich Rockefeller Folk Art Collection, The 1466
A. Bierstadt 637
Abraham Rattner 1051
Abstract Painting 570
Abstract Painting and Sculpture in America 90
Across the Wide Missouri 683, 966
Adolph Gottlieb 816
Adolph Gottlieb: Paintings, 1959-71 815
Ad Reinhardt 1058
Adventures in the Arts 827
Afro-American Art and Craft 64
Afro-American Artist 28
After the Hunt: William Harnett and Other American Still Life Painters, 1870-1900 522, 823
A.H. Maurer 963
Albert Bierstadt 638
Albert Pinkham Ryder 1090
Albert P. Ryder 1085

Albert P. Ryder: Memorial Exhibition 1087
Alexander Calder 1297
Alexander Wyant 1214
Alfonso Ossorio 1383
Alfred Ciles 321
Alfred H. Maurer 1868-1932 965
Allan Kaprow 901
Allgemeines Lexikon der Bildenden Kunstler 47
Allgemeines Lexikon der Bildenden Kunstler: Des XX Jahrhunderts 48
Allston 609
American Abstract Artists: 1936-1966 569
American Academy of Fine Arts and American Art-Union 111
American Antiques, 1800-1900 1450
American Architectural Books 14
American Architecture (Kimball) 141
American Architecture (Schuyler) 143
American Architecture and Other Writings 276

B

N

Short-Title Index

Raymond Hood, Architect 351
R. Buckminster Fuller 332
Readers' Guide to Periodical Literature 22
Readings in American Art since 1900 78
Reality of Appearance, The 523
Recent Ideals of American Art 543
Recent Work by Distinguished Sculptors 1228
Recollections of Charley Russell 1080
Recollections of John Ferguson, The 1190
Reginald Marsh 956
Reginald Marsh: Etchings, Engravings, Lithographs 959
Register of Portraits Painted by Thomas Sully, A 1156
Remade in America 183
Reminiscences of a Portrait Painter 839
Reminiscences of Augustus Saint-Gaudens, The 1412
Reminiscences of the South Seas 922
Report on a Plan for San Francisco 285
Retrospective Exhibition of an American Artist 1206
Revolution and Tradition in American Painting 557
Richard Lindner 940
Richard Stankiewicz, Robert Indiana 1428
Richard Upjohn 432
Rico Lebrun 933
Rise of an American Architecture, The 262
Rise of the Skyscraper, The 147
R.M. Schindler 410
Robert Feke 798
Robert Feke, Colonial Portrait Painter 796
Robert Feke, the Early Newport Portrait Painter and the Beginnings of Colonial Painting 797
Robert Henri 845
Robert Henri: His Life and Works 847

Robert Henri and His Circle 843
Robert Indiana 877
Robert Mills 388
Robert Morris (Compton) 1369
Robert Morris (Tucker) 1370
Robert Motherwell 982
Robert Rauschenberg 1054
Robert S. Duncanson 757
Rockwell Kent 906
Rockwellkentiana 905
Romance of the Patchwork Quilt in America, The 1581
Romanticism and American Architecture 184
Romanticism of Eilshemius, The 787
Roots of Contemporary American Architecture 186
Roy Lichtenstein (Coplins) 938
Roy Lichtenstein (Waldman) 939
Rufus Porter 1036
Rural Household Inventories 1455
Ryder 1089

S

Saint-Gaudens and the Gilded Era 1413
Saint Memin 1092
Saint Memin in Virginia 1091
Sam Francis 800
Samuel F.B. Morse: American Painter 976
Samuel F.B. Morse: His Letters and Journals 977
Samuel F.B. Morse and American Democratic Art 974
Samuel McIntire 377
Sanford Robinson Gifford (1823–1900) 806
Sargent Watercolors 1096
Schindler 411
Sculptors' Guild Travelling Exhibition, 1940–1941 1262
Sculptor's World, A 1377
Sculpture at the Exposition 1259
Sculpture in America 1236
Sculpture in Modern America 1260
Sculpture in the Park 1252
Sculpture, 1955 1261
Sculpture of Elie Nadelman, The 1371

W

Y

Z

SUBJECT INDEX

A

Abbey, Edwin Austin 597–99
Abstract art 84, 90
 painting 550, 562, 564–65, 568–
 70, 572–73, 579, 584, 587–
 89, 592, 623, 658, 665–67,
 729–32, 736–38, 750–51, 754–
 55, 793–94, 800–802, 811,
 814, 816, 820–21, 826, 854,
 890–91, 901, 910–11, 917,
 941, 948–49, 952–53, 981,
 995–96, 1002, 1028, 1034,
 1051, 1071, 1079, 1104, 1110,
 1142, 1176
 sculpture 1222–23, 1256–57,
 1269, 1280, 1309–11, 1314,
 1359, 1361, 1373, 1423, 1429
 See also Hard-edge movement;
 Modernism
Academic architecture 276, 300,
 337. See also Architectural
 education
Academic art 556, 656, 713, 1263,
 1273. See also Art education
Academy of Dusseldorf. See Dussel-
 dorf, Academy of
Adams, Herbert 1273
Adams, John Quincy 74
Adler, Dankmar 147
Aesthetics 99–100, 102, 109
 in architecture 131, 230, 244,
 256, 300, 308, 337, 367, 403,
 406
 in painting 473, 518

 in sculpture 1356 (see also Natu-
 ralism in sculpture)
 See also Art, philosophy; Art and
 literature; Art and morals;
 Art and nature; Classicism;
 Cubism; Dadaism; Expression-
 ism; Idealism; Impressionism;
 Realism; Romanticism; Surreal-
 ism
Albers, Josef 600–601
Albright, Ivan 602
Alloway, Lawrence 1247
Allston, Washington 603–9
American Academy in Rome 378
American Academy of Fine Arts 111
American Art-Union 111
Ames, Ezra 610
Amon G. Carter Collection. See
 Carter (Amon G.) Collection
Andrews (Edward Deming) Collection
 1507
Animals in art 616–17, 1279, 1306,
 1315, 1342, 1391–92
Anschutz, Thomas Pollock 611–13
Antiques 1150, 1454, 1456–59,
 1461, 1468, 1475. See also
 Furniture and furniture makers;
 Glass and glassware; Interior
 furnishings
Applique 1579, 1589. See also
 Blankets and quilts; Needle-
 work
Architects 31, 50, 238

Subject Index

black 25
public relations 370
See also Names of individual
 architects and firms
Architectural decoration and ornament.
 See Decoration and ornament,
 architectural
Architectural designs 293, 295, 327–
 29, 387, 403, 406, 444. See
 also Industrial design
Architectural education 348, 422,
 425. See also Academic ar-
 chitecture
Architectural firms 295, 303. See
 also Names of specific archi-
 tectural firms
Architecture
 bibliography 3, 10–11, 14, 22,
 25, 42
 conservation and restoration 294,
 297, 470 (see also Historic
 preservation)
 directories 20 (see also Names
 of individual architects and
 firms)
 education (see Architectural edu-
 cation)
 philosophy 182–89, 319, 332–33,
 348, 422–24, 452, 467
 plans (see Architectural designs)
 See also Architects; Barns; Bridge
 construction; Building, adobe;
 Building materials; Campus ar-
 chitecture; Church architecture;
 Classicism, in architecture;
 Commercial buildings; Court
 Houses; Decoration and orna-
 ment, architectural; Domestic
 architecture; Geodesic struc-
 tures; Glass in architecture;
 Gothic revival in architecture;
 Greek revival architecture;
 Landscape architecture; Library
 architecture; Lighthouses; Mills;
 Monuments; Office buildings;
 Parks; Prairie School of Archi-
 tecture; Prefabricated buildings;
 Public buildings; Pueblos; Rail-
 road stations; Renaissance In-
 fluence, in architecture; Roof;

Shopping centers; Skyscrapers;
 Spatial organization in archi-
 tecture; Texture, in architec-
 ture; Urban architecture; Ur-
 ban renewal; Headings begin-
 ning with the terms Architec-
 tural and Architecture.
Architecture, classical. See Archi-
 tecture, history of (by period),
 19th century; Classicism, in
 architecture
Architecture, history of (by period)
 general 128–45, 178–79, 181
 colonial period 192–94, 198,
 201–2, 205–6, 209, 212–13,
 215–16, 218–20, 225 (see
 also Architecture, Georgian)
 nineteenth century 71, 106, 218,
 236, 239–42, 244, 248, 251–
 52, 257–62, 268–70, 272–76,
 279– 82 (see also Architecture,
 Romanesque; Architecture,
 Queen Anne; Classicism, in
 architecture; Gothic revival
 in architecture; Greek revival
 architecture; Renaissance in-
 fluence, in architecture)
 twentieth century 69, 71–72, 77–
 78, 283–84, 288–91, 293, 295–
 301, 303–4, 306–9 (see also
 Modernism, in architecture)
 See also Domestic architecture,
 history of (by period)
Architecture, history of (by place)
 Baltimore 149
 Boston 259
 California 157, 168, 261, 283,
 291, 304, 342–43, 410–11
 Charleston, S.C. 165
 Chicago 101, 147, 161–62, 280,
 284, 286, 302, 331, 362,
 383, 401, 403, 413, 429,
 Connecticut 204
 Delaware 151
 Detroit 153, 251
 Florida 160
 Georgia 212, 272
 Iowa 305
 Jamestown, Va. 196
 Kentucky 269

Subject Index

Subject Index

Subject Index

Subject Index

Structural drawing 930
Structure in painting 930
Stuart, Gilbert 1147–54
Sullivan, Louis Henri 143, 147, 248, 276, 300, 331, 349, 417–26, 1286
Sully, Thomas 1155–58
Surrealism 92, 602, 659–60, 746, 813, 981, 1165, 1303, 1314, 1333, 1424. See also Dadaism
Symbolism in art. See Imagery in art
Synagogues. See Church architecture
Synchromist movement 549, 945–46

T

Taft, Leonardo 1433–34
Tanner, Henry Ossawa 1159–60
Tempera painting 1218
Temples. See Church architecture
Terra-cottas 1302, 1346, 1374
Textiles 1585, 1587
Texture
 in architecture 341
 in painting 719, 1021
Thayer, Abbott 1161–63
Theater in art 75
Theus, Jeremiah 1164
Thorton, William 359, 427
Three dimensional art. See Form, in sculpture
Tiffany, Louis C. 1561, 1568, 1574
Tile Club 1193
Tobey, Mark 1165
Tombs 439. See also Gravestones
Tomlin, Bradley Walker 1166
Tonalism 516
Tooker, George 1167
Topographic painting 487, 501, 532, 547–48, 647, 1205. See also Landscape painters and painting; Marine painting
Town, Ethiel 428
Town and Davis 322, 428. See also Davis, Alexander Jackson
Townsend family, furniture makers 1153
Trompe l'ciel tradition in painting 523
Trost, Henry Charles 145, 429

Trost and Trost 145
Trova, Ernest 1435–36
Trumbull, John 430–31, 1168–71
Tryon, Dwight W. 1172
Tuscan Revival. See Classicism, in architecture
Twachtman, John Henry 1173–75, 1192
Twitchell, Tollyn Jules 404
Tworkov, Jack 1176

U

Ulrick, Charles F. 533
United Nations Building 131
Universities. See Academic architecture; Academic art; Architectural education; Art education; Campus architecture
University of Illinois, Chicago Campus. See Illinois, University of, Chicago Campus
Upjohn, Richard M. 432–33
Urban architecture 166, 176–81, 204, 222–23, 297, 305, 307–8, 388, 466. See also Cairo, Illinois; Chicago, Illinois; New Amsterdam, New York; New France, Canada; San Francisco, California; Washington, D.C.
Urban renewal 307

V

Van Alstyne (Eleanor and Mabel) Collection 1479
Vanderlyn, John 1177
Van Dorenstaw, Howard 445
Van Rensselaer, Mariana 1097
Vaux, Calvert 434–35
Vedder, Elihu 1178–80
Venturi, Robert 307
Vesell, Elliot C. 702
Victorian art. See Arts and crafts movement
Virginia. Capitol Building 357–59